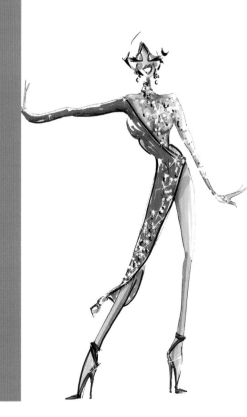

She's Got Legs

She's Got *Legs*

A History of
Hemlines & Fashion

Jane Merrill and Keren Ben-Horin

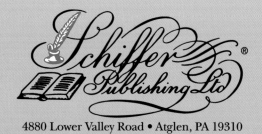

Schiffer Publishing Ltd®

4880 Lower Valley Road • Atglen, PA 19310

Published by Schiffer Publishing, Ltd.
4880 Lower Valley Road
Atglen, PA 19310
Phone: (610) 593-1777; Fax: (610) 593-2002
E-mail: Info@schifferbooks.com

Other Schiffer Books by Jane Merrill:
I Love Those Earrings: A Popular History from Ancient to Modern, 978-0-7643-4516-6

Other Schiffer books on fashion history:
California Casual: Fashions, 1930s–1970s, by Maureen Reilly, 978-0-7643-1246-5

Collectible Fashions of the Turbulent 1930s, by Ellie Laubner, 978-0-7643-0867-3

Fashions of the Roaring '20s, by Ellie Laubner, 978-0-7643-0017-2

For our complete selection of fine books on this and related subjects, please visit our website at www.schifferbooks.com. You may also write for a free catalog.

We are always looking for people to write books on new and related subjects. If you have an idea for a book, please contact us at proposals@schifferbooks.com.

Schiffer Publishing's titles are available at special discounts for bulk purchases for sales promotions or premiums. Special editions, including personalized covers, corporate imprints, and excerpts can be created in large quantities for special needs. For more information, contact the publisher.

Photographs by Nasser K., 2014.

Designed by RoS
Type set in Futura Std/Perpetua
Cover image: French silk stockings with garters by pinup artist David Wright, 1947. © Estate of David Wright/Mary Evans/The Image Works.

ISBN: 978-0-7643-4952-2
Printed in China

Half-title page image: Courtesy of Mistinguett Productions, Inc.
Title page image: Woman on Ladder, HIP/Art Resource, NY

Contents

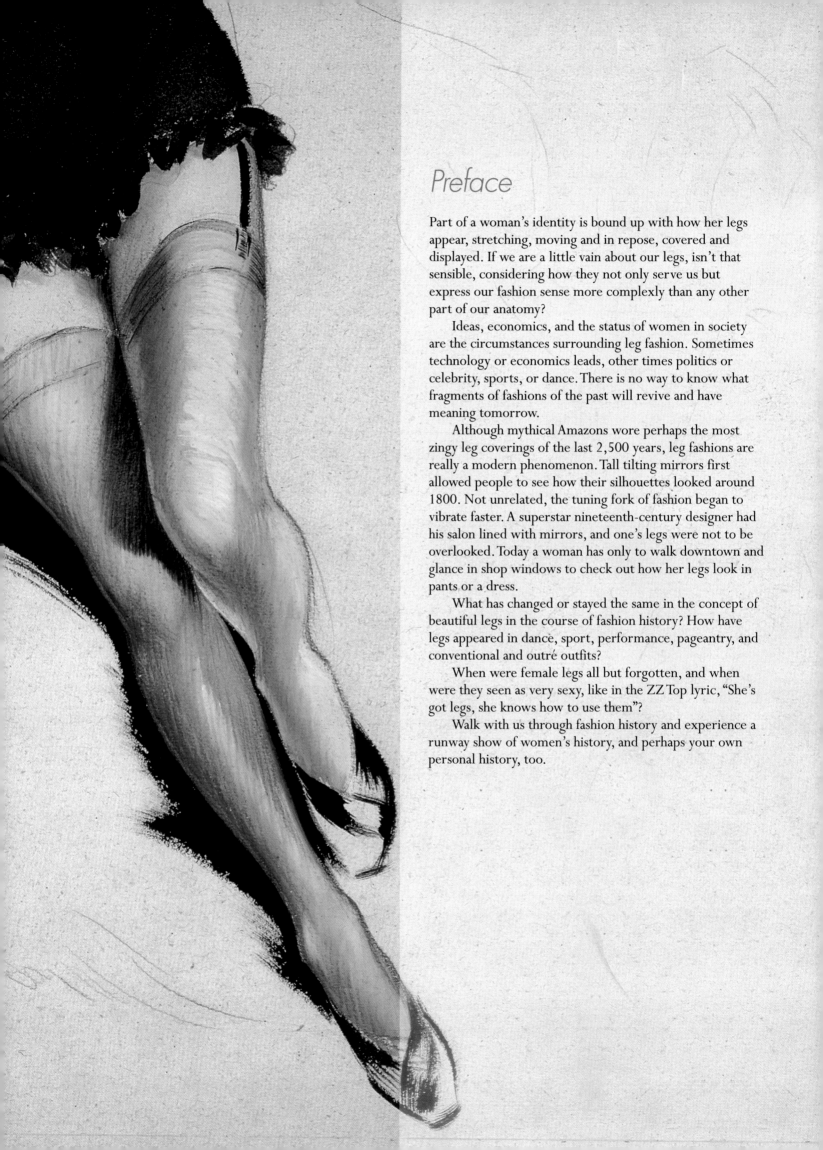

Preface

Part of a woman's identity is bound up with how her legs appear, stretching, moving and in repose, covered and displayed. If we are a little vain about our legs, isn't that sensible, considering how they not only serve us but express our fashion sense more complexly than any other part of our anatomy?

Ideas, economics, and the status of women in society are the circumstances surrounding leg fashion. Sometimes technology or economics leads, other times politics or celebrity, sports, or dance. There is no way to know what fragments of fashions of the past will revive and have meaning tomorrow.

Although mythical Amazons wore perhaps the most zingy leg coverings of the last 2,500 years, leg fashions are really a modern phenomenon. Tall tilting mirrors first allowed people to see how their silhouettes looked around 1800. Not unrelated, the tuning fork of fashion began to vibrate faster. A superstar nineteenth-century designer had his salon lined with mirrors, and one's legs were not to be overlooked. Today a woman has only to walk downtown and glance in shop windows to check out how her legs look in pants or a dress.

What has changed or stayed the same in the concept of beautiful legs in the course of fashion history? How have legs appeared in dance, sport, performance, pageantry, and conventional and outré outfits?

When were female legs all but forgotten, and when were they seen as very sexy, like in the ZZ Top lyric, "She's got legs, she knows how to use them"?

Walk with us through fashion history and experience a runway show of women's history, and perhaps your own personal history, too.

CHAPTER 1

Sway and Swish: Prehistory

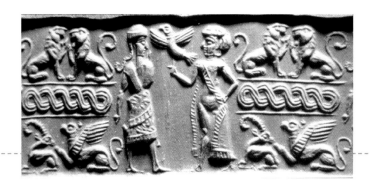

From the dawn of civilization, women's legs have been a source of pride—and attention. Love may come in at the eye but the humans of prehistory lived in small groups. If seated around the campfire, they could look deep in the eyes of their brothers and sisters, whereas more distant figures—seen walking, running, or trading—presented a different genetic lineage and captivated the heart.

The skin is the body's largest organ and regulates body temperature so well that in prehistory it was physiologically necessary for humans to wear clothes only in extreme environments. Yet along with protection from exposure, beauty had a value.

A woman dresses for her identity, or to feel "bien dans son peau" and to look fine, a combined rationale neatly satirized in Anatole France's *Island of the Penguins* (1908). In the story, an aged priest with very poor eyesight arrives on the island, mistakes the penguins for innocent primitives, and baptizes the whole colony.

The birds, though, are capable of and indulge in the "sins of Eve." A shifty monk brings a chest of clothes and proposes to a male penguin that he will ascend to a higher spiritual plane when he no longer sees the female penguins in their feathers: "his vague desires will extend in all sorts of dreams and illusions; in short he will understand love and its unfortunate follies."

The monk catches a female penguin and gives her footwear with two-inch heels, which make her legs appear longer, and a pink tunic. The bird likes her new look and shows how she will raise the skirt with her wing. Off she marches and the males, who were drifting around or dozing, bound up after her, a long line of penguins forming over a stream and up a hill. But walking, she finds, is hard going. Fashion is in constant flux but wearing pretty clothes is a feature of the mating dance and not so subject to reason.

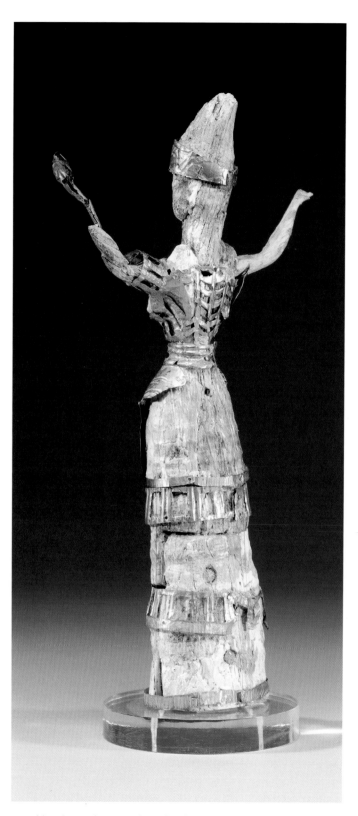

Gold and ivory figurine adorned with snakes from the sanctuary of the Minoan palace of Cnossus, Crete (sixteenth century BC). She wears a tiered, bell-shaped skirt and a close-fitting top. Walters Art Museum, Baltimore, Maryland.

▪ Vive la Différence

The discovery of "Lucy" (*Australopithecus afarensis*) in Ethiopia in 1974 proved that people have been walking upright on two legs for 3.2 million years. In 2000 there was a discovery in the same region where Lucy was found: "Big Man" was a hominid with long legs, a narrow chest, and an inwardly curving back, implying he was based on the ground and had a humanlike gait. Anthropologist C. Owen Lovejoy, director of Kent State University's anthropology institute, describes Big Man as an excellent runner whose pelvis supported human-like hamstrings and whose feet had arches.[1] This find suggests that Lucy too had a good stride, her short legs being in proportion to her smaller height (three and a half feet, compared with his five to five and a half feet). While nobody questions whether Lucy climbed trees, it seems that unlike the other primates, she was an ideal walking companion and had a straight-legged stride.

Meanwhile, Lucy's bipedal walk changed her sex life. As Lucy and her descendants found their two feet and left the trees forever, hominids repositioned sexual intercourse to the front. About 200,000 years ago humans who separated from their hominid forebears generally preferred sex face-to-face. Therefore women's legs spread to accept the man, and became so closely associated with sex that women tended to sit and walk with their legs held close and studiously clothe their lower bodies.

As Lucy and her descendants left the trees for the savannah, their children's brains increased in size. The birth canal expanded in order to bear such bright creatures, and the pelvis of the woman widened. This anatomical adjustment gave females a distinctive sway when they walked. When it came to hunting down game they were slower than men and generally stayed close to the hearth to tend to babies and supper. Women's interest in adorning their bodies probably began with an awareness of how their legs looked in movement and their desire to accentuate their hips, the only difference in their skeletal anatomy from men's.

▪ The Sewing Edge

An Australian anthropologist named Ian Gilligan researched the needle and its prehistoric origins. He postulates that the innovation of the needle may have given our species an evolutionary edge over other hominids, and that attending to how we look in clothes ushered in the other signature behaviors like building shelters and hearths, and making tools and bread and jewelry.

The Neanderthals had shorter limbs and more hair than our modern man ancestors and adapted to cold—but only up to a point. They perdured through glacial cycles until a series of abrupt fluctuations led to extreme cold and exceedingly strong winds about 30,000 years ago. Unprepared for the wind chill spikes, they retreated southward into warmer regions, where they dwindled and disappeared.

Meanwhile, modern humans from Africa migrated north into northern Spain by 40,000 BC. They developed clothing to keep themselves warm. Ironically, it turned out that having to adapt to cold gave modern man a step forward in evolutionary behavior. With the sewing of clothes, other modern technologies and behaviors emerged.

▪ The Skirt Is Born

In *The Iliad*, Homer tells of Hera, the queen of heaven and goddess of marriage, primping for Zeus. Hera spends a lot of time reining in her philandering husband. In this particular episode, she puts on a garment with 100 tassels and then borrows Aphrodite's "embroidered strap" for further cachet. This very early Greek garment was both ornamental and sexy.

Hera's tasseled gown can be traced back to 20,000 years ago. After the glaciers receded, the cave-dwelling Paleolithic hunters and gatherers carved wood-chipped stone blades and fashioned objects of string and fiber. On the earliest figurines of women are examples of twisted string skirtlets that contradict the idea of people at the dawn of Western civilization garbed only in fur pelts. Already among the very early human, it was important to women to wear a garment that enhanced the attractiveness of their legs by moving as they walked.

The woman of prehistory was concerned with showing she was fleet of foot, because that was healthy. If she clothed her legs to show status, we do not know. However, from what we know of how she arrayed herself in Eurasia, she unquestionably declared her prettiness.

Paleolithic cord skirts were, according to anthropologist Dr. Elizabeth Barber, a cultural signal that the woman was of child-bearing age. This wasn't an undergarment. Carved representations show that the skirts, first of twisted string and then flax, hemp, nettle, and similar plants, either hung down just on the front or tapered to tailcoat-like backs and had a nice symmetry. Some had fringe as well as the twisted cord. "I'm pretty" was their primal fashion statement. With it, they could have worn capes of furry pelts.

Evidence shows that many of the early European women ran around in just their little skirts. In *Women's Work*, Barber recounts how her Finnish friends and their children were in their shirtsleeves in subfreezing weather when she, a Californian, was wearing umpteen layers and shivering. "Your body accustoms itself to cold by retracting the capillaries from the surface of the skin, and accustoms itself to warm weather by moving the blood vessels to the surface to cool off. So they almost certainly did run around in only string skirts."

Minis of the Bronze Age

Actual corded skirts have been discovered from the Bronze Age in Scandinavia. Clothing had come a long way in those intervening 20,000 years and craftspeople demonstrated variety in the skirts they created. Barber notes that by this time in history, beauty was almost certainly involved, as well as message.

An amazing fully preserved skirt from 1300 BC was found at Egtved in Denmark, from an oak-log coffin burial. It belonged to a girl between sixteen and eighteen years old. She wore a bodice, had a tasseled belt, her hair was held back with a cord, and over the lower part of her body she wore a knee-length corded skirt of brown coarse tabby, a basic weave where the thread passes over and under alternate warp threads (somewhat like the pot holders that children make on a loom with loops).

The skirt was designed to hang attractively from her hips. Thick twists of wool, woven into the waistband, hang down fifteen inches (the example is longer than the common style seems to have been). The bottom of the Egtved skirt has knots, and a cord around the lower part of the twists keeps them in order. Other remnants of corded skirts from the Bronze Age had bronze tubes. There is nothing like this for men during pre-history. It's possible to imagine how these long-ago women wore their cute little skirts. Almost two decorative yards of weave wrapped around the body twice and sat on the hips, while the skirt's tie-belt wrapped around and knotted in front. A contemporary woman could virtually wear the same skirt, which looks like the apron of a folk dance costume from the Balkans today.

That the skirts were preserved in the boggy Jutland peninsula of Denmark is amazing. No one knows if the women who wore the little skirts were wives of rich men, priestesses, or powerful women in their societies, or just good weavers. Archaeologists have concluded that the weavers were creative and fashioned the skirts to suit their tastes: few corded skirts were identical. Sophie Bergerbrant, a Norwegian specialist in prehistoric attire wrote, "The women in the higher social strata of the Bronze Age did not seem to worry too much about practicality."[2]

Evidence of these low-slung skirts extends legs' fashion history back dizzily in time. The key fact about the corded skirts is that the women who crafted and wore them were dressing up and drawing attention to the part of their anatomy that was different from men's, their hips. A well-made corded skirt, such as the Egtved skirt on display at the National Museum of Denmark, showed off a woman's movement and walk. This one was originally the color of the wool used to make it, but darkened from the oak coffin combined with groundwater for thousands of years.

Another, even older, skirt, dated 3900 BC, woven of straw with colorful patterns, made news in 2010 when it was discovered in southern Armenia, near the border of Turkey and Iran. Woven 5,900 years ago and described by the archaeologists as "of rhythmic colored hues," it was found in the same cave as the world's oldest leather shoe.

Style from the Steppes

John Wertime, an expert on Central Asian textiles, explains that both the transformation from draped to tubular sewn tunic and the wearing of trousers probably took place in the wild steppes of Eastern Europe, Russia, and Central Asia. According to the familiar adage, the person who wears the pants (or trousers) calls the shots. In fact, female graves of Scandinavia and Eurasia from the Bronze Age contain both weapons like bows and arrows, riding gear, and daggers and artifacts that are traditionally seen as feminine, like the textile remains of skirts, spindle-whorls, and bronze mirrors. The burials suggest that women were active warriors and that the origin of trousers may have been less gender-related than has been assumed.

Contrary to what one might imagine, a basic style of clothing that became the norm in the West was developed not by the sedentary people but by mobile Indo-European herders in the steppe before and during the second millennium BC. The highly functional steppe style of dress—consisting of tunic, then jacket and trousers—became the clothing of conquerors and rulers in much of Eurasia. Sedentary society's contribution came in the form of materials, dyes, techniques of decoration, and designs. This apparel was often fashion driven and subject to change, but only in its details. The basic structure of the garments and accessories always remained the same.

The original tunic was fashioned from a single rectangular cloth folded lengthwise and pinned at the top, ankle length, and belted at the waist. This is what the Classical Greek wore and called the chiton.

The tubular body and tubular sleeves traveled across the steppe just as the new spoke-wheeled chariot had. The new style of garment complemented the horse culture of the chariot riders and their wives. As a closed garment, the tubular tunic helped to preserve body warmth; as a linen undergarment worn with a "cloak," it also protected against scratchy wool. Next the closed tubular tunic was given an open front, thereby creating the caftan or jacket.

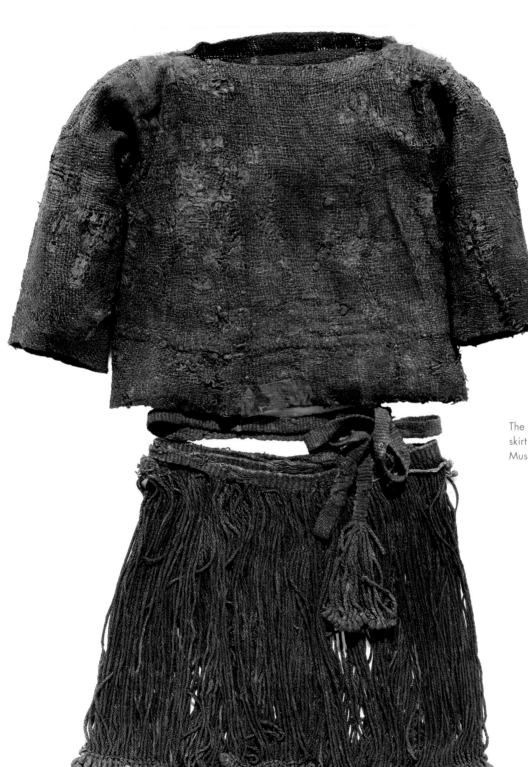

The "Egtvedgirl" bodice and skirt (1370 BC). The National Museum of Denmark.

Babylonia and the Tufted Skirt

Given that the civilization of Babylonia spanned 2,000 years until finally replaced by the Selucid Dynasty in 312 BC, skirts and leg attire for women went through many permutations. Expert weaving and not too much folding were the constants. From 2500 BC, the Middle Eastern clothing of southern Mesopotamia shows characteristics of draping (indigenous) and cutting and sewing (in hemmed garments brought in perhaps by trade and settling nomads).

In Sumer and Akkad, the Fertile Crescent, sculpted goddesses and real women wore garments with round necklines, sleeves, and seams joining the widths of fur in tiered flounces. To make a costume sumptuous, patterns were added, and beads of gold, lapis, agate, or cornelian were sewn on. The stylish length was mid-calf, and the dress was worn with a long fringed shawl.

Decorating and fringing the garment's hem began with sheepskin. When heavy thick wool or haircloth replaced sheepskins, the Babylonians deliberately fringed the garments at the hem to simulate tufts of fleece. Augusta McMahon, scholar of ancient Mesopotamia at the University of Cambridge, notes that, "the garments shown in the statues, of tufted fleece, or a woven and tufted imitation of fleece, would have been desperately hot in the summer climate, so it's a bit of a mystery—it could be a ceremonial garment not used for everyday wear."[3]

By the second millennium BC, women's clothes showed a penchant for bright colors and geometric patterns all over or on the borders, embroidered or block printed. The hemline varied between ankle and knee length, with a tendency for richer women to have longer gowns.

Power Play

Ishtar was a complicated goddess, feminine and fierce, of the ancient Near East and was especially prominent early in the first millenium. In the exquisite cylinder seal shown here, she wears a short kilt and a long cloak, with her leg revealed like a showgirl doing a dance step. This is thought to be the clothing of a warrior, since Ishtar functioned as the goddess of war. Male warriors, according to Zainab Bahrani, professor of Near Eastern history at Columbia University and author of *Women of Babylon: Gender and Representation in Mesopotamia*, wore short kilts at this time, too.

Ishtar is also the goddess of love and sexuality and revealing her legs in this way portrays her feminine allure. She is supposed to be a sexy goddess, a femme fatale. Women would have worn long gowns, either with separate layered tiers, or with a wrap-around fringed cloth. Scholars suggest this was only worn by Ishtar because the only images represented in art that depict this kind of costume are those worn by her. Of course that does not mean with certainty that no one else ever wore similar clothing.

Ishtar is in a frontal position and looks as though she has just twisted forward. Her leg is slightly bent and is exposed by the skirt's deep slit. She has a dynamic pose with a muscular leg thrust forward and planted firmly to the side. Bahrani suggests that the pose isn't merely a reference to power but seems to be an act of communication between two realms, appropriate for a goddess who transgresses boundaries.

Shadow Play of the Elegant Leg

Women of ancient Egypt wore sheaths to their ankles that must have felt very good and cool on the legs. The non-elite women wore a gown of a rectangle of fabric that was wrapped around the body, with an additional half-turn that brought a corner up to tie at the shoulder. Sheath dresses that attired the elite were sewn down one side, then hemmed, with broad straps added to go over the shoulder. It was decorated with patterns, often diamond-shaped, which might be a bead-nct. This sheath dress was not as form-fitting as depicted in the many representations of Egyptian goddesses and women in Egyptian art. The basic sheath was worn for thousands of years, although naturally with varieties: Queen Nefertiti was dressed in a long sheet of fabric draped around the body twice and self-tied in front, leaving one shoulder bare.[4]

The sheaths were linen. Spun from the fibers of the flax plant, linen has a long staple, or individual fiber length, compared to cotton, and flows over, rather than hugs, the body. The Egyptians even used flax as currency. Fine linen

Cylinder seal imprint showing a male figure before a goddess drawing aside her mantle, with a bird perched on her finger (1650–1350 BC). The Pierpont Morgan Library/Art Resource, NY.

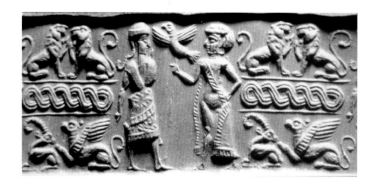

The Royal Descendant Hetepheres (Egyptian, Eleventh Dynasty, ca. 2440 BC). Worcester Art Museum, Worcester, MA.

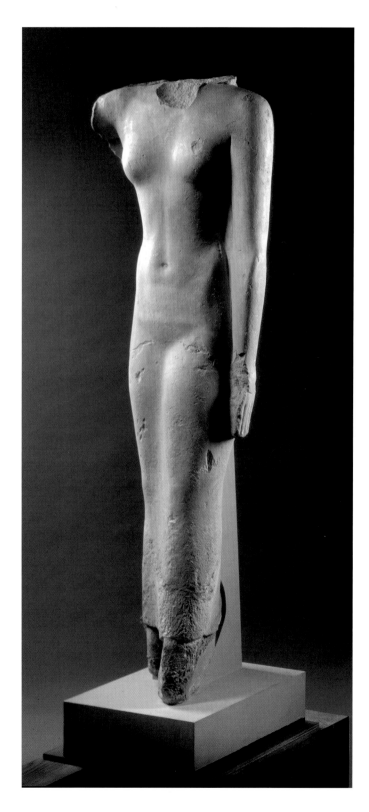

was a wonder of antiquity. It came in different weights, was sometimes formed into a fishnet fabric, like macramé, and color variations lent themselves to crimping. Anyone who has sewed with linen—cool, stiff and smooth—understands that it looks best when allowed to drape and flow.

The noble appearance of the ancient Egyptian in her sheath continued for more than a thousand years, until the end of the New Kingdom, around 1000 BC. The Egyptians found the best design that works with linen and stuck with it. As the American mummy expert Bob Brier explains, "The ancient Egyptians were a very conservative people and did not seek change in their lives. They had a concept called Divine Order that meant that if all was right—unchanging in Egypt, all was right with the world. The concept carried over into their art and in their style of clothing—the linen sheath, cool and practical in the desert heat. They did not seek change for the sake of novelty."[5]

The ancient Egyptians weren't much for tailoring their clothes. In the ancient world, eyed needles and scissors only came into use late in their history, mid-first millennium. In addition, linen has a mind of its own. Egyptians, like the civilizations of ancient India and classical Greece and Roman that followed them, were intent on weaving not sewing. They mostly tore the fabric straight down, and sheared at the neck to shape. All the same, they used needles of copper, bronze, and silver, and pierced bone to sew the tube-shaped dress. They also used needle cases and stone finger guards. The needles used to sew the mummies were large, and the ones used for the best linen, which was prized all over the known world, were very fine.

Undoubtedly the prize for the longest lasting leg fashion goes to ancient Egypt, where from 3000 or so BC until 600 BC women wore the tunic-like *kalasiris*, or tube sheath, to their ankles. Clothes meant status, and the more cloth the more status, while slaves were naked and performers topless.

Already during the "golden age" of the Old Kingdom, about 2500 BC, in the Fourth Dynasty, sheaths were very tight. The kalasiris was diaphanous and pleated. Its smooth, flowing texture made a woman feel sensuous and

encouraged her flowing, outward gestures of hands and graceful movements of legs, as seen in the art of the time.

The Middle Kingdom was unisex vis-à-vis clothes and men were even depicted with what looked like female breasts, unisex hair, and long skirts. It was the belt tied at the waist that identified the men, and the straight yet curvy drop of the kalasiris that belonged to women. Below the level of regent, women held office, and when succession was uncertain, they ruled independently. A queen's power was shown by revealing her body from hips down, with strong, slender legs under the lightest linen garment. The naked leg showed her sexuality, while the clothing symbolized her wealth and authority. In artworks, thighs, knees, and the calves of these powerful women were shown in clear contour even though the kalasiris covered the feet. While the molding of the sheaths to the legs in art may have exaggerated what the clothes were like, it does seem that very smooth and finely woven linen was the top quality of at least four different weights of linen, varying from "smooth" to "royal."

In the Eighteenth Dynasty, deities still wore sheath-dresses but for Egyptians new styles came in. During the New Kingdom (1580–1090 BC), which was the latter part of the Eighteenth Dynasty, Egypt had a new theology and the king changed his name. Akhenaten was now the intermediary of the people for the one and only sun god. The religion included a high place for his wife, Nefertiti, the iconic beauty who was his co-ruler. The ideal of female beauty also changed from lithe to a fuller lower body—big hips, pronounced buttocks, and a rounded belly. An upper-class woman wore a shawl over a long and thin draped tunic—self-tied, and leaving one shoulder bare. Artists exaggerated the thinness of the garments so the pleats, fringes, and the ends of the knots or tasseled ends defined graphically with oblique and vertical lines the shape of the woman's body.

Queen Nefertiti and her six daughters wore long high-waisted dresses under a tunic with wide sleeves down to the elbows. Akhenaten founded a new capital, at Amarna, building it in less than ten years. The figures in art there differ considerably from other ancient Egyptian art. From the tomb-chapel of a high official is a picture of Nefertiti wearing a long open skirt and looking like an exotic dancer. Knotted high at the waist, it falls in folds opening from her hips to reveal her stomach and sex, thighs, and one leg, while the other leg is fully visible through the transparent skirt. The skirt covers her body at the back to the ground.

The artistic convention had been to give figures legs and feet that were identical on the left and right sides. However, at this period in time, the artists of the Thutmose workshops drew more realistic representations. In an article titled "Seeing through Ancient Egyptian Clothes," Canadian Egyptologist Lyn Green notes that in the Eighteenth Dynasty, the older queens and noblewomen were represented naturalistically, with thickened waists, less pert breasts, and even the detail of a few sagging facial muscles:

> These deviations from the accepted ideal of eternal youth are compensated for by the considerably elaborated clothing worn by both individuals… layers of multiple draped garments, decorated with fringes, crimping and pleating, as well as massive elaborated curled wigs, offset any loss of dignity implied by the representation of the natural ravages of time.

These Eighteenth Dynasty examples of dress appropriate to the older woman are a historical first.

As far as representations of Nefertiti, who was at the peak of her youthful beauty, the artistic convention was to show her in a transparent pleated robe tied high (usually under the bust) and completely open, testifying that her form was elegant and the linen of her clothing superfine. She was so lovely that she could be shown next to naked, both queen and fertility symbol. Egyptologist Joyce Tyldesley notes in her biography *Nefertiti: Egypt's Sun Queen* that the standard attire of real women of the time was baggy linen dresses with sleeves and a shawl but "representations of Nefertiti did not necessarily conform to modern ideas of feminine modesty, and her garments are occasionally so clinging that they can only be detected by the presence of the thin line denoting the neckline." The last sculptures from the workshop of Tuthmosis at Amarna show an older Nefertiti wearing a dress that drops straight down over a more pear-shaped body.

Servants had to hand-starch and press the pleats that gave these garments their classy look—a time-consuming task, though not on the scale of building a pyramid. The kalasiris fabric called "royal linen" from Hatnofer's tomb in Thebes (fifteenth century BC), on display in the Egyptian galleries of the Metropolitan Museum, is so feathery as to be transparent and has an inlaid fringe that must have graced a hemline. It took very young flax to make textile of this quality.

Soon Tuthmosis III expanded the empire and brought foreign weavers to Egypt, who created the fine textiles in Tutankhamen's tomb. The New Kingdom paintings represent women's garments by dimming the tint of the flesh seen through the material and showing the folds by shading in white and black.

Herodotus in his ancient history wrote that the eye was drawn to the legs of the kalasiris: "They wear tunics made of linen with fringes hanging about the legs." As for Cleopatra, her hems were woven with gold. When she wore a fringed mantle knotted at the chest over her tunic, she was in her guise of Isis, the goddess of life.

▪The Flouncy Skirts of Crete

The skirts of Crete were like nothing before and little since. While not preserved, these Bronze Age Aegean clothes of the Minoan civilization (3000–1600 BC) are seen in art. Snake goddess figurines and palace frescoes at Knossos reveal what Minoan women, as well as those of mainland Greece and the Cycladic Islands, wore. The Minoan women of Crete had elaborate hairdos and maquillage and garbed the lower half of their bodies in the most sensational fashions of the ancient world—long flared skirts made of overlapping flounces or, possibly, horizontal strips sewn on the skirt. It is suggested that they wore the first version of crinolines, supported with hoops of rushes or metal. Their skirts were thigh-length and had vivid colors—elements of red, blue, yellow and purple—with flounces sewn from hips to the feet. Some were two-tiered, some pointed in front, some were of graduated depth, and some formed a checkerboard of colors. The typical Minoan multicolored flared and flouced skirts evolved to a bell shape. Over time the skirts became dressier with embroidery and decorations as well as tiered flounces. A woman athlete wears tight shorts as she holds out her arms to catch a jumping athlete in the celebrated Toreador Fresco, a Minoan wall painting. In ancient times, dancing girls and gymnasts wore outfits that gave them more freedom of movement.

Mycenaeans who invaded in 1450 BC adopted Minoan dress styles of the long flared skirt. When the Cretan civilization was wiped out around 1400 BC, the strong, free leg went into eclipse and the columnar draped leg dominated fashions during the Greco-Roman era.

In *The Clothed Body in the Ancient World,* Ariane Marcar, a specialist in Aegean costumes of the Bronze Age, writes that cutting cloth on the bias explains the tight-fitting aspect of Minoan and Mycenaean bodices in iconography that added to the belled effect of the skirts in an era where full-tailoring was not yet practiced or known.

Gold and ivory figurine adorned with snakes from the sanctuary of the Minoan palace of Cnossus, Crete (sixteenth century BC) Walters Art Museum, Baltimore, MD.

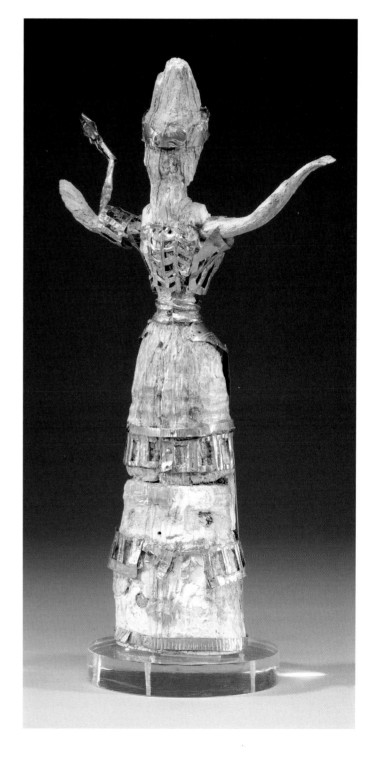

▪ The African Queen

The Queen of Sheba visited Solomon, who asked her to rid the hair from her legs before they slept together. This stirring event seems to have occurred around 960 BC. There are early strands of the story in Jewish, Arab, and Ethiopian oral tradition, as well as I Kings 10 in the Bible and in the Koran. (Deborah M. Coulter-Harris, author of *The Queen of Sheba*, builds a thesis that the Queen of the South, Hatshepsut of Egypt, is identical to the Queen of Sheba.) News circulated of the beauty and brilliance of the Queen of Sheba that crisscrossed with tales of the glory of King Solomon. Sheba wanted to meet Solomon, and he dreamed of her. Taking the initiative, Solomon sent a colorful, orange-crested messenger bird, the hoopoe, over great expanses of desert, to Saba, probably present-day Yemen and Ethiopia, to spy on Sheba.

The hoopoe proved an ambassador who spurred the powerful queen to make the long journey to Solomon's court. When the King heard she was coming, he began to obsess about her beauty. Though everybody praised the queen, the *jinn*, who built Solomon's palaces, said she had the hairy legs and hooves of a mountain goat. The Koran (early seventh century AD) is the earliest certifiable description of Solomon's concern about Sheba's feet.

The wily king devised a trap, a polished tile courtyard of marble that he ordered filled with water an inch deep. When Sheba and her entourage entered, Solomon peered up her skirts in the pool's reflection. Indeed, the beauty's legs were covered with hair like a beast's. On the bright side, her feet were human.

Meanwhile, Solomon delighted in the queen. He called his demons and told them to bring a certain sticky pitch down from the hills—the first depilatory. The lotion was effective, the royal persons consummated their love, and Sheba went home pregnant to rule her own kingdom and spawn the first king of a long-lived Ethiopian dynasty.

In fact, the fashion of removing hair from the legs goes back to ancient Egypt. When linen became fine, women decided that hair on the legs, matted down and showing through, had to go. They used sugaring, which is like waxing in that a sticky paste of oil and honey was stripped off once it was partly dry, or a cream lotion to dissolve hair, or threading, where twisted cotton thread is rolled across the skin and catches on the hair.

Wherever fine Egyptian linen was traded, the fashion of having smooth legs went as well, implying that legs were seen, either when women lifted up their tunics to climb stairs, or merely through the translucent delicacy of the fabric.

Royal Cross-Dressers

HATSHEPSUT, the demi-goddess of Egypt

Queen Hatshepsut (1508–1458 BC) declared herself a pharaoh. She would strap a gold beard to her chin and go out before the citizens or on expeditions posing as a man—wearing a pharoah's traditional main piece of clothing, the shendyt, a wraparound pleated garment. Positioned at the right hip and wrapped around the body, back to front, the shendyt was made of thin linen. Kilt-length, reaching to just above the knees, it can be construed as proto-trousers that were not seamed.

When her nephew Thutmose III was seven years old, Hatshepsut had already been crowned king and adopted the royal protocol of Egyptian monarchs. Formal portraits show a man wearing the traditional kilt, crown or head-cloth, and false beard, the first recorded image of a cross-dressing queen. She chose this masculine guise, and wore male pharaohs' robes while out in public and with her court. (A similar story is told in the tales of the Queen of Sheba. In fact, Hatshepsut may have been one and the same as the Queen of Sheba, who dressed as a man when she met Solomon and reportedly dressed in male pharaonic attire for all public occasions.)

Hatshepsut claimed to be the daughter of a male god whom she represented on earth; if she appeared dressed as a man, her political power and authority were less likely to be threatened or challenged when dealing with politicians, priests, or the public. Coulter-Harris says that Hatshepsut engineered an androgynous or hermaphroditic physiology to create an image of a woman equal in status to male Egyptian kings.[6]

SEMIRAMIS, Assyrian queen of ancient Babylon

Semiramis (circa thirteenth century BC) was, according to the Greek writer Diodorus, the daughter of a fish goddess and a mortal who restored the ancient city of Babylon. She lived in a time of a struggle for the kingship and the reigning king, Ninus, took her away from her husband, an officer (as Solomon

did Bathsheba). When Ninus died, she took over as regent for her son and went on a conquering expedition in western Asia. She also built a huge temple to her husband. Diodorus wrote that Semiramis wore trousers to protect herself from the heat and to move unhindered. He went on to say that the Persians were still wearing her dress of tunic and trousers. In European art, Semiramis has often been depicted like an Amazon in trousers.

ZENOBIA, the legendary queen of Syria

Zenobia (third century AD) was a female ruler in the male-dominated ancient world and notorious for wearing trousers. She married a prince named Odenathus when she was fourteen and he was middle-aged. She probably had noble lineage and likely was descended, as she claimed, from Cleopatra of Egypt. Her name derives from "beautiful long hair" in Arabic, and she was intelligent, beautiful, and daring.

Zenobia loved to hunt and ride with her husband, the ruler of Palmyra. The horseback riding prepared her to lead an army against the Romans. The notion that we wore trousers comes from literary sources, as artists in the ancient world never showed a woman in trousers.

Circumstantial evidence suggests she wasn't wearing rough trousers sewn up from a couple of rectangles of coarse fiber straight from a wooly sheep, but, rather, baggy trousers cinched in at the ankles (i.e., harem pants). A few surviving remains of woven silk garments have extraordinary bands of flowers and animals; these would have been her leisure trousers.

Other women in Palmyra wore long chitons with or without sleeves, either long or short, often of silk, covered with richly colored robes of multicolored wool or cotton, while Palmyrene young men favored silk brocade pants banded at the ankles, as illustrated in Roman funerary portraiture. Palmyra was one of a number of Roman holdings in Syria. By the time the

Emperor Augustus annexed it in 14 AD, Palmyra was a flourishing kingdom between Persia and Rome, and an important node on the silk route from the Far East. Given the Roman desire by then for silk, the desert oasis of Palmyra rose to prosperity and Palmyrenes themselves had a reputation for living in luxury.

The Roman emperor Aurelian reduced Palmyra's walls to rubble and arrived in Rome with Zenobia as prisoner in gold chains in 273. Zenobia had lost her husband and at least the first of her sons, but in her enforced retirement in a villa in Tivoli she had the Romans' respect, and it is known she remarried and had another family.

ATOSSA

There was an actual Persian queen named Atossa, the daughter of Cyrus the Great. She is mentioned in Herodotus's writings, among others. A second Atossa, the one who is said to have worn trousers, is described very briefly in a summary of a lost work by the Greek historian Hellanicus. This Atossa may have been Persian and may have been a historical or legendary figure.

The brief summary of Hellanicus's lost description of Atossa, found in *Warrior Women: the Anonymous Tractatus de Mulieribus* by Deborah Levine Gera says, "Atossa was raised by her father Ariaspes as a male and inherited the kingdom. Hiding her feminine mentality, she was the first to wear a tiara, the first to wear trousers, and to invent the use of eunuchs and make her replies in writing. She rules many tribes and was most warlike and brave in every deed."

Atossa used a variety of means—different clothing, a protective wall of eunuchs, and written correspondence—to conceal from her subjects the fact that a queen is ruling them and not a king, and that is why she wore trousers.

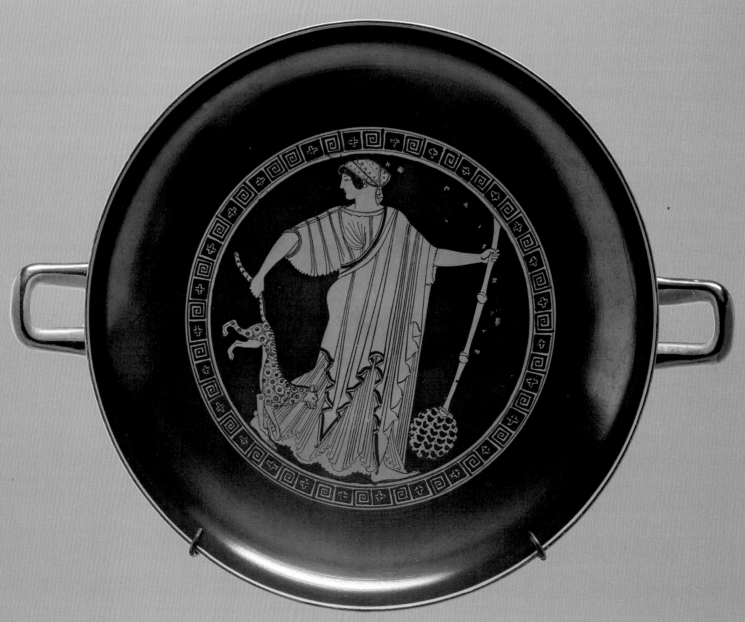

Red-figure terracotta cup showing a maenad on the
interior, by Douris (ca. 480 BC). Kimbell Art Museum,
Forth Worth, TX.

CHAPTER 2

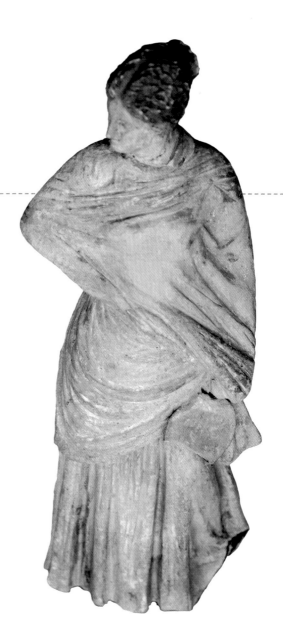

The Classical Overture

▪ The Columnar Silhouette

The legs of the caryatids hold up the porch of the Acropolis, and there is a corresponding columnar feeling to Classical female attire. The draping is time-honored, unchanged for centuries, stately and rather heavy. As the woman took a step, there was a slight delay in the movement of her clothes, as if a reminder that she belonged to a society with civilized cadence.

The other ancient Greek leg fashion, the filmy dresses slit up to the thighs of goddesses and maenads that danced with leaping feet, has come to us through red-figured and black-figured frieze designs on ancient ware. The nymphs could go on a hunt with Artemis and the maenads could keep up with Dionysus because they too had strong legs, yet with the effect of the diaphanous outfits appear more limber.

In Aristophanes's *Lysistrata*, the heroine unveils to the Athenian women a strategy to get the men to make peace with Sparta, by a sex strike. The women have to enflame their husbands' passions. They do it not by undressing but by dressing up—covering the body and putting on saffron gowns, and slipping into see-through chitons.

Athenian women were to walk daintily and not take long strides or run; they were proper, so any visual lifting of

Tanagra figurine of Kore standing (fifth century BC). Davis Museum at Wellesley College, Wellesley, MA.

a skirt expressed sensuality. Dancing was clearly an activity where the skirt was held up. In a play by Aristophanes, to get away from a policeman a girl is told, "Remember what I taught you—lift up your skirt and skip lightly." When an image on the inside of a wine cup shows a slim young woman raising her dress with both hands as she dances at a symposium, the gesture suggests sex after the dance. When a young woman made a point of showing her ankles, it was an invitation.

In ancient Greece, it was not what you wore but what your clothing was made of. Greeks used mostly wool but also linen and in Classical times cotton (Herodotus called it "wool from a tree"). Women spent much of their day spinning and weaving through the Classical period. This was their power base. Later (around 600 BC) the Greeks would turn to imports and being able to weave clothes for the family (or, like Penelope, a shroud for your father-in-law) was less valued.

The archaic Greece free-flowing *peplos*, a rectangle of cloth with the top third folded over, and fixed with two or more pins at the shoulders, was the foundation piece donned by everybody from aristocrats' wives to slaves. It was all folds, with even the belt hidden by the deep cuff or over-fold. While the poorer classes and slaves wore plain wool, the richer women wore costly cloth colored with some neat dyes made from shellfish (purple), beetles (red), and saffron (yellow).

Sometimes women put weights in the hem so the peplos would hang better. The hem was the decorative part of the garment. Euripides described Athena's peplos as having an embroidered hem with an image of the Battle of the Giants.

Classical sculptures, mosaics, ceramics, and murals often show feminine legs prancing, running, or dancing in garments whose fluidity betokens fine weaving and lightness. In a period in which drapery was a status symbol, these postures show off the finery and luxury of the fabric.

The long peplos trailed on the ground in back. There was no question if a woman had means, as the fine cloth signaled it. The finest cloth took three times as much yarn as the coarser, and it could take three working days or 150 to weave a fine linen peplos. Hans van Wees of the University College, London, in an essay in *Body Language in the Greek and Roman Worlds*, describes the peplos as a blanket-dress: "The larger the better. It was a case of female dress exploiting size to display wealth and leisure."

Van Wees analyzed *The Iliad* and *The Odyssey* to learn how important making and wearing clothes was to ancient Greeks. "In Menelaus's house, Helen stands besides the clothes chest in which she keeps the peplos she made herself. In *The Iliad*, another piece of Helen's handiwork

was a peplos with scenes of the Trojan War, the source both of her guilt and future fame, woven into it."

An ally of Menelaus offers Helen a golden spindle and a wool basket on wheels made of silver with a gold rim. When Menelaus gives Telemachus a golden cup and a silver mixing bowl, Helen adds her gift of a peplos for his future wife. According to Van Wees, this demonstrated "a female sphere of gift exchange, almost entirely separate from the male." Textiles were a prized possession for their ability to signal wealth and status.

After Homer the peplos got even longer (and more restrictive) until tastes changed again. Sappho refers to a beudos, a short diaphanous tunic, possibly red-purple, and mocks the girl in a "rustic outfit" who "does not know how to pull her rags down to her ankles"—in other words, who wears a dowdy peplos.

The open and draped Classical attire lasted for different lenghts of time in various Greek city-states. The Doric style evolved into an Ionic style. The progression was from plain to fancy, just as with the architectural columns with the same names. Classicist Marcar compares Egyptian women's dress to that of the Greeks: "The fundamental similarity between the two cultures lies in the lack of knowledge of true tailoring."[1]

The switch from the Dorian peplos to the *chiton*, a linen tunic that closed on both sides and that the historian Thucydides said was more luxurious, came in the sixth century BC.

Fastening the peplos with the fibulae, or pins, at the shoulder was a defining characteristic of this Greek national female dress. Why women shifted from the bulkier peplos that looks great in marble to the simpler chiton is explained by a sensational story. Herodotus pinpointed the change to a single year, 568 BC, when the women of Athens were outraged after a disastrous war between Athens and the island of Aegina, from which only one man of Athens survived. When he returned to the city-state, the women were angry that their husbands all died, except this sole survivor. They avenged themselves by removing their fibulae or brooch pins from their dresses and stabbing him to death. According to this strange drama, the Athenians imposed the Ionian costume on women to chastise them for having killed the only survivor of battle.

Women's chitons involved some sewing on the long sides but basically these were wraps. Fashion historian Bronwyn Cosgrave writes in *The Complete History of Fashion from Ancient Egypt to the Present Day*, "A woman could cover her hands and feet and wear her garment loosely, or draw it close, wrapping the folds to the contours of her body." Greek drapery in statues and on pottery illustrates that it naturally shifted from concealing the shape to revealing it.

Tanagra figurine of Kore standing (fifth century BC). Davis Museum at Wellesley College, Wellesley, MA.

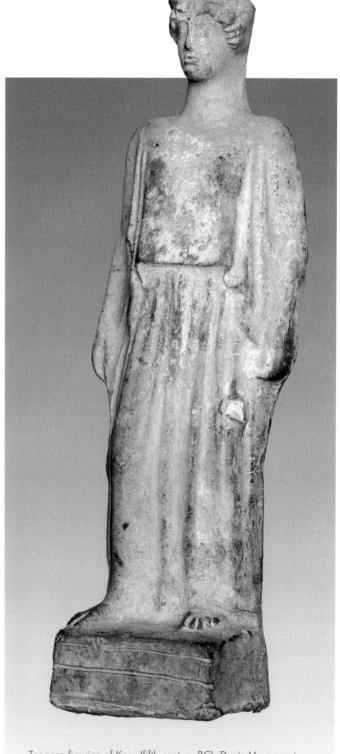

Tanagra figurine of Kora (fifth century BC). Davis Museum at Wellesley College, Wellesley, MA.

While it was often shown without color, the chitons had patterns including rosettes, flowers, and stars at the borders and hem.

If a woman was represented in art wearing a short chiton, that was a tip-off that she was either an Amazon or a young Spartan athlete participating in a race. In an Attic red-figure kylix, 470–460 BC, from Vulci, now in the Staatliche Antikensammlung in Munich, Penthesilea wears the shortest of chitons with crisp pleats and fringe at the hem. These short chitons tended to hug the hips and have bands at the waist and hem, appearing as a svelte girdle.

Amazon figures wore remarkably flashy leggings in many depictions in Classical Greece. The leggings had zigzag

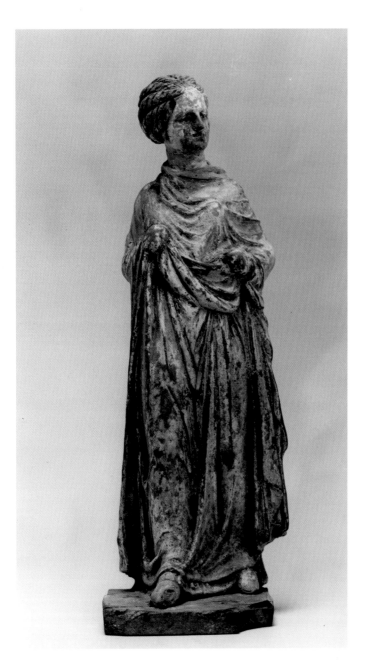

horizontal bands of contrasting colors, a pattern of dots all over, or layers of fringe or fringelike patterns. The shirt of the Amazon women either repeats the gaudy leg design or coordinates with it, and was close-fitting like the leggings.

Amazons were not victims but perpetrators. Their mythical race fascinated the ancient world. A Greek legend endowed Amazon queens such as Hippolyta and Penthesilia with exaggerated qualities of beauty and fierceness. These women were warriors, and their fury was feared more than a male enemy's. In a legend from Asia Minor, only those Amazons who had killed a man could mate with the Gargarians during the spring season. According to another legend, the Amazons burned off their right breasts in order to handle the bow more forcibly.

The short skirt worn by the Amazons in Greek depictions indicated that they were barbarians. Grisly or marginalized figures whose dress displayed their legs, the Amazons contrasted with respectable ladies and goddesses, who were garbed in long skirts.

Explains historian Dr. Tammy Jo Eckhart in her thesis about Amazons in the ancient world, "After the Persian wars, during the height of Athens's power, the Amazons are no longer shown in Persian styles in art or literature but have a Scythian look. For example, in the work of Herodotus he directly connects Amazon history to Scythians, claiming that they are a branch of that historical people. During the Classical period, Scythians were used as a slave force in Athens, so this connection to their dress may bolster the legends about Athens conquering and then defending itself from Amazons, by equating their dress to that of enslaved Scythians.[2]

The basic voluminous Greek peplos went far and wide. Although there are no full-length depictions of Cleopatra, portraits on "queen" jugs of the Ptolemaic era show the queen wearing a dress with ample vertical folds, draped and pinned at both shoulders—the same fashionable garment of Greek women at that time. As for the Amazons, their powerful mythology went into Etruscan and Roman art. However, in that art, observes Eckhart, they were not outfitted as a particular foreign group. According to Eckhart, the Etruscan images of Amazons are more femininely garbed, while for Romans the Amazons tended to be more sexualized with more skin shown, matching a heightened sexual element in later authors as well, during the Imperial period.

Greek figurine, late fourth to early third century BC. The Greek lady gracefully holds up her skirt with both hands as she walks. Walters Art Museum, Baltimore, MD.

■The Fashionistas of Etruria

The ancient society most delightful for a woman to have been born in was Etruria. Coincidentally, women's dress looks much more like outfits today, a top and calf-length skirt. The Etruscans came to Italy from Turkey, and the women were the most liberated of the ancient world. They wore chitons, whose adornment included border decorations on the hems, short enough to reveal their varied footwear of boots and sandals, which were so popular they were exported to other Mediterranean lands.

By contrast to Roman women, who had secluded lives, the Etruscan women mingled publicly with the men. They rode alongside their husbands in carriages and promenaded in town. They took part in banquets, unlike the Greek symposiums where women were allowed only if they were entertainers or prostitutes. They liked exercise and their sandals were hinged at the arch to create an easy and attractive gait. They had children from multiple men and their husbands took care of them as their own. They could become priestesses and instead of having only the last names of their fathers and then their husbands, they had their own names.

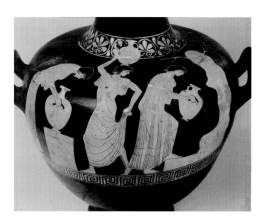

Thrakian women at the well; red-figured hydria (ca. 470–460 BC). Louvre, Paris, FrancePhoto. Erich Lessing/Art Resource, NY.

Although no texts exist in the Etrurian language, everything indicates they took pleasure in life, and that women had equality with men. They reclined on couches with their husbands with their legs gracefully extended. Lastly, they could shop in the world's first stores, and because of Etruria's trade, they had buying power for the international goods.[3]

Greek dress influenced the Etruscans' chiton, only their version was extremely colorful and, because their land was cooler, always wool. The wool took dye better than linen, and Etruscans exploited this fact by creating all-over plaids and colorful borders at the hem. Etruscan women wove together and took spinning and weaving equipment to their graves. The Etruscans often wove garments to size, and shaped and sewed them, versus the simple shapes but complicated drapery and folds of the Greeks.

Terracotta ash urn in the form of a woman lying in bed. She wears fashionable shoes with upturned toes. British Museum. Eric Lessing/Art Resource, NY.

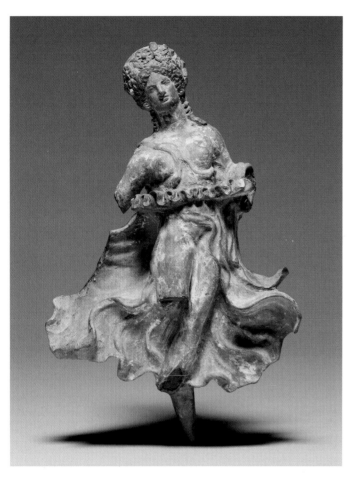

Perfume vessel shaped like a flying Nike, with agitated, wind-blown drapery (fourth century BC). This goddess seems to flutter rather daintily in her role of Victory looking to reward heroes. Walters Art Museum, Baltimore, MD.

Etruscan shoes were prized—women even in Athens flocked to shoe merchants to buy them. Etruscans took their shoes to their graves as well, where they were placed next to the deceased. There were two types of these shoes—the sandals that they wore and exported, and pointed slippers, which began as unisex and eventually were just for women.

The sandals were made of cork, leather, or wood. The soles of these astonishing sandals were hinged, formed of two separate wooden pieces framed by a bronze or iron border, and articulated at the instep by leather straps.[4]

The pointed shoes usually were laced high boots, reaching to mid-calf, red or black, with a thin sole of a different color that followed the foot to the upturned curve of the toes. Cross-lacing went down the front, horizontal straps bound the ankle, and another strap passed through an ivory buckle called the luna. The pointy shoes lasted three-quarters of a century, from 550 to 475 BC.

▪Rome and the Right to Wear the Stola

In Roman portrait sculpture, the goddess Artemis wears a short hunting tunic, and Aphrodite's garb is a little something wrapped around her legs. By contrast, in Pompeian frescoes of dining scenes, real women lounge showing off just their ankles and feet. Usually they are shod in sandals while sometimes they wear boots that tie over the calf, clearly meant to be seen, trimmed with pearls and gold. The garments were like the Greek's—simple, elegant, and wearable—but in a variety of textiles including more linen and also silk, and cloth was woven into rectangular pieces on a loom. Originally the garments were wool. Later they were made from more lightweight materials, such as linen, cotton, or silk, and were in colors like deep blue, yellow, red, green, and light pink. Dress signified rank. In 195 BC the Roman tribune L. Valerius commented that women should be able to display marks of honor as men did: "No offices, no priesthoods, no triumphs, no decorations, no gifts, no spoils of war can come to them; elegance of appearance, adornment, apparel—these are the women's badges of honor."[5]

The respectable Roman married woman wore a *stola*, a bulky, ankle-length draped outfit, with a *palla*, a versatile rectangle of woolen cloth that veiled her when she went outside. Only the stola descended to cover the legs. The stola attached to shoulder straps, adapted from the Greek chiton, and had a belt. Theoretically it covered the feet and therefore exhibited that the wearer was a lady who didn't have to work and travel in the dust but lived in the lap of comfort. It was a status symbol that became elevated during the Augustan era to make a statement of marital fidelity. Originally only for patricians, after the Second Punic War the right to wear the stola extended to wives of all citizens, including freedwomen.

However, that only begins to tell the stola's story. A woman could shift its folds or pleats and show a bit of ankle, and when she lounged she could set the folds aside so only a thin layer covered her legs. The stola could have sleeves, or be fastened at the shoulder with the fibula, over a sleeved undergarment. Sometimes it had a border that was embroidered or appliqued or woven with a picture; the very richest woman's borders were of gold or silver threads. This border was the limbus, sometimes a symbolic purplish red to protect health. In Virgil, Pallas Athena always had the "effulgent hem." The pretty borders made the stola's hem hang more gracefully, showed off the latest embroidering and weaving pattern, and also coordinated with the ubiquitous veil.

Greek vase from the Etruscan city of Vulci, depicting Achilles and Penthesilea (470–460 BC); photograph by Renate Kuling. Staatliche Antikensammlungen und Glyptothek, Munich, Germany.

Young Female Attendant, Greek, late Classical period (ca. 340–330 BC). Kimbell Art Museum, Forth Worth, TXth.

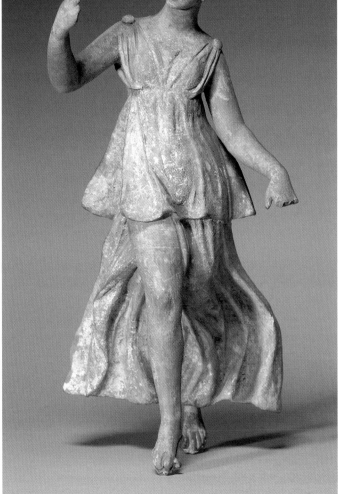

A representation of the goddess of victory Nike on a Hellenistic terracotta from Myrina on the west coast of Turkey (ca. 200–150 BC) The artist may have taken liberties in styling the dress to show the thinness of the fabric. Walters Art Museum, Baltimore, MD.

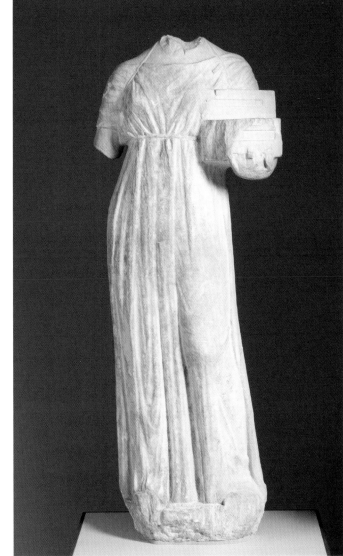

Terracotta relief of a maiden running in a windblown garment (fourth century BC). Compared with the naturalism of the goddesses on the Parthenon, the skirt of this girl's chiton is remarkably more fluid. The Walters Art Museum, Baltimore, MD.

Stolas came in different fabrics like muslin from India and cotton from Babylon, as well as wool, linen, and cotton blends. By 200 BC the stola came in a rainbow of colors, dyed by methods and natural herbs and flowers of the Empire. Especially desired in the second century was Tyrean purple. Purple had four hues, from light to dark. Most were made from a liquid dye produced by crushing a marine gastropod, *Murex conchylium*, and mixing the liquid with honey as a preservative. Another purple came from the egg sacks of a female insect that lived on a small oak bush in the Near East, *Quercus coccifera*. Thousands of the insects were needed to make an ounce of the crushed liquefied egg

sacks. Like the men's toga, the stola over time grew more costly, so in approximately 100 AD the poet Juvenal declared, "Here everyone lives above their means" (Hic ultra vires habitus nitor).[6]

Publishing mockeries of fashion was an established sport by the time the Stoic philosopher Seneca (circa 4 BC–65 AD) wrote the following:

> I see silk clothes, if these qualify as "clothes," which do nothing to hide the body, not even the genitals. Women wearing them can barely swear in good conscience they're not naked. These clothes are imported from far-off countries and cost a fortune, and the end result? Our women have nothing left to show their lovers in the bedroom that they haven't already revealed on the street.[7]

The leaders of fashion were the rich ruling class, and at least one public disagreement occurred over a princess going too far and provoking her father's ire when she wanted to be represented wearing light clothes instead of the stola for a public sculpture.[8] Says British classicist Shelley Hales, "Between her and Augustus it was a pitched battle of the 'you're not going out dressed like that' variety. It was almost more modest to be naked in one's statue than depart from the appropriate matronly dress."[9]

Slaves dressed basically like their masters, the farm slaves less fashionably than the ones in town. Once there was a resolution in the Roman senate that slaves should wear a distinctive dress. When the senators voted it down, one argument was that if slaves dressed alike they would see how numerous they were and revolt.

The well-born Roman was against his young wife doing anything that might bring her to notice in public. During the Roman Republic, various noblemen divorced their wives for being seen with a freedwoman, for attending the games, and for appearing in public uncovered. Contrarily, rich husbands used their older wives as markers of their wealth. Clothing your legs in the ample folds of the stola called attention to a husband's buying power.

The drapery of ancient times called attention to the clothed body and stemmed a conversation and criticism that went on to shape how we view the fashionable body today. The issues that bothered Seneca centuries ago continued to be raised with every changing fashion and every shift in taste.

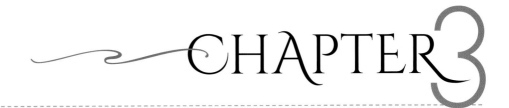

CHAPTER 3

The Long Recession

In the Book of Genesis, after Eve succumbed to temptation and persuaded Adam to eat the forbidden fruit, the two sewed fig leaves into aprons to hide their nakedness. In medieval times, until men started flaunting their legs in fine hose, the lower body generally was a zone of mystery for both genders, even as adults. Beginning around the time of the Crusades, men had the great legs. The outlaw Robin Hood probably wore a short tunic and hose; hence, Henry VIII appeared as Robin at a May Day fair in 1515 to show off his calves to the French ambassador. Contrarily, female legs were not visible on a properly clad Christian woman during the Middle Ages, even if they were seen routinely in paintings and tapestries of Eve (white, boneless legs) and the purgatorial people in Hieronymus Bosch and Pieter Bruegel the Elder's artworks.

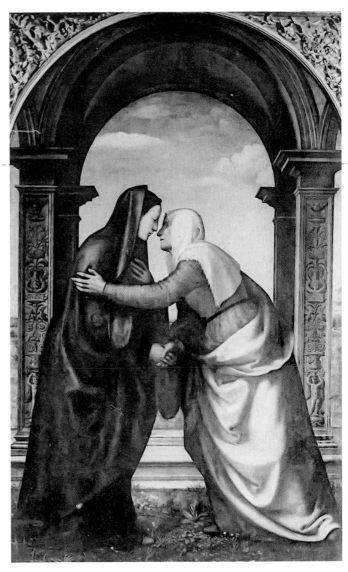

The amount of fabric required to create the draped gowns of the High Renaissance religious paintings is staggering. Mariotto Albertinelli painted this *Visitation of the Virgin* for the Congregazione di San Martino, a church in Florence, Italy (1503). Antique postcard.

Closer to the present day, in January 1936, the first Pahlavi shah of Iran ruled that all Persian women must unveil. The day after the royal decree was enacted, the headman of a village near the Caspian Sea went forth from his home and for the first time saw a woman without her veil. To avert his eyes he looked down, whereupon the sight of her legs and ankles overpowered him, and the wheels of a passing cart ran him over in the middle of the street.

During the "long recession" in Europe, America, and the Middle East, female legs, covered, became a taboo sexualized in movement through clothes. Only the common people had hemlines well above the ankles, and only in dance and other spectacles did a woman wear shorter gowns. A woman raising her skirts, like gesturing with her fan, must have been a significant sign.

▪ Two Centuries of His Not Hers

Perversely just as fashion was taking off, women's rights to own the clothes on their backs ebbed. No matter the praises a lady received for her apparel, her clothes belonged to her husband's estate. During the fourteenth and fifteenth centuries, a widow did not recover her dowry: her dresses went to her husband's family at his decease. Even the pretty clothing a husband gave his bride in the first blush of the marriage was often sold early in the marriage. Historian Christiane Klapisch-Zuber relays that a Florentine widow, Madalena, had to borrow a few clothes to cross the street in order to make a decent entrance into the house of her new husband. That same day he cut and had made for her a rose-colored dress and a black twill overdress.

This system tended to keep the woman's dresses impersonal. The same could be claimed of jewelry except that a woman could claim that the jewels were lost, or sell them, or walk out with them to a new life or return to her girlhood home. In Italy the trousseau went to the husband's house the day following the wedding and was valued independently by two clothes dealers.

Along the same "exchangeable" lines, sovereigns bestowed men and women almost identical gowns, having insignia of various sorts representing their sovereign. The French historian R. C. Famiglietti recounts how for a lavish wedding in April 1402, Philip the Bold of Burgundy had a great hall specially built in Arras and ordered 102 gowns of green velvet lined with white satin for the guests to wear.

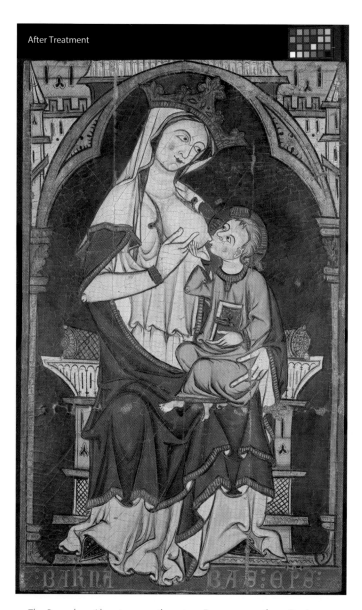

The Barnabas Altarpiece, southwestern France or northern Spain (ca. 1275–1350). Kimbell Art Museum, Forth Worth, TX.

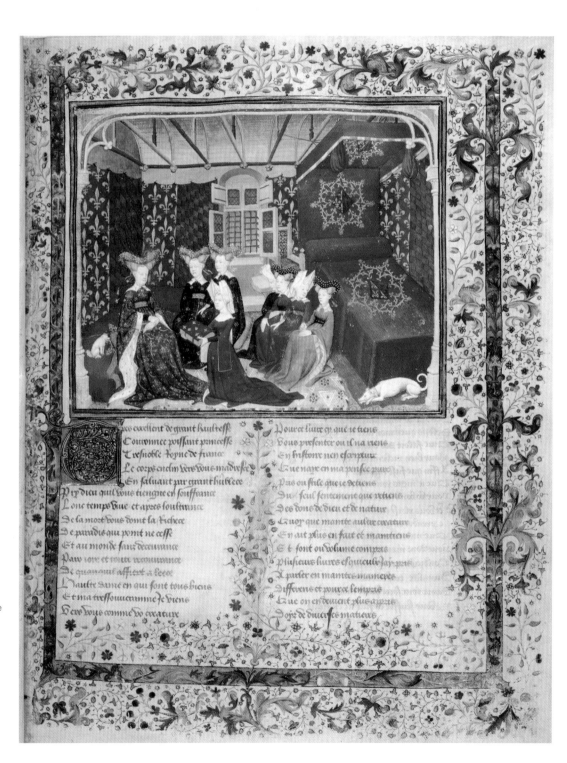

Christine de Pisan with her book (1410–1411). Christine de Pisan (1364–c.1430). Collected Works of Christine de Pisan/Art Resource, NY.

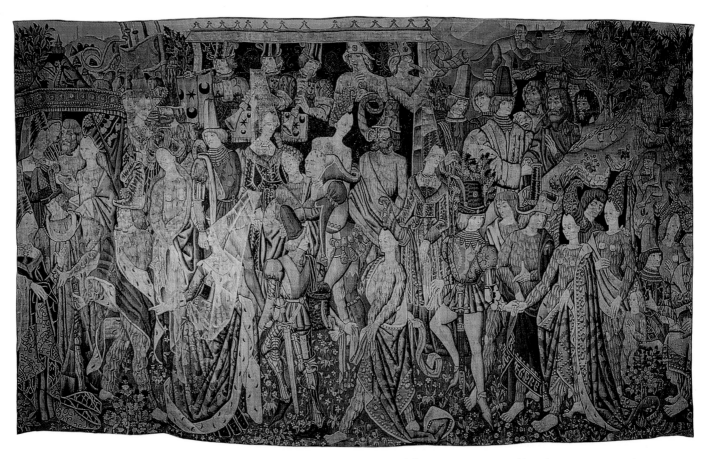

Le Bal des Sauvages tapestry (fifteenth century). Musée de Saumur.

▪ Loathly Ladies

When women's legs disappeared, where did they go? First, they went to the hinterlands. The Greeks had their Amazons and the medieval Europeans their witchy ladies. In the fifteenth-century tapestry *Bal de Sauvages*, today at the Chateau de Saumur in the Loire Valley, there is a rare glimpse of women's legs. They appear in a group scene, but then, the two broad-stepping ladies belong to the troupe of barbarians, and close up one sees the hair follicles, or fur, drawn on their legs. The barbarians were a living memory, especially before the Great Schism in 1054, when they threatened the whole Christian world. Nothing would have struck the medieval mind as less civilized than a display of female legs.

One had to be strange and horrid to have legs unclothed. The ideal woman wore ample skirts just as the Virgin Mary did, pictured riding a donkey, kneeling by the crèche, or making a hammock of her mantle for the holy child. She was human but not earthly and was portrayed as the feminine model.

Le Bal des Sauvages tapestry, detail (fifteenth century). Musée de Saumur.

As a corollary to the taboo, the topic of female legs became alive with risky meaning. In an English ballad called "Thomas of Erceldone," exposure of the legs of the female protagonist was fraught with terror. The ballad relates the adventures of a knight with a "lady gaye," her transformation into a Loathly Lady (the trope of a witch in disguise), and her subsequent retransformation. When Thomas comes upon this charming person in the countryside, she is on horseback. Thomas wants her to lie with him, and although she warns him he will destroy her beauty, she consents. They make love seven times until she complains, "Thou marst me micke" (you make me shrink from duty), and Thomas sees she speaks sincerely. Her rich clothing falls away, exposing literally leaden legs, one gray and one black. Yet Thomas agrees to marry her and the Loathly Lady takes him on a twelve-month journey of the other world beneath the swamp of Elder Hill. After that her beautiful legs are restored and "fair and good/and also fresh o her palfry" the couple goes to her kingdom beyond the mountains.

The Loathly Lady has a counterpart in another supernatural being whose legs are a matter of mystery, the fairy Melusina. In the Melusina cycle of stories it's all about legs. The knight Raymond tarries by a fountain and marries the water-sprite that guards it. She makes him promise never to see her on Saturday, a vow he abjures and she turns into a combination dragon and femme. He sees that a serpent's tale has replaced her legs but puts up with it as she goes around in human form most of the time. Raymond, in fact, doesn't say a word to anybody until one of their sons misbehaves and Raymond accuses Melusina of contaminating his line. All right, she retorts, if you think I'm disgusting, I'll be disgusting. Then she goes completely serpentine and becomes a monster.

All the old magical stories whipped up around female legs suggest a fear of feminine power, causing artists to imagine weird or barbarous legs hidden beneath women's skirts—not fabulous, but merely "other."

▪Lengthy Court Dress

Meanwhile, all over medieval Europe the woman of means wore what is seen in the Ravenna mosaics, the long straight gown and cloak established by Theodora, wife of the Byzantine emperor Constantine. Theodora was an erotic dancer before she became a Christian empress, and ruled that all Constantinople's prostitutes either marry or lose any property they owned. The mosaic shows Theodora in a hieratic pose with a long purple cloak fastened at one shoulder. It has a deep gold border with a procession of human figures in short tunics at the hem. During the Middle Ages, the basic garb was coat and surcoat, over the chemise, that a woman wore to bed or saved for the next day, and slept nude. The cloak often was her most gorgeous piece of apparel. It could be fur-lined—ermine or white fox for a queen, squirrel for a person of lower rank—and a noblewoman might have medallions, symbols of power, emblazoned on it.

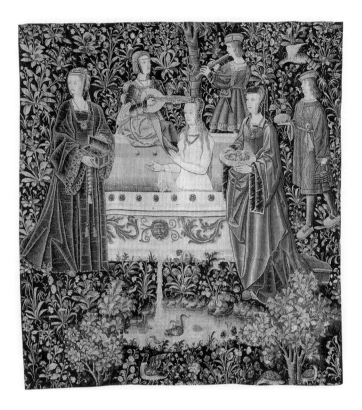

La Vie Seigneuriale – Le Bain (First quarter of the sixteenth century). Bibliotheque Nationale de France. While the top part of the body is exposed, the legs are concealed under voluminous fabric. Vintage postcard.

Laced up and narrow in form was the rule for women's fashion in the mid-fourteenth century. Perhaps the idea was not to subject the skin to any sickness or cold, as these were Europe's first plague years. According to John of Reading, an English Franciscan chronicler of the time, quoted by Stella Mary Newton in *Fashion in the Age of the Black Prince: A Study of the Years 1340–1365*, women's clothing in England had become so bizarrely tight that they wore the tails of foxes hanging under their skirts at the back, or the buttocks would be indecently in evidence.

Skirts didn't just rustle through until 1600; they rattled and jingled. A woman clanged when she walked, wearing on her hip a *demi-ceint,* from which hung either keys to her castle/inn/house or little tools for her work. The princesses of Burgundy at the time of Philip the Bold wore real bells on their dresses, and when Philip married Margaret of Flanders her garments (white velvet spangled with gold stars under a cloak of crimson silk) were so heavy that she had to be carried to the church by two attendants.

The Dance at the Court of Herod by Israhel van Meckenem (ca. 1500). National Gallery of Art, Washington, DC.

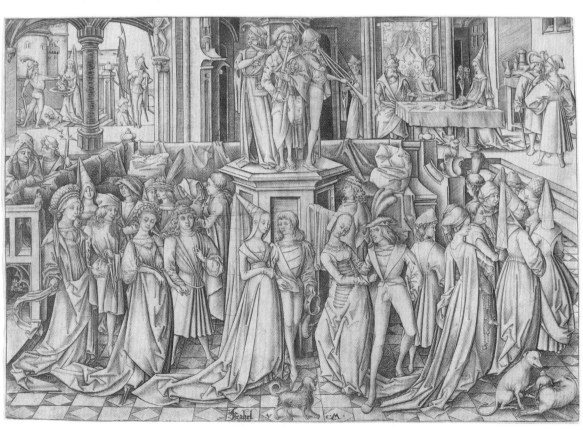

▪ The Common Fashions

The great exception to the vanished female legs appears in images of country dancing where legs had a distinct visibility. Peasants apparently danced more exuberantly around a bonfire or at a wedding than their betters did at the court dances. Their skirts naturally were shorter so the dancers didn't have to hold up trains or risk tripping. When the regional dances of the peasants were taken up by the ruling classes, the noble lady showed her legs too in kicking up her heels.

Whereas poor city dewellers women wore tattered castoffs, country folk had distinct styles of dress designed for working. Therefore, the second answer to where the legs went is that the female common folk showed them all along. A peasant might wear a hat or head covering in public, but her dress hem did not extend far below her knees. The dresses worn by the peasants raking and piling up hay in *Les Tres Riches Heures du Duc de Berry*, 1412–16, by the Limbourg brothers, look modern compared with those of the court ladies in the calendar. Their kirtles have tight bodices with low round necks, just as seen on the aristocrats, but the skirts stop about two inches below the knees. The energetic legs almost appear to be leaping as the peasants work. Artists impressed their clients by depicting figures in

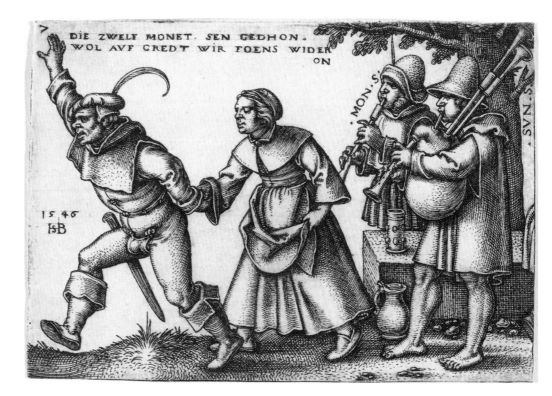

The Year's End by Sebald Beham (1546). Rosenwald Collection, National Gallery of Art, Washington, DC.

luxurious clothing, but this magnificent illuminated manuscript by the Limbourg brothers, as well as narrative paintings of the time, testifies to a practical, shorter skirt being a common style after all.

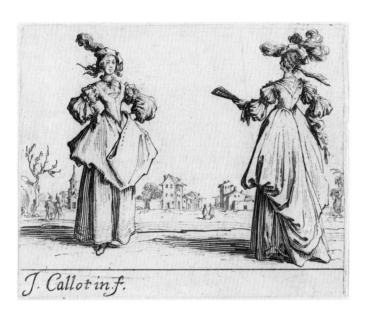

Two Society Women by Jacques Callot (1623). Rosenwald Collection, National Gallery of Art, Washington, DC.

▪Courtesans Defy and Inspire

Rising like Botticelli's Venus, the courtesans of Venice revealed attractive legs in gowns and shoes at the height of fashion. Courtesans had a short but brilliant bloom. They needed to be noticed, so were not disposed to adhere to the sumptuary city laws about female dress. The courtesans wore embroidered hosiery, and at Carnival they sometimes wore men's breeches under their colorful gowns. They also set a trend for *zoccoli*, stilt shoes made of wood with leather work or painting, which gave them several additional inches of height so they would tower over less fashionable women walking in the palace halls. Engravings indicate that one style they wore was a skirt with a flap and short pantalettes underneath (fashions in Renaissance Venice changed as fast as every twenty years). An engraving by Pietro Bertelli (1591) is a cartoon showing a flap flying up to cover the courtesan's face. According to Professor Margaret Rosenthal, director of the Veronica Franco Project at USC and author of *The Honorable Courtesan*, the pantalettes were linen and embroidered with playful phrases like "I want your heart."

The fabled citadel of pleasure and watery international commerce suited gorgeous clothes. The Venetian masters Titian, Tintoretto, and Veronese only had to look at elegant courtesans strolling the canals to get the female forms for their mythical and allegorical scenes. Titian's *Rape of Europa* portrays Europa with a tremendous muscular tension and twist to her legs. The dynamic torque animates her whole body. A lingering on legs is also true of quieter subjects like Venus simply being Venus (Titian's *Venus and the Lute Player*), or the same artist's *Danae,* in which Zeus aims a shower of gold at her upper thighs. The accent is on feminine strength, sensuality, and secularity.

During the Renaissance, anatomy was studied with live models. In the Kingdom of Naples, Jusepe De Ribera (1591–1652) did remarkable studies of the female leg. To understand the fashions of the time one should start by looking at nudes to see which part of the body was emphasized.

The classy prostitutes dressed as widows or young girls, covering their brocade skirts with silk overskirts and wearing fancy high heels inside high clogs. Meanwhile, the "public" prostitutes found standing in doorways and on streets to draw customers often wore men's britches and jewelry of silver pieces.

Bourgeoise with Muff by Israel Henriet after Jacques Callot (seventeenth century). National Gallery of Art, Washington, DC.

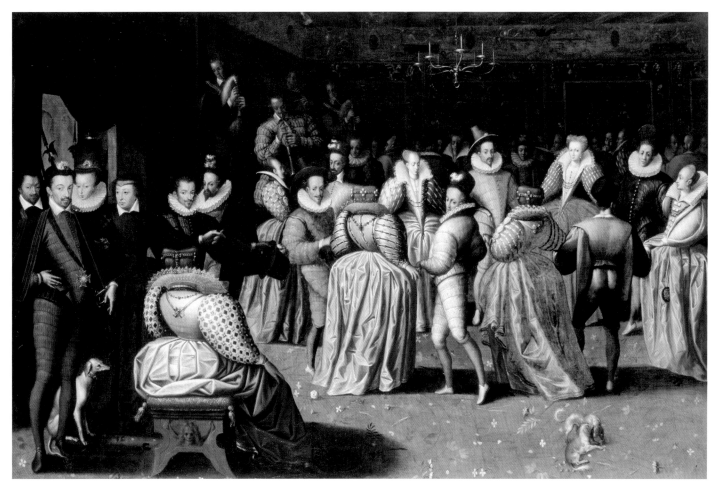

Ball at the Court of Henry III (1551–84), or the Duc of Alençon's Ball. RMN-Grand Palais/Art Resource, NY.

Fantasy Dressing

In the English court, the nobility participated in masques, dances in fancy dress with a story theme. Participants were masked and also engaged in dramatic play. Here, women could show a bit of leg. Queen Elizabeth danced every day, demonstrating that she was a sun around which her courtiers rotated. Her successor in producing such entertainments, James I's wife Anne, directed and danced in masques where ladies took central roles. For spectacle, they donned the costumes of nymphs and goddesses, whereas at court they still wore the formal extended skirts.

Thus the third and last place that legs went in the pre-modern period was the purlieus of spectacle. It all began with the Medici jousting festivities in Italy. During the intermezzi, women frolicked as nymphs in dances. When she became the queen of France in 1547, Catherine de Medici introduced to the French court the same sort of plays and festivities she had watched in Florence. After her husband was killed in a duel in 1559, she forbade heavy tilting (a form of jousting) in what were called her magnificences, and starting featuring dance instead as the climax to her entertainment. Catherine expressly wanted to equal the festivities of the Roman emperors. She told her Italian ballet master, Baltasar de Beaujoyeulx, to stay with happy endings, which is why they were known as ballets comiques.

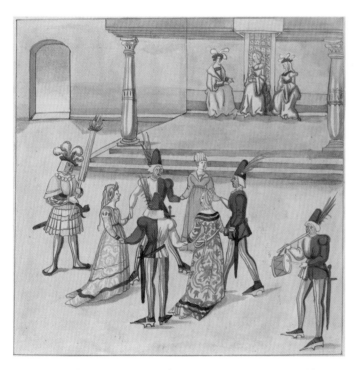

Masquerade, Germany, sixteenth century (ca. 1515). Rosenwald Collection, National Gallery of Art, Washington, DC.

Female dancers wore exquisite costumes, variations on what aristocrats wore to balls, only with flounces and ruffles to catch the light and show off the movements, and headdresses and masks as signs of their stage roles. Nowhere else in the Renaissance period were partially clothed sirens being pulled on moving rocks and swimming or at least performing in the canals of chateaux. For the women in Catherine's retinue who were the main corps of the dances, this was the occasion to show their comely ankles and calves and nimble movements. They wore shorter dresses than a noblewoman would ever normally wear, some with colorful tiers or piquant designs like a shepherdess's with an apron sort of overskirt. The dresses of the ubiquitous nymphs were diaphanous in the extreme and possibly (illustrations indicate) floated in the water as the dancers clung to the prop boats or floats in the mythological scenes.

In 1564, Catherine and her son Charles IX, who became king in 1561 at the age of 10, went on a two-year tour, or progress, through the country. They took courtiers and ambassadors, musicians, and even nine dwarves in their own miniature coaches. Catherine hoped the royal display would relay news of her splendor to governments far and wide. It seems, however, more likely the playful entertainments ended up as elements of the classic French fairy tales like Cinderella and The White Cat. The apex of the tour came when the royal party linked with the Spanish court in Bayonne. Among the mock battles and jousts were the pretty ballets whose female participants showed off their grace as nymphs and goddesses. A scholar of French history, R. J. Knight, in his *Catherine the Great*, describes an entertainment at a lavish banquet on June 23, 1565:

> Guests were taken there in splendidly decorated boats, enabling them to watch on the way fishermen harpooning an artificial whale which spewed red wine from its wounds. They also encountered six tritons sitting on a large turtle, blowing conch shells. Neptune in a chariot pulled by sea-horses, Arion riding on two dolphins, and sirens singing praises of the royal guests. On the island, they were treated to regional dances performed by girls dressed as shepherdesses, and invited by sirens to celebrate the accord between France and Spain. This banquet was followed by a ballet of nymphs and satyrs.

In a time of invisibility of female legs, how amazing it is to imagine the ladies swimming or appearing to swim in the canals, and being rescued from enchanted islands. They were garbed in diaphanous silk, cotton, and muslin costumes, with visible lower limbs. The players in the festivities could, exceptionally, have on gowns that showed their legs, because the august theme sublimated the female

Portrait of Henri II (1519–1559) and his wife Catherine de Medici (1519-1589). Chateau, Anet, FrancePhoto. Scala/White Images/Art Resource, NY.

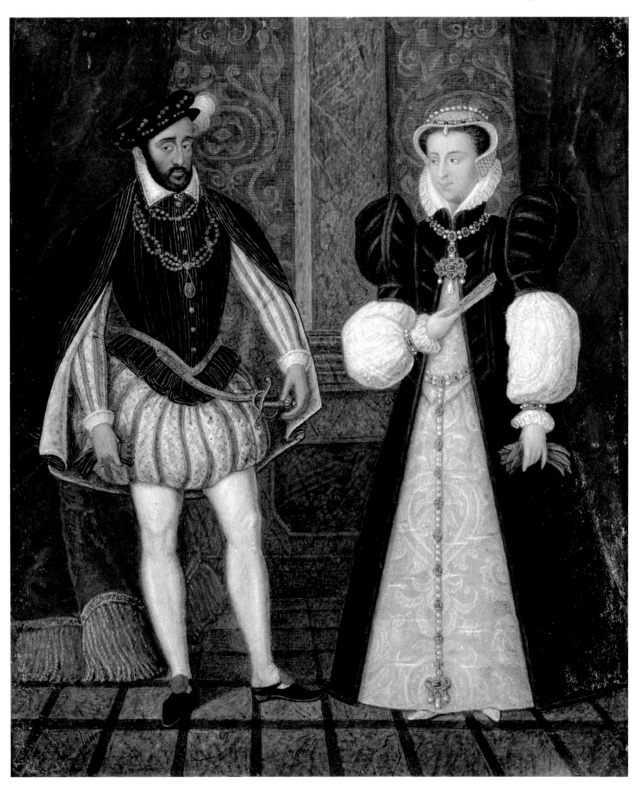

form. The sirens and nymphs wore skirts of silk that were of uncommon lightness. Moreover, the vigorous dancers showed considerable leg. During the long recession of legs, when the ladies of the court trailed their trains, the corps of dancers in briefer skirts represented a fantasy, more modest than, but yet comparable to, the nude females in the Renaissance sculptures.

▪La Volta

Court dances all through the medieval and Renaissance periods were when gentry kicked up their heels and women's skirts flew. The dances were not sedate. In the sixteenth- century courante (flying dance), which would be in the next century Louis XIV's favorite, men's and women's legs surely flew while two and a half–inch heels must have hampered the women.

As a man and woman who meet under hanging mistletoe are obliged to kiss, a couple performing the athletic Renaissance dance called *la volta* had to embrace. In La Volta, the male partner embraces the woman, positioning his left thigh against her right thigh. They step with hops, leaps, and turns, and with her left hand she keeps her dress from flying up. Queen Elizabeth I danced the daring la volta with Robert Dudley.

Country dances such as la volta, a later form of the *galliard*, are so important to leg fashion history because they changed the "eye" of spectators. In the more stately Renaissance dances, the dancers' feet did not leave the ground, so they were known as *basse* whereas the dances with energetic leaps and lifts were called *haute* dance. A woman wore a gown shorter than the formal type and no train, and was lifted up in laughter and joy. In the original galliard, which Queen Elizabeth danced every morning for exercise, the couple danced down the length of the room and the man did most of the hops and leaps, in mock wooing, but in the late Renaissance la volta the courting was more balanced, and his partner showed her stockinged leg.

▪The Masque of Blackness

At the time when Anne of Denmark, wife of James I, King of England, put her heart, soul, and the royal treasury into costuming the masques, no actresses performed on the London stage—not until a female played Desdemona in *Othello* in 1660. The overarching concept of the masques was Arcadia, and the queen and her ladies wore skirts that ended considerably above the ankle.

King James liked to watch dancing but not to step out himself, whereas Anne loved to dance. She and her ladies made a big splash, and many ideas about stage costume and design were born in the masques. The costumes adapted features from antiquity and Italian *commedia dell'arte*, and were inches shorter than what the female aristocrats wore in other circumstances.

The genius behind the masques was a London clothier's son, Palladian architect Inigo Jones (1573–1652). Under the aegis of the Stuart rulers he took the grand spectacles indoors and developed costume and set design. The themes of the Stuart court masques were similar to the French court festivals. Renaissance historian Roy Strong writes in *Renaissance Festivals, 1450–1650*, that the spectacles on both sides of the Channel "express the power of the monarchy to bring harmony, the rich gifts of nature and the natural world into obedience. All move from initial statements of disorder and cosmic chaos toward revealing king and court abstracted in emblematic form as gods and goddesses, heroes and heroines, sun and stars."

The rage for court masques began in 1604 when Queen Anne commissioned the poet Ben Jonson to conceive a masque that her ladies could perform for the court at Christmastime. She requested specifically a masque of "female blackamoors" so she could really transform herself and present some dramatic fantasy African costumes and have dark skin that would look exciting at night. The sets for *The Masque of Blackness*, 1605, were elaborate. Heavenly visitants could come down and move forward as if on a cloud, or ride in gondola-like boats. The masques climaxed with a display of Anne and her ladies dancing in fabulous gowns.

In *The Masque of Blackness*, the Moon wore silver, certain women were barefooted, the Daughters of Niger were painted black, and sea nymphs were wheeled in on the half-shell. The nymphs wore gauzy gowns made of lace extending a few inches past their knees, with half-skirts over them of silver cloth. The emphasis of the costuming was on frothy skirts, often silk and satin. A royal inventory of the Queen's wardrobe describes a masquing outfit that Queen Anne wore in 1610 and testifies how the costumes did not merely copy fashions of the day:

Album, Fairy Ballet of St. Germain forest, "Perrette the Incompetent" and a Cat by Daniel Rabel (seventeenth century); photograph by Thierry Le Mage. Louvre, Paris, France Photo. RMN-Grand Palais/ Art Resource, NY.

One maskeinge gowne of satten: the bodies Jagges and tagges of white sattne Imbroydery verye rich with gold purle plaett and owesthe skertes of grasse greene satten Imbroydery with silver owes alover Cutt rounde belowe with beakes and scollops and edged with a silver fringe lind with greene sarsnett.

Between 1615 and 1640, the designs of Jones for the masques at the courts of both James I and Charles I showed lady masquers wearing double sheets loaded with sequins and gold and silver fringes as though they were fairy creatures. The inventive designs gave a strobe effect, merging antiquity, Renaissance, and the outlandish. Some of the women in the hundreds of existing historical drawings are costumed in jagged filmy skirts or wearing leafy overskirts or wings; some have complex sandals with straps going up their calves, or bottines with the same design motif as the dress. The costumes were usually worn just once; although the wardrobe master could remove the theatrical accouterments, the extravaganzas were playthings of the revelry of the moment.

In his drawings, Jones shows the ladies' breasts and nude calves, but he may have been showing idealized allegorical figures. Through the early seventeenth century in European courts, fake breasts were worn by cross-dressing male actors. These men wore what the English called "skin coats," which could cover the body and legs and were made of fabric, papier-maché, or plaster. These theatrical accessories had their origins in Italy. Known as "vizards," the early versions were masks crafted in Venice that were made by soaking leather and then fixing it on a model for a day. The vizards were then colored, polished, and refined. It's easy to imagine that "women" dressed in mid-calf skirts or uncommon hemlines had their skin mostly covered though it looked uncovered by the light of candles and torches.

According to Barbara Ravelhofer's *Early Stuart Masque*, Anne put theatrical values over convention in her costumes, wearing "Barbaresque mantels to the halfe legg" that exposed buskins encrusted with jewels in *The Masque of Blackness*. In *The Vision of the Twelve Goddesses* (1604), Anne wore a daring gown to play Athena. A contemporary observer, Dudley Carlton, described her to his friend: "Pallas had a trick by herself; for her clothes were not so much below the knee but that we might see a woman had both feet and legs, which I never knew before."[1]

These costumes are blamed for nearly bankrupting the realm; Anne wanted every last jewel on all her lady dancers in Ben Jonson's productions to be perfection. Sometimes it was several years before the tailors, shoemakers, and merchants were paid for their contributions to the extravaganzas. Anne, only too happy to dress up as a Moorish princess or die her arms and legs blue, insisted on farthingales as proper attire for ladies at court.

▪Republican Length

Almost two centuries later, it would be activist women, who helped overthrow the Bourbon king, who sported skirts a foot off the ground, as well as severe jackets and wide, tough belts—militant attire.

But after Josephine Beauharnais (whose was imprisoned with her soon-to-be-executed husband during the Reign of Terror and would later marry Napoleon Bonaparte) and her best friend Thérésa Tallien got out of prison, they mutated from aristocrats to leaders in the new society. As such, they wore the clingy white silk or muslin dresses of Greek and Roman influence that became the style of the giddy *Merveilleuses* of the period. Tallien favored jeweled headbands, gold bangle bracelets, and toe rings, so the outfits were scarcely plain. The diplomat Talleyrand observed, "One could not be more sumptuously undressed!" Notably, it was to the ballet that Thérésa Tallien wore her white silk gown without a petticoat.

Photograph by Nasser K., 2014.

CHAPTER 4

Fashion and Posture, a Pas de Deux

A formulaic feature of publications aimed at women pairs the images of two people dressed up in the same outfit. They are both famous and presumably made their purchases on the advice of a Bergdorf Goodman personal shopper or scoop up the items in a Rodeo Drive boutique. Both wear their outfit out on the town—oops. Readers are asked: Who wore it best?

When two girls wear the same dress to their prom it doesn't have to be an embarrassing moment—it can instead be more of an object lesson in individuality and how a person's posture and mood makes the clothes. If the girls in the look-alike dresses project being happy and elated, the respective dresses will look nice on each of them, though very different. On the other hand, bridesmaid dresses are designed to be unremarkable and generic—one dress fits all to mask personal style.

But why does one woman look better? Good posture, including confidence and ease with self are the ticket, helped by the right pose. Stars like Lupita Nyong'o, Jennifer Lopez, and Charlize Theron have a natural lovely posture, and anything they wear is going to be the height of fashion.

Elegance, said Gabrielle "Coco" Chanel, does not consist of putting on a new dress. Before anything else it relates to posture. As Shakespeare wrote in Sonnet 130, "My mistress, when she walks, treads on the ground." How people orient emotionally is bound up with how they orient in space. The position of legs and the line the body takes are the carriers or motifs for different messages. Posture, how women move, arrange, and display their legs in clothes, is fashion's quiet backdrop.

Fashion also forms posture and gait. A woman sitting on the floor spreads her skirt under legs bent at the knees, or if she has on jeans places an elbow on one crossed leg. Outlandish clothes can be exciting and invigorating but who knows how to stand, walk, and sit in them? Moreover, attractive posture tends to pair up with *le juste moyen*. In a black jersey dress a woman slinks, in a ball gown she glides, in a pants suit she masculinizes her gestures, and in short shorts she walks lean. In ten petticoats and a perruque, she winds and labors. At the most restrictive end of the spectrum, long kimonos tightly wrapped with obi sashes require a mincing walk.

Men's legs go in a straight line from hips to floor whereas women have curves —even female legs have more of a curve (and appear longer than they are). Overall, in the history of fashion, the hips and thighs of a woman's body— precisely what distinguish her physique most from a

man's—were concealed by clothes yet pronounced in movement. This paradox is an essential point when looking at fashion of previous eras. A corollary is that the essence of a woman's attractiveness is her posture combined with movement, which makes her legs beautiful whether seen or below petticoats.

Wide skirts and fine sandals allowed Etruscan ladies to promenade with easy gait, whereas a five-meter train on Princess Charlene of Monaco's bridal gown must have caused her to have a hesitant carriage during the royal wedding. A twenty-something can lilt in leggings or stroll gracefully even in skin-tight jeans. Catherine Deneuve at an homage for Yves Saint-Laurent's tuxedos told Suzy Menkes that the style "really does make you feel different as a woman, it changes the gestures." In an Edith Wharton story, "The Temperate Zone," a couple is well-heeled and only in their early forties, yet they appear dated in their attire as they "belonged . . . to a period before the triumph of the slack and the slouching." Leg posture changes with the style of clothes because the innate requirements of clothes have governed the etiquette of posture through history. In the case of the couple in the Wharton story, they had not adapted to a relaxation in posture that happened in America during a quite short span after 1900.

■ Standing Tall

A songwriter noticed people walking awkwardly on a ferry and wrote "Walk Like an Egyptian," a pop hit in 1986: "If they move too quick (oh whey oh)/ They're falling down like a domino." Ancient Egyptian wives in the monuments of the Valley of the Kings are tiny compared to the men, yet don't look insignificant because they stand tall. The beautiful posture of ancient Egyptian women is apparent in their depictions on every sculpture and painting in a museum. They look like majestic dominoes standing and sitting, kneeling and crouching. Often the pose is refined to placing one foot in front of the other, and the woman is shown from the front or the side, the head elegantly raised up.

According to evolutionary biologist Dan Lieberman, the ability to sustain a running movement was key to human evolution, as we have heads that allow us to focus and don't bob as we move. A special muscle connects each arm to neck and head, and we dash ahead swinging our arms, which become counterweights that stabilize the head. This lift of the head and focus of the eyes defines a person's affect and draws interest.

The Egyptians also observed the fact, seminal for fashion history, that a woman keeps her movements and

gestures close, compared with a man. In Egyptian art of the Ptolemaic period (second century BC), the goddess of femininity who wears the most elegant raiment, Hathor, positions her legs close together while her arms extend down her sides, hands flat against the thighs.

All over what were once the provinces of the Roman Empire, statuary commemorated venerable Roman citizens. These sculptures were virtually mass-produced. Take a head from one of the portrait busts and put it on the body of another, and they would fit. The Greek slaves who sculpted them were concerned only with making the people look prosperous and dignified. What's interesting regarding this statuary is how different the women's posture looks from the men's. Glendy Davies, a classicist at the University of Edinburgh, differentiates between the depictions of males —broad open shoulders, heroic stance, sturdy sandaled feet and muscular calves—and females, with their narrow body posture, arms in long sleeves held into and across the body, and expensive dresses trailing over the feet. "They often are fiddling with the drapery," said Davies in a conversation with the author.

The sedate posture of citizens characterized the high point of Greco-Roman culture. However, in Hellenic times, the posture of women loosened up. Nymphs are shown in mid-flight, dancers leap and run, and the supernaturals pose realistically. The new kinetic look of sculptures in this period shows how nicely garments like chitons and peploses moved with the wearer. In a sculptural group at the Walters Museum in Baltimore, two women crouch and play knucklebones, a form of jacks, with no difficulty despite their long tunics (330–200 BC).

Religious leaders have often proclaimed the perfect posture to be a humble, even craven, one. In the Old Testament's Book of Isaiah, 3:16-20, the eighth-century prophet castigated the ladies of fashion of his time:

> Then the Lord said: Because the women of Zion hold themselves high and walk with necks outstretched and wanton glances moving with mincing gait and jingling feet, the Lord will given the women of Zion bald heads, the Lord will strip the hair from their foreheads.

The prophet enumerates his dislikes from bangles to nose-rings to perfumes, and fumes that in a future day of judgment, the Lord will "take away all finery." Isaiah includes flounced skirts in his castigation, but the most powerful portion of his harangue is his diatribe against women's confident, sexy posture.

Proponents of good posture in modern times have had to fight the idea that walking with a bowed head and curved spine displays humility. A mother superior told her nephew John Costello, a ten-year-old choirboy in 1937, to straighten up: "Be proud but not in excess."

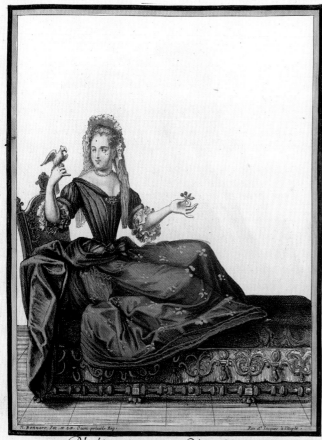

Phyllis playing with a Bird (Phillis se Jouant d'un Oyseau) by Nicolas Bonnart (ca. 1682–1686). Los Angeles County Museum of Art.

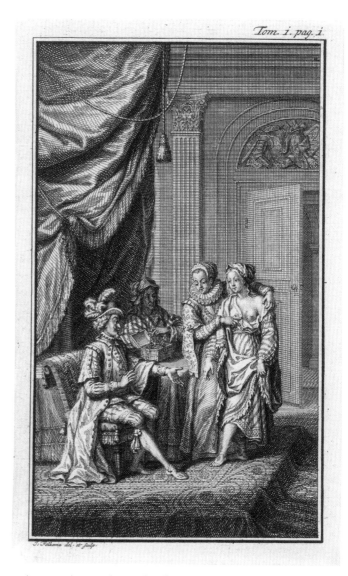

The Spanish Gypsy by Jacob Folkema (1702–1767). Rijksmuseum, Amsterdam.

▪ Proxies and Pistachios

So legs were concealed, and carriage and bearing were the emphasis through the Renaissance, but there was a hitch: nobility rode. Commoners, the populace, walked but the high-ranking woman was seen legless. The fairy tale "The Princess and the Pea" hinges on a princess's posture. The story's pivotal point is the failure of people to recognize her station, given how she bore herself when she arrived at the castle door. Her daintiness (she was used to the most luxurious bedding) finds her out, but her royal stature would have shown through her bedraggled appearance to anybody with discernment. When royal persons paraded to a saint's shrine or through the populace at a festival, their walk must have been a measured and slow drum roll. All over Renaissance Europe, men and women of nobility

walked by positioning the legs one in front of the other, with the hips turned outward. Walking with the legs and feet straight was considered low class.

While dancing or in everyday activities, the lower classes always showed more leg; for instance the carpenter's wife in Chaucer's "Miller's Tale" has her "shoes laced on her legges hye." Whereas a lady might wear embroidered slippers of leather and velvet inside cork chopines, the woman of lower class had wooden clogs, and her movements were a bit ruder and noisier as well.

The pointed-toe medieval slippers called poulaines or pistachios grew longer and longer in the fourteenth century, especially for nobility as there were sumptuary laws pertaining to ordinary people. The pistachios created a mincing, birdlike

walk. Women presumably walked more naturally than the dandified men because a nobleman's pistachios at the height of their folly measured twenty-four inches.

A curious royal custom was the proxy marriage. Marie Antoinette was married by proxy in Vienna, with her elder brother standing in for the French dauphin. All her brother had to do was appear at the church and have dinner. Often the proxy marriage included the pretense of consummating by the exposure of the princess's legs. This was the realistic proxy wedding; when a princess exposed her leg it was a public promise. When King Henry VIII's sister Mary Tudor was nineteen, she married the fifty-two-year-old Louis XII, king of France, according to her brother's wishes. In fact, Mary married Louis twice. The first ceremony, by proxy, took place in England in 1514, where a nobleman by the name of the Duc de Longville represented Louis. At the wedding ceremony, the duke stood in for Louis, and Mary represented herself. After the ceremony came the pretense of consummation. Mary dressed in a nightgown and sat in the bed, legs exposed. The duke removed his red hose and with his leg touched Mary's leg: a flesh-to-flesh proxy consummation. Then Mary traveled to France to wed the gouty Louis in person. (Louis perished just three months into the marriage and four months later, Mary married Charles Brandon, a commoner. This time, she married for love.)

A dancing master in Venice, Fabritio Caroso, advised a lady on her walk in a treatise in 1600. She should take great care never to give the impression that her feet were more than three fingers off the ground. By planting her foot firmly and straightening her knee with exactitude, she would advance with beauty and decorum. Giovanni Della Casa, the Florentine author of *Il Galateo* (1558), regarded as the greatest Renaissance guide to everyday behavior, referred to the walk of a woman or a bride as pacing "stately or demurely." Men could walk with more sprezzatura, but Galateo advised a person of quality not to let his arms dangle, "nor wing them backward and forward, nor throw them about so that it looks like he is sowing seed in a field."

According to Renaissance scholar M. F. Rusnak, the focus of *Galateo* was on "mocking or lampooning those singular actions that cause ignominy or should cause humiliations."[1] Rusnak emphasizes the importance of posture and walk in demonstrating one's station: "There was a misogynistic vein to a lot of 'academic' treatises of the period,"[2] the code of

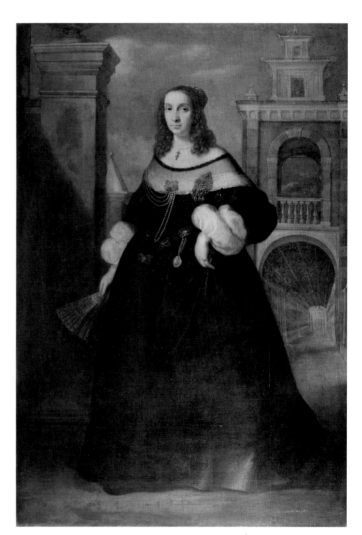

Portrait of a Noblewoman of Ancona by Luigi Primo (1650–60). The lady is depicted gliding across an inner courtyard, not on the street. Walters Art Museum, Baltimore, MD.

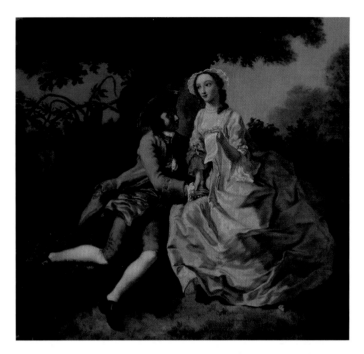

Lovers in a Landscape by Pieter Jan van Reysschoot (1740). Yale Center for British Art, Paul Mellon Collection.

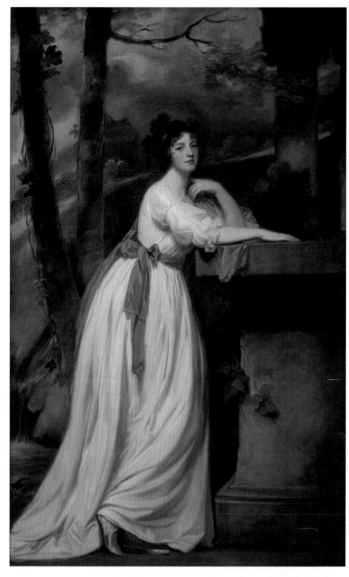

Portrait of Mrs. Andrew Reid by George Romney (ca. 1780–88). Kimbell Art Museum, Forth Worth, TX.

polite posture for both men and women was to be a paragon of your status, not give offense, and display "grace of measure"—in posture terms, a discreet, measured, self-aware gliding across space. The noble woman would not carry anything that might alter her lofty bearing—perhaps just a fan or keys to her tea caddy. In *Portrait of a Noblewoman of Ancona* (1650–60), a painting at the Walters Museum by Luigi Primo, an upper-class woman strolls through her private courtyard and raises her skirt off the pavement in the slightest gesture that allows a minimal step forward.

The comfort of extinct corsets and beehive substructures to skirts is still debated. Probably feeling consummately attired compensated somewhat for the wearer's discomfort, and if the garments were well made, they would have hurt less. However, art of the sixteenth century does not lie about the ill results of the fashion of the farthingale on posture. The long bodice that rested on the beehive descended below the natural waist so top and bottom could look like a stick that froze into a popsicle at a peculiar angle. In the scene at Henry III's ball, the painter captures the women's swayed-back posture.

In the memoirs of the court of Louis XIV, people were praised or derided for their walks, and a courtier had to have red soles to enter the Palace of Versailles. All nobles were subservient at the court and if a woman tripped or showed a hole in her stocking, it was a scandal and cause for rebuke.

▪ Rigid Clothing

Robert Herrick, the seventeenth-century poet who advised to "gather ye rosebuds while ye may," never married but loved refined sensuality. In "On Julia's Clothes," a narrator watches the object of his desire pass by in silks. It's not her face or figure but how she moves in clothes that mesmerizes him. He describes Julia's clothes in three ways—as a liquid, a vibration, and a glittering. "Whenas in silks my Julia goes, / Then, then (methinks) how sweetly flows. That liquefaction of her clothes." The faceless object of the poet's desire has an unspoken natural elegance that sets her apart

Lady Reading a Letter by Camaron Boronat (eighteenth century). Museo de Bellas Artes, Bilbao, Spain.

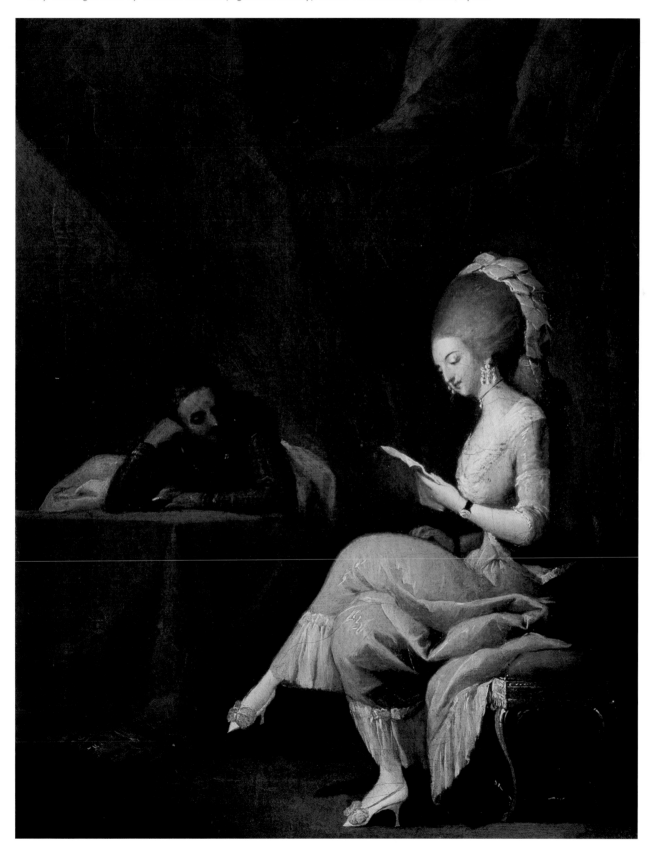

yet identifies her as part of the cultural elite. She gives the impression of self-command and composure. She is a vision because of the becoming way she wafts in the folds of the yards and yards of fabric.

Herrick had a poetical vision, but seventeenth- and eighteenth-century European clothes and corseting underscored a stiff noble bearing. When Charles Perrault wrote *Contes du Temps Passé* (1697), Cinderella had trouble walking down the staircase in her glass slippers and lavish ball gown. Similarly, the women at Versailles could hardly walk to the gate in their little pink stockings and fragile stacked heels, if they wanted to.

In 1700 in France, a girl of the noble class was a political pawn who could expect to be married as young as twelve or thirteen, be pregnant continually, have some surviving children, and often lose her fortune to a blackguard husband and die neglected and young. Such would have been the life-story of the Countess Marie d'Aulnoy (1650–1705), a provincial heiress married at sixteen to a Parisian gambler and wheeler-dealer, Baron François de la Motte, except she rose to fame and stature. She became known as the muse of history and found a lover who lasted and fathered her children. At nineteen, the Countess was involved in a plot to accuse de la Motte of treason and perhaps to poison him. Pregnant with her love child she escaped to Spain. The Countess was away from Paris for fifteen years, writing the first soi-disant "fairy tales" and also travelogues to Spain and England, before Louis XIV pardoned her because of the popularity of her writings.

The Countess recounted in her *Voyage to Spain* (1691) the Spanish fashions she saw on the way to and in Madrid and how women carried themselves and walked in their clothes. She noted that the women were wearing hoops less exaggerated than those worn by a Portuguese princess in a painting who had two pots of flowers on the sides of her dress. Rather, they were wearing sacristains, or sextons, the "children" of the flower-pot hoops, under up to a dozen rich skirts ending in a lace or muslin petticoat next to the body. Their shoes were black kid slip-ons in which "they fly when they walk. They hold their elbows close to their bodies and slide without raising their feet." She described how fashion met culture:

> These skirts are so long in front and at the sides that they drag a lot on the ground, but never at the back. They wear them close to the ground, and wish to walk over them, so that no one can see their feet, which they go to great lengths to hide. I heard that after a lady has had all the compliments possible by a cavalier, it's in showing him her foot that she affirms her attachment, and so they call this 'the ultimate tenderness.'[3]

Eventually women rebelled against the impediments to walking. They remembered Marie Antoinette, who gathered flowers and fresh eggs in her hamlet, dressed in the shorter skirts of a peasant, and the painter Jean-Honoré Fragonard celebrated young women on tree swings, kicking up frothy skirts.

▪ Impractical Outfits

In Colonial Williamsburg, Virginia, how did those who wore even modified corsets perform their roles? The Federalist women wore corsets that deformed their posture and walk from girlhood. Pushing the chest forward and the posterior back deformed the hips and allowed the daughter or wife of a man of property only a stately, not natural, walk and posture. Good posture was firmly tied to self-discipline—holding oneself erect and to high standards. And yet the American woman despised idleness and read Voltaire on the topic of a lady's graceful walk. John Adams warned that a slouching and twitching posture could badly impact social relations.

Another aspect of women's posture will be understood at once by anyone who ever waited for a bus with bare knees or outside a movie house in a miniskirt on a cold day. In eighteenth-century America, a woman used to freeze if she had inadequate clothing. The Colonial or early nineteenth-century woman was dressed appropriately for being near the hearth, but when she walked long distances, she wrapped herself in a cloak, like Hetty in *The Scarlett Letter*, and her legs were cold.

It simply hadn't been a sign of breeding for women to promenade. For instance, in the 1674 etiquette manual *The Ladies Calling*, Richard Allestree advised, "'Tis pronounced a piece of ill breeding, a sign of a country gentleman, to see a man go abroad with his own wife."

Suffering was part of obedience. Wrote a memoirist in New England of the beginning of the nineteenth century,

> In earlier times, women seem to have undergone more privations and suffered more discomforts from insufficient clothing than men. Their outer protections were very meager. Like their brethren they were not provided with flannels, waistcoats, or frocks for the chest and trunk, and less with drawers for the rest of the form. The last were not known under the first quarter of this century. They were therefore very much exposed in the winter. Their skirts were light and narrow and often short. The winds easily reached and chilled their unprotected surface.

▪ Who Am I?

In pre-modern times, no woman evaluated her whole look—there was no three-way mirror insight. When Italian glaziers were brought to Versailles at the king's command, they were to create a hall of mirrors, and while this corridor still exists, it disappointed the Sun King because the mirrors were smaller than expected. It was not yet feasible to give the king the walls of mirror he wanted to blaze in candlelight and reflect his glory. In the eighteenth century, it was beginning to be possible to see oneself in a full mirror. Wearing a farthingale and sumptuous bell gown with ribbons and metal embroidery, a woman could look down and see how she shone. However, with the full mirror it became possible to see one's entire form.

The fashionable boudoir where Madame de Pompadour, during the Ancien Régime, or Madame de Récamier, under Napoleon's rule, received guests had a large cheval-glass in which she or her guests could see themselves not through the eyes of their flattering friends but as they actually were. It was called a Psyché, after the mythical beauty who caused such trouble and triumph to Cupid and herself, and in this innovative style of mirror a woman could see her reflection head to toe.

In the late eighteenth century a woman could at last objectively see how she appeared—the fit and line of the dress, the way she held her body, and how she moved. And thanks to improvements in oil lamps and candles, dresses no longer needed as many ornaments to catch flickering light. At the theater, the stage was lit by Argand lamps. Candles burned more efficient and brighter—first those made from spermaceti, wax from sperm whale oil that didn't smell like tallow, then those made from rapeseed that flamed clear and smokeless, and then finally long-burning candles that had stearin as a hardening agent. Makeup lightened as did the clothes, and stylish women liked to pose in fluid, graceful movements as opposed to hieratic stiffness.

Study of a Seated Woman (ca. 1791). Yale Center for British Art, Paul Mellon Collection.

Emma's "Attitudes"

Born in poverty, her mother shortly widowed by her blacksmith husband, Emma Hamilton went to work while still a girl. She lost her place as a lady's maid and took a job at an eating establishment frequented by a bohemian crowd of artists and musicians. Her story continued like a bodice-ripping romance. By the time she was sixteen, a young baronet had come into her life and kept her as a mistress until she became pregnant, when he dumped her. She modeled for the painters George Romney and Sir Joshua Reynolds. Next the Honorable Charles Grenville chose her as his mistress and then when he married for money he passed her on to his widowed uncle, Sir William Grenville, a diplomat, vulcanologist, and connoisseur of antiquities while they were being excavated from Pompeii. As the British ambassador to the court of Naples, vases, urns, and classical statuary filled his villa in Porici, overlooking the Bay of Naples. In 1786, he was persuaded to marry Emma (he was sixty-one and she twenty-six), at which point the story rather goes downhill due to the scandal for which she is most remembered. Now with a ring on her finger, Emma had an adulterous and blatant relationship with the great Lord Horatio Nelson, a much younger man. Emma met Nelson when he arrived by sea to try to gain the King of Naples's assent in the war against Napoleon. Together they would have a child (she has descendants today).

Early on, though, Emma and Sir William formed a perfect pair. He was her *tabula rasa,* and she was eager to become cultivated and put her old life behind her. He delighted in her beauty and in showing her to society as his protégée.

Emma had beauty, a good singing voice, and a talent for languages. She was a charming hostess to Sir William's posh guests. Emma wanted to distinguish herself, keep busy and please Sir William, to which end she took his passion for Classical myths and history grafted on it her own bold verve, creating pantomimes of legendary figures. It began when Sir William objected to how a limb of marble statue of Athena in the royal galleries of Naples had been badly renovated. Emma took the same pose and got it exactly right. When they went home, she started to imitate the figures in his collection, and Sir William, evidently with time to kill, coached her.

She developed a show for Sir William and then the elite world that involved moving from pose to pose in a range of what eventually became 200 different pantomimes. The concept was her creation. As a young girl, she may have

been a stage goddess in the Temple of Health, run by a galvanist who cured people with electricity. She may also have danced on the baronet's tables and seen the impersonations, called Attitudes, that were a stock in trade of brothels. Her pantomimes raised the bar very high, and thousands of tourists to Naples came to see her perform them in the privacy of Sir William's villa. Her pantomimes included Venus, Cleopatra, Helen of Troy, one of the Three Graces, Niobe, Danae being showered with gold by Zeus, and more. She also performed male characters. She wore short tunics when doing male roles such as a blinded Oedipus and Orestes sacrificing his sister. For the female roles, such as Bacchantes, Hebe and Juno, she wore a very light, loose, muslin chemise and swished a pair of shawls as props around her body. The pantomimes were called Attitudes and she flipped through them with only a pause between. She was conscious she was bringing alive sexual stories, but because spectators were asked to guess the pose, the Attitudes were acceptably highbrow and received stellar praise from Goethe, Horace Walpole, and naturally Sir William, who told a friend that "she only of the sex exhibited the beautiful lines he found on his Etruscan vases."[4]

A caricature by Thomas Rowlandson in 1791 shows Lady Hamilton performing her Attitudes naked on a model's stage, before a group of lusting old men. The satire touched on the reaction this revolutionary performance provoked, but in fact, Emma did her movements not naked but scantily dressed. The first time she entertained Sir William's guests with her Attitudes, she was in a huge box, turned upright and painted black inside, and usually she would perform by candlelight for more effect. It was a romantic age, and she had a sensitive heart and vivid imagination captivated by the Classical stories; in 1792 she wrote in a letter: "Oh, my dear friend, for a time I own through distress my virtue was vanquished, but my sense of virtue was not overcome."[5]

Sir William presented Emma to Marie Antoinette while she was in the Bastille, shortly before she was beheaded. Emma was very moved; there is no record of her portraying the French queen or other contemporaries in her Attitudes, however her impact on the society women who saw her garb and dancing movements in the drawing rooms of grandees was great. They talked and wrote of her, and by the time she died at age forty-nine, they were dressing in the same little chemises she had worn in the Attitudes. ■

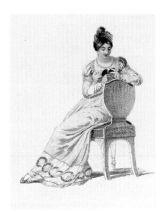

Fashion plate of evening dress by Rudolph Ackermann (England, early nineteenth century). Los Angeles County Museum of Art.

▪ Revolutionizing Posture

Women at Napoleon's court wore slippers so as not to dwarf the emperor. This also gave them a more natural carriage and accustomed people to the view of female legs, suggested through filmy gowns. They modeled their posture on images from Greek vases. Madame de Rumusat in her memoirs described how the dancing master to Marie Antoinette was summoned to the imperial court to give posture and curtsey lessons to all the court ladies (mostly drawn from the nouveau riche):

> He taught us how to walk and how to bow; and thus a little boundary-line, trifling enough in itself, but which acquired some importance from its motive, was drawn between the ladies of the Imperial Court and those belonging to other circles.

Looking at Greek and Roman statutes made women adopt gestures like lounging or bending the knee to emphasize the drapes of fabric. Once relegated to mistresses, stretching out on a divan was now the height of fashion. The stretched out legs were delicately contoured by the light

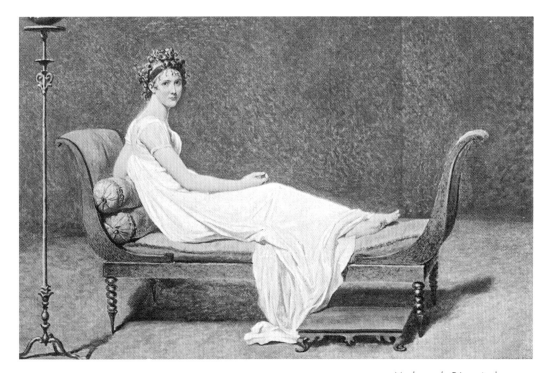

Madame de Récamier by Jacques-Louis David (1810). Neoclassical furniture, dress, and posture were in vogue after the French Revolution. Fashionable women like Madame de Récamier, a banker's wife, in their minimalist white dresses "à l'antique" lay on Empire-style sofas or in their beds to entertain guests. Antique postcard. Collection of J. M.

fabric of the white chemise gown alluding to the marble of Classical times. The neo-Classical foot was encased in a flat supple shoe, which by 1820 was completely flat. If a girl was self-conscious about the size of her feet, then the fashions of the 1830s must have been one of her worst nightmares. Small feet were desired and the calf-length hem decorated with heavy trimmings drew the attention downward.

▪Proper Reserve

As the strict support of clothing was reduced, the question arose whether the lack of stays came with lack of discipline; all through the nineteenth century, etiquette pundits sounded the clarion on the importance of posture discipline. Emma Parker's etiquette book published in 1817 said that people will judge a woman by posture and "the body should partake as little as possible in the motion of the limbs."

In proper circles, the lounging attitude decreased until the last place the girls were carefree was that tree swing. Writers on proper social conduct warned against posture that could peg a woman as lowly. A woman had to be on guard to walk and stand, as well as dress, well. "The true lady walks the street, wrapped in a mantle of proper reserve, so impenetrable that insult and coarse familiarity shrink from her.... By her pre-occupation [she] is secure from any annoyance to which a person of less perfect breeding might be subjected."[6]

The genteel woman glided smoothly through the crowd whereas the prostitute attracted male attention by her walk. Sketches by the nineteenth-century illustrator Constantin Guys show the *grisettes*, or Parisian working girls (called "grays" because of the cheap fabric of their typical gray dresses) slightly raising the hems of their skirts. John F. Kasson, professor at UNC Chapel Hill and author of *Rudeness & Civility: Manners in Nineteenth-Century Urban America*, contrasts the "inconspicuous passage of the proper lady with the Bowery Girl whose "very walk… had a wink of mischief and defiance in it."

A woman's posture in the nineteenth century bespoke her quality and measured her character. Novelist Maria Edgeworth, a staunch Unitarian and social activist, turned a critical eye on the mien of women in their hoops in her 1801 novel *Belinda*. A recognized authority on the niceties of fashion, Lady Delacourt, a doyenne of society, tells her friend Clarence Hervey and her young houseguest Belinda that everybody wears hoops but "how very few can manage them." Her mockery continues:

> There's my friend lady C—in an elegant undress; she passes for very genteel, but put her in a hoop and she looks as pitiable a figure—as much a prisoner—and as little able to walk as a child in a go-cart. She gets on, I grant you, and so does the poor child, but getting on you know is not walking… Encouraged by Clarence Hervey's laughter, lady Delacourt went on to mimic what she called the hoop awkwardness of all her acquaintance.[7]

Writers who seized on undergarments as something to mock in a newspaper exaggerated for effect, but Edgeworth drew attention, credibly, not to the hoops but to the posture/walk of women who, for one reason or another, are clumsy in their hoops.

Just as muscular Christianity emphasized the virtues of fitness for young males, attention was devoted to posture education for females in the late Victorian age. The fervent concern with standing up straight was central to Victorians. Two US historians, David Yosifon and Peter N. Stearns, trace the origins of the stiff posture as a social norm only to the late eighteenth century in America. The Victorian concern with a woman's posture, they explain, was a counterattack against shifts in clothing and furniture, which were reducing their structural supports of rigid posture beginning with the empire style.

The rigid formality of the nineteenth century relaxed in the last two decades with the increase in sportive pursuits for women and the rise in fashion of shirtwaists and suiting with tailored skirts. Women joined the work force and needed to walk and stand with ease. The feminine suit built on a tradition of the men's fashion that began mid-century and reflected the changes in women's roles in society. However, in some circles, the devil was thought to find a way to corrupt young women through their new ease of motion. There were posture-correcting devices for recalcitrant cases. Doctors jumped in, and the combined zeal of their scrutiny resulted in 1914 in the formation of the American Posture League that distributed kits to schools.

Diversions of a Summer Girl (1896). Library of Congress Prints and Photographs Division.

▪ The Admirable Stride

Another current, however, was the fervor for walking. William Wordsworth and all the Romantic poets loved to walk, and so did the transcendentalists. Margaret Fuller, a feminist and transcendentalist, declared "the especial genius of women I believe to be electrical in movement."[8] There had long been "walking skirts," which didn't have trains, but exuberant cross-country hiking required, or indicated, a shorter skirt. Such an outing could not be a spontaneous idea. As late as 1900, among the upper crust in Newport, Rhode Island, it meant telling one's maid to prepare a walking dress and reserving a time for the carriage to transport the prospective hiker to the site. The bodice-ripping romances are correct in showing that the upper-class Regency woman had a dress for every occasion, including the outdoorsy, as Jennifer Kloester describes in *Georgette Heyer's Regency World*.

The Empress Eugenie was most likely the greatest fashion influence of her time. Although the crinolines she wore required tutelage to walk in and set the lower back in a vice, Eugenie walked and rode horseback in the public *bois*. Other women followed. In previous times, a woman did not go to a public place unaccompanied by her mate. "Something always happens on taking a walk," as Charles Dickens famously said, which is precisely why walking abroad was frowned upon. Yet now an empress was seen walking in public constantly, in the bois and at the seaside and this had as much impact on fashion as her taste for elaborate fans, parasols, and camellia-like gowns.

Walking was not reserved just to the countryside or resort towns. In cities, the fashion for promenading—in addition to the fact that women now moved more freely in the public space—created a need for specialized clothing. In the 1860s, a walking dress for visiting or strolling down the promenade had ribbon loops that pulled up the skirt to ankle length, allowing women to walk more comfortably. Often handsomely pulled up in drapes at the back, this fashion eventually led to the bustled silhouette of the following decade.

Walking dresses came in different fabrications, depending on the season, and could be simple in decoration or elaborately trimmed if they were made by a couture house like Worth. One thing was a constant: the style always conformed to the fashionable body shape of the period. While the ankle had a moment of relief, the corset still made routine movements associated with household chores virtually impossible. Posture, which is essentially the relationship between the upper and lower body, was therefore hardly affected by a temporary adjustment of the hemline.

Lady Leaning on a Column (possibly a sketch for "Miss Woodley") by George Romney (1734–1802). Yale Center for British Art, Paul Mellon Collection, New Haven, CT.

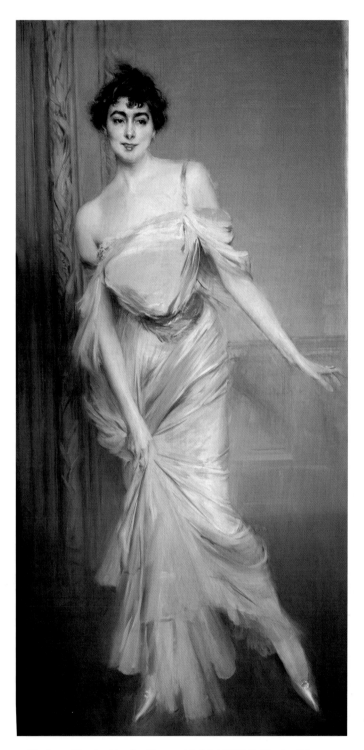

Madame Charles Max by Giovanni Boldini (1896). Musée d'Orsay, Paris, FrancePhoto. Erich Lessing/Art Resource, NY.

▪The Edwardian Stance

Charles Dana Gibson's illustrations epitomized the movement-oriented fashions of the Edwardian period. His artwork showed women that to be fashionable, one must be outdoorsy, active, and athletic. In comparison to the elaborate dress of the mid-nineteenth century, the undecorated skirts and pristine shirtwaists of the Gibson Girls seemed wholly modern. Yet, these clothes were worn on foundation garments that created the erect posture so strongly associated with Gibson's illustrations. It is curious that just when women stood like chickens to look most fashionable, the lives of women were pushing in another direction. Whether she roller-skated, played lawn tennis, rowed, or bicycled, the American woman now had access to sports. In the early twentieth century both dress and furnishings became more relaxed. Instead of sitting at the edge of a horsehair-covered sofa in the parlor, a woman rested back on a more comfortable chair and wore clothes that gave the opportunity for less rigid posture. Once an individual had streaked across the ice or experienced speed on a bicycle, she simply couldn't put all the armor back on. It was a nice conceit that dancing star Caroline Otero rarely wore a corset but had one covered in her admirers' gifts of jewels, which she relegated to a bank vault. However, through mid-century, girls were taught to sit at the edge of the chair in company, so as to keep their backs straight.

It wasn't until fashion designer Paul Poiret looked at non-Western sources for inspiration that clothes informed a new posture. In fashion, the twentieth century started in 1907 with Poiret's modern outlook on clothes, attitude, and, by extension, posture. Poiret advocated a corsetless silhouette that shaped the imagery he created with illustrators Georges Lepape and Paul Iribe in his catalogs and advertisements. The slightly bent torso and light leg lift produced a streamlined movement that would not have been possible with a corset. Although he would later design the hobble skirt, which constrained the legs and made women walk like geishas on the verge of toppling, his Eastern-influenced designs emphasized a relaxed posture and ease of movement.

A Mason Giving the Password. The object of the gallant's flirtation is clearly going nowhere, entailed by the skirt. Antique postcard. Collection of J.M.

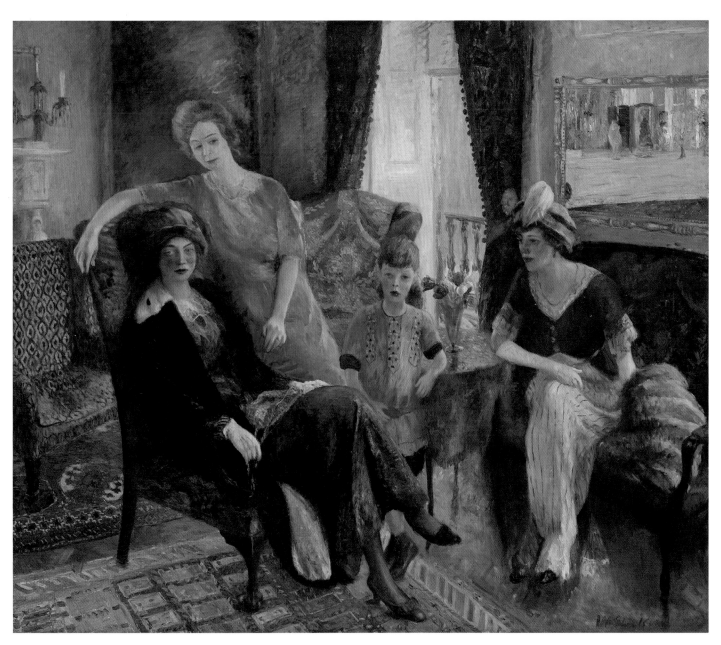

Family Group by William Glackens (ca. 1910–11). Gift of Mr. and
Mrs. Iran Glackens, National Gallery of Art, Washington, DC.

L'An Nouveau, the new year that this postcard greeted with "Bonne Année," shows the importance of fine stockings for the new shorter length (ca. 1920s). Collection of J. M.

▪ The Debutante's Slouch

The pre-war stance of the Poiret-wearing woman evolved to reflect modernism and youthfulness in the post-war years. In the 1920s, etiquette advice conflicted with what was taught on the dance floor. African-American dances and jazz influenced posture—the cakewalk and shimmy and then the Charleston required swiveling the body and bending the torso and legs. Flapper mentality was a rebellion in many traditional behaviors, including posture.

The jerky fast movements of the popular dances would have been impossible in the old corsets. Crouching, slithering and dropping one's head forward were part of the popular dances, and with no corsets and stays to keep the girls rigid, many mothers despaired over their daughters' poor posture. The silent movies and early talkies used a trope of the female caving in physically to her seducer while she fingered a long string of pearls and placed a hand on her hip or stiffened a leg, suggesting she had lovemaking in mind. Sometimes she actually slouched into the man's arms, and he carried her off for debauchery.

The rounding of shoulders and sinking of head took on the name "debutante's slouch." Popeye's Sweet Pea slouched, and society girls were photographed in insouciant relaxed postures in loose-fitting short dresses with dropped waists. Paris couturiers showed fashions with straight lines in 1914.

Albert Einstein said we cannot do anything about the march of time, but we can self-determine space. The flapper couldn't go back and change the ravages of war, but she could flout authority, rouge her knees, and go barelegged. The slouched stance mirrored the spirit of the time and the new woman that occupied it.

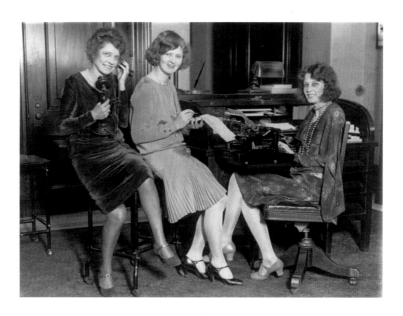

Secretarial staff of V. P. Charles Curtis at work (Published May 1, 1929). Library of Congress Prints and Photographs Division.

Fancy Footwork *By Marion Diamond*

By the late Renaissance, kneeling was reserved to show respect for God, and men bowed and women curtsied to show respect for other people. A dress hit the floor when one's knee bent, so the natural movement was to raise the hem at both sides and, given the style of dresses, bowing was out of the question for women.

The full or deep curtsey is associated with the presentation of debutantes. The idea of the Season began in earnest with Queen Charlotte, wife of George III, and died out in the mid-twentieth century. At coming out balls, debutantes in many countries including the US continued to do the full or deep curtsy.

I learned to curtsy at school in the late 1950s, at age twelve. The wife of the Queensland governor, Lady May Abel-Smith, a great-granddaughter of Queen Victoria, was coming to present the prizes, and the recipients were lined up in frog-green uniforms and decidedly inelegant black leather tie shoes. We practiced for days—place one leg behind the other, lock knees, and bend.

It was impossible to descend evenly, since everything tends to bend, not just the knees, resulting in an awkward waddle, the shoulders at an angle, and the back and neck jutting forward. The aim of a proper curtsy was to go down, and rise again, with a stiff, straight back. I'm sure nobody curtsied in city streets, but in private it was a standard form of greeting between women, or between a man and a woman, in fairly formal circumstances such as at a ball, or during an introduction. I'm sure Elizabeth Bennett curtsied to Lady Catherine de Burgh, that she and Miss Darcy curtsied to each other, but that she and Charlotte would have kissed. When Jane Austen says that Miss Anne de Burgh didn't get up to greet Elizabeth and Charlotte, I believe she's really saying that she didn't curtsey, and she should have done so.

We probably looked cute executing our curtsies for Lady May, but as you grow up, Nancy Mitford's description in *Love in a Cold Climate* (1949) of Lady Montdore at her dinner party of grandees becomes increasingly accurate: "She scrambled down like a camel, rising again backside foremost like a cow, a strange performance, painful it might be supposed to the performer." Curtsies, outside the ballet, are always a bit like this.

Crinolines, despite all the Punch cartoons, weren't that unwieldy. The various hoops just collapsed into each other. Other petticoat styles operated much the same.

The older method, if you want to try it out for a costume party, was as follows:

Place your feet in ballet second position—feet at an angle to each other, and bend your knees in a plié (dip) with back remaining straight. This looked elegant when all the action took place behind a long and voluminous skirt, but those widespread knees became unacceptable when hemlines rose in the early twentieth century, and physically impossible in the narrow skirts in the 1920s. The modern curtsy, insofar as it exists, is more of a compromise bob. ■

Marion Diamond is professor emeritus of the University of Queensland in Brisbane, Australia, and author of Historians are Past Caring, a blog.

Posture Class *By Jo Kuszmar*

Not long ago, being appropriate and proper meant upholding the prevailing notions of womanhood, including showing modesty and being a support to the husband. Notions of good posture reflected this. Broadly speaking, this was about demonstrating self-control: holding the tummy in, straight spine, holding oneself up or in psychologically as well as physically. The "foundation" garments of the day reflected this as much as the overtly feminine tea and cocktail dresses. Girls were expected to "save themselves" for a husband; as a corollary, legs were to be demurely held together no matter how full the skirt.

Posture until the mid-1960s was about correctness. Today, the majority of posture clients want to look more youthful, rather than "pert and alert." They also want to feel secure in their appearance and make an impression.

I tell my clients that posture is a part of good manners —good posture helps you put other people at their ease. Formerly about keeping distance, now good posture is not about being either superior or seeing yourself as an idealized object but about being real.

A posture class back in the day would have involved holding tummies in, pushing shoulders back, and balancing books on the head, requiring a measure of force, control, and containment; today, although the outcome will still be to be able to balance a book on your head, the object of a lesson is to address the habitual patterns of tension that cause distortion and to release the body from those habits, and return it to its beautiful upright position. An elderly countess told me about the magnificent wardrobe once in her possession, but also that she put all her back problems down to the strict deportment lessons she underwent as a young woman.

Of course, materials, such as Lycra, have made a huge difference not only in the range of clothes choice we now enjoy but also in the way our clothes no longer have to restrict us. Recent years have seen a return to body-shaping underwear. On one hand, this is a response to more sedentary lifestyles and the rise of thicker waistlines. On the other, these new materials help those with toned athletic bodies show them off in a way that would have been, until recently, considered immodest. The big difference in portrayal of women in the last fifty years has been the degree of sexualization and suggestiveness in fashion photos. This totally transformed the way models pose; the influence on real women is somewhat less. ∎

Jo Kuszmar is a shiatsu and deportment expert, Eau de Vie, Oxford, England.

▪ Posture Class

Posture study was a required course at elite women's colleges for the first hundred years of their existence. Its syllabus involved, for example, how to cross one leg over the other and point the foot when sitting in a chair, how to stretch out the legs and cross the ankles when seated on a bleacher, and how to look crisp and cool carrying a suitcase.

Under the new head of education at Vassar in 1930, posture class was reclassified as a "liberal art." It was noted in the Vassar *Miscellany News* that the average posture grade of members of the class of 1943 had gone down to C from the previous year's level of B. The *News* detailed the 317 students with "heads pushed forward into the future" and "posture peculiarities" including the slouch, the widow's hump, and rounded shoulders: "This slack attitude towards life is emphasized by the accompanying manifestation of the low chest." To the reporter, "even more demoralizing" was the relaxed abdomen and the tail tucked in of 131 freshmen.

In the last decades of hegemony of the "Seven Sisters" colleges, the biggest rumor was college boys stealing the posture pictures. The 1964 Wellesley course catalog noted every entering student "was expected to attain a satisfactory standing posture," which she might breeze through or have to take two seasons of body mechanics to pass.

In a required course for freshman, Fundamentals of Movement, Wellesley students, dressed in black leotards, practiced walking carrying suitcases (the old metal-frame type), with the aplomb expected of a Wellesley girl. Students also practiced demure sitting posture, feet together and at the side.

The screenwriter and author Nora Ephron (Wellesley, 1962) mentioned in a commencement address in 1996 that she was taught in posture class how to get in and out of the back seat of a car. Judith Richards Hope, who wrote the memoir *Pinstripes & Pearls: The Women of the Harvard Law Class of '64 Who Forged an Old Girl Network and Paved the Way for Future Generations* (Scribner 2003), recalled from the same Wellesley era the "bizarre ritual" of standing naked for posture pictures and then practicing how to enter a car "without sticking my rear end in my date's face when he held the door open," and "how to place a suitcase on the overhead rack of a train or look sufficiently helpless that some man or other would leap up to assist me, how to walk with a book on my head, how to shed an overcoat gracefully." Hope, with a powerful career in the law, credited the class with helping her learn "grace and poise."

▪ The Walk and the Swing

The heyday of runway models in local and urban fashion shows of the 1950s gave posture a boost. The professional models and the amateurs who took modeling courses practiced the right posture for the fashionable shoulder-padded dresses. Walking tall was a general concern and modeling teachers came up with something called the plumb line. Imagine a string attached to the top of your head that suspends you. As it is pulled, you feel your body grow taller and your spinal cord lengthen. Your chest rises, and your fanny goes where it belongs, behind not under the hips. At a fashion show, clothes were presented according to the reigning concept of drop-dead elegance, involving discreet movements and a stately walk. However, rock 'n' roll added excitement to the showings of designers in the '60s. With music blaring, models moved more aggressively and jerkier. Training for runway modeling was no longer an influence on posture.

Posture informs attitude and vice versa—comparing the fashion of the 1950s to that of the 1960s shows the greatest divide. While Christian Dior, the architect of the corseted style of the 1950s looked to the Belle Époque for inspiration, the designers who emerged in the 1960s sought to break away with tradition with movement and swing.

The youth culture brought in short skirts but women of all ages benefitted from the effect on styles. First came the new orientation of a woman to her body. Girls typically had to work at loosening up their hip movements. They put paper footprints on the floor and did the swivel that had been hitherto taboo. Men stopped fixating their gaze on the upper body and the breasts; now legs and silhouette caught their attention. To look good in a miniskirt, a woman didn't have to be young—she had to be "empowered" about her body from the waist down. It was a rediscovery of sorts of the hips, a frozen part of the mid-twentieth-century female public self.

With skirts shorter than they had ever been, what was a woman to do about how she walked and stood? First she could exert bravura, a devil-may-care attitude, her body language projecting, as in the song, "These boots are gonna walk all over you." However, most women either could not afford or didn't choose to wear thigh-high boots, and tights got runs. So women found themselves wearing very short skirts with bare legs. This required walking cautiously, and self-consciously, since women instinctively temper their posture to self-protect. According to psychologists Martha Davis and Shirley Weitze, who scientifically studied sex differences in body movements and positions, "It isn't simply that men sit with ankle on knee or women sit with ankles crossed, these are specific examples of a general tendency to wide or narrow movements and positions."[9]

Not every glamorous woman wanted to look girlish —European bombshells like Sophia Loren and Claudia Cardinale opted for a curvaceous mature style. This airy lightness, natural to many teenagers, could only be maintained by grown women by staying undernourished.

Celeste Yarnall and Elvis Presley in "Live a Little, Love a Little", 1968. Courtesy of Celeste Yarnall.

The models Twiggy and Jane Shrimpton epitomized the 1960s idealization of the young and slender. The decade's greatest innovation in posture was the turned-over V shape created by standing with open leg with hands resting on the hips. The miniskirts of the 1960s allowed leg models to confidently spread the legs, which in turn changed how they moved on the catwalk and how they posed for photo shoots.

Susan J. Vincent, author of *The Anatomy of Fashion*, comments that modern locomotion "finds its extreme expression on the runway, in the walk taught to female models." She says that the feet are not only placed directly in front of the other in a single straight line but sometimes with the front foot crossing over. This gait "helps the hips sway and gives the model the look of, as we interpret it, strutting insouciances."

Araks. Photograph by Trevor Owsley.

▪ Heroin Chic

Fashionable posture then evolved from the athletic, robust 1970s and '80s to the sickly "heroin chic" of the 1990s. Corinne Day's photographs of young Kate Moss epitomized the look of the decade. Films like Larry Clark's *Kids* with Chloe Sevigny and Danny Boyle's *Trainspotting* with Ewan McGregor further glamorized a look that obviously alluded to drug use and sleepless nights, but was also very young. The so-called heroin chic, however, wasn't just fair skin, eyes circled in black, and skinniness; rather, it was the nonchalant, au naturale manner in which these young people carried themselves that was the biggest leap from decades past.

Donatella Versace, among many designers, played with these notions. On May 7, 1996, she was quoted by the *New York Times* saying, "I don't think they [my models] look like heroin addicts. To me they look like a young girl on the street now. It's not about drugs; it's about an attitude. Girls don't need a lot of makeup or a hairdo to feel good about themselves," adding that "when I do the fittings with the new girls and see how they arrive in the show, how they talk, how they move, I don't want to put on strong makeup. I want them to be themselves. I respect the way they look in real life rather than change them into something else."

The concept that reigned in the mid-1990s was to look blasé and insouciant regarding fashion. If the clothes had to look like a casual, unintended accident, all one was left to work with was posture. Since the 1990s promoted a slenderness that even Twiggy could not have imagined, skinny legs were essential for the right look. It was even better if heavy boots clad the legs so they seemed slender to the point of skeletal. The look was slouched by clothes that looked almost too heavy and big for the bony body that carried them. The spin was slightly curved with hands in pockets or arms crossed at the waist.

Legs were not only skinny, but also very long. Fashion illustrations from the period, like caricature in the nineteenth century, point the eyes to what fashion deemed most important. In this case, legs so long they take two thirds of the body height and zigzag in front when walking. The posture of legs went from invisible to complementing fashion to leading it.

Photograph by Nasser K., 2014.

CHAPTER5

Hemline History

Contrary to what your mother told you, wrote Hadley Freeman in *The Meaning of Sunglasses: And a Guide to Almost All Things Fashionable*, an outfit's quota of tackiness has nothing to do with the height of a hem, the inches of a heel or the tightness of a skirt. It has to do with the obviousness of its message.

This chapter looks at hems and hemlines, an ineffable and recessive matter of fashion history. Words in French, Spanish, and Italian for "hem" all originated in the fourteenth century when for the first time women debated how many inches off the ground they wanted to have their hemlines. As Rosemary Horrox writes in *The Black Death*, for many observers of the plague, the arrival of disease was associated with unwelcome changes in women's fashion. According to a chronicle of a monk of Westminster abbey writing of the year 1344, shorter hemlines and the tight female garments meant sometimes fox tails were hung inside skirts at the back to cover the fanny. This was interpreted in the pulpit as wantonness and a reason for the plague during the period it ravaged Europe.

In the Renaissance, skirts concealed the legs, and it was the train that varied in length. Seen as a status symbol, the train got quite long. In the thirteenth century in Siena, a provision was passed reducing the trains on women's dresses. The Age of Exploration brought fabulous cloth to Europe, exhibited in the elite woman's full skirt with its train. The dresses had ankle-length elaborate petticoats, often colored, beneath them. In the early Renaissance, women held up their skirts to show the petticoats, or engaged a page or maid to carry the train. Sometimes the dress was looped up, so it had the complex effect of several hemlines as the woman walked. It was noted by a French chronicler in 1487 that ladies were no longer wearing the train, and were substituting eighteen-inch wide trimmings of feathers, fur, or velvet. The bookish Charlotte of Savoy (1461–83), the second wife of Louis, whom he abandoned in a castle in Burgundy, was depicted wearing a hem that skimmed the ground but a long veil trailing just like a train, creating a second hemline.

Hemlines of ladies touched the ground to the late eighteenth century—this went for little girls as well, who were scale models of their mothers until Jean-Jacques Rousseau's notions of childhood had an impact in the eighteenth century. As art historian Anne Hollander has observed in her book *Seeing Through Clothes*, superfluous drapery signals wealth, high rank, and moral worth (like saints and Biblical characters).

Beginning in the late fifteenth century, the Spanish farthingale expanded the shape of the silhouette around the hemline into a nearly perfect circle. The farthingale was made of wooden hoops that supported the dress from underneath, allowing beautiful, rich textiles to drape about it from the waist down, showing them to great effect.

Farthingales were part of the style of lengthening the torso and making the legs look short, which is seen to an extreme in Velasquez's portraits of Spanish princesses. If the hoops were well engineered, the wearer could use her arms to propel herself and lift the hem. The baroque high-born woman presented rather like a masted sailing ship with her hem marking the water line.

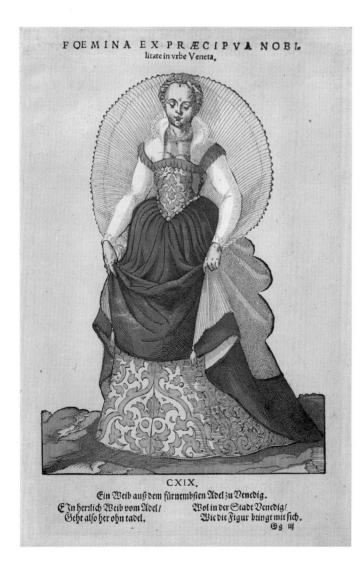

"Foemina ex Praecipua Nobi" from *Trachtenbuch von Nurnberg* (*Costume Book of Nuremberg*) by Jost Amman (1577). Los Angeles County Museum of Art.

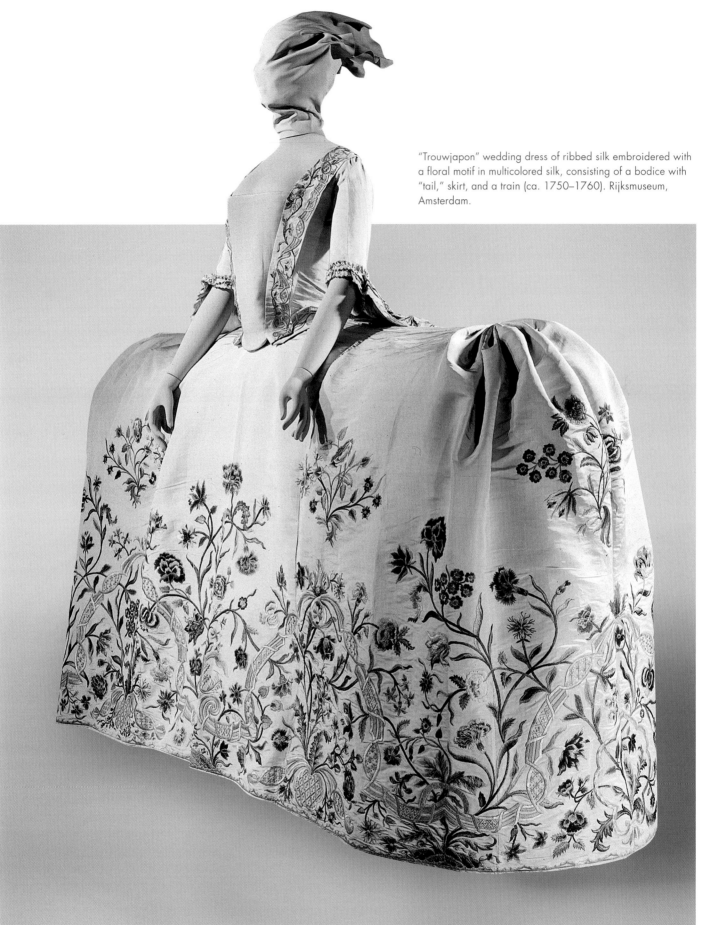

"Trouwjapon" wedding dress of ribbed silk embroidered with a floral motif in multicolored silk, consisting of a bodice with "tail," skirt, and a train (ca. 1750–1760). Rijksmuseum, Amsterdam.

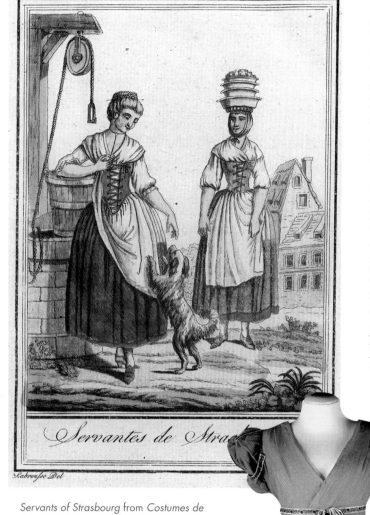

Servants of Strasbourg from *Costumes de Differents Pays* by Jacques Grasset de Saint-Sauveur (ca. 1797). Los Angeles County Museum of Art.

During the eighteenth century, hemlines continued to grow around the ankles. New, more elaborate undergarments expanded the circumference of dresses even farther, with noble women occupying increasing space. The wide and long hemlines beautifully showcased the ability of elite classes to splurge on luxurious textiles and trimmings. In France, now the center of European textile production and export, excess symbolized the detachment of the noble class from the common people and brought about the nobility's demise.

The nostalgia fashion wave that dressed women like Grecian goddesses or shepherdesses and the weaving of lighter fabrics converged to destabilize the hemline just before, and as one harbinger of, the French Revolution. Also, entering from stage left to center stage were the popular illustrated fashion magazines advertising France's luxury trades in silk, lace, and accessories, which promoted new styles of dress. Since few would have had a cheval-glass capable of reflecting what covered their legs, and gentlemen would not lower their gaze to the ankles either, the concept of looking at a model as an object from top to bottom was a revelation.

After the French Revolution and during the new Empire, when flimsy white dresses ruled, this seemingly simple attire communicated the new social order and blurred class distinctions. Fashion, however, resists the plain and by the mid-1820s rich decoration started to appear around the hemline. White-on-white embroidery, known as tambour work, added richness to the hem. Sometimes *rolleaux*, or padded rolls, were sewn at the bottom to weight and flare the hem, and skirts were a little shorter to show the shoe. Although the shape continued to be tubular, heavily decorated hemlines drew the eyes downward, a trend that would eventually evolve into the widening of the skirt in the 1830s.

Dress of orange-yellow wool twill, trimmed with white wool and white silk with woven cashmere motifs of colored wool (ca. 1810). Utrecht Museum, Amsterdam, Netherlands.

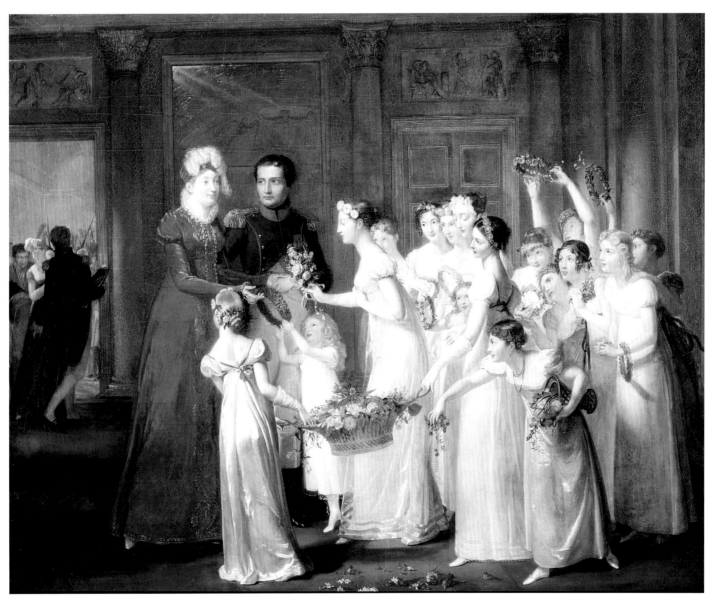

*Marie-Louise of Austria arriving at the Chateau de Compiègne, 28
March 1810* by Pauline Auzou. Musée du Chateau de Versailles Photo
Credit: Gianni Dagli Orti/The Art Archive at Art Resource, NY.

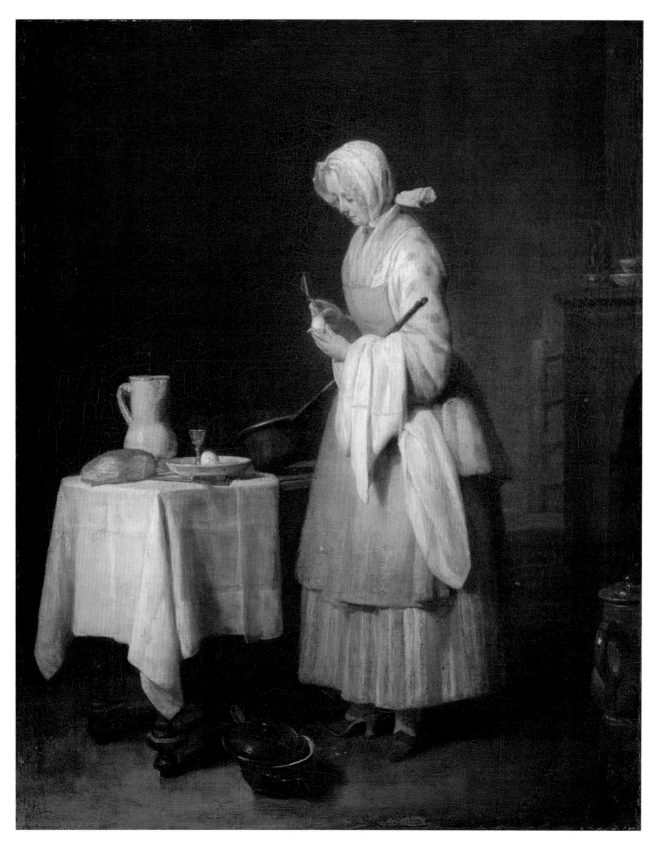

The Attentive Nurse by Jean Siméon Chardin (1746 or 1747). The nurse, who stands opening
a boiled egg, is a working person and so wears a considerably shorter gown than a woman of
high status wore. National Gallery of Art, Washington DC.

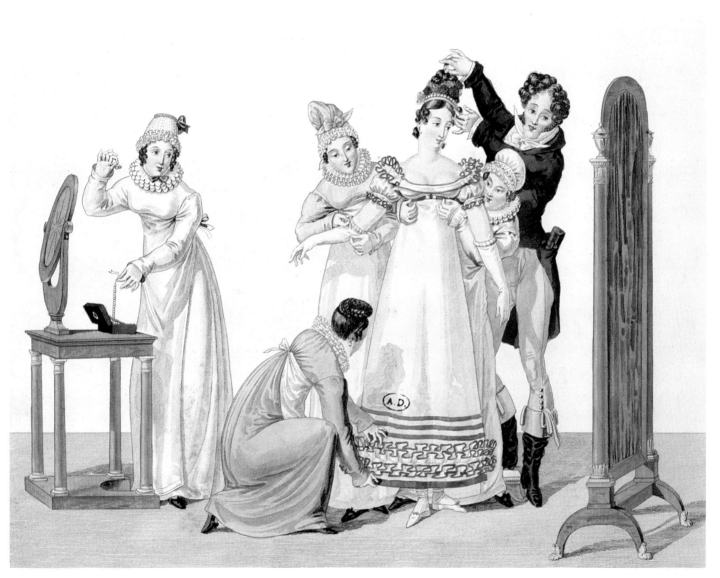

Five for One (*Cinque pour une*), plate 3 from the series *Le Bon Genre,*
French School (early nineteenth century). Bibliotheque des Arts
Decoratifs, Paris/ Archives Charmet/The Bridgeman Art Library.

Fashion plate by Rudolph Ackermann, London, 1825. Los Angeles County Museum of Art.

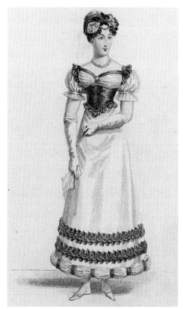

Fashion plate (Parisian ball dress) by John Bell, London, February 1821. Los Angeles County Museum of Art.

Fashion plate of ball dress by Rudolph Ackermann, London, March 1, 1825. Los Angeles County Museum of Art.

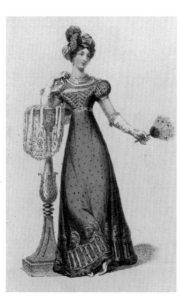

Fashion plate of full dress by Rudolph Ackermann, London, December 1, 1823. Los Angeles County Museum of Art.

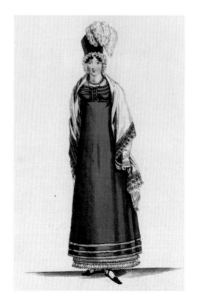

The Last Parsien Fashion by John Bell, fashion plate, London, February 1815. Los Angeles County Museum of Art.

▪From Wide to Wider

During the 1840s the "hem-saver," a stiff braid of wool and horse hair, was sewn on the inside of dresses to protect the hems, now made to touch the floor, from wear. Before age fourteen, young girls wore mid-calf-length skirts over drawers or pantalettes. It was a mark of womanhood when a girl discarded her drawers for a floor-length skirt.[1]

The foundation of the Victorian dress, the stiff crinoline, was worn over many layers of cotton or wool petticoats in order to achieve the fashionable fullness of the 1850s. Skirts reached up to seven yards in circumference. Walking in their heavy layers was a laborious task. When petticoats reached their maximum achievable circumference, it was the outside of the dress that was widened; three layers of ruffled flounces, almost like a layered wedding cake, created an optical illusion of an even wider skirt.

In the 1860s, similar to changes in centuries past, new undergarments informed new hemlines. The cage crinoline, a light-weight undergarment made of metal hoops in graduated sizes, replaced the cumbersome layers of petticoats and allowed dresses to continue to expand away from the legs and feet. For the hemline, what the cage crinoline contrived was not a vertical change but a horizontal one. At the fabric border between skirt and legs it allowed for as much of a "blank canvas" as Phidias's Elgin marbles for the Parthenon. Pleats and frills, fur trim, garlands, and rosettes made the Early Victorian era a high point for the hemline.

Ankles were glimpsed, naturally, but not flaunted. An answer as to how much they were seen appears in Gwen Raverat's memoir of her English late Victorian childhood, *Period Piece*.

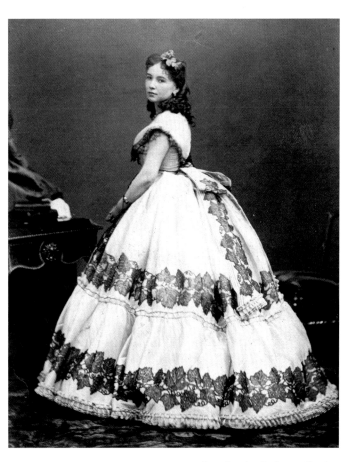

Cora Pearl, née Emma Cruch, English courtesan, photographed by Eugene Disderi (1865). Adoc-photos/ Art Resource, NY.

One of our governesses, thinking to be very modern and dashing, once ordered a new skirt, which cleared the ground by quite two inches. But when it came she was too bashful to wear it, and finally only solved the difficulty by always wearing spats with it. For, of course, ankles ought never to be seen at all and, if they were, the lady they belonged to was not quite a nice lady. Legs had no value, except that of impropriety.

This was the reason why quite well-dressed, but respectable, women did not seem to mind wearing shabby shoes and stocking – though even the most proper lady could not help letting her shoes peep out sometimes. Well-brought-up young men were taught by careful mothers to get over a stile before a lady, and then stand with their backs to it, looking at the view, while they stuck out an anonymous hand sideways to help her out of her embarrassing position.

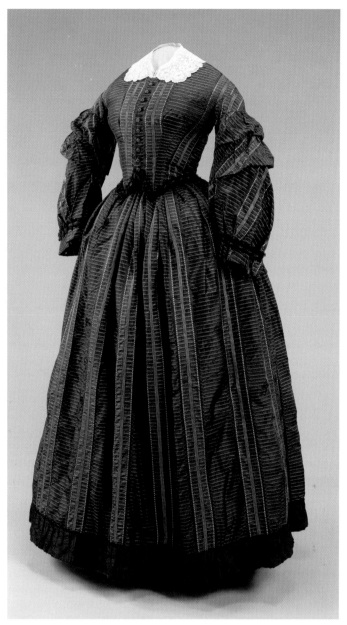

This plaid wedding dress, first worn in 1858, was somewhat remodeled in the 1860s. According to Historic Deerfield curator Ned Lazaro, the skirt has been lengthened with silk box pleated trim to reflect the change in hemlines. Photograph by Penny Leveritt. Courtesy of Historic Deerfield, Deerfield, MA.

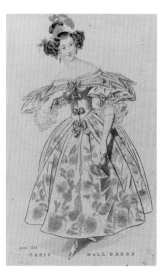

Fashion plate (Parisian ball dress), London, April 1833. Los Angeles County Museum of Art.

Incredibly, the crinoline's dome of textile was considered inadequate coverage when the woman moved so that the gentleman averted his eyes.

After skirts reached their fullest, the shape of the cage crinoline became more oval—flatter at the front with the fullness extending to the back. To keep walking dresses from touching the ground, women of the 1860s used complicated cord systems to pull the fabric of skirts up in a fashionable manner. A belt with several cords hanging down was worn under the skirt and over the hoops. The cords, looped through eyelets in the fabric, pulled the hemline of the skirt several inches above the ground. That meant that not only were fabric handsomely draped from the waist down, but that petticoats were now visible. As a result, petticoats received more attention and started to be made from fashionable, appealing fabrics. Despite the draped folds of skirts, women's legs and ankles were still securely concealed under floor-length petticoats.

In the Victorian era, leg-phobia was matched by hem-centricity. In addition to a wide range of contraptions that were worn under skirts, trimmings and decorations were also elaborate to the extreme. Gradually women started wearing two layers of skirts, with the underlayer hemmed with wide flounces, often with different types of pleats, folds, fastening, covered buttons, fringe, applications, and ruffles. There was no end to the creativity of hemline decorations, which peaked at the early 1870s. Since the fashionable shape of the period was molded over a bustle, decorations often drew the eyes sideways and back, with trains dragging behind elegant women.

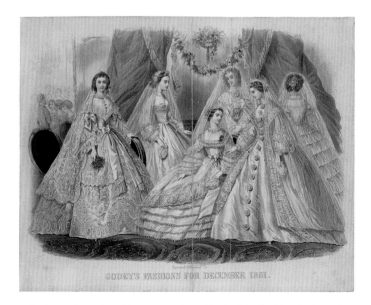

Fashion plate of wedding gowns from *Godey's Ladies' Book*, December 1861. Library of Congress Prints and Photographs Division, Washington, DC.

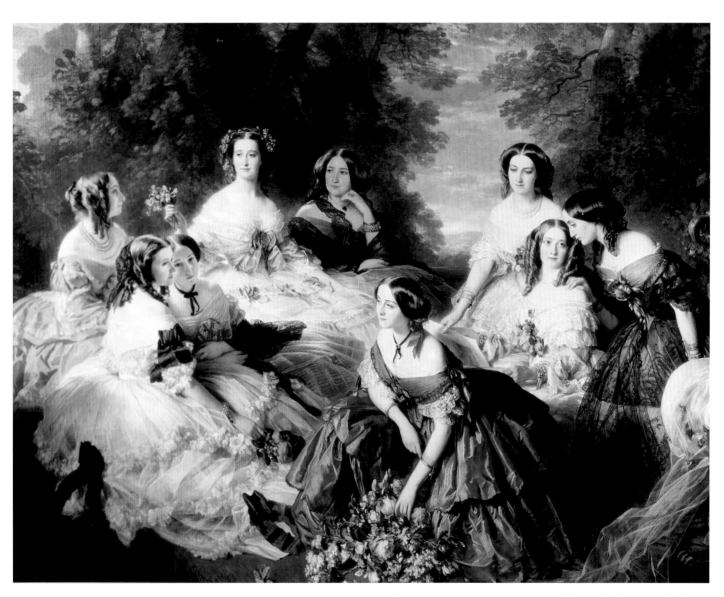

Eugénie, Empress of France, surrounded by ladies of her court by Franz Winterhalter (1855). Chateau, Compiegne, FrncePhoto. Gianni Dagli Orti/The Art Archive at Art Resource, NY.

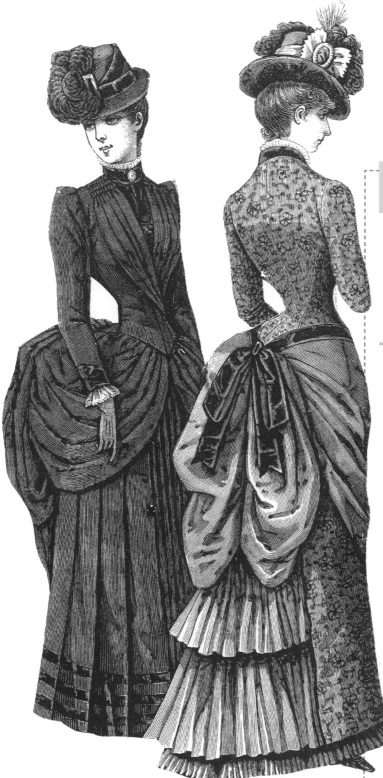

Day Dresses, 1883. Victorian Fashions: Pictorial Archive. Selected and arranged by Carol Belanger Grafton, Dover Publications.

150 Years of Hemming

The quest to appear proper and correct once made one's tailoring and hemline a serious matter, especially given the price of quality fabric. To keep herself and her two daughters fashionable, Harriet Hanson Robinson of Malden, Massachusetts, devoted May and June primarily to sewing. "She bought her first sewing machine in 1859 and later a new Singer, in 1871, for which she paid $100, less a $20 trade-in. When Harriet wrote that she had bought a new dress, she meant that she had bought the yardage and trimmings to make it... She could finish up a dress in two or three days, even thought fashion required '27... mortal buttonholes' down the front. She ingeniously remade old clothes, particularly during the Civil War."[2]

Alex Askaroff is an author who runs a specialist repair business in the southeast of England maintaining sewing machinery. He is considered one of the foremost experts of pioneering machines and their inventors. Here he gives an overview of home sewing equipment in the Victorian Age:

There is little difference between a treadle sewing machine of 1860 and a basic electric of 1960. In fact many people prefer the control of a treadle sewing machine and still use them today. In most third-world countries where electricity is either rare or irregular, hand and treadle sewing machines still rule. Hence, sewing a hem has not changed and may have even been easier 100 years ago as the machines had narrow feet where rolled hemming attachments worked better.

A rolled hem is used to neatly finish off a seam, say at the bottom of a dress. You simply roll the raw edge over and stitch it closed. The rolled hemmers are available in many different sizes depending on how much of the hem you want rolled. In 1865 Willcox & Gibbs supplied hemming attachments, as did most of the major sewing machine suppliers.

Modern machines have wide feet and hemmers are not as close to the needle.

Imagine a beautiful Victorian evening gown all made by the humble sewing machine. The quality and work is unsurpassed; certainly nothing today has more work. The quality of the garment is down to the individual's skills rather than the machine. What the machine did was speed things up by a factor of ten.

One important point is that hand-sewing took ages and cost much more. Some beautiful handmade dresses would have cost the equivalent of a year's wage. With the invention of the sewing machine, all that changed. For the first time in history clothes could be made quicker and cheaper.

The first sewing machines were used in factories back to 1815, mainly for uniforms for various wars. One German inventor, Krems, made his own machines to make hats for the French Army, as did Barthélemy Thimonnier in France in the 1830s.

The sewing machine really caught on in America around 1850 with the arrival of Isaac Singer's first decent machine in 1851. They say that Elias Howe invented his sewing machine after watching his wife sew by hand while he was ill (she took in sewing to pay the bills). Both men became fabulously rich from their inventions.

Only when sewing machines became smaller and cheaper did they move from the factory to the home. They say that it was Isaac Singer's accountant who invented the first proper purchase scheme to allow people to buy their sewing machines over months and sometimes years. Boy has he got a lot to answer for!

Once the sewing machine caught on big-time, manufacturers of cotton thread had to modify their products to work properly on sewing machines. Clark's brought out a six-cord sewing thread especially for sewing machines in the 1860s called Our New Thread, or Clark's ONT.

Although the sewing machine has been a godsend as a time-saving device there are a few jobs that are still carried out by hand, and hemming is one of them. You can hem by sewing machine but it is usually neater by hand. Many high-quality suppliers of dresses and suits will still hand- hem garments if you pay the extra cost. The same goes for buttonholes.

Today when your sewing machine goes wrong you just pop it over to your local repair specialist, but back in Victorian times when travel was not so easy, you could send word for the journeyman to come and fix your machine. This took weeks in some places.

Walter Hunt was so worried about the effect that the sewing machine would have on the workforce of nineteenth-century America that he did not patent or sell his sewing machine invention. Hunt became famous for inventing the safety pin. He was completely wrong about the effect of the sewing machine. The invention of the sewing machine helped employ millions of people around the world.

Women traditionally were better on sewing machines than men, so the men cut out and finished off in factories, much as they do today, while the women did the tricky work on the sewing machines. The sewing machine may not have changed fashions, but it made fashion possible for the everyday person in the street.

The humble sewing machine has quietly changed our world, which is why Gandhi said it was one of the only useful inventions that man ever made, and has been said to be one of the most important inventions in history. Today millions of people are still employed in the manufacture and use of the sewing machine. It is one of the unsung heroes of our world and touches most people's lives. ■

The sawtooth pattern zigzags around the hips and long hem and lends a snappy stylishness to the gown. *Journal de Demoiselles*, 1866. Collection of J. M.

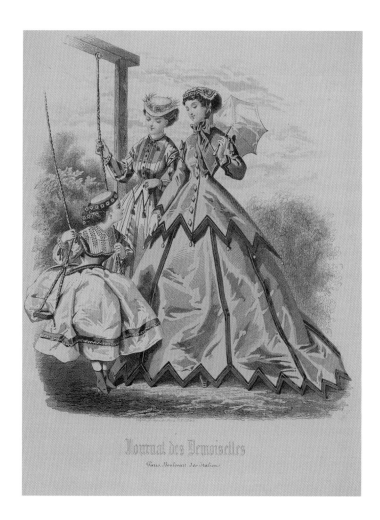

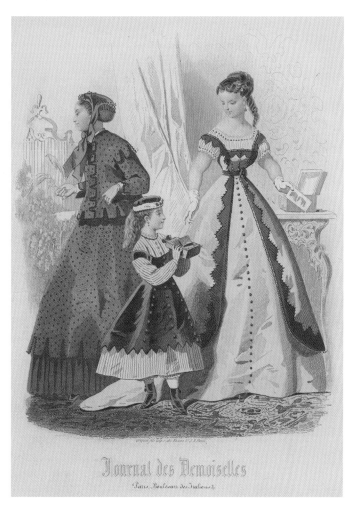

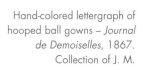

Hand-colored lettergraph of two elegant women and a child. *Journal de Demoiselles*, 1866. Collection of J. M.

Hand-colored lettergraph of hooped ball gowns – *Journal de Demoiselles*, 1867. Collection of J. M.

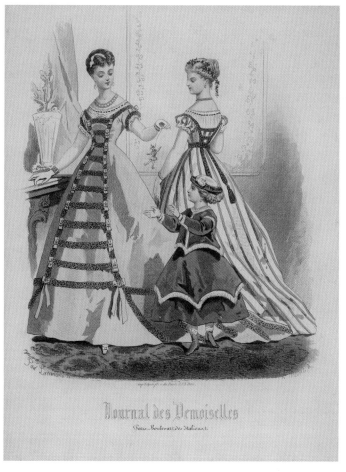

Day Dress, 1872. Victorian Fashions: Pictorial Archive. Selected and arranged by Carol Belanger Grafton, Dover Publications.

In the early 1880s, bustles temporarily disappeared due to the narrower skirt, but hemlines remained intricate. Urbanites could purchase trimmings at department stores that became palaces of consumption. More available public transportation meant that even women living outside of city and commercial centers could purchase fashionable fabric, trims, undergarments, and accessories. In addition, sewing machines and paper patterns made fashion more accessible to more women and afforded personal creativity when it came to finishing and decorating a dress. A woman who made her own dress at home, rather than commissioning a seamstress to do it, could still go out to a department store and buy the latest trimmings.

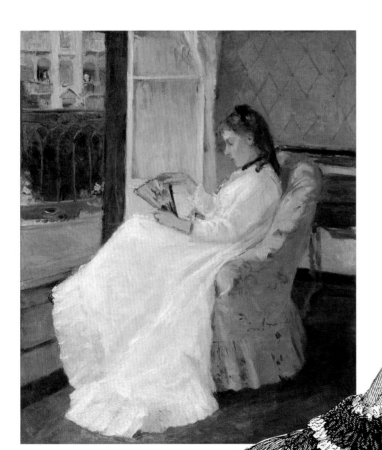

The Artist's Sister at a Window by Berthe Morisot (1869). National Gallery of Art, Washington, DC.

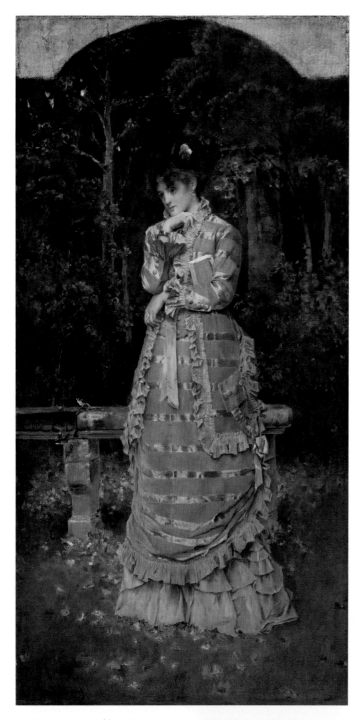

"The trimmings of her dress, as they quivered against the light, showed how agitated she was," Thomas Hardy. *Fall,* Alfred Stevens (1877). Sterling and Francine Clark Art Institute, Williamstown, Massachusetts.

▪ A Slight Lift and a Step

The ups and downs of hemlines derived, or at least got a boost, from athletics. Riding and cycling were the only two occasions for which it was acceptable to wear pants and even then only under a skirt or skirt-like covering, whose standard length was shorter than on street clothes. Different skirt lengths for different purposes emerged first for walking and for female athletes who trekked across continents and climbed mountains. In the 1860s, women wore a shorter skirt to roller skate and that showed off boots and shoes for archery and riding. As strolling along promenades and in parks became an acceptable pastime activity for women, the walking dress was adopted. Its shorter hemline allowed more movement and exposed the shoes. By the 1870s, the women were hitching up their long skirts to play lawn tennis. The safety bike appeared in 1885, and the pneumatic tire in 1888; cycling was genteel because at first only the rich could afford the riding machines. Meanwhile no one blinked an eye when an Edwardian lady showed her petticoats and embroidered stockings as she stepped up to the tram.

Evening wear continued to be floor length but the skirts of day wear dresses were quite plain. Hemlines grew to the sides, skirts hugged the hips but fell down and out in a kind of tulip shape. Pleats, gores, and darts at the side or back of the skirt made the front fashionably flat and plain, the hips tight, and all the volume blooming at the hemline.

In about 1905, the hemline on day dresses first rose above the floor. The look was more streamlined and columnar. The fabrics became lighter, as did the foundation garments, and the silhouette required a tight corset fitting down over the hips. Art nouveau and the fictive Gibson girl influenced the S curve and flare near the hemline. However opulent the look for evening, day dresses, with their ruffles and lace, were as lighthearted as the US president's teenage daughter, Alice Roosevelt. Also tailored suits and skirts and blouses sometimes had a distinctly shortened hemline. This suited a more athletic ideal and (until the hobble skirt) would maximize the wearer's movements.

Peasant by Auguste Giraudon (1870). National Gallery of Art, Washington, DC.

While a well-attired mid-century Victorian's skirt had folds, drapes and pleats, a working woman such as a teacher could wear a tailored version (ca. 1860). S. S. Vose & Son, Waterville, ME. Collection of J. M.

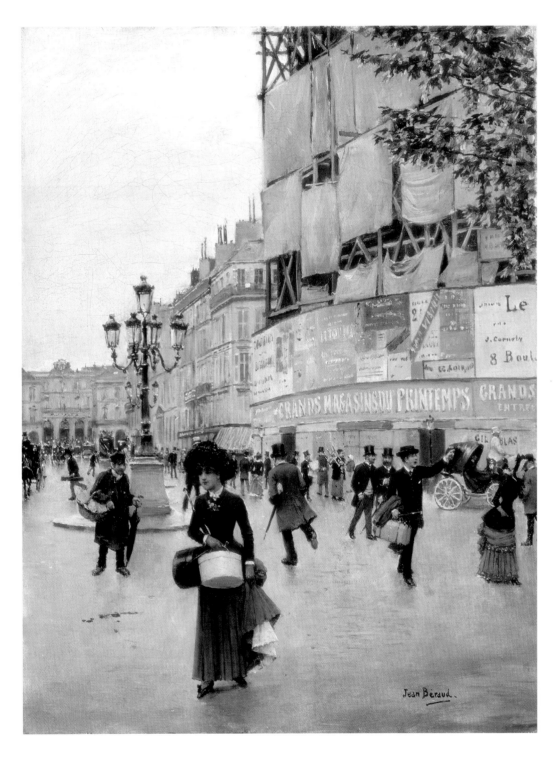

Paris, rue du Havre by Jean Béraud (ca. 1882). Ailsa Mellon Bruce Collection, National Gallery of Art, Washington, DC.

▪The Long, Lean, and Columnar Century

In the late 1890s, fashionable women began to wear a new style of dress called the "lingerie dress." Taking inspiration from the chemise gown of the eighteenth century, this style of dress was usually white, cream, or a light pastel color, and was often worn over a slip of vibrant color showing through the dainty fabric and insets of elaborate lace. Stockings in matching colors and ornamented shoes for ladies of means were only slightly visible when the sweeping hemline was lifted for seating or walking. The lingerie style of dress remained virtually unchanged throughout the first decade of the twentieth century, but the trimmings and decoration did change, drawing the eyes to where fashion was going. Early in the decade wide flounces, horizontal inserts of lace, pin tucking, and ruffles drew attention to the width of the body, creating wider hemlines. By 1905 women began wearing tighter skirts and longer corsets that hugged the hips—and the trimming changed accordingly, now emphasizing the length of the body with vertical inserts of similar trimmings. Fashion once again referenced classical times, and in 1910 the fashionable woman aspired to a long and slim figure that was balanced out with a huge hat. Longer, tighter dresses made women into "columns" of sorts.

Agnes A. Walsh, Class of 1899. This lacy graduation dress required stiff corseting and had layers of flounces and tucks at the hem. Collection of J. M.

Mary B. Prince, M.W.S. Class of '08 – possibly Michigan Women's School, 1908. Collection of J. M.

Summer frocks, hemmed to a similar few inches above the ankles, appear to have been shortened by the women by several inches (ca. 1900–1910). Old photograph. Collection of J.M.

The heavy, long skirt of this Edwardian lady is almost clean of decoration. Paired with a white blouse with puffy sleeves and dark necktie, it shows how younger ladies of that generation were looking to adopt a simpler style of dress by borrowing from menswear. US, (ca. 1900). Collection of J. M.

Woman in Turn-of-the Century Dress by Phillip William May (ca. 1900). Yale Center for British Art, Paul Mellon Collection, New Haven, CT.

3560

Gage d'amitié

Token of Friendship (gage d'amitié); postcard postmarked 1912.
Hand-tinted postcard. Collection of J. M.

The French couturier Paul Poiret took the new fashionable slimness to the next level when he introduced the hobble skirt. Tapering down at the legs and ending with an extremely narrow hemline, it made women complain that they could no longer walk or get into a carriage.[3] Sometimes the hobble skirt had a slit at the sides and narrowed towards the ankle, and other times a pointed train was tangled around the ankles. In some of the hobble skirt's more daring or extreme versions, the style often exposed a woman's legs well up her calves.

Parisian designer Madeleine Vionnet, known as the architect of dressmakers, flouted the cardinal convention that a hemline be generally straight. Born a year after Isadora Duncan, and likewise from a poor family, very ambitious, and believing her work was true art, she designed clothes with the flowing lines of Isadora Duncan's modern dance and was influenced by the dancer's unconstrained Grecian-style costume. Early in her career she was the lead designer at the couture house of Jacques Doucet, where she was hired to modernize the line and fired for having the models walk out barefoot. Establishing her *maison* in 1912, by the 1920s and '30s, Vionnet, who presented models *dans leur peau*, with neither shoes nor corsets, draped the models for her dresses on artists' wooden mannequins. The draped fabric was then adapted to paper patterns from which human-sized dresses were cut. Bias-cut fabrics were used for effect centuries before Vionnet, but her greatest innovation was to cut entire garments on the bias, which gave woven fabrics the elasticity of knits. Bias-cut dresses conformed to the body's contour and moved fluidly with it. Dresses were often simple rectangles, squares or quadrangles that fell like the points of a handkerchief. Through the 1930s, Vionnet was a preeminent designer whose creations were seen on American movie sirens.

Lady Duff Gordon, known as Lucile, was another designer who exploited how hemlines informed movement and elegance. The aristocratic title she gained with her 1900 marriage to Sir Cosmo Duff Gordon helped to propel her couture house and make her the favorite of socialites, movie stars, and young middle-class women. Lucile draped her designs directly on the body, anchoring the fabric over a skin-toned slip. Her designs interplayed sheer and lacy layers that hung naturally from a high, empire-style waistline. The draped hemlines of her dresses were often uneven and pointed, which drew attention to the movement of legs. In a period when dancing was on everyone's mind and in which hemlines started to gradually rise, Lucile's dresses moved gracefully around the calf, swaying and dancing with every tango dip and waltz stride. No wonder she was the favorite designer of Irene Castle, the dancer turned style icon.

During World War I, the hemline crept up to three inches above the ankle. High-heeled boots were a wearer's identification with soldiers. In 1915 a markedly shortened style called the "war crinoline" became the patriotic fashion and lasted two years, until hems went down again. A slogan in 1916 was that "The war is long but the skirts are short." The style had sloping shoulders and a bell skirt and the hemline was raised to mid-calf.

Flounces draw attention to the skirt length that is moving up (ca.1915); postcard printed in Milan, Italy. Collection of J. M.

A long, columnar silhouette is emphasized by the trailing hem in a postcard drawn by R. Ford Harper; postmarked December 24, 1912. Collection of J. M.

'Sorbet' dress by Paul Poiret (1913). This example of the dress was worn by Anita Carolyn Blair to the debut of Gladys High in Chicago. The loose fit and bold elements of this evening dress would have made a daring fashion choice for the young lady. Chicago History Museum.

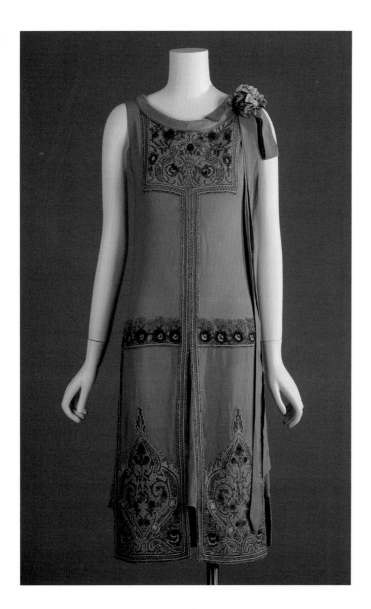

▪Post-War Freedom

"Flare and the world flares with you, cling and you cling alone" quipped Cecil Beaton, and after the war women had no desire to squeeze back into hobble skirts. Instead, a new style of dress emerged, *robe de style*. Taking inspiration from the eighteenth-century court of Louis XV, the robe de style incorporated a long unfitted bodice and a low waistline from which a bell-shaped fluffy skirt extended, recalling the panniers of years past. Jeanne Lanvin constructed her versions from crispy silk taffeta reaching above the ankles in the earlier years and creeping up to mid-calf-length later into the 1920s. Lanvin's dress often had a rosette in an array of materials and techniques placed at the low waistline, which in turn furthered the contrast between the billowy skirt and the long, narrow bodice. Her romantic touch and

Worn by Mary Louise Wright as a wedding dress in a civil ceremony, New Year's Eve day, 1927, in Indianapolis, ID. Chicago History Museum.

the eighteenth-century inspiration are evident in details like a trim of sheer material that hung from the hem.

It was in the 1920s that well-shaped legs became an asset. The look was young and emphasized a sexiness that hadn't been flaunted for at least a century. The flapper style was filmy and sheer and entailed a minimum of undergarments, which in turn meant the distance between the skin and the dress was minimal. Petal hems appeared in the spring of 1921, and there soon followed the handkerchief skirt with points hanging to calf level and accentuating legs. Drawing attention to the legs, these hemlines gave young women sex appeal that reflected their free spirit.

In 1922, skirts were four to six inches from the ground in Paris and already eight inches from the ground in the US. After skirts definitively came up for the decade, in 1920, they rarely came down for long. In his book *Only Yesterday: An Informal History of the 1920s* (1931), Frederick Allen Lewis writes that the new youths were "making mincemeat" of the code of behavior their parents lived by:

The dresses that the girls—and for that matter most of the older women—were wearing seemed alarming enough. In July, 1920, a fashion writer reported in the *New York Times* that 'the American woman… has lifted her skirts far beyond any modest limitation,' which was another way of saying that the hem was now all of nine inches above the ground. It was freely predicted that skirts would come down again in the winter of 1920–21, but instead they climbed a few scandalous inches farther. The flappers wore thin dresses, short-sleeved and occasionally (in the evening) sleeveless; some of the wilder young things rolled their stockings below their knees, revealing to the shocked eyes of virtue a fleeting glance of shin-bones and knee-cap.

Beaded fringe sample card. Italy, Venice, Casa G. Grili (1902–1925). Collection of The Corning Museum of Glass, Corning, NY.

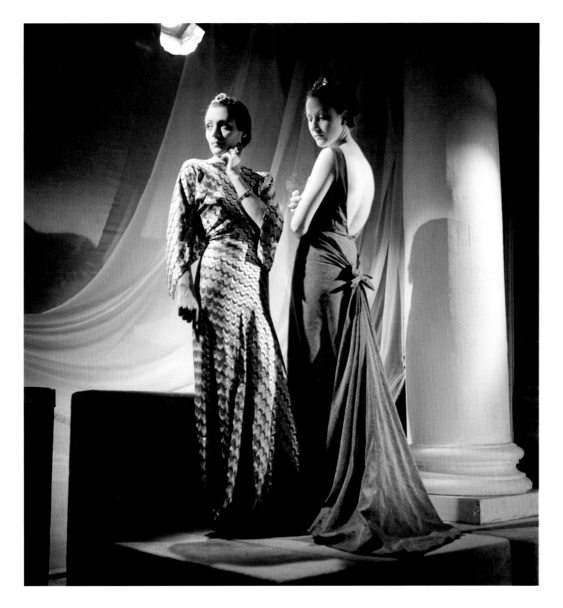

Dresses designed by Elsa Schiaparelli and Marcelle Alix, Paris, France (December 1934). Boris Lipnitzki/ Roger-Viollet/The Image Works.

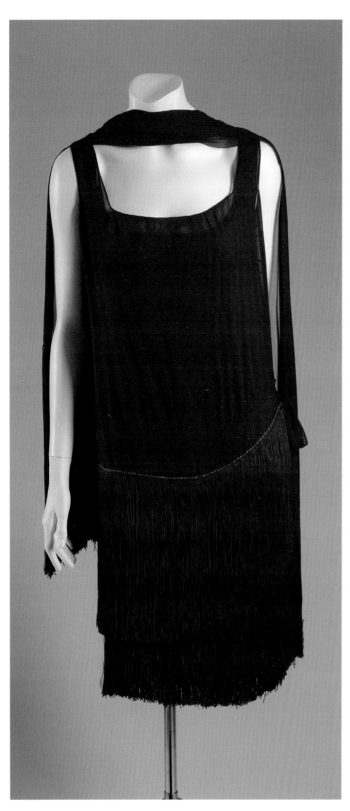

A dress by Coco Chanel worn by Mrs. I. Newton Perry (ca. 1925). Chicago History Museum.

The Roaring Twenties were a fashion roller coaster. Hemlines went down in 1923, and then came up to the knees in 1925. By 1928, skirts were descending and in the Paris winter 1929 collection (designed and made before the collapse of the New York Stock Exchange in October) reached below the knee again. Interestingly, the low waistline silhouette of this period made women's legs seem shorter. Legs were very important in this period because of the dancing craze that swept America and Europe. Fashionable beaded fabrics and the long, dangling jewelry enhanced the body's movement, and hemlines shimmered with beads and borders to swing as women (and not just flappers) danced.

The rise continued—ten to twelve inches were lopped off the hem by 1925, and fifteen in 1927 when skirts were edging to knee length. This provoked protests from moral leaders including politicians, ministers, and college presidents. They deemed the shorter skirts immodest and immoral but women were delighted to feel more youthful and modern. The flapper dresses put legs in the spotlight and one experiment, in 1928–29, was the uneven hem that was longer at the sides or the back.

Whatever the state of fashion, the sexy legs of movie stars, models, and sports figures were newsworthy. On screen, audiences got a glimpse of Jean Harlow, sans underwear, with her legs visible from slits in her white negligees. The true leg candy, the Rockettes (originally the Roxyettes) came to Radio City Music Hall in 1932. Their entire eighty-plus year history has been built around women who form kick lines as a profession.

Into the 1930s hemlines fell dramatically. In daywear the hemline dropped gradually, while evening gowns grazed the floor. Trains continued to be an important component of evening wear but the cut of the dress emphasized a streamlined silhouette. Fabrics twirled and hugged the body from the shoulders down to the ankles, and hemlines remained long and ample until World War II when a regulation called L-85 enforced limitations on fabric use and brough the hemline up again.

▪From Utility to Excess

Due to scarcities during the Second World War, skirts narrowed and became skimpier. Throughout the 1940s, American women revealed more leg than ever before. In the movies, Cyd Charisse and her long, lean legs danced across the floor with Fred Astaire, and Betty Grable, whose legs were insured with Lloyd's of London for $1,250,000, posed for pinup shots in a bathing suit and high heels. "There are two reasons why I'm in show business, and I'm standing on both of them" was Grable's famous line. Since haute couture was not restricted by fabric rationing, movie stars and socialites could still be clothed in long, luxurious silks.

In 1947 designer Christian Dior dashed legginess with his New Look featuring full calf-length skirts. In the US, as Valerie Steele notes, women protested Dior's collection with a Little Below the Knee Club and picket signs reading, "Keep 'Em Short" and "Protect the American Leg," all resisting the New Look's most obvious change—the dramatic drop of the hemline.[4] Nevertheless, Dior's style reigned in the 1950s, when fabric rationing was a thing of the past.

The New silhouette existed prior to the war and was not exclusive to the house of Dior. In the United States, American

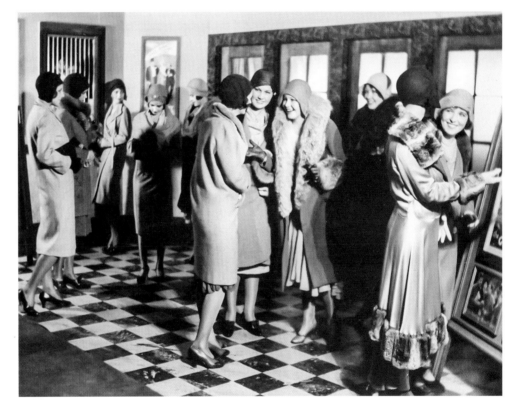

The mid-calf hemlines were well suited to winter outerwear and this became a high time for stylish coats (ca. 1930s). Collection of J. M.

designers enjoyed an unprecedented success and temporary independence from the dictates of French couture during the war years. As early as 1941, the successful designer Claire McCardell showed similar nipped-in waists and full, flowing skirts that hung loosely around the hips down to the calf. A shortage of metals during the war encouraged her to replace zippers with ties. Spaghetti straps wrapped around the body to produce a narrow waist and fabric folds surrounded the hips. Since war restrictions demanded shorter hemlines, the skirt merely reached calf-length.

Observing Hemlines

By Clara Berg

It seems that whenever there is a recession or an economic boom, someone trots out the "hemline index" as a possible topic of relevance. The theory of the hemline index states that in times of economic prosperity skirts get shorter, and during economic downturn they lengthen (although occasionally it will be quoted as the reverse, longer in good times and shorter in bad). The phenomenon has been plotted out on graphs, discussed in books about investing, dissected in academic studies, and brought up by journalists wanting to spice up a story about the stock market. But very little of the evidence for the hemline index holds up to much scrutiny. The fact is, economics and fashion are both complicated creatures, and while some data points may line up at certain times, they are as likely to diverge the next.

The case for the hemline index focuses mostly on the twentieth century with two particular eras used as key evidence: the change between the 1920s and '30s, and the one between the 1960s and '70s. As the American stock market boomed in the '20s, skirts grew increasingly short. When the market took a dive in 1929 it seemed that hemlines suddenly did too, leading to long skirts for the first decade of the Great Depression. Then miniskirts appeared during good economic times in the 1960s, while the mid-calf (midi) skirts of the early '70s seemed to coincide with economic downturn. But a closer look at both periods shows a more nuanced picture. Hemlines rose during WWI, lengthened at the beginning of the 1920s, rose in the middle years of the decade, and began lengthening again as early as 1927. In the case of the miniskirt, it is worth noting that economic growth was steadier in the 1950s, and was actually beginning to slow down during the '60s. In fact, the 1950s are the most notable counter-example to the hemline theory. Skirts during that prosperous decade were longer than they had been at the end of the Great Depression. It is also worth pointing out that while styles were freely crossing the Atlantic, economic boom or bust in America did not always coincide with equal conditions in France, England, and Italy.

The hemline index also seems to ignore the fact that many fashion eras allowed for multiple hemline options, as well as the increasing ubiquity of pants as a staple of women's wardrobes. For most of the twentieth century it was common to have shorter hems during the day and longer for formal evening wear. The early 1970s was not just the era of the midi skirt, but of hot pants as well, not to mention lingering miniskirts, maxi skirts, and full length pants. Today, while there are trends in hem lengths, there are multiple lengths available in stores to accommodate different occasions and different tastes. It is also worth remembering that the exact same skirt can be purchased by a tall woman and a petite one—with different hemline results.

What is interesting about the hemline index is not whether skirt length can predict stock market turns, but the way the theory highlights a discussion about fashion and women's roles in broader world events. Perhaps not surprisingly, most of the people writing about the theory (particularly those who think it has some merit) are men. In most discussions about the hemline index, it is clear that investors and skirt-wearers are assumed to be different groups of people. The theory is almost always framed as an outsider's view. The question seems to be, "Is there something we can learn from watching skirt lengths?" rather than, "Are our own clothing choices linked to larger forces?"

In attempting to answer the question of why skirt length would be connected to the economy, the prevailing theory is that showing off legs is a way for women to express confidence, comfort, and economic stability. That may have been true for some women and some point in time, but of course women are not a monolithic force. Not all will express confidence in the same way, and even among those who consciously or subconsciously express it by baring more skin, not all will chose the legs as the body part to reveal. Fashion for women and men is influenced in big and small ways by politics, economics, and social attitudes. But with factors of individual tastes, varying designer visions, and the outlook of a different place and time, it is impossible to have a one-to-one equation of "if this, then that." Show off your legs, show off your arms, or stay covered up—and woe to anyone trying to play the stock market based on how much skin they see. ∎

Clara Berg is a Collections Specialist for Costumes and Textiles at the Museum of History & Industry

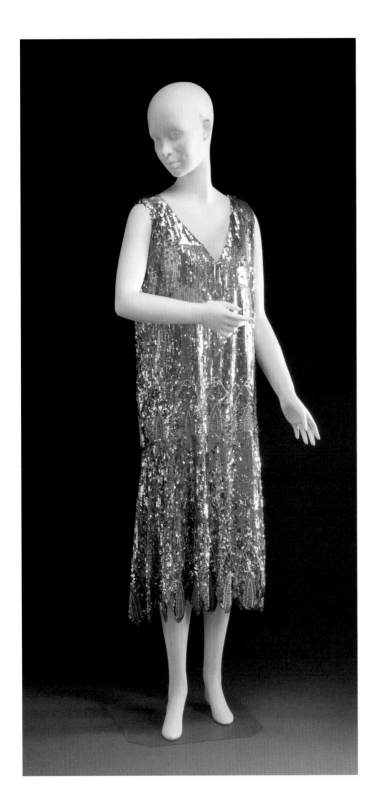

The detail of the below-the-knee hem of this French "skyscraper dress," France (1925–27), has repeating embroidery resembling a New York skyscraper. Photograph by Penny Leveritt. Courtesy of Historic Deerfield, Deerfield, MA.

This sequined chemise-cut dress has all-over embroidery of gold and silver sequins on a rayon or net ground (1925–27). Photograph by Penny Leveritt. Courtesy of Historic Deerfield, Deerfield, MA.

Dior himself did not take credit for the invention of the New Look: "No one person can change fashion—a big fashion change imposes itself. It was because women longed to look like women again that they adopted the New Look."[5]

In the US, the elegant cinched-in waist and billowing skirt morphed into the ballerina skirt, especially for younger women, who wore these often multi-layered, mid-calf skirts with black stockings, evoking their origin in dance attire. A cartoon in the *New Yorker* at the time shows two elderly gentlemen at their club looking out the window at 1950s ballerina skirts, and one says to the other, "I'm afraid, Jeffrey, hemlines will not go up again in our time."

Dior and McCardell differed in attitude, though: while Dior's designs alluded to his Belle Époque childhood, McCardell aspired to modernize fashion for the urban women. The New Look silhouette dominated the scene throughout the 1950s until a new generation came along and revolutionized fashion once again. It erased Dior's sculptured, curvaceous body, while trading on McCardell's expression of freedom and youth.

At the house of Dior, the young Yves Saint Laurent took over in 1958 after the founder's sudden death. Saint Laurent's first collection introduced an un-waisted, trapeze shape; a year later he shocked Dior's older costumers by raising the hemline above the knee; and finally he was booed out of the house in 1960 following the presentation of the Beat collection, which resonated with the hip crowd of Saint-Germain.

The Cocktail Dress *By Laird Persson*

Cocktail attire is inherently flirtatious, in part because it exposes the leg. When one is seated at a table, it's the "waist up" appeal that counts.[6] At a cocktail party, where the idea is to mingle and "work the room," one is seen in full view.

The cocktail party, despite Prohibition, became associated with the Roaring Twenties as a relatively new form of entertainment. There was a desperate need for escapism after the horrors of World War I, and the war had broken down many social and class barriers, making this more democratic type of co-ed entertainment possible and popular. A new occasion created the need for a new type of attire, and the cocktail dress was born.

A cousin to the tea gown, the cocktail frock was originally an afternoon dress that could transition into early evening (hence the popularity of basic black), often with the addition of a cocktail hat or ring. "I believe in accessories as the prime factor for cocktail garb,"[7] wrote the American designer Anne Fogarty in her 1959 advice book *Wife Dressing*. Short is a relative term, but a cocktail dress, by definition, is not long, nor is it formal, in keeping with the brief, carefree span and spirit of the drinks party.

While a cocktail dress can be almost any color or style, the most classic is the Little Black Dress (LBD): one thinks of the Givenchy-clad Audrey Hepburn as Holly Golightly in *Breakfast at Tiffany's* (1961), or Nicolas Ghesquière's slit, second-skin numbers for Balenciaga (fall 2008). The accent is on versatility and understatement; usually the LBD is short, suggesting affordability whatever its price tag.

Is it a coincidence that economist George Taylor's hemline index—which posits that skirt lengths rise and fall with the stock market—was introduced in the same year, 1926, that Chanel launched her LBD, which Vogue dubbed a fashion "Ford" (suggesting that like a Ford car, every American woman should own one)? Leggy looks were then, and remain, a visual expression of women's mobility. To this day, the abbreviated, streamlined flapper frock looks modern in comparison to the throw-back New Look silhouette launched by Christian Dior in 1947. Though curvy, Dior's fit-and-flare style and dropped hemline narrowed the steps of the emancipated women.

Cocktail attire generally follows the prevailing silhouette of the decade, so a suburban June Cleaver–type would reach for a very different looking dress than vampy Louise Brooks would when dressing for drinks, and be appropriately garbed. Part of the appeal of cocktail dressing is the way that it mixes informality with a sense of occasion. The result is a heady concoction, which, over the years, has been proven to "have legs." ∎

Winnie East's business card.
Courtesy of Beverley East.

▪ Minimized

By 1960, hemlines skyrocketed with the miniskirt. The average skirt length of twenty-five or twenty-six inches from waist to below the knees in the early 1960s, went above the knee in 1964, and to a general eighteen inches by 1966. It is disputed whether it was the British Mary Quant or the French André Courrèges who invented the miniskirt, although there is no dispute that Quant gave the style its name, after her favorite car, the Mini. Fashion historian Christine Bard points out that Courrèges introduced his version in 1965, almost seven years after Quant debuted the look in her London boutique.[8] Quant herself never took credit for the invention; instead she pointed to the young crowd that flocked King's Road in short skirts and black stockings. The Quant look for women consisted of the little skirt, patterned stockings and flat shoes, a new, younger ideal of feminine beauty. Even First Lady Jackie Kennedy adopted above-the-knee skirts, which were designed for her by the American designer Oleg Cassini, though she paired them with formal white gloves.

Courrèges too, introduced similar designs in which skirts hung gracefully seven inches above the knees. His geometric aesthetic sculptured the upper body, flattened the chest, and streamlined the waistline, but afforded total freedom for the legs. Combined with opaque tights and calf-high flat boots, the look was fresh and modern. In the mid-1960s, Neiman Marcus had college-age salesclerks wear the innovative Courrèges miniskirts and white boots, and legs began to gain attention with sometimes gorgeous and sparkling and sometimes ridiculous and ungainly experiments in leg fashion. The dominance of couture weakened and individualism began to flourish, with clothing being a major area of female assertiveness.

London and the scene that evolved around experimental boutiques like Quant's made that city, and not Paris, the fashion center of the new international youth culture. Barry Gibb, reflecting on the year 1967 when he and his brothers of the band Bee Gees arrived in London, said that: "... the miniskirts were really mini. Not like today—you could see everything."[9] Quant's biggest success was achieved when she opted for mass production in addition to her more exclusive, though not profitable, Bazaar boutique. However, Carnaby Street and King's and

Winnie East, a dressmaker in London, fashioned her skirt and the dresses for her two daughters Beverley and Jay, *comme il faut*, with hems that make a horizontal line about eight inches from the ground in the photograph (ca. 1958). Courtesy of Beverley East

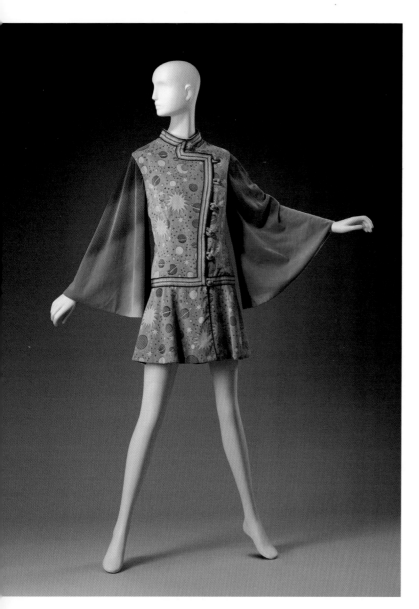

Woman's Jacket, cotton velvet, nylon, polyester and plastic by Barry and Yosha Finch. Shown in the *Hippie Chic* exhibition at the Museum of Fine Arts, 2013. Museum of Fine Arts, Boston.

Portobello roads were the mod center. Richard Lester in *Boutique London* writes that these neighborhoods "created a 'network of cool' which was to sustain a group of boutiques destined to become tourist attractions... with names like Granny Takes a Trip and I was Lord Kitchener's Valet, they subverted the rules of retailing as they saw them, mixing Victorian clothing, military uniforms, and ephemera with modern design, psychedelic imagery, and Art Nouveau."

In New York, the influential boutique Paraphernalia became a hub for young, innovative designers who played with new materials for clothing like PVC, paper, vinyl, and foil. The clothes retailed for about $50 per article, which communicated their alternative nature and the concept that fashion was changing, and fast. "People will spend $100 for an outfit they will wear for a year. Next year, they will be going new places. Doing new dances—they will want new clothes," said the young designer Victor Joris to *The New York Times* after he won a Coty award in 1965.

Miniskirt wearers were not like cheerleaders all dressed alike. The hemlines were as individualistic as the clothes. Combining a long coat with a mini or a mini with pants underneath was done in the spirit of the rebellious youth movement. Andy Warhol recalls how the "kids" at the Dom club in St. Mark's Place in Greenwich Village

> looked really great, glittering and reflecting in vinyl, suede, and feathers, in skirts, and boots and bright-colored mesh tights, and patent leather shoes, and silver and gold hip-riding miniskirts, and the Paco Rabanne thin plastic look with the linked plastic disks in the dresses, and lots of bell-bottoms and poor-boy sweaters, and short, short dresses that flared out at the shoulders and ended way above the knee.[10]

Mainstream fashion caught on: *Vogue*, *Life*, and *Time* magazines all featured Edie Sedgwick in her oversized T-shirts over dancer's tights.

Retracing Coolness *By Paul b. Magit*

I've always felt that those who put out our fashion year after year are in a kind of zone. . . . When the collections are released, there is always a similarity of shapes or colors or lengths—and that without a drop of collaboration between them. It seems like it just falls from the sky and everyone who is in "the zone" receives the message.

Miniskirts were happening and I just wanted to uncover legs. I had a huge back stock of jeans and pants, so I just cut them off . . . a thousand pair. Et voilà, "Hot Pants." These days I'm a bit more critical when I see women wearing them that should not, but then it was just great to see all those legs.

Minis really did come from London and Mary Quant. Paraphernalia was the mod London shop that opened its Chicago store in 1965 the same day I opened my first paul b shop half a block away. Their customers bought the "mod and rocker" looks and mine came in for the pieces that I searched for in the nooks and crannies of the Southern California beach towns, Greenwich Village, and the attic ateliers of Paris.

With a full Afro, long sideburns, and a bushy mustache that didn't quit, I was quite different from my parents. Owning fashion shops was great for a young single guy. Truth be told, I was as interested in the beautiful clients as selling the clothes. The women buying the clothes wore their new style as a badge—a statement that they wanted to be prettier and more attractive than their girlfriends in order to get the guys. They wanted to be dressed up all day, looking great and wearing clothes that felt good to the touch as well. Clothes that showed off the body rather than the fashion brought women to the shops in droves. The "Burn-the-bra" movement was a statement that began the sexual revolution. Hefner's *Playboy* played a big part. Women became emboldened. Drugs and unrestrained sex created a freedom women had never known. The clothes women wore said, "I'm me and I do what I want".

In 1965 at my first paul b shop I remember an outfit that put us on the map. This was an ensemble consisting of tight plastic bright-colored patent leather shoe-boots that zipped on the inside by a small New York company called Battani. With them we coordinated low-slung tight bellbottom corduroy jeans with wide belts with big buckles from Oops of California, and a long sleeved turtleneck, ribbed cotton leotard kind of top that snapped in the crotch made by Ardee. Lots of clunky plastic bangles and necklaces on top of that. Can't even imagine how many times we reordered. The look was hip space age for that time. Each item came in thirty or forty colors so we were able to create unlimited looks Bingo!

Miniskirts could be made out of anything, but for the ankle-length maxis we required fabrics that were supple and flowing. I liked matte jersey for the slinky look. While living and meditating in India in the '80s, I created a collection featuring gorgeous, sensual maxiskirts out of hand-woven, flowing cotton voiles that we dyed in the most amazing colors.

The icons of the hip London scene at the time, that you'd see plastered all over the fashion and gossip magazines and read about in the columns, who perfected the long, sexy look were Bianca Jagger, Angela Bowie, and June Bolan, wife of T Rex front man Marc Bolan. These were the fashion leaders. All were wives of superstars. The most outrageous was Bianca who held court at Tramp. She paired her maxi with a classy walking stick and wore a monocle.

The '60s and '70s ushered in new ideas that didn't betray their counterculture roots by becoming a precise look. Every girl wanted to be attractive and look free and natural and original. There were macramé, cutwork, and patchwork, but the mini and maxi never gave way to the midi, a length that wasn't flattering and didn't take hold at all.

Since living in India and several European countries for several years, my taste and sense of style have evolved along with my life experiences. Fashion to me now is a very personal thing. I feel each individual's style comes from the inside and must reflect who they are and how they feel at the moment . . . not what the industry or the designers dictate. ∎

Paul b. Magit achieved an international reputation for making shopping itself hip. Under various labels, and radiating from his paul b and Fiorucci stores in Chicago, he sold clothes of European chic with an anti-establishment attitude to polo hippies. "Fashion to the People" was his mantra.

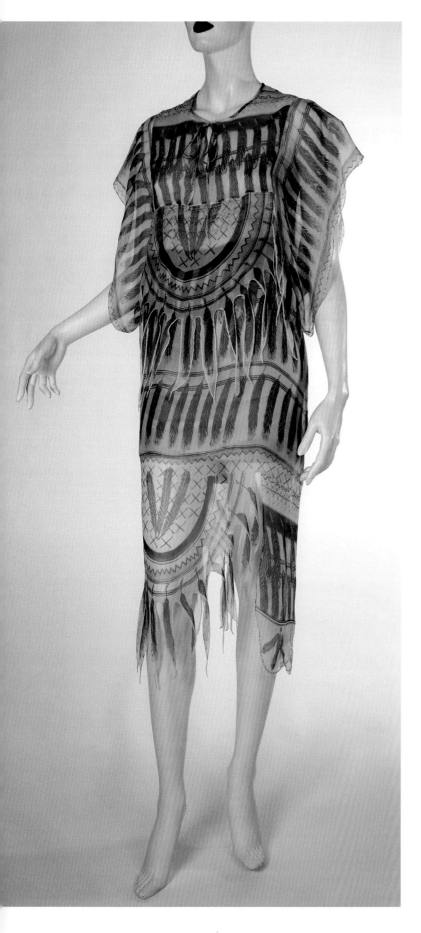

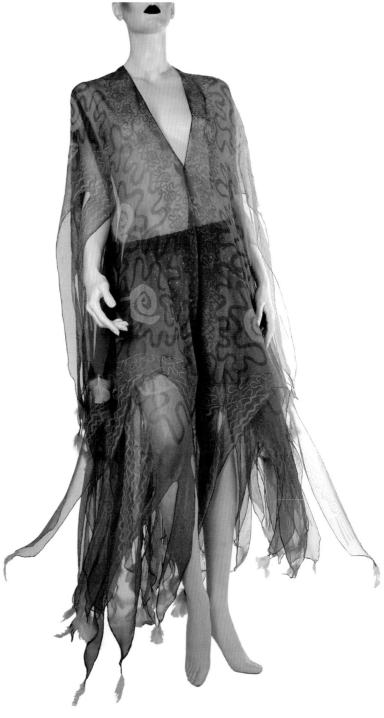

Pink caftan with "wiggle" print by Zandra Rhodes (1970). Photograph by Robyn Beeche. Courtesy of the designer.

Caftan (with feathers) by Zandra Rhodes (1970). Photograph by Clive Arrowsmith. Courtesy of the designer.

Girl with surfboard in caftan by Zandra Rhodes, *TIME*, 2003. Courtesy of the designer.

▪ From Short to Long and Anything in Between

The 1970s saw ingenious solutions to the instability of the hemline, such as Pierre Cardin's two-in-one minidress that had long panels ending in circular disks, that spun to show the short kilt underneath, and Valentino's layered ensembles with a long, open-fronted skirt over matching shorts. Meanwhile, Jackie Kennedy, like other great icons of dress stood apart, and wore trouser-tunic combinations by Halston, day or evening.

By the late 1960s young consumers broke completely loose of the dictates of French couture and instead either made their own clothes or customized thrift store finds. Fashion also moved away from the modern ideas of the early 1960s. The clean lines and experimental materials were replaced with natural fibers such as silk and wool and shapes that took inspiration from non-Western cultures (like the caftan) and historical dress (any period from the 1930s and as far back as the Renaissance). The hemline swept the ground again. Only this time, the legs were sometimes visible thanks to sheer chiffons and lightweight jersey, and were free to move under skirts rich with yards of loose-fitting fabric. For centuries, legs had erotic power simply because they were concealed under skirts. The suggestion of nakedness, rather than complete exposure of the legs, was the innovation. The British designer Ossie Clark, for example, launched in 1968 the Nude Look, which featured floor sweeping chiffon dresses worn without any underwear. The American designer Halston created, from a single length of fabric, silk chiffon caftans that cascaded along the body, ending at the ankle with sometimes slits or waterfalls of fabric draping asymmetrically to reveal a naked calf.

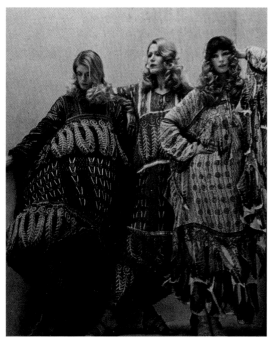

Three women in caftans (1970) by Zandra Rhodes. Courtesy of the designer.

Miniskirts and maxis were simultaneously in vogue and hemlines didn't settle down until the 1980s, when the long hems belonged to the chic pants suits. The French designer Christian Lacroix, a devoted student of fashion history, dazzled with the bubble skirt, or "la pouf," a puff of taffeta reaching to mid-thigh. It was the perfect style for the strong, muscular legs of the 1980s as it allowed legs to be the graceful stem for the peony shape of the skirt.

While unmistakable sexiness and luxurious clothing were the markers of the 1980s, some designers offered totally different ideas of beauty. In 1981 two Japanese designers, Rei Kawakubo and Yohji Yamamoto, presented their first Paris collections and became the mother and father of the alternative, all-black chic look of the 1980s. Both designers experimented throughout their careers with clothing that questioned conventional beauty ideals and blurred the lines between masculine and feminine. Yamamoto dressed women in ample, unconstructed shapes rich with layers of fabric and folds, unfinished hemlines, skirts worn over trousers, and voluminous shapes that obscured the body's shape. Kawakubo, too,

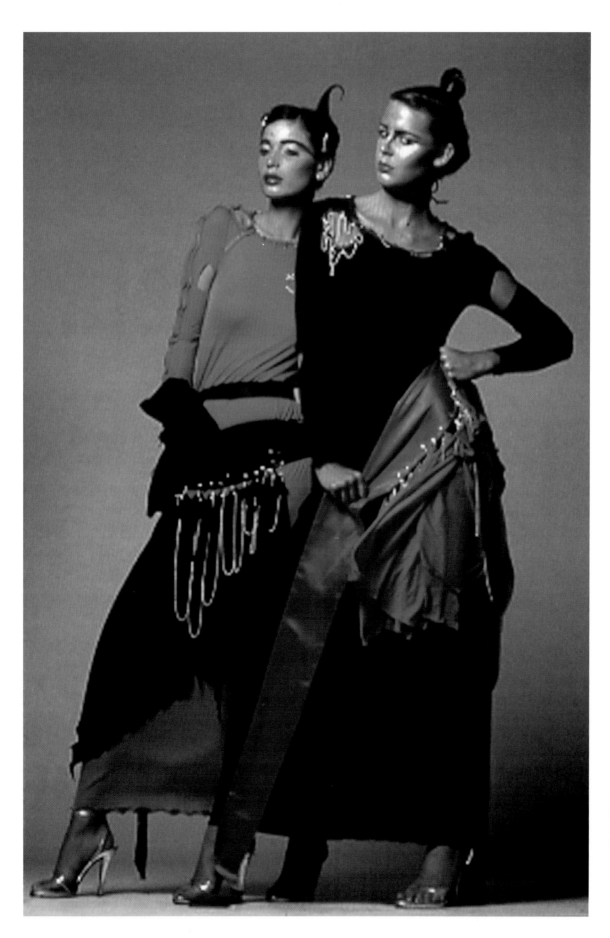

Fashions by Zandra
Rhodes (1977).
Photograph by
Clive Arrowsmith.
Courtesy of Zandra
Rhodes.

became known for her asymmetrical, sometimes oversized shapes that appealed to women who were looking for an alternative to the power suiting of the 1980s.

Eventually women began wearing no hose and flip-flops to formal events like the Oscars and whatever hem length they fancied. Skirts became slimmer and clothes had a more minimalist look. On the other end, Marc Jacobs, then a young, hip designer, brought Seattle grunge's anti-fashion attitude to the runway. At this point of his career Jacobs's genius was not in the design of the clothes but rather in the styling of the outfit. Models clad in plaid dresses that seemed bought at the Salvation Army but were really made of fine silk wore heavy Doc Martens combat boots. Oversized angora sweaters, kilts, and silk dresses that grazed the knee had a uniform scruffy, grungy look. Like Saint Laurent a few generations prior, Jacobs was highly criticized for selling downtown chic with a couture price tag. Nevertheless, other designers followed, and *Vogue* happily featured the likes of Jacobs and Anna Sui in lengthy editorials.

Sui herself created one of the early 1990s unforgettable looks: very short shorts, usually knitted, worn under a long knitted vest reaching all the way to the ankles. In the 1990s, showing a lot of leg became mainstream again and actresses Nicole Kidman, Cameron Diaz, and Demi Moore personified the millennium leg—taut and fit. Women aimed to be buff and went to the gym in droves. The whole idea of an arbiter of hemlines was discredited as the 1990s was a time where all ends met. High style met downtown chic, anti-fashion was the fashion, and day and evening were interchangeable. The postmodernist fashion was born in the 1980s and came into age in the new millennium. While trends were always the building blocks of fashion, in the new millennium no rigid raising or dropping of the hemline seems to be in store. Instead, the hemlines in the wardrobes of modern women are as varied and diversified as women themselves.

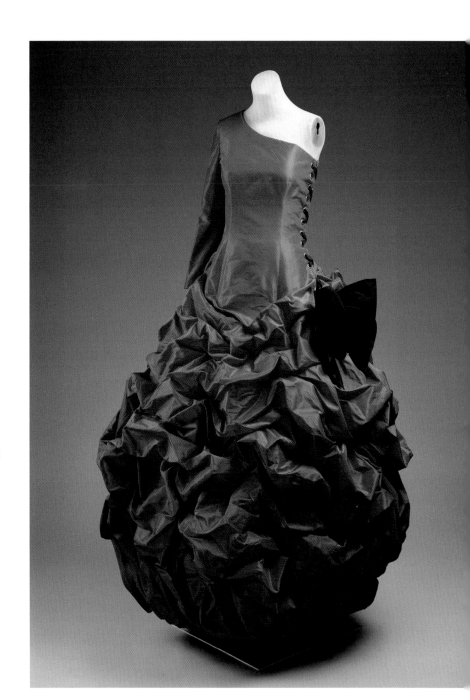

Evening dress (1987). House of Patou, France, founded 1919. Metropolitan Museum of Art/Art Resource.

Time Travelers *by Joan Son*

Original paper doll dresses from 1958. Photos by Joan Son, www. joanson.com, Time Travelers installation 2014.

Way back when I was nine years old I had a passion to design and paint paper doll dresses. I worked on them for several days and used up all my mother's good typing paper. It was an intense pleasure to create an entire wardrobe for each of my two paper dolls. Then I forgot about them for a long time. When I had a daughter of my own, my mother surprised me and brought out the dresses I had painted so many years before. She had saved them all that time while sending my brothers' comic books and baseball cards to the paper drives of those days. I dedicated my *Time Travelers* project to her. It received an Individual Artist Grant from the city of Houston through the Houston Arts Alliance and it was on view from April 1 to 29, 2014, at the Jung Center Gallery.

I chose six dresses from the original collection of sixty-five designs. Each one represented a very different look and distinctive hemline: from a bubble skirt and a long white sheath (with a slit up to nearly the waist) to a mermaid kick skirt covered with appliques of green ferns. And my scarf dress revealed an old thumb print in the black paint just below the waist line. I uncovered so many details from my early paintings that were incorporated into the final creations . . . full-size paper dresses displayed on plexiglass cylinders that were lighted within to represent portals of time, each with a distinctive hemline and character from my very early imagination. ■

CHAPTER 6

From Shalvars to Shorts, the Story of Pants

"I like to move fast," Katharine Hepburn famously said, "and wearing high heels was tough, and low heels with a skirt is unattractive. So pants took over." Pants for women have gone the gamut, from protective garments for warrior women and gauzy harem attire to symbols of egalitarianism and feminism, athletic essentials, and the trappings of consumerism. Yet flaunting the well-turned ankle and muscular calf has been through most of history the province of men. The objections to a woman's wearing of pants have always regarded her dressing like a man.

Katharine Hepburn. Clarence Sinclair Bull/ The Kobal Collection at Art Resource.

Women's pants have been an on-and-off-again custom, though mostly off. Ironically, Romans and medieval Europeans thought pants were effeminate. A man only wore them under a long tunic in a Byzantine-influenced style; Charlemagne may have worn pants around the castle but wore robes for his ceremonial dress. Pants as women's wear have often been decried as indecent.

The oldest known pants are associated with the time period when Central Asian nomads began moving their herds across the land on horseback. A 3,000-year-old pair of trousers, the oldest known example, was excavated from tombs in China's Tarim Basin in 2014. These men's pants have various beautiful patterns woven like ribbon over the wool. The origin of females wearing pants likely goes back to 2500 BC. Peter B. Golden of Rutgers University notes, "Pants, and pantaloons were a carryover from the steppes and the pastoral nomadic life of the Turkic peoples, where women were as expert in horseback riding as men. In some societies women also fought in combat—accounts of this go back to Herodotus and were as equally true of the Iranian (Scythian) nomads that dominated much of the steppe before the advent of the Turkish nomads."[1]

The styles of clothes of the Bronze Age spread from the steppe people of Central Europe and Western Asia to Europe and the Middle East. John Wertime, an expert and author on ancient textiles, says, "Like the writing of history, clothing styles are dictated by winners."[2]

The person who wears the pants (or as the English say, trousers) calls the shots. In fact, female graves in Scandinavia and Eurasia from the Bronze Age contain weapons like bow and arrow, riding gear, and daggers as well as the same burial artifacts that are traditionally seen as feminine: textile remains of skirts, spindle-whorls, and bronze mirrors. The burials show women as active warriors, suggesting that the adoption of pants may have been less gender-related than is assumed.

The nomads of the steppes cut and sewed cloth to more fitted attire for riding: the clothes were straight-fitting and with a wide crotch. Their cloth pants, worn with belts or sashes, permitted charioteers and warriors to ride for long periods of time in order to conquer widely spread territories. Scythian nomads who raided and roamed in Persia in the first millennium wore long, decorated gowns, or skirts and bodices, but when they were on the move they wore pants of wool, leather, or felt, embellished with embroidery or tassels. As the conquerors moved into Persia, they introduced long pants there—represented, for example, on reliefs at Persepolis. Wertime says, "This was the attire of world conquerors who were dressed to kill."

Evidently when the Jews returned to Judah from exile in Babylonia, they were concerned to not establish any cross-dressing, as Deuteronomy XXII, 5, probably written in the mid-seventh century, says, "The woman shall not wear that which pertaineth until a man." (The same censure went for the man who put on women's clothing.)

Orry and John Costello. "A man is a woman's best accessory." Weston, MA. Nasser K., 2013.

▪ Amazonian Attire

Since Amazons did not exist any more than Venus or Hera did, the artists of ancient Greece used their fancy to depict them. By mid-sixth century on Attic black-figured pottery, womanly figures with breasts and hips are engaged in combat with heroes.

On the Parthenon, the Amazons wear short chitons, emphasizing their femininity, but on many vase paintings of Classical Greece, Amazons wear garish leggings or trousers. In a single painting, one Amazon wears a short chiton and draws a chariot while her trousered cohorts harness and ride horses. Many of the depictions illustrate the fierce warrior ladies in long, patterned bodysuits, sometimes with one leg represented in solid polka dots and the other in slashing zigzags. Sometimes the Amazons were decked in necklaces and earrings, notwithstanding the pants.[3]

With these fabulous inventions, the artists conveyed to their fellow Athenians that all invaders (Persians, Scythians) were aliens, "not like us." The Amazon attire was mix and match; some Amazons combine elements of Persian and Greek clothing, such as a plain Greek chiton worn with patterned pants—which scholars say no real person would have worn, Greek or foreigner. Above all, the Amazons' pants signaled them as dangerous threats. In the stories and art of the ancient Greeks, Amazons figured as the untamed part of women. Moreover, marrying an Amazon didn't make her safe. Either Theseus, King of Athens, abducted Antiope or she went willingly with him, and they married. But her Amazon sisters became furious and made war to retake her and her son by Theseus, Hippolytus. One of the Amazons slays Antiope in a tragic error and in turn is slain by Theseus.

Greeks and Romans did not for a moment lose sight of the barbaric origins of pants. Garbed in the folds and drapery of their garments and blanket-like mantles, the ancients mocked pants, the clothes of the people of the steppes, as repressing a man's sexual prowess.

Photograph by Nasser K., 2014.

▪ Shalvar

In ancient Persia, men and women dressed the same; clothing styles distinguished class and status, not gender. The women's garment, attached at the back and with pleats formed with wheat starch, permitted a long stride. Underneath in a minor capacity were shalvar, which is the Persian word for pants. The word pajama also comes from the Persian name for their silk or brocade pants for both sexes: pei = leg and jama = garment. Under Roman influence, the Persians stopped wearing pants, until the pants style became a patriotic backward glance in the courts of subsequent rulers.

In a later period the Ottoman women of Turkey as well as the Persians had baggy pants, worn with straight or A-line tunics. A style of pants with leggings attached to soft shoes was popular as well for women at court or in a harem. Both referenced the Sassanian sheath pleated at the knee and corresponding knee-length tunic over trousers.

Often pants don't look like pants in a Persian miniature, the same way the divide doesn't show in skorts. Silk brocade in ancient Persian miniatures, painted with cat or squirrel hair, shows the flower sprigs on a sleeve and the embroidery on a cuff, but voluminous cloth covers the bifurcation of lower garments. *Illustrations of Women's Costume of the Middle East* (Routledge Curzon, 2003) by Jennifer Scarce shows drawstring pants so ample and in such light fabric that they balloon like full skirts as they fall over the feet.

Whether or not pants were worn in Western Europe was for a long time influenced by the living presence or rule by people from the East. In the Balkans, the provinces not ruled by the Ottoman Empire were skirt/robe territory for both sexes; the ones that were Ottoman had various permutations of the shalvar. In Europe, the change began to occur by the tenth century, after which pants became universal male attire just for men.

Mughal painting, Delhi, India, showing the trousers (*shawar/shalvar*) common in western Asia dress, in a court scene. Collection of J. M.

▪ The Breeches Role

The theater, in Shakespeare's time, mixed gender and class in their plots. Cross-dressing on the stage was a source of complex hilarity, as women were not allowed to perform. For instance, in Shakespeare's *Twelfth Night* the role of Viola disguising as a man would have been played by a man playing a woman playing a man. (From the nineteenth century, in amateur productions at female educational establishments, a woman would play Viola's twin brother pretending to be a woman). Shakespeare provided opportunities for the breeches role *avant la lettre*! In the story, swept up on shore, Viola disguises as a man and takes employment in the household of the Duke of Orsino, and then Olivia, the daughter of a neighboring nobleman, falls in love with Viola as "Cesario."

Later there was a ban on theater in England during the rule of Oliver Cromwell, but when Charles II became king in 1660, the theaters reopened. Professional actresses were allowed to perform, and the stage became a legitimate place to see a woman's legs. The

breeches role was the excuse. Furthermore, from 1660 until 1700, a quarter of the 375 plays produced on the public stage in London had female roles in which the actress wore men's clothing as a disguise. Naturally when the true identity was revealed, the woman whose legs had been exposed had to prove she wasn't who she seemed.

There would be no speculation about the sexual orientation of the trousered actress. The actress's femininity showed through. It highlighted the woman's transformative ability and some plays used the role to mock macho behavior. Writes Elizabeth Howe, theater historian and author of *The First English Actresses: Women and Drama, 1660–1700*, "The breeches role titillated both by the mere fact of a woman's being boldly and indecorously dressed in male costume and, of course, by the costume suggestively outlining the actress's hips, buttocks, and legs, usually concealed by a skirt."[4]

A popular actress with a notorious reputation spends most of the tragicomedy *The Generous Enemies* (1671) disguised as a man and then says in the epilogue, "'Tis worth Money that such Legs appear, / These are not to be seen so cheap elsewhere." In an epilogue of the comedy *Sir Anthony Love* (1690), Lucia, who has outdone gallant males on all counts as Sir Anthony, winks at the audience, suggesting that the action was just another way to view gams: "You'll hear with Patience a dull Scene, to see, / In a contented lazy waggery, / The Female Mounteford bare above the knees".

The Restoration comedies wrapped up their last acts with the actress in the breeches role appearing in a pretty skirt. The breeches roles required tight-fitting, knee-length pants and evolved into the role of "Principal Boy" in Victorian theater, where it was acceptable to see the calf or well-turned ankles of an actress playing Aladdin in harem pants or Dick Wittington in hose and leather pants.

Actresses who wore panniers to occupy more space on stage (and thereby have more presence) were an influence bringing that style to elite and commoners alike. Similarly, because of women on stage in the breeches role, the eye of the spectator became accustomed to the sight of women in pants. Mary Martin wearing dance tights in the Broadway production of *Peter Pan* in 1954 was a nostalgic reference to the breeches role, when wearing pants was Never Never Land. In amateur theatricals, women could play men and do what would otherwise have been unseemly in advance of the twentieth century: wear trousers. For instance, the Danish princess who became Queen Sophia Magdalena of Sweden, had a reputation for being shy and reserved, yet participated in the amateur court theater. In 1777, costumed as an Italian sailor, she took part in a mock battle at sea between Italy and Spain.

▪ Coastal Departure

Western women of the working class have customarily worn aprons and long skirts; only women in the fishing industry have had to "breech" their skirts and effectively wear pants.

Victorian Englishmen came from miles to Yorkshire to see women dressed this way, legs bare to the knees. The fishergirl illustrated here may be a cheeky pose of a tourist at the seaside or one of the actually working women. In any event, strapping fishwives surely found disapproval all over Northern Europe and New England when they "breeched" their skirts to row and tow while their husbands were at sea and to work in fisheries. Paris fishwives started the French Revolution by walking to Versailles in a protest against the King. Risking disapproval, commoners pinned their petticoats up in the shape of a pair of trousers, leaving their legs uncovered to the knee.

In the age of the sailing ships, a young woman might be following her sweetheart or estranged from the community or poor and restless with nothing to lose. She banded her breasts and donned trousers. Thus attired, such women took part in sea battles and published racy accounts of their lives. They fooled men on board for months or even years, blending in with adolescent boys, because of the principle that "seeing is believing." Maritime historian David Cordingly notes that a sailor's clothes—loose shirt, waistcoat or jacket, baggy trousers or "petticoat breeches," and neck kerchiefs were ideal for concealing a woman's shape.[5]

For her services to the crown, Hannah Snell was awarded a pension and "the liberty of wearing Men's Cloaths and also a Cockade in her hat."[6] Another female seaman, Mary Lacy, was a domestic servant who in the wake of an unrequited love affair, left town with an old frock coat, breeches, stockings and pumps, and hat. She changed into men's clothes and left her own under a hedge. Mary became a shipwright's apprentice who graduated to shipwright.

Putting on breeches and waistcoat was one thing and serving as an able seaman another. According to the maritime historian, at least one woman confessed her sex when having trouble scurrying up a mast. However, a woman of color who went by the name William Brown had the most impressive career of women disguised as sailors. She joined the navy at nineteen, in 1804, after a quarrel with her husband, and rose to captain of the foretop on the flagship *Queen Charlotte*. Her job was to lead seamen up to furl or set the highest sails. Discovered in 1815 to be a woman, she rejoined the crew after said husband claimed her prize money.

Fanny Campbell of Lynn, Massachusetts, would never have imagined putting on trousers except to pursue her seaman fiancé, William Lovell. Before William departed for a two-year sea voyage to South America, he taught Fanny what he had learned about sailing. Pirates attacked the ship William was on and he was wounded fighting them. He escaped when the pirate ship docked but was arrested as a pirate himself, and when his trial came up, was charged and sent to prison. Fanny got word through a sailor friend of William's plight, and under the name of "Channing," she signed on as a second officer on a merchant ship in Boston bound for England by way of Cuba. There was a suspicion on board that the unpopular captain intended to have the whole crew impressed in the British navy when they reached England, a discontent that Fanny used to start a mutiny, be elected captain, and then send a party in a rowboat to the prison fortress in Havana, freeing William and about ten other Americans. Now the American Revolution had begun, and William and Fanny went legal as privateers, filing for papers in Marblehead on their return with a captured British ship. William remained a privateer, and Fanny stayed ashore and raised their large family.

▪ Pirates of the Caribbean

While prostitutes wore castoff faded female finery, lady pirates wore castoff sailor clothes. Elizabeth Gaskell described a prostitute in *Mary Barton* (1848) as wearing "the muslin gown, all draggled, and soaking wet up to the very knees." This would never have done on the high seas. To cope with the lifestyle and go up and down the masts required highly functional outfits. In the devil-may-care atmosphere of the pirate ship, some women even gained acceptance. An eighteenth-century bestseller about the pirates' life tantalized readers with the shocking exploits of the best-known female pirates, Mary Read and Anne Bonny. The two probably met in Nassau and joined Calico Jack Rackham, who mauradered in the Bahamas. Sailors as yet had no uniforms. The ordinary seamen, as opposed to the officers of this period, had bare feet when working on a wet deck, and put on shoes when going ashore and in cold weather. Pirates wore buttoned jackets and long sailor's trousers.

Read's young mother, the widow of a sailor lost at sea, dressed little Mary Read (1690–1721) like a boy to fool a grandmother into giving the girl the weekly allowance she had

At age fifteen, an English girl, Ann Jane Thornton (1817–1877), obtained passage as a cabin boy to sail to New York to join her lover. Her adventures became a popular song and novel. The British Library.

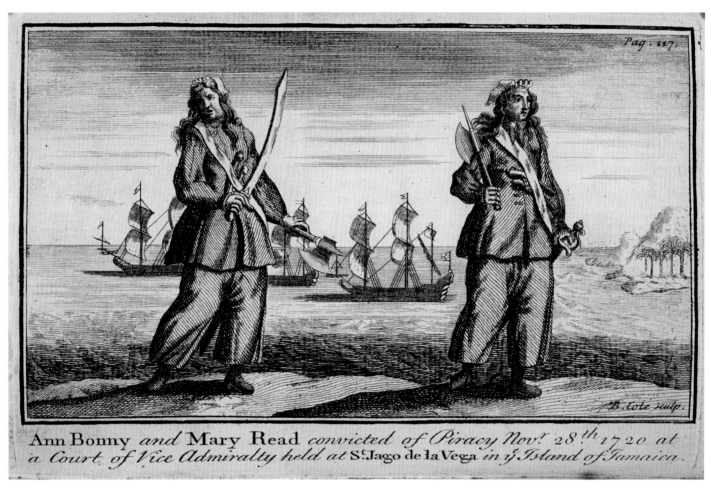

Ann Bonny *and* Mary Read *convicted of Piracy Nov.ʳ 28 ͭ ͪ 1720 at a Court of Vice Admiralty held at* Sᵗ Jago de la Vega *in y͂ Island of Jamaica.*

Caribbean Pirates Anne Bonny and Mary Read (ca. 1720). The British Library.

promised for the keep of her grandson. Mary continued wearing the breeches and having adventures. She joined the Navy and a cavalry regiment, ran a tavern near Breda in the Netherlands with a Flemish officer she married, and when he died, went off again to the West Indies. Calico Jack Rackam ("Calico" due to his striped cotton pants) captured the vessel, and she joined the crew in her man clothes.

The daughter of an Irish lawyer who ran away with a maidservant to America, Anne Bonny (1698–1782) grew up in Charleston, where as a girl she saw Blackbeard, who made a deep impression on her. Disowned when she married a penniless sailor, Anne became bored with him and hung out in Nassau, a pirate haven, where Calico Jack Rackam wooed her. Anne hooked up with the flamboyant pirate and when she sailed away with him, she disguised as a man on his ship—coming on as a woman would have been considered unlucky.

Anne wore a pair of dark (black or blue) velvet trousers with polished silver coins along the outside seams, cut her hair, and used the same weapons as the men. However, she did not pretend to be a man as Mary did. The women met and made the discovery they were both women. The clothing was such a complete disguise that, as Daniel Defoe recounted in his *A General History of the Pyrates*, Anne "suffered the Discovery to be made, by carfully shewing her Breasts, which were very white." It is said the female pirates were so adept with pistol and cutlass that none questioned their gender.

Calico Jack wasn't the worst breed of pirate. He let people go after he took their booty. He had a chance to go straight when the governor of the Bahamas was given a mandate to pardon pirates if they gave up their trade. However, Calico Jack didn't give up piracy and eventually hung for it. Meanwhile, Anne and Mary were captured and tried too, but they pleaded pregnancy. Maritime historian David Cordingly writes:

Two Frenchmen who were present when Rackam attached Spendlow's schooner explained with the aid of an interpreter how the women were very active on board, and that Anne Bonny handed gunpowder to the men; also, "that when they saw any vessel, gave chase, or attacked, they wore men's clothes; and at other times, they wore women's clothes.[7]

Cordingly explains that the female pirates would have worn a loose shirt, sometimes a waistcoat, and often a neck cloth loosely knotted around the neck, "though they may have exchanged some garments for more expensive clothes captured from civilians when looting a ship."[8]

▪ Orientalizing

Accompanying her husband, appointed ambassador to Constantinople in 1716, Lady Mary Montagu wrote back in her embassy letters about the Ottoman court. She painted a glossy picture of the lives of Ottoman women, pointing out they had property rights that Western women lacked, and on top of that dressed in more comfortable and modest clothes. When Lady Montagu returned to England, she brought inoculation with her, inoculating her own children. She also continued to wear Turkish trousers beneath her sumptuous gowns.

In the midst of the formalities of Versailles, which Louis XV followed to the letter, his most powerful mistress, Madame de Pompadour (1721–64), born Jeanne Antoinette Poisson, waited for her royal lover wearing pantaloons like a harem girl. She first dressed this way for theatricals and must have liked the exotic at-home wear because she commissioned Carl van Loo to paint a series of paintings of her in seraglio dress. Madame de Pompadour loved the *Arabian Nights*, a book so popular in 1704–17 that people threw stones at the translator's window to have him send down his latest installment. La Pompadour's wardrobe was full of Persian-this and Turkish-that, including harem pants. Other French women wore them to costume balls, but she wore them to entertain her lover.

Madame de Pompadour was the fashion leader of the French court and her affinity for Turkish-style dress helped it gain status as a marker of good taste. La Pompadour owned at least eight pairs of pantaloons, which were part of her accouterments to create an image of herself as both brainy saloniste and sultana, thus solidifying her position as advisor to the king and "sultana" of the bevy of young unmarried girls who replaced her in his majesty's bed. (Rousseau in his Lettre d'Alembert called the salons the "harems of France" and the French fantasized that the women had great sexual power over the husbands who held them captive).

Harem pants were not just imagined, as the French at the time had diplomatic relations with Turkey and Persia. French travelers penned accounts of their experiences in the Near East, ambassadors' wives brought the pants home, and sultana characters on the stages of the Paris wore them. The fun of cross-dressing in Paris halted when Napoleon became consul as

a sumptuary law enacted on November 7, 1800, forbade women from wearing the dress of the other sex.

Jane Derby (1807–1881), a wealthy and beautiful Englishwoman, had a love life of unparalleled exoticism that few Regency romances could equal. Jane had sexual affairs with a Bohemian prince, Ludwig I, a Greek bandit chieftain, and so on. Ultimately she married and found happiness with a Bedouin sheik twenty years her junior. In their nomadic journeying, she would go from European clothes to pants where, being tall and an expert rider, she was sometimes taken for an Albanian tribesman.

Early nineteenth-century artists, however, gravitated towards Orientalizing themes including slave girls in harem pants. In Ingres's famed *Odalisque with Slave*, her legs per se are covered while the torso is nude—typical of how legs appear in this motif. Eugene Delacroix owned a book of photos that included Arab slave girls in Constantinople's slave market. Delacroix's slave girls are wild haired with arched backs; usually the torso is nude and legs covered, often with transparent material that reveals the limbs. In *Woman with Parrot*, 1827, the woman reclines like an odalisque while her legs are crossed at the knee.

Impressionists, who painted the fashions they saw around them, also traveled, and fastened on exotic Near Eastern dress. Matisse made several trips to Morocco, the first in 1906. His odalisques also are the type with nude torso, and veiled, in harem pants, often cross-legged, the poses not sexy so much as a foil for a mélange of decoration patterns. Despite the exotic clothes, these figures depict real people at the dance, the bar, or in the family, often more at ease in their outfits than women of bourgeois society in Matisse paintings.

To wear anything like these pants, a woman had to be as outrageous as George Sand, who received Chopin, Berlioz, and de Musset in pants at her chateau. The styles were not from fantasy. In Istanbul in the late nineteenth-century, the harem pants were full and so long that they were hard to manage without tripping, while in the provinces of eastern Turkey, the folds ended at the ankle, and the pants were of flowered material in the Balkans. These styles gave European artists fashions to work with for their odalisques and gave inspiration for fashion designers of Europe.

▪Blooming Ideas

During the Victorian Age, although it was an apex of reticence, women were taking possession of the future. Politically this meant that dress reform was proposed and debated, and in the 1830s some members of utopian socialist movements wore pants. Amelia Bloomer launched the Rational Dress Campaign in 1849 in her feminist paper *The Lily*. Several key people in the women's rights movement wore pants. Elizabeth Smith Miller of Geneva, New York, was gardening when she had the notion of trading her long skirt for pantaloons: "The resolution was at once put into practice. Turkish trousers to the ankle with a skirt reaching some four inches below the knee were substituted for the heavy, untidy and exasperating old garment."[9] Her cousin Elizabeth Cady Stanton and her neighbor Amelia Bloomer adopted the new costume.

Mrs. Miller went to Washington, DC, when her father was in Congress. He approved her outfit while Mrs. Stanton inspired her with words that are tonic for anybody: "The question is no longer, how do you look, but woman, how do you feel?" and said she felt less conspicuous garbed in her new style. "My street dress was a dark brown corded silk, short skirt, and straight trousers, a short but graceful and richly trimmed French cloak of black velvet, sable tipped and plumed low-crowned beaver hat."[10]

The outfit didn't drag in the streets and allowed Mrs. Miller to carry her babies up and down stairs more easily, but Mrs. Miller decided that the effect of pants when sitting was uncouth, and went back to long, but not trailing, skirts.

In 1851, Mrs. Bloomer's daughter wore a red silk cravat with lavender tunic and white trousers. Lucy Stone, who is famous for keeping her maiden name, came home from Seneca Falls in 1852 and bought black silk and had her tailor make her trousers. Women made these themselves but the social opprobrium was great and the bloomers were considered eccentric. When the American Civil war came, and various units wore a knock-off of the brightly colored gathered trousers that Algerian Berbers wore as soldiers, a woman in the US who wore bloomers was called a Zouave, which became impossible to bear (and interfered with suffrage work). A British feminist commented that to wear bloomers "was to incur a social martyrdom out of all proportion to the relief obtained." From the perspective of dress reformers, pants were not the symbol of women's rights so much as a practical, safe, and tidy attire for the home. Betty Friedan would dismiss the sartorial gesture at nonconformity, writing in *The Feminine Mystique* in 1963 that, "Some of the early feminists cut their hair short and wore bloomers, and tried to be like men".

▪ On and Off the Modern Stage

The international star and very early film star Sarah Bernhardt often took male roles. Edmund Rostand wrote a part for her as Napoleon's only son, in *L'Aiglon* (*The Eagle*) in which she wore pants, and to play Shylock in *The Merchant of Venice* she donned a beard. She can be seen in tight leggings in the two-minute *Le Duel de Hamlet* (1900), where fencing movements show her legs to advantage. As a result of an accident to her knee when she fell off a parapet during a performance, she lost her right leg in 1905, which did not stop her from her vigorous acting career for nearly another two decades.

Pants made their way to the legs of European women via the stage and through dress-up in non-Western styles. It was easier for the audience to accept women in masculine attire if it was worn as a costume. The failure of the dress reform attests to how subversive wearing a "man's" garment was considered, even by women themselves. The comfort it offered was not sufficient to make it an acceptable, fashionable choice.

On stage or in a costume ball, it had a sophisticated flare to it. La Belle Otero, one of the world's first international stars, danced in glittering pants influenced by her native Spanish dress in 1909. At around the same time, Diaghilev presented the Ballets Russes in Paris and commissioned costumes inspired by non-Western clothes. The colors, fabrics, and new shapes dazzled the French audience and facilitated a tolerance for the sight of trousered legs.

Another Belle Époque luminary, fashion designer Paul Poiret believed himself to have been an Eastern prince in a previous lifetime. He created soft, draped harem pants for daring women of fashion. The illustrator Georges Lepape immortalized the look when he sketched Denise, Poiret's wife, in the costume she wore for "The Thousand and Second Night" party in 1911. The outfit, designed by Poiret himself, was comprised of harem pants cuffed at the ankle and worn under a fluid tunic. Denise, in bare feet decorated with Eastern jewels, epitomized the sophistication attached to the style. In 1911 Poiret advertised harem trousers paired with brocaded and embroidered tunics as the "fashion of tomorrow." These outfits were for lounging and "pajama parties." The costume museum at Bath, England, has a pair of red silk hostess pajamas that were owned by the actress Dame Edith Evans ("Lady Bracknell" to those familiar with the film version of *The Importance of Being Earnest*).

JULIA SANDERSON.

Julia Sanderson, about twenty-one years of age, cross-dressed for a Broadway musical. Postcard photograph; postcard with postmark of October 1909. Collection of J. M.

▪Outfitting the Legs

By the end of the nineteenth century, working women, especially shop girls, adopted tailored suits inspired by menswear. Comprised of a white shirtwaist and black jacket and skirt clean of decoration, the subdued outfit provided a professional, uniformed look. It would take almost a hundred years for pants to replace skirts at the work place with the power suiting of the 1980s.

Gimble Bros. fashion plate featuring the lampshade tunic, the trouser skirt, and tournure drapery. November 1913. Library of Congress Prints and Photographs Division.

Meanwhile pants penetrated the feminine wardrobe with a modern twist through specialized outfits for sports and leisure. During the 1920s, shorts and trousers were worn for leisure, keeping to the jaunty marine theme of white and blue. Coco Chanel promoted yachting slacks of jersey in neutral colors. She wore white sailor wide-leg pants to the beach of Deauville, and expensive couture shorts were seen on the tennis court. "Carriknickers" were a short chemise with a flap that buttoned between the legs. They came along in the 1920s and would flare briefly thereafter as a style but are a staple of girls' school gym outfits.

As the decade came to an end, leisure pajamas were increasingly seen in *Vogue* and other fashion publications. Following the fashionable line, trousers fell in drapes along the body, creating an elongated silhouette. While women wore slacks and shorts in the 1920s for certain sports, cruises, and riding, it was in the mid-1930s that upscale women played tennis, gardened, and passed the day at a resort in pants.

Despite their coverage in fashion magazines and their established place in the leisure wardrobe, pants in other settings still had a shocking effect. Helen Hulick, a twenty-eight-year-old Los Angeles kindergarten teacher, was called to testify in a burglary case in November 1938. Yet, when she appeared in court garbed in slacks, the attention shifted to her, and the judge ordered her to come back another time wearing a dress. When five days later she returned with her slacks yet again, the *Los Angeles Times* reported the judge's fuming reaction:

> The last time you were in this court dressed as you are now and reclining on your neck on the back of your chair, you drew more attention from spectators, prisoners and court attaches than the legal business at hand. You were requested to return in garb acceptable to courtroom procedure.
>
> Today you come back dressed in pants and openly defying the court and its duties to conduct judicial proceedings in an orderly manner. It's time a decision was reached on this matter and on the power the court has to maintain what it considers orderly conduct.
>
> The court hereby orders and directs you to return tomorrow in accepted dress. If you insist on wearing slacks again you will be prevented from testifying because that would hinder the administration of justice. But be prepared to be punished according to law for contempt of court.[11]

Un-phased and unwilling to budge, Ms. Hulick reportedly said, "Listen, I've worn slacks since I was fifteen. I don't own a dress except a formal. If he wants me to appear in a formal gown that's okay with me. I'll come back in slacks and if he puts me in jail I hope it will help to free women forever of anti-slackism."[12] Indeed the very next day, she was held in contempt for not wearing a dress.

Eventually, after a hearing in front of the Appellate Court, the judge's contempt citation was overturned, allowing the young free-spirited teacher to wear slacks in court.

Trouser Skirt, Paris (March, 1911). Library of Congress Prints and Photographs Division.

▪ Powerful Legs

Like the stage, Hollywood and its stars made the sight of trousered women more acceptable and even sexy. When Marlene Dietrich's movie heroines cross-dressed, the effect was enchanting and powerful. Her scandalous appearance in the 1933 film *Morocco* in tailcoat and trousers solidified her defying sex appeal. Even then, her protagonist wore the masculine attire only on stage in a sort of rebellious role-play. Off the screen, Dietrich became known for wearing pants, which furthered her ambiguous sexual orientation and outrageous glamour. Wearing pants was still viewed as an attempt to weaken male dominance or at least as an intrusion on the male sphere.

Two-legged fashion attire carried an undertone of lesbianism. This was the reason the Pierpont Morgan Library & Museum kept at least one skirt in the cloakroom and made female visitors who arrived in pants change into it, in the same way upscale restaurants keep sports jackets and ties on hand for men. In the 1920s, Virginia Woolf lunched at the flat of the editor of British *Vogue*, Dorothy Todd, with Todd's protégé and lover Madge Garland. Woolf described the scene in her diary, "Todd in sponge bag trouser; Garland in pearls and silks," accentuating the contrast of mannishness and femininity.

A report in *Vogue* January 1, 1936, titled "Tailor-Mates," covered new fashions borrowed from men. The author asserted that a modern woman's "busy life grows more and more comparable to a man's." So much so "that she turns copy-cat and steals ideas from men's clothes for herself. All this has nothing to do with Marlene Dietrich and pants, but with practical and tailored fashions for daylight and dark." The report's illustrations, however, showed only women in tailored skirts and jackets.

While borrowing from men's clothes was acceptable for sports, that's where pants stayed until the mid-1960s. Yves Saint Laurent, the young French designer, always looked to his age group for inspiration, and by that time many women around him were proudly sporting pants. Saint Laurent played with ideas of power and sexiness and created *Le Smoking* in 1966. This version of a men's tuxedo blurred the line between feminine and masculine. Saint Laurent's design offered women an alternative for formal events, instead of old-fashioned, floor-sweeping evening dresses, they could wear his glamorized version of a tailcoat.

The following year Saint Laurent introduced the pantsuit, a continuation of the same idea only meant as day wear. Here lie Saint Laurent's innovation and timeliness; while pants have been worn by women for recreation and sports for at least half a century, Saint

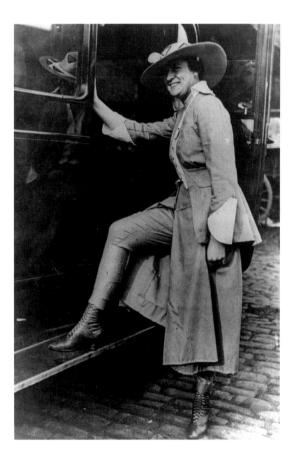

Woman modeling a marching costume for Chicago's suffrage parade, June 6, 1916. George Grantham Bain Collection, Library of Congress.

Laurent's Le Smoking and pantsuit made it fashionable to wear pants for every occasion and for any hour of the day. From a specialized wardrobe piece, pants became the epitome of modernized, powerful dressing. That resonated with a drove of daring women like Francoise Hardy, Elsa Martinelli, and Lauren Bacall, already known for glamorously appearing in pants on the silver screen several decades prior.

Saint Laurent defined the sharp-lined tuxedo suit for women as style, not fashion, and pantsuits became a permanent fixture of his collections. Each season throughout his career he continued to develop and explore these ideas, mixing feminine and masculine details to create a modern look.

Whereas thirty years before, women who wore men's clothing were rejected from the fancier establishments, now, in their high-style suits, women were admitted. The innovative Le Smoking ensemble was elegant and richly accessorized with strappy satin heels and even a bowtie. Models memorable for wearing pantsuits included Twiggy in double-breasted pinstripes, Jean Shrimpton in a tweedy version with a flared jacket and flared pants, and Bianca Jagger, bare-chested beneath the tuxedo jacket she wore to marry Mick Jagger. Nan Kempner, a New York socialite, paired pricey Yves Saint Laurent jackets with boys' Levis. The anecdote is told in *Vogue* how, wearing tunic and black satin pants from the Winter 1968 collection, she was denied entry to the New York restaurant La Côte Basque. In a flash she took off the trousers and went in wearing only her tunic as a minidress.

The pantsuit epitomized work wear for women when many women who went out to work weren't sure what garments, shoes, and colors were appropriate. Women had been wearing pants since the 1920s, but pants had never managed to struggle out of the weekend and into the office. The pantsuit allegedly put women on an equal sartorial footing with men.

In *Vogue*'s September 1976 issue, a fourteen-page fashion spread showcased more than a dozen suits for work. Georgio Armani led the way, having launched his women's wear label in 1975 in an era of "hippie" fashion when he noticed his sister Rosanna at a loss what to wear professionally. He made tailored suits that had exaggerated shoulders and were in the "power colors": dove gray, beige, and charcoals.

Twiggy projected herself as a harlequin waif with wide pants on her tiny frame but most women in '70s chose conservative pants suits they could wear to the office. They could accessorize the pants suit with different blouses and shoes, wearing it (and demonstrating they were too busy

for "clothes") day after day. Wearing pants signaled that a new generation of women was ready to enter the previously male-dominated business setting. As Linda Grant of *The Guardian* wrote on June 2, 2008, "The trouser suit, not the urban myth about bra-burning, is what fashion gave to feminism. When wearing it, your legs took longer steps; men looked at your face, not your ankles, and were forced to listen to the words that came out of your mouth."

A most iconic look of the era came from Diane Keaton, whose outfits in *Annie Hall* (1977) echoed her real-life, la-de-da style—men's brown pants, unpressed white shirt, black vest, and long tie. Keaton's charm and wit were evidence that a woman in pants could be feminine and sexy, albeit in a clumsy kind of way. Ideas that were planted by Yves Saint Laurent a decade earlier now bloomed, and women embraced feminized menswear all day long.

Women entering the workplace in the 1980s wanted to project competence and confidence. Some said that wearing a pantsuit changed their attitude and their gestures. In the 1988 film *Working Girl*, Melanie Griffith's character is a street-smart secretary from Staten Island who raids the closet of her wealthy and mean boss, played by Sigourney Weaver. Griffith is seemingly ready for success when she dons a chic black suit from the boss's closet, which transforms her appearance and erases her self-doubt. Conversely, the turning point in the film occurs when Griffith's protaganist slips into a tight, little black dress she is using to full advantage to seduce Harrison Ford's character. "I have a head for business and a body for sin, is there something wrong with that?" she asks. The Hollywood blockbuster suggests that despite an ability to intellectually maneuver through a "man's world," the most valuable asset a woman had was still her body.

The Frick Collection in New York did not admit women unless they wore skirts until 1982. That's the kind of tension that women in pants conjured until relatively recently in history.

On August 8, 2013, *Wall Street Journal* reporter Christina Binkley heralded "The Leaner, Meaner Power Suit." Actually the look Armani and other designers and design houses like The Row and Carolina Herrera were promoting for fall 2014 had the knife-edged tailoring and strong jacket of the 1980s but with more flattering lines and without the big shoulder pads. According to *WSJ*, the football player look was no more and pants could now be cropped or flowing while all designers gave a nod to the masculine origins of the power suit: "The one constant— the key to its power—is the strong jacket, which serves as a piece of armor."

Westerns & Women's Wear *By Stephen Bly*

The main drawback to some Western movies is what I call Shane's Disease. This is a cinematic illness that's not just common to Western movies, and it's nonfatal. However, it weakens an otherwise decent movie.

For instance, in a couple of different scenes of one of Tom Selleck's Western movies, *Last Stand of Saber River*, Lorraine Kidston (played well by Tracey Needham) wears pants. The movie is set in 1865, Arizona Territory. No lady of any standing would have dreamed of wearing pants.

The two chief weaknesses in my opinion to the Western movie *Shane* are the whiny incessant cries by Joey Starrett (Brandon De Wilde): "Shane! Come back Shane!" and the fact that Marian Starrett (played by Jean Arthur) wears pants. Other than that, the film adaptation of Jack Schaefer's novel is classic.

Now let me make one thing clear. I don't mind women wearing pants. I like the looks of a gal in jeans. When it comes to a novel or film though, especially Western movies, I want them to make it historically correct. The only pre-1900 references to women wearing pants I can find are a couple of Arizona stagecoach robbers in the early 1890s. They dressed as men and held up a stage. And Calamity Jane (noted most as a petty thief and one who seldom took a bath) would on a drunken occasion wear men's clothing. That shocked the women of Deadwood. They figured even a soiled dove like CJ would have the decency to wear a dress.

The split skirt became popular among horsewomen in the late 1890s. And in the era of the "cowboy girl" from 1905 to 1930, split skirts were preferred by most women who rode horses. The Roaring Twenties gave women the freedom to break a few clothing habits. Still, even in the 1930s, women seldom wore pants.

Check this out for yourself. Look at old family pictures. I do recall a photo of my mother and dad in 1939 in the snow on a ski trip where she wore pants, boots, and a heavy coat.

The Second World War changed the habits of women the most, as so many had to work in the defense industry where pants constituted a safety requirement. After that, pants became more common for gals.

So, for me, Shane's Disease is about appropriate attire, but also applies to women's hairstyles. Don't get me started on that. You can tell what decade Western movies were made by looking at the hair. ■

Award-winning Western author **Stephen Bly** *published over 100 books. His last novel, Selah Award Finalist Stuart Brannon's Final Shot, was completed with the help of his widow and three sons.*

▪Le Blue Jean

Blue jeans defied several boundaries. Making their way from the work attire of American miners in the 1880s, through rodeo cowboys and Hollywood chic, to the hippie generation and eventually to the zenith of high fashion, the jeans have epitomize youthfulness and style in the twentieth and twenty-first centuries. Yves Saint Laurent was famously quoted in *New York Magazine* on November 28, 1983: "I have often said that I wish I had invented blue jeans: the most spectacular, the most practical, the most relaxed and nonchalant. They have expression, modesty, sex appeal, simplicity—all I hope for in my clothes."

To understand how jeans got their cool factor, one must look back to the early 1940s. During World War II, American men and women sported the utilitarian garment both on the front and back home. In the August 1, 1944, issue of *Vogue*, Mrs. Rathborne, wife of Major J. Corenlius Rathborne of the Air Corps, is seen in her blue jeans while chatting with one of the workmen on the South Carolina plantation she was running in her husband's absence.

On June 15, 1943, *Vogue* advertised flesh-colored lingerie, stating that "no other lingerie is so bulk-less under the jeans. So right for slacks and shorts. For climbing to the tip of a giant airplane-in-the-making or simply for drawing a cheque for another War Bond." The blue jean signified women's ability to participate in and contribute to the war effort by taking over men's roles. The sex appeal of jeans stemmed from that exact tension. But how did the utilitarian garments make it from specialized work item to the symbol of freedom and youth?

After the war, army surplus was left in abundance all over Europe and the United States. American GI's uniforms were picked up by a new generation of young people, who, wishing to carve a new identity for themselves, rejected their parents' style of dress. *Haute couture* in particular was perceived as old and irrelevant, and baby boomers, coming of age in the late 1950s, instead rummaged flea markets or their mother's old closets for garments they could customize and make their own.

High fashion was trying to follow but missing the point. *Vogue*'s fourteen-page editorial in January 1968 features the stunning Verushka in an array of denim miniskirts and dresses but still no pants in sight. By that time, denim, like sportswear two decades earlier, was perceived as inherently American, embodying the free spirit of the 1960s' youth culture, as well as the "classic" American cowboy look.

Fiorucci advertising (ca. 1980s). Courtesy of the proprietor of all registered including figurative Fiorucci trademarks, the Edwin Co. Ltd.

Boutique owner Paul b. Magit remembers:

In 1972 jeans began to go upscale. Levis and Wranglers gave way to the most expensive denim pants for women anyone had ever seen – four times the price than anyone had ever paid for blue jeans. The first and best were from France from a young designer by the name of Colette Nivelle. They were washed out, faded and so tight that the client would have to go home and stretch out in a tub of warm water to close them. Once on, they'd form to her body like a second skin. We couldn't keep them in stock.[13]

When in the late 1970s Calvin Klein turned jeans into a highly fashioned, sexualized item, they were already charged with the rebellious attitude of rock 'n' roll. Klein however was among the first to recognize that jeans' unisex appeal coupled with racy ad campaigns would place denim at center stage for generations to come. In 1981 Klein shocked the fashion world when he featured young Brooke Shields squeezed into tight pants in his famous Calvin Jeans commercial. Thirteen years later, he again redefined casual coolness with his ads for the unisex fragrance CK1. Shot by famed fashion photographer Steven Meisel, the ad campaign featured the androgynous Kate Moss in cut-off jeans, and a drove of cool, sexually ambiguous youngsters in slouchy jeans. It's not surprising that to promote his new unisex fragrance (a pioneering idea in itself) Klein selected the garment that not only made his name as a designer, but also more than any other item of clothing represents gender-bending ideas.

The cut-off jeans. Photograph by Nasser K., 2014

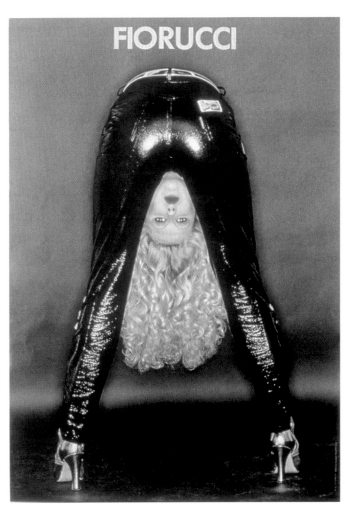

Fiorucci advertising (ca. 1980s). Courtesy of the proprietor of all
registered including figurative Fiorucci trademarks, the Edwin Co. Ltd.

Photograph by Nasser K., 2013

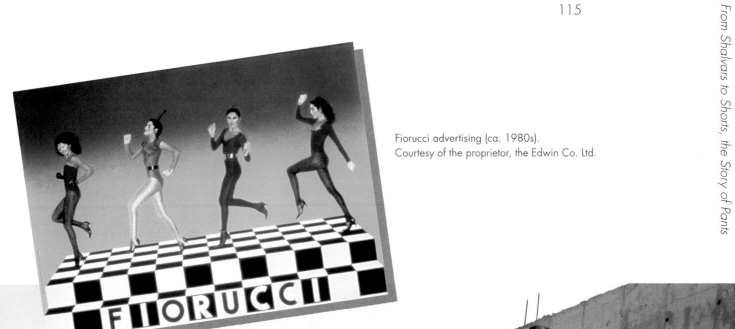

Fiorucci advertising (ca. 1980s).
Courtesy of the proprietor, the Edwin Co. Ltd.

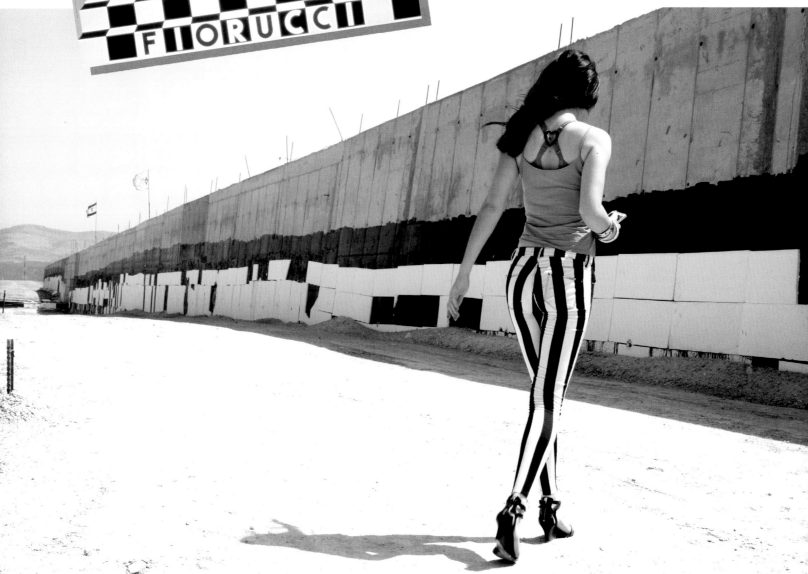

Photograph by Yaron Ben-Horin, 2014.

The Trouser Skirt

The reports of the "trouser" skirt that is at present furnishing matter for the funny writer of the daily papers… cannot be seriously considered any more than was the "hobble" skirt born of madness of last mid-summer. One cannot imagine a refined woman appearing in public in a divided skirt except astride a horse, or mounted on a bicycle after a by-gone fad.

These words appeared in *Vogue* on March 1911, at a time when women dared not wear trousers, not at home, and certainly not in public. This fashion-forward trend, which the reporter dismissed as a bygone fad, was indeed short lived, but despite the harsh criticism it received, was actually hailed by fashion leaders as sophisticated and modern.

Paul Poiret, who admitted to shackling the feet of fashionable women in the narrow and long hobble skirt, paid back by introducing luxurious trouser skirts for the evening.[14] A month later, *Vogue* dedicated full-page coverage of several styles of "Jupe-Culotte" or trouser skirt. Among them was a draped lace evening gown worn over Turkish trousers, and a day dress by Parisian couturier Margaine Lacroix, with pantaloons peeking out of a long side slit.

Poiret looked to the East for inspiration. His exquisite kimono shapes for evening, use of vivid colors for linings, and admiration for print and pattern sprang from his interest in non-Western cultures. He most likely took inspiration from Turkish, North African, and Middle Eastern sources when he went to work on the trouser skirt.

Other cultural forces may have been at play. In 1909 the establishment of the Ballets Russes and its novice approach to set and costume design had a tremendous influence on taste and tastemakers. For *Scheherazade*, which premiered at the Garnier Opera in 1910, Leon Bakst broke away from ballet tradition when he dressed both male and female dancers in harem pants. These full, loose-fitting trousers provided room for movement and tapped into an increasing interest in non-Western cultures.

The dance craze of the 1910s was another wonderful arena in which women could experiment with non-confining and otherwise unacceptable fashions. The dancer Irene Castle was a fashion leader in her own right. Her fashion advice and direction were sought after by young women in Paris, New York, and all over the US. She favored skirts rich with fabric and pleats that allowed her legs to perform that energetic, almost acrobatic, act for which she and her husband Vernon were known. At times she appeared with silk bloomers under her skirt, while other times she simply deceived the eye by wearing a very wide-legged split skirt "carefully draped to hide the split, and a plaited petticoat underneath."[15]

During World War I, on the fashion front women could explore comfortable, less formal clothing. In 1917, even *Vogue* had to admit the trouser skirt fad may have given some women freedom they would have a hard time giving up:

The revival of a trouser-skirt is hailed with mingled joy and fear by those who have hitherto worn skirts. Into what new fields will this new garment lead us? Once over the stile and into the pantaloon, shall we ever be able to get back again? It is a question for serious consideration. Shall we even want to get back again? The war has led women into many a new "pasture"; will it also lead us into trousered freedom?[16]

These beautifully decorated gowns are worn over Turkish trousers (ca. 1911). Collection of J. M.

Trouser Dress from Paris. Published February 14, 1914. Library of Congress Prints and Photographs Division.

Shaping an Ideal Form

*How often has virtue
been preserved in the world,
by its being enabled to resist
the first onset!*

—*Lady's Magazine*, 1800

Fashion plate of evening dress by Rudolph Ackermann (London, March 1814). Los Angeles County Museum of Art.

Undergarments with respect to legs are a contradiction in terms. They have been frilly signs of erotic play. They have been as cute as Little Bo-Peep's pantaloons, as spartan as the shift and stockings billeted to a young Jane Eyre at the Lowood School, and as minimalist as a nude body tight by La Perla or Capezio. Elaborate armatures for shaping the ideal form collapse but are revived, even though bid "good riddance" as modes change. When dress styles have been extreme and the core of the body controlled and constrained, legs have contrarily been freed like the clapper of a bell.

Colleen Hill, associate curator at The Museum at FIT explains in her exhibition *Exposed: A History of Lingerie*, that there are two types of undergarments, soft or hard. In other words, while constructed undergarments, like corsets and bustles, shape the body to the ideal form, unconstructed slips and panties follow the natural lines. For centuries, undergarments informed the silhouette of fashionable clothes.

In olden days, drawing the clothes away from the legs with some sort of border garment resulted in fewer washings and an extra layer of protection from heat or cold. Layers to create a certain shape came and went in Europe from the Renaissance. The undergarments that have supported the ideal female forms were developed to accommodate physical needs and were also later used as markers of class and of erotic prowess.

▪Keeping Up with Men

A sea change occurred in fashion with the sudden shortening of European men's costume in 1350. While Henry VIII was showing off his legs in hose, women's dresses began to take on a shape that didn't correspond to nature in order to render a stylish silhouette.

It was around this time that undergarments started to shape the exterior outline. Rigid underpinning allowed women to conform to the dictates of fashion. In the thirteenth century, it was a long, tight bodice that slenderized the upper body. An improved way to stiffen fabric assisted in achieving this ideal body, explains costume historian Elizabeth Ewing in *Dress and Undress: A History of Women's Underwear*:

> Under the tight, elongated bodices there was worn, in addition to the traditional voluminous shift or smock, a stiffened linen underbodice. This was originally known as a 'cott,' an early French word used for any close-fitting garment and similar in meaning to "cote," the word for ribs. As the cult of the slim figure progressed, this garment was made increasingly figure-defining and rigid by the use of paste as a stiffener between two layers of linen.

The paste was reapplied between washings and in addition to giving the wearer a crisp look, the underbodice absorbed grime, keeping it from penetrating the cloth.

One word had two meanings when petticoats started being worn as a separate garment hung from the waist: the skirt

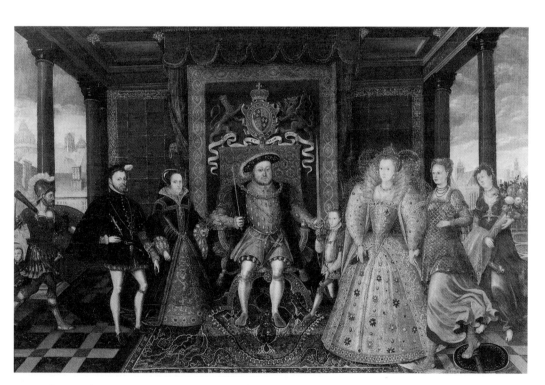

An Allegory of the Tudor Succession: The Family of Henry VIII by Lucas de Heere (ca. 1572). The mythical figure of Peace holding Elizabeth Rex's hand (Plenty follows them) has a shorter, fluttery skirt as she's a deity, whereas the Queen's gown, stiff with fabric and gems, represents the stability of her dynasty. National Museum of Wales.

that showed through an open robe, versus the under-petticoat, which was well established by Shakespeare's time and tied by laces to the body. The Bard described it prettily in *Much Ado About Nothing* (Act 3, scene 4): "And skirts, round underbourne with a bluish tinsel." Petticoats from that period became a jocular metonymy by which men designated women.

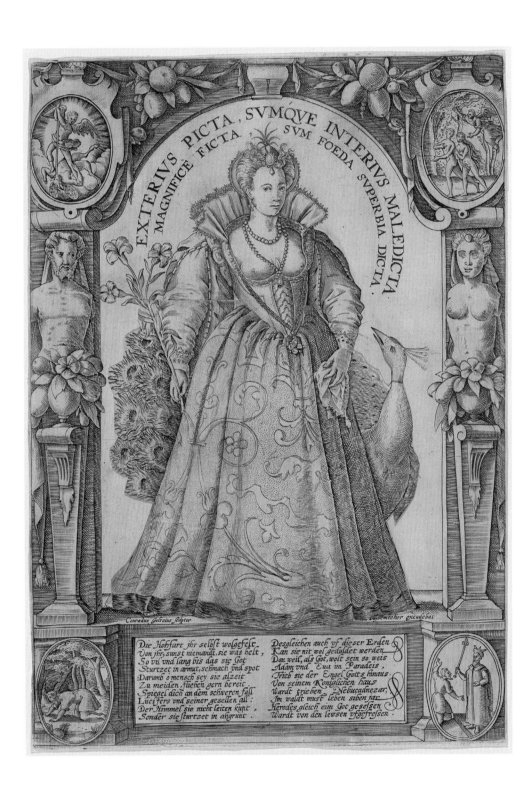

Pride by Conrad Golzius (late sixteenth century). Rosenwald Collection, National Gallery of Art, Washington, DC.

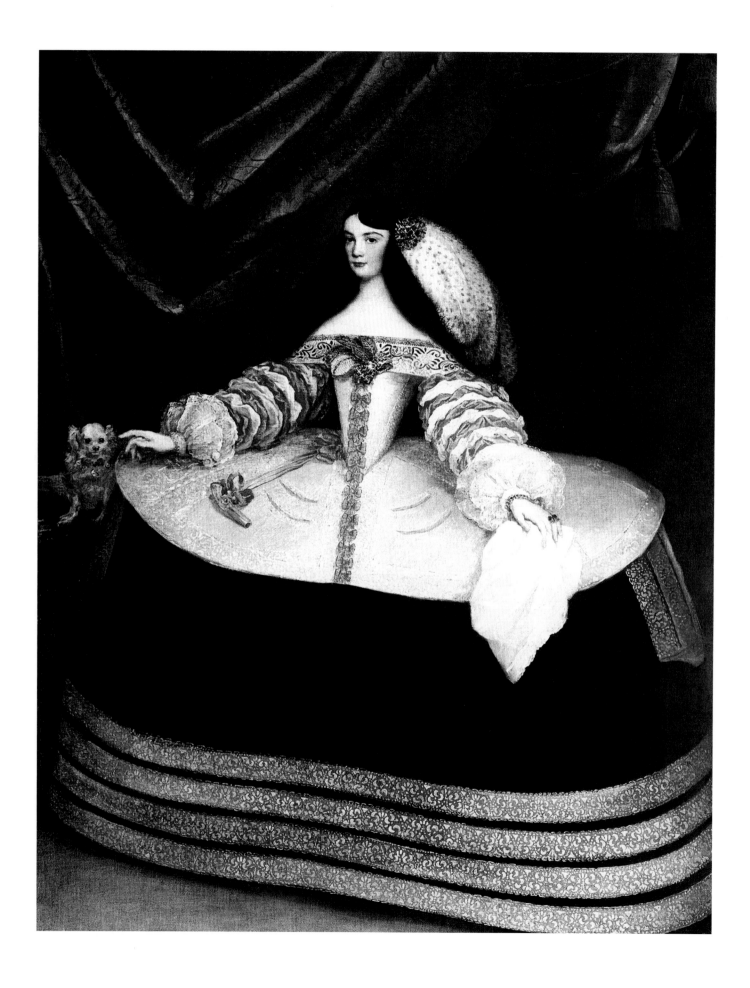

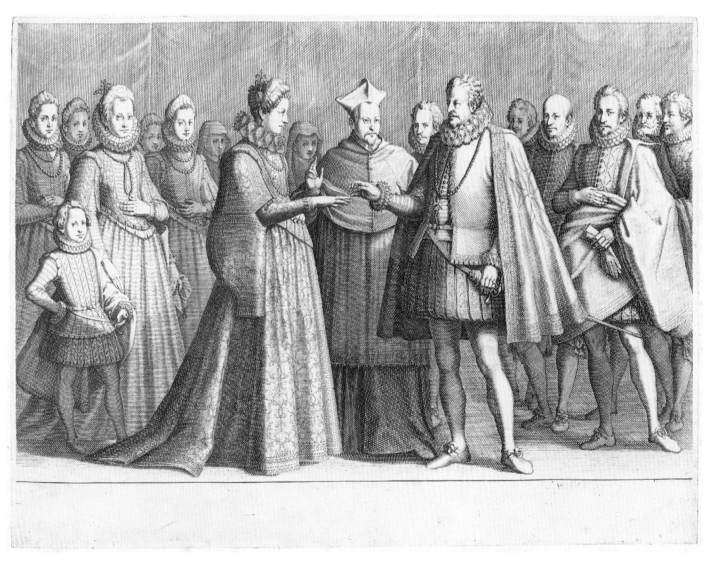

The Marriage of Ferdinando and Christine of Lorraine by Jacques
Callot, 1614. National Gallery of Art, Washington, DC.

Opposite: *Dona Ines de Zuniga* by Juan Carreno de Miranda (1660).
Lazaro Galdiano Foundation, Iberfoto/ The Image Works.

In the Renaissance, fashion was skipping from one country to the other for wealthy and noble women. A striking look requiring extreme undergarments caught on among the elite in the sixteenth century and moved from Spain to the courts of Europe. The ancestral *vertugado*, or farthingale, consisted of an open cone-shaped cage of colorful wool or rich fabric that went under the skirt. Graduated hoops of willow laths or whalebone (both of which could be bent without breaking, and whalebone could also be subject to heat) were sewn into the petticoat. A farthingale required as much as fifty yards of the laths or bone, and paintings by Diego Velasquez immortalize the sloping line that it gave to the skirt. Not only did this armature give the dress a cone form, but it kept it away from the body; as water was suspected of carrying diseases, the European lady changed her lace and linen, which projected cleanliness, but apparently bathed less, not more, as the Renaissance progressed.

The term vertugado derives from the Spanish word *verdugo,* a stick cut while still green. In Spain and Italy, sumptuous silks, satins, brocades, velvets, and damasks, brought from overseas during the Age of Exploration, were heavy; this armature was invented to make them stand out firmly. The big gorgeous stiff skirts showcased the hips and made the waist look like a broomstick. The Spanish court was legendary for its formality, and no one said the style was practical. Other courts of Europe adopted it, in mid-sixteenth century. The French, who were known for borrowing fashions and putting their stamp on them, called them *vertugadins*, corrupted from "virtue guardians." In France, a sumptuary law was initially legislated against the farthingdale's excesses.

Technically the farthingale is an extensor, so the wearer extended into its surface, and the petticoat became part of her body, the way a tennis racket lengthens the player's arm. It gave an illusion to the lady of the court of personal extension in space. However, as Penny Storm observes in her study of fashion theory, "If a garment is so big that it impedes the wearer's body movement, it may cause her to feel smaller, less significant, and more inadequate."[1] Besides, wearing any such contraption is likely to require continual readjustment and be distracting. In any event, the die was cast of reshaping in a major way the female body in fashion.

When Katharine of Aragon, the youngest surviving child of Ferdinand and Isabella, married Henry VIII's younger brother, Prince Arthur, in 1501 her gown was described as "after the same form the remnant of the ladies of Spain were arrayed." The farthingale would come and go like any extreme fashion but always kept its ceremonial and royal identity. In the royal chess game, Henry VIII married his younger sister, Mary Tudor, to the much older king of France, who died three months later, reputedly from the exertions of his honeymoon. Mary was considered the loveliest princess in Europe. She wore a farthingale as did Queen Elizabeth. The farthingale was supposed to be only for court ladies. Her godson, John Harington, the attributed inventor of the flush toilet, wrote an epigram about how the rule against non-royals wearing the broad skirt styles was ineffectual: "For though the laws against it are express, / Each lady like a queen herself doth dress, a merchant's wife like a baroness." Queen Anne, who is said to have bankrupted England with clothes for herself and her ladies, wore a farthingale four feet wide at the hips.

Eleanor of Castile married Francois I in 1530 and may have brought the style of the Spanish farthingale to the French court. In terms of symmetry, the farthingale's ellipse balanced nicely with the neck ruff that Catherine de Medici introduced to France mid-sixteenth century. The dress, tight at the waist and very full at the hips, had padded rolls enlarged by the whalebone and steel farthingale.

The circumference of the farthingale was as great as three yards, going out nearly four feet across the body. However, an Elizabethan-era woman had an alternative to the farthingale, a bum roll or "sausage" of stiffened material that she wore around her waist under her skirts, holding them out a degree, if not to the dramatic extent of the farthingale. The bum roll rendered a more natural form and arrived from Italy where the geometric shape enforced by the farthingale has not been fully received. When Puritans came to power, women's clothing in England became plain and hoops disappeared, only to reemerge with the restoration of the monarchy.

The Farthingale Becomes French

The Spanish empire had widespread possessions but its economy did not keep up. Now the French courtiers set the European fashions and refashioned the farthingale as their own. It turned French first as a tub-shaped petticoat with vertical sides, combined with a bolster round the hips and under the skirt, for a more circular shape, and by 1620 it was a wheel, a structure that took the skirt out at right angles from the waist, before falling vertically to the floor.

In the first half of the seventeenth century, skirts became shorter by a few inches and wider, necessitating the hooped petticoats. To name the undergarment that extended them sideways, the French preferred *pannier* because one could sit one's hands atop the exaggerated

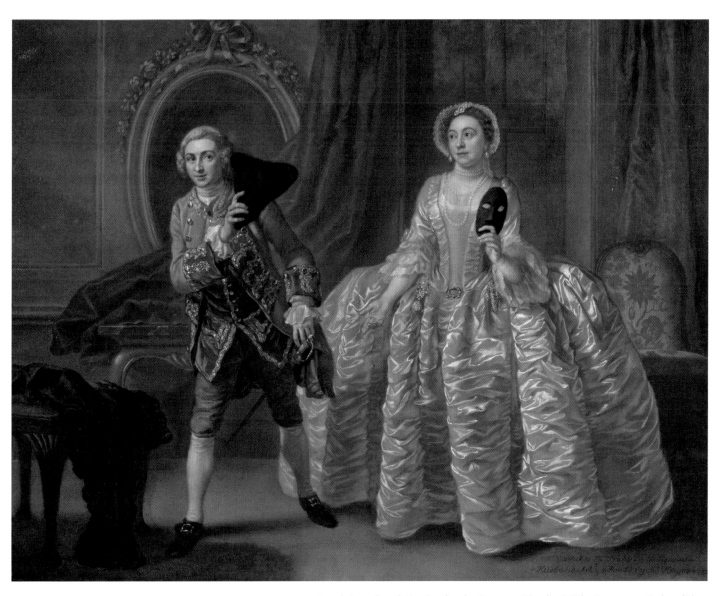

David Garrick and Mrs. Pritchard in Benjamin Hoadley's "The Suspicious Husband" by Francis Hayman (1747). Yale Center for British Art, Paul Mellon Collection, New Haven, CT.

Rebe de Cour moyen panier, un feul' retrouflis, elle cü d'hyver, de fatin bleu garnie de bandes de queues
de martre et les bandes de martre attachées avec des nœuds de ruban blanc fur tout le devant de la juppe.

French Court Dress (*robe de cour*) by Etienne Claude Voysard (second half of eighteenth century). The blue satin dress decorated with bands of sable fur tails and white ribbons is described as "moyen." Los Angeles County Museum of Art.

Antoine de La Roque, the editor of the popular French magazine *Le Mercure*, complained in March 1729 that the panniers were increasing in awkwardness and size. The editor said that they were made like "a kind of cage or basket to hold poultry." The style proclaimed a woman was somebody of importance, with pages, servants, and ladies in waiting to do her bidding. Fashion historian Anne Hollander pointed out, in relation to the second half of the eighteenth century, that "women of this period took up more space than men, and seemed taller."[2] A gentleman wore tight waistcoat and breeches, while a lady's clothes had voluminous skirts.

A lady held her pannier up on one side or down on the other. In doing so, she showed her legs and feet, which looked small given the round immensity of the dress. Since women all wanted small hands and feet, the smallness was accomplished by optical illusion. In her panniers, a lady may have occupied extended territory but her body seemed slender.

All in all, the elite broadcast the styles, but women of middle and lower class also adapted them. If a servant was dressing up, she could stuff her skirt with whatever was at hand to create a roll at the back of the skirt.

By 1780 the style that once dictated the shape and silhouette for most European women was only reserved for court appearances.

horizontal "basket" at either side. The pannier became the iconic silhouette of the eighteenth century. Often flounces or pleats muted the rim and the whole affair tilted to the front. Extending the fullness evenly around the body, the pannier accented the waist and showed the ankles when a woman walked. By 1740, panniers reached their widest and the English court took it to the extreme with panniers so skinny, yet wide, that the wearer looked like a paper doll.

In a time when clothes denoted different levels of formality, structure and volume were distinctive markers. The *robe volante*, fashionable from 1705–1715, had a less structured shape and so was reserved for occasions outside of the formal king's court. The robe volante was an evolution of the negligee, an undergarment worn at home. Unlike the negligee it was supported by an architectural understructure of bone or laths and went from round dome to flattened oval by 1730. Such progression, from an undergarment to an outergarment, informs some of the major advancements in Western fashion from that time on.

Opposite: *The Duchess of Devonshire and the Countess of Bessborough* by Thomas Rowlandson (1790). Yale Center for British Art, Paul Mellon Collection, New Haven, CT.

Portrait of a Woman by Thomas Gainsborough (ca. 1750). Yale Center for British Art, Paul Mellon Collection, New Haven, CT.

▪ The Americanization of the Pannier

In America, ministers made moral pronouncements about men's wigs and women's hoops, the latter of which Ben Franklin would famously parody as there seeming "a Necessity either of making our Doors bigger, or their Hoops less." Solomon Stoddard, the esteemed pastor of a church in Northampton, Massachusetts, protested in 1722 that women twisted and contorted to get through doorways and narrow passages; straight was the gate to heaven and he could quote scriptural passages to prove his point. A woman in a hooped skirt not only made getting through a doorway a production but took up more space than others did in a pew. For the reverend's part, he ended one sermon with a parting shot at hoops, mixed dance parties, and alcoholic punch, declaring "Hooped petticoats have something of Nakedness."

At the time of the American Revolution, the European fashions prevailed in the colonies. The robe *à la française*, with its hip panniers, was going out of fashion. Most Americans chose to wear other imported fashions, like the robe volante (also called sack dress); the robe *à l'anglaise*, which had pleats at the back from the shoulders and no panniers, rendering the more relaxed English form; and the three-part skirt, called the Circassian. The polonaise gown, with the looped up skirt worn with quilted petticoats, was an informal fashion that reflected the changing attitude of the period. Like the basic dress with panniers, it drew attention to the drapery-parted opening at the front. This was especially apropos of the American ladies who quilted with cotton wool in elaborate patterns, when the skirts were open at the front to display the petticoat, from about 1740. Jessica Glasscock in the *Heilbrunn Timeline of Art History* explains that the polonaise gown subtly shifted the eighteenth- century style of skirt:

> The fullness of the polonaise gown was achieved through the voluminous drapery of fabric, most often via rings sewn on the underside of the skirt, which were drawn up with cording to create puffs at the back and side of the dress. The puffs of fabric rested on full petticoats to create the still expansive base of the silhouette; the real shift was one of weight, giving as it did an overall lighter impression of the body within.

The Americans, like the English, tended to adopt more relaxed styles than their French contemporaries. The fullness at the side hips was created typically by oval bands of cane suspended in channels sewn into a linen skirt. It might tie at the waist in the center back and have several hoops of graduated size. The cane hoops were split and bent into ovals and at the hips; batting padded pocket slits. In her seminal study, *Eighteenth-Century Clothing at Williamsburg*, Linda Baumgarten describes "layers of undergarments" supporting the elite female clothes—a loose cotton or linen shift that came below the knees, several cotton under-petticoats, pleated narrow tape waistbands, boned stays, and the silk satin petticoat that showed through the gown. Hoops could be fastened around the waist or sometimes

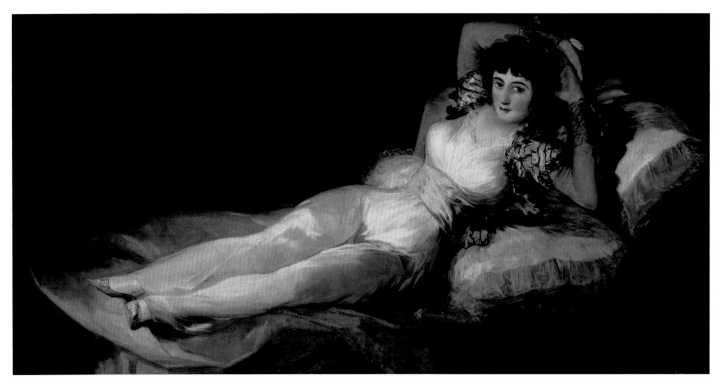

The Clothed Maja by Francisco de Goya (ca. 1800). Museo del Prado, Madrid, Spain. Erich Lessing/Art Resource, NY.

were built into a petticoat. However, Baumgarten explains that hoops were outdated for daily wear by the 1760s.

Baumgarten points out that in late eighteenth-century America, fashion became commercialized and democratized. Women adopted styles such as the polonaise gown with skirts "puffed up like dairymaids." Stays were worn by many working women as support garments, while the hooped panniers were attire for the balls and ceremonies of the upper class.

In the collection of Historic Williamsburg is a petticoat, probably from Virginia, of blue-green silk satin quilted over a layer of cotton bat to linen, with a several-inch-wide band of lacy embroidery at the hem. All women, including sometimes slaves and indentured servants, wore quilted petticoats. Runaway women from South Carolina and Virginia are documented to have worn quilted petticoats of black, red, and blue, lined with colors like yellow, dark brown, and green.

In this era dresses were likely to be altered or redyed. To make it easier to take them apart, the seams were sewn with long running stitches secured with the occasional backstitch. Linda Baumgarten notes, "Full skirts did not receive much stress, and the long running stitches were easy to rip out when a gown was remodeled."

▪ The Imperial Pause

When towards the end of the eighteenth century, panniers like boned bodices became nearly extinct, a visitor to London in 1810 was astonished to see ladies carried to the palace in sedan chairs "in the fashion of fifty years ago, as more suitable, I suppose, to the age of their majesties, with their immense hoops… folded like wings, pointing forward on each side."[3] For centuries, styles that were once the height of fashion became with passing time mere ceremonial attire, a relic of the past.

Marie Antoinette had foreshadowed the literally revolutionary look of the neo-classical fashion in what she and her ladies wore in her playhouse, le Hameau. The Queen, who had been sinking a fortune into adornments, eventually tended to renounce lace borders, bows, and artificial flowers and had Elisabeth Vigée-Lebrun paint her in 1783 in a dress of blousy white cotton muslin holding up a real rose. The dress was a radical departure from the frills and poufs of the royal dressmaker Rose Bertin. For the contemporary eye, accustomed to the heavy, lavish style of the period, it was the same as seeing the Queen in her underwear, despite the fact that it was worn with a linen chemise under it. The portrait, needless to say, was not received well by the opponents of the already disliked Queen.

Ironically, after the apocalyptic scenes of the French Revolution, the most fashionable dress evolved from the dress seen in that hated portrait that came to symbolize the Queen's detachment from her people. The chemise gown was an uncanny expression of new philosophical ideas that attempted to erase class distinction. It wasn't literally a chemise but it mimicked the look of one. Chemise dresses were sheer and pure; the merest ribbon or embroidery served as embellishment. These dresses depended on imported fabric—muslin from Madras, India, that had a woven pattern on a transparent ground, organdy with a raised spot pattern, and "gauzy" silk from Gaza in Palestine.

Respectable women wore the sheer muslin dresses with a linen slip underneath; while the daring young women called Les Merveilleuses wore their chemise dresses sans undergarments. Worn with slippers, the chemise gowns of the Napoleonic era gave women a more natural carriage and accustomed people to the view of female legs, gracefully suggested through filmy gowns.

The imagery that informed the mode of the early nineteenth century came from the Classical art found in museums. Americans and Europeans alike found nothing offensive in the nudity of Greek and Roman statues. The bare legs of the Greek and Roman goddesses and matrons, in statues, on friezes, and on sarcophagi were quite like what contemporary ladies in their ethereal gowns were wearing. The disgraced vice-president of the United States Aaron Burr patronized a young artist, John Vanderlyn, who went to Paris and won a salon prize with the first painting exhibited by an American of a lady with naked legs.

With the new realism came an increasing differentiation between what women wore and men wore, and a new admission of legs as part of a woman's sexiness. Legs emerged from desuetude. Women promenaded in the capitals of Europe, and men wore clothes that looked old on purpose. The French minister Charles Maurice de Talleyrand was present at the Tuileries where several ladies were to take an oath of fidelity to Napoleon on their new appointments. The emperor remarked upon a lady who wore a short petticoat that showed her delicate ankles. Someone asked Talleyrand what he thought of her *tout ensemble* to which the minister replied, "I think that her dress is too short to take an oath of fidelity."

Fashion plate of promenade dress by Rudolph Ackermann (London, August 1, 1809). Los Angeles County Museum of Art.

The Portrait of a Lady Standing near a Lake (ca. 1802). Yale Center for British Art, Paul Mellon Collection.

■ The Bell

The Industrial Revolution played a big part in the evolvement of undergarments that started to incorporate new materials like steel underpinning. After the Napoleonic era, the empire waistline gradually started to drop until it reached its natural place, and then technology intervened and created stiff corsets that extended over the abdomen and smoothed the shape. The fashionable silhouette started to grow around the hem, and by the 1830s, skirts were wider and more elaborate. In order to achieve the desired fullness, full-skirted petticoats were worn under the dress, expanding the circumference, but also the hips. By the 1840s the corset was shortened again, reaching above the hipbone and ending in a point. The new corset shaped the upper body while at the same time allowed skirts to be fuller around the hips. Gradually, from the 1840s for the next two decades, skirts continued to grow and expand to monstrous sizes. A petticoat reinforced by horsehair and several layers of linen or cotton petticoats were indispensable. The look was of a stiff bell.

From the 1840s to 1860s, women had to wear four to six petticoats for the desired shape. The petticoats could be starched and reinforced with rows of cording at the hem. At this time, a woman could go to a store and buy petticoats ready-made. Julia Gardiner, future wife of President John Tyler, wore a flounced dress when she scandalized the upper crust by appearing in a dry goods merchant's ad in 1836, bearing on her arm a placard that said: "I'll Purchase at Bogert & Mccamly's, No. 86, 9th Avenue. Their goods are Beautiful and Astonishing Cheap."

It was difficult to move in the layers of petticoats because they would tangle between the legs. According to *The Chit-Chat of Fashions* of May 1844, "Men are never sufficiently sensible of our humility, in considering it so necessary to increase our attractions for the pains we bestow in the attempts."

In April 1855, the *Petit Courrier des Dames* advised wearing petticoats with rows of thin whalebone from the hem up to the knees to inflate one's Parisian frock. Then the problem of reducing the weight of one's fine gown was solved in 1856 when the cage crinoline, made from thin strips of wire suspended by tapes in ever-widening circles, was introduced. The cage crinoline, which may strike us as a horrible contraption, actually provided some relief. And

Fashion Plate (Walking and Dinner Dresses), London, September 1829. Los Angeles County Museum of Art.

Peruvian Girl *By James Oles*

This recently rediscovered portrait from Lima probably shows one of the daughters of María Rosa de Salazar y Gabiño and Fernando Carrillo de Albornoz Bravo de Laguna; she would thus have been a member of the richest family in colonial Peru. She wears an embroidered and lacy chemise under a more ornate bodice, partly covered by a black lace shawl. The dainty embroidered apron alludes to domestic work; the same silver and pearl jewels appear in portraits of her mother. The raised ballooning skirt, however, is the most distinctive aspect of her ensemble. For, although they used imported textiles, women in Lima appear to have consciously rejected the French-inspired international styles of the day. The dress was known at the time as a *faldallín* and was supported by some sort of framework and petticoats. It may have origins in more informal Spanish dresses of the seventeenth century; the high hemline surely insulated the garment from muddy streets. The portrait might have been created for a wedding or betrothal, and while it is possible that the artist used fashion plates as a source, wealthy Limeñas did own such costumes, as documented in period watercolors and paintings. The same dress was much later adopted by indigenous women, and remains in use today, especially in towns in the highlands of Peru and Bolivia, where it is known as a *pollera*. ∎

James Oles *is professor of art history at Wellesley College and curator of Latin American Art at the Davis Museum.*

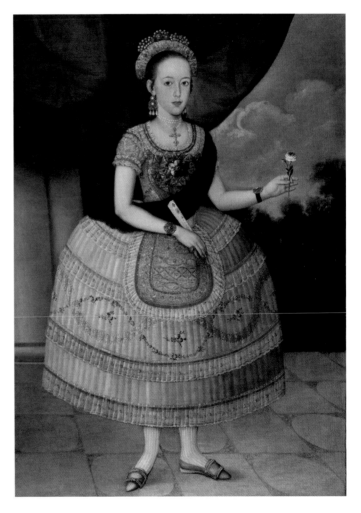

Portrait of a Young Woman attributed to Pedro José Diaz, 1795–1810. Davis Museum at Wellesley College, Wellesley, MA.

although it required some practice to sit and handle the flexible hoops, it was a perfect timing for this technical advance to arrive and free the legs of European and American women.

Huge quantities of these steel bands were produced, and the style spread by railroad as well as fashion magazine. Only a rustic like the lady in a Mrs. Gaskell's novel would suppose the apparatus was a birdcage when it arrived as a gift from Paris.

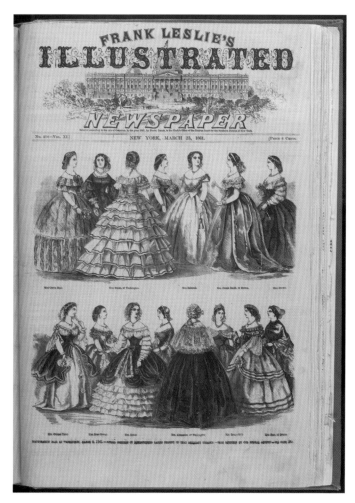

The height of fashion at the Inauguration Ball at Washington, March 4, 1861. Library of Congress Prints and Photographs Division.

▪ The Caged Legs

Over time, the skirt and the scaffolding went from dome to more pyramidal, and then flattened in front. The crinoline would have many varieties in material and shape. The "Imperial" dress elevator had weighted strings to raise or lower the skirt, and keep it clear of the sidewalk. The makers boasted that the dress would rise even and not hitch up in one spot and drag down in another.

The crinoline was an ultimate technology applied to fashion. Middle-class women, who found it obviated the weight of massive petticoats and also the expense of owning, washing and starching them, wore it. An important patent was issu,ed to the American W. S. Thompson in 1856. The steel bands were braided with yarn so as not to make ridges under a petticoat or two. One variety of extension skirt, reserved for wet weather, was covered with gutta-percha, a natural rubber. Inventors beat a door to patent a more marketable version. One device had the front halves of the bottom two hoops hinged at the sides, with a string going up inside the skirt to the waist. The wearer could draw up the front of the crinoline to clear her ankles when ascending a staircase.

Not every American was a fashion plate or wore the crinoline. If she did, likely she had a maid, read *Godey's* and *Peterson's*, and didn't do manual labor. Skirts continued to increase in volume with the crinoline extending to its widest point in about 1860. The dresses, despite the hollow cage, swept the floor and had heft. In *Period Piece*, her memoir, Gwen Raverat, Charles Darwin's granddaughter, reminisced about the crinolines and bustles of the second half of the nineteenth century:

> The ladies never seemed at ease, or even quite as if they were wearing their own clothes. For their dresses were always made too tight, and the bodices wrinkled laterally from the strain; and the stays showed in a sharp ledge across the middles of their backs. And in spite of whalebone, they were apt to bulge over the waist in front; for, poor dears, they were but human after all, and they had to expand somewhere. How my heart went out to a fat French lady we met once in a train who said she was going into the country for a holiday 'pour prendre mes aises sans corset'... We did rebel against stays. Margaret says that the first time she was put into them — when she was about thirteen — she ran round and round the nursery screaming with rage. I did not do that. I simply went and took them off.

Yet comfort is a question of perspective. She once asked her Aunt Etty what it had been like to wear a crinoline and her aunt replied, "Oh, it was delightful. I've

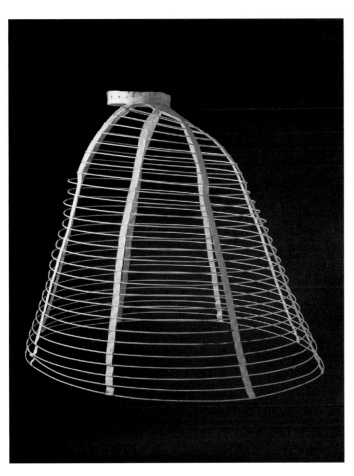

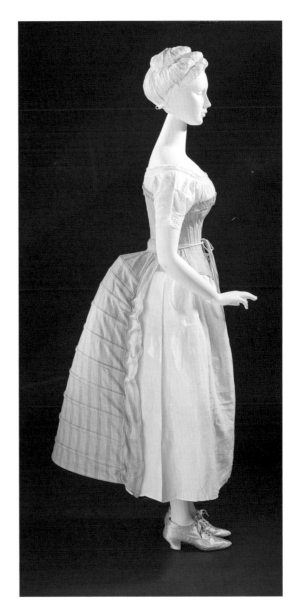

Cage crinoline, English; cotton-braid-covered steel, cotton twill, and plain-weave double-cloth tape, cane, and metal (ca. 1865). Los Angeles County Museum of Art.

Bustle, English; cotton twill, cotton-braid-covered steel, and cotton-braid cord (circa 1885). Los Angeles County Museum of Art.

never been so comfortable since they went out. It kept your petticoats away from your legs and made walking so light and easy."

The wide skirts gave a canvas for beautiful fabric and trimmings and colorful coordination, stripes, prints, and plaids. It must have been fun in a rotundity of skirt to whoosh and glide into a room or along a path. However, while pigs were still collecting garbage in New York, the fullness wouldn't have suited urban walks, and to wear a crinoline all day would have been burdensome.

In her *The Anatomy of Fashion*, Susan J. Vincent summarized the effect of the cage crinoline as "a particularly subtle materialization of the 'angle in the house' topos, that did not so much trap the wearer within' the domestic realm, as gave the domestic realm, sartorial form and then draped it about her person."

With the advent of industrialization trimmings, accessories, and undergarments were available ready-made in department stores (which were also a place to socialize for urban women). In addition, many women at this time owned domestic sewing machines, which enabled them not only to sew fashionable garments at home (using the many available patterns offered by sewing machine companies and fashion magazines) but also to update dresses with trimmings newly bought at department stores. This meant that even women of lesser means could participate in fashion.

▪Blurring and Redefining the Lines

The undergarment beneath one's skirt has to have been the slowest evolving apparel in the history of fashion. Catherine de Medici is said to have introduced drawers (named for how they are drawn onto the legs) into France from Florence, along with the fork, when she married the French king. Drawers took a few hundred years to become commonly worn, mainly because their association with men's clothes was perceived as immodest. C. Willett and Phillies Cunnington in their *History of Underclothes* explain that the turning point for drawers came from Princess Charlotte (1796–1817), who not only wore them, but also publicized the fact. In the subsequent years, drawers were slowly accepted and by the 1840s were common but optional throughout the century. Most were cotton or linen early in the century and plain except for the merest inset of ribbon around the bottoms. In the crinoline era when they took on frills and lace trimmings. Synthetic dyes changed the fashionable palette and did not skip drawers, which in the 1860s were available in red and magenta.

Crinolines that hitched up required wearing an undergarment, and drawers filled the need. Drawers were both modest (concealing the legs) and erotic (contouring the legs and pointing attention to private parts). Jill Fields, in her study *An Intimate Affair: Women, Lingerie, and Sexuality*, explains that "women could wear a divided garment if it were feminized and sexualized, and this feminization of the garment assured that 'real' trousers would still be worn only by 'real' men."

▪The Industrial Age

Victorians opposed clothing that mixed gender and class. Even riding habits were voluminous and long. Dress trains with beading and embroidery at the hem reinforced the prevailing opinion that a woman's legs ought neither be seen nor mentioned. The metonymy of the sexy ankle—a token is seen but the entirety imagined—made even piano legs something to dress quaintly in Victorian-era America. Captain Frederick Marryat, in his *Diary in America*, described the piano leg coverings as "modest little trousers with frills at the bottom" when he visited a seminary for young ladies. This habit more likely originated from the Victorians' affinity for dainty drapery, but it nevertheless reflected the taste of the period.

The Industrial Age packed a wallop on social patterns and the thrust of Victorian mores became to preserve the status quo. Dressing a la mode had become within reach with the advent of synthetic dyestuffs and the evolving sewing machine. To not be vulgar was the repeated message of etiquette guides. For example, in *The Art of Dressing Well* (1870), American etiquette maven Sarah Annie Frost wrote, "The utmost elegance and richness may be permitted if the effect is so subdued as to avoid any conspicuous display, or any glaring effect."

This is what shocked the public about Eduard Manet's *Olympia*. While nudes had been part and parcel of great art, in this work, the young woman is depicted realistically, not as the idealized and allegorical nudes of the past. She looks at the viewer with a direct, rather than averted, gaze. Her complete nudity is offset/underscored by her bracelet, a black ribbon at the throat, satin mules, an embroidered silk throw under her legs, and an outsized pink flower in her hair (along with her hand splayed over her crotch, an allusion to her sex itself). Olympia's legs are short, with prominent knees rather than the idealized long slender, jointless legs of traditional nudes. The legs bespeak a specific woman who is a common artist's model. She crosses them at the ankle—a nod to modesty in the face of

Rolla by Henri Gervex (1878). RMN-Grand Palais/Art Resource, NY.

Petticoats were at the apex of titillating in 1875, when the Salon de Paris caused Henri Gervex's small painting called *Rolla* to be removed, not because of the classical nude but because of the petticoats, garter, and corset piled up by the bed—a clear sign of lovemaking between the gentleman and the prostitute. The painting depicted a scene from a very long poem by Alfred de Musset that ends with the debauched young male client being offered money by the whore, and then committing suicide. The painting caused a sensation and made the career of the painter.

full body display and a suggestion of a casual, insouciant attitude.

Issue after issue of *Godey's* had a new type of foundation garment for the lower body. No other contraption, not umbrellas, corsets or hairdos—got this equal space. For instance, skirt lifters went around the circumference of the skirt and clipped to the inner seams to raise the overskirt in a series of decorative swags. Given the push for machinery at the time, and that a boy's dream was not to win the lottery but acquire a patent, the inventions were mercurial and flooded the market. The hoop skirts were priced according to the number of springs, which ranged from eighteen to fifty. In 1868, the "Winged Lace" skirt had the upper part of the underskirt laced together, then a few hoops, and below, the open winged front. This style prevented the feet from getting entangled. It could be put in the tub and washed, and retailed for three dollars.

In small-town, olden-days America, there were few store-bought clothes. Mail-order garments were often the solution and for a hundred years more, until about 1965, all American women crowded onto the stools when the new catalogs came into the dry goods or fabric store. Hypnotically glued to the pattern books that sat on big angled tables, women quietly analyzed the possibilities, and the little children played underneath, tugging their mothers' legs, virtually unnoticed. The heart-stopping moment once Butterick, Simplicity, and McCall's began distributing their patterns from designated stores, in tidy envelopes, was whether the fabric store had the desired pattern in stock. Usually it did. Then the women went home to carefully unwrap the crisp tissue pattern, with its darts and cutting edges all marked. The patterns made a rustle when pinned to fabric. Singer had quick courses to teach women how to sew from a pattern. All this began in the 1850s, when Ellen and William Demorest displayed two dozen trimmed paper patterns in the parlor of their house in Philadelphia, facing Franklin Square. The sewing machine was becoming popular and not everybody could design and sew a dress out of the air. The idea to sell trimmed paper patterns came to Ellen from watching her African-American maid cut out a dress using patterns of coarse brown wrapping paper. Seeing potential business value, the Demorests moved to New York City and opened a shop at 473 Broadway, from which they produced patterns of thin paper and distributed them widely.

In 1860, the husband and wife team began to publish *Mme. Demorest's Mirror of Fashion*, which took its place alongside *Godey's*. That women could sew their own clothes even if they weren't champion seamstresses, was the great fashion divide of the nineteenth century. As Valerie Steele writes in *Paris Fashions*, clothes were democratized because all classes adopted similar types of clothing. Middle-class women strolling in the Bois de Boulogne saw the splendor of Empress Eugenie and copied her, for instance, whereas previously royalty was a caste apart. The Impressionist artists were a tuning fork, as the rise of the middle class had led to middle-class patronage and a desire of the patrons to have themselves and their world painted. According to Gloria Groom, who wrote the book *Impressionism, Fashion, and Modernity*, "the prototype of the Parisienne became in the 1860s a fashion statement; the dress, not the face, was the focus." All social classes became fascinated with fashion. For a French woman dressing to the gills was patriotic and for an American it was a dimension of striving for success in a fluid society. Using the magazine as the base, the Demorests papered the nation and made the name Demorest a household world. Soon the Demorests were manufacturing an inexpensive, small "Quaker hoop skirt," which was innovative in that it had many metal staves close together so the heel would not catch on them. Mrs. Demorest made regular trips to Europe to keep up with the luxury trade, the latest gowns and accessories. *The Mirror of Fashion* simply did not address the Civil War, only mentioning when Mrs. Lincoln was in town shopping at Arnold Constable, the most fashionable department store in New York in the nineteenth century, and stayed clear of dress reform, promoting ladylike dress above all. Yet they were social activists, Ellen championing women's rights, and William temperance.

By 1866, there were 300 branches of "Mme. Demorest's Magasin des Modes" in the US, Europe, Canada, and Latin America, each run by a female entrepreneur. The company continued to distribute patterns via the magazine through the 1880s, at which time Ebenezer Butterick, a Massachusetts tailor, had cornered the paper pattern market. Although the Demorests did not spearhead new fashion trends, Ellen reported in the fall of 1860 from Paris that the crinoline was dying and "the length of her train no longer marks the lady, and ladies of high rank sometimes set the example of leaving their carriage, and taking a stroll down the boulevards."

Virginia Gerson and her sister in fancy dress for the Crinoline Ball by Käsebier Gertrude (1906). Library of Congress Prints and Photographs Division.

▪ Fashion Trickling Down... and Bubbling Up

By the 1870s, the volume of the dress shifted to the back, and the cage crinoline disappeared. The silhouette narrowed, while the emphasis continued on the small waist. There followed a multiplicity of armatures for poufs, fishtails, and bustles that created what fashionable women desired, a protruding rear end.

In fashion, England ruled via Paris. The great name that reigned over Paris fashion, and by extension, the rest of the Western world, was Charles Fredrick Worth. Worth came from a middle-class English family and worked as a salesman at English and then French dry-goods stores. It was at Gagelin-Opigez, a dry-goods store in Paris, that he met Marie Augustine Vernet, his future wife. In the store, Vernet modeled dress designs that encouraged and inspired women to purchase fabrics. Vernet's physique must have inspired Worth, as in just a few years he begun to design dresses for Gagelin-Opigez and she modeled them.

When Worth moved on to open his own house, he became renowned for the ethereal style of Empress Eugenie. Although he is mostly known for the Empress's frilly dome-shaped gowns, he was also responsible in part for introducing the bustle and narrowing the skirt. He understood that the cage crinoline couldn't extend any larger and was ready to take fashion to the next level. Worth said: "The 1870 Revolution is not much in comparison with my revolution: I dethroned the crinoline!"[4]

Worth slipped the bustle, or tournure, down the figure in the 1870s, and lengthened it to extend from the back of the skirt to the knee; a long frilly petticoat was featured to point up the train. Sometimes the only buttressing was a lining of horsehair or self-flutings. By 1893, below the waist the bustle had shrunk in size to the dimensions of a mere pad while a corset above the waist created the S-shape of early Edwardian fashions. Between the soft bustle of 1870 and the shelf bustle of mid-1880s came a unique phenomenon for undergarments: a bodice fitted down all the way below the hips, molding the figure to what was called the cuirass shape, taking its name from the word for the medieval armor covering back and chest.

Meanwhile, the short and intense craze for Dolly Varden dresses, with their bandbox cheer, vividly illustrates the democratization of fashion. Women sewed their own

Bustle Day Dress, 1884. Victorian Fashions: Pictorial Archive. Selected and arranged by Carol Belanger Grafton, Dover Publications.

Day Dress, 1886. Victorian Fashions: Pictorial Archive. Selected and arranged by Carol Belanger Grafton, Dover Publications.

Dolly Varden frocks or bought them ready-made. The English and American fashion was named after a coquette in *Barnaby Rudge* by Charles Dickens, which was published in 1841 and set in the previous century. This was the first time a non-royal set a fashion. Dolly was the flirtatious daughter of a locksmith, and her polonaise of floral or striped chintz or print cotton over a plain bright skirt a few inches above her ankle was caught up and pinned at the back, as though she had something more active to do than sip tea and direct the servants. The silhouette conformed to the fashion of the moment with undergarments emphasizing the rear and skirts smaller in circumference than the previous decade. The appealing Dolly Varden fad was a very early middle-class fashion that was not adopted by upper-class women of refined taste. It took a great deal of colorful eighteenth century-style fabric, was loaded with trimmings, and paired with a beribboned straw hat.

It's no coincidence that the eighteenth-century inspired style became fashionable in the 1870s, a time in which the House of Worth was a dominating force of fashion. Worth himself looked back to the previous century for inspiration, and from studying the past he developed a liking for elaborate petticoats, draped rich fabrics, and an abundance of trimmings.

Like the cage crinoline, the bustle lent itself to technological wonders, like one with a system of pulleys at the back that brought three elements (tail and two wings) up so they fell in curves over the underskirt. The bustle never had the dominance of the crinoline. It didn't rule fashion but fashion ruled it, and it came and went—first in the soft mode between 1869 and 1876, including the "fishtail" look, and then a "shelf bustle" that sat on the hips, circa 1883.

In his novel *Ragtime*, E. L. Doctorow has Emma Goldman react to Evelyn Nesbitt's posture:

> It is ironic that you are thought of in homes all over America as a licentious shameless wanton, Goldman said pulling the laces out of the grommets, loosening the garment and pulling it down Evelyn's legs. Step out, she said. Evelyn obeyed. Her undershift remained stuck to her body in the pattern of the stays. Breathe, Goldman commanded, raise your arms, stretch your legs and breathe. Evelyn obeyed. Goldman plucked at the shift, then lifted it over her head. Then she knelt and slid Evelyn's lace-trimmed underdrawers to her feet. Step out, she commanded.... Women kill themselves, Goldman said.

Late Victorian women were garbed in restrictive, tight, and elaborate clothing that narrowed their steps and mired their movement. A *Punch* cartoon shows a mustachioed military officer in his fancy jacket, tight trousers, and high boots next to a young lady swathed in a high-fashion gown with a nipped-in waist and a train. She has dropped her handkerchief and while she flutters her fan, looks at him to pick it up. His eyes drop nervously to the handkerchief. Neither individual's dress permits them to bend to pick it up.

The padding has gone to the back and black stockings are in vogue (postcard postmarked August 14, 1908). Collection of J. M.

▪ Sinuous Lines

From the 1870s to 1890s, influenced by the artists of the pre-Raphaelite circle, some daring sophisticates wore romantically flowing dresses designed according to vaguely medieval lines. This unconstructed style of the aesthetic movement, more or less life imitating art, provided an alternative to corsets and bustles. In 1889, to play Lady Macbeth, Ellen Terry wore a dress embellished with the wings of a thousand green beetles. It looked like a stained glass window. Lady Randolph Churchill had a flowing gown covered with iridescent insect wings as well. The keynote was flow and no construction beneath or in the garment. Dress reformers had been trying to free the body from the constraints of fashion for over fifty years by this time with little luck. The pre-Raphaelites, too, created their own fashion, but in regards to clothing of ordinary women had little influence.

The appeal and disaffection women felt toward the undergarments they wore to support dress styles is expressed perfectly in Amy Lowell's magnificent poem "Patterns." The poem looks back to the eighteenth century, yet Lowell (1874-1925) wrote it during the period of suffragettes, imagining herself into the past, as we do when we look at yesteryear's fashions. Women were no longer wearing the armature unless they wanted to make their shape just so, yet Lowell, who was born in 1874, well recalled when the conventions of fashion demanded it.

"What are patterns for?" asks the highborn lady, sinking, flopping into her flat, conventional, and ornamented existence. Her lover is reported dead in a letter. Losing him, she has lost her hope of escaping the boundaries that society has placed on her.

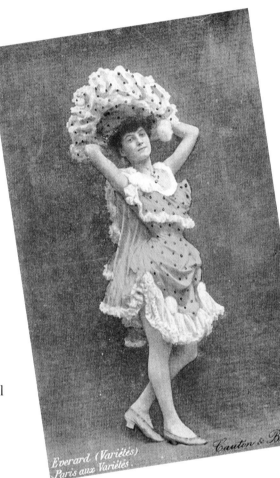

Parisian showgirl in white stockings and luxurious frills (ca. 1900). Antique postcard produced by Everard Variétés. Collection of J. M.

> I walk down the patterned garden paths
> In my stiff, brocaded gown,
> With my powdered hair and jeweled fan,
> I too am a rare
> Pattern. As I wander down
> The garden paths.
>
> My dress is richly figured,
> And the train
> Makes a pink and silver stain
> On the gravel, and the thrift of the borders.
> Just a plate of current fashion,
> Tripping by in high-heeled ribboned shows.
> Not a softness anywhere about me,
> Only whale-bone and brocade.
> And I sink on a seat in the side
> Of a lime tree. For my passion
> Wars against the stiff brocade.

The most fashionable silhouette of the Gay Nineties was attainted by a long and rigid S-shaped corset that forced the bosom forward and the pelvis backwards. The brutal undergarment created an exterior sinuous form in dialog with the graceful lines of art nouveau. Women of the Edwardian period had elaborate underwear under their skirts. Trimming and embroideries made a seductive barrier between the body and the dress, and silky, lightweight fabrics came into play in lieu of the linen and cotton of the Victorian era.

The undergarments of the Edwardian era invented a new fashion, one only known to and seen by the wearer and her intimate counterpart. "Lingerie", rather than undergarments, now described the garments that instead of being practical carried an erotic meaning, suggesting laces and silky fabrics having a seductive power. These notions transferred seamlessly into the new centuries, leaving the prudence of the long Victorian era behind.

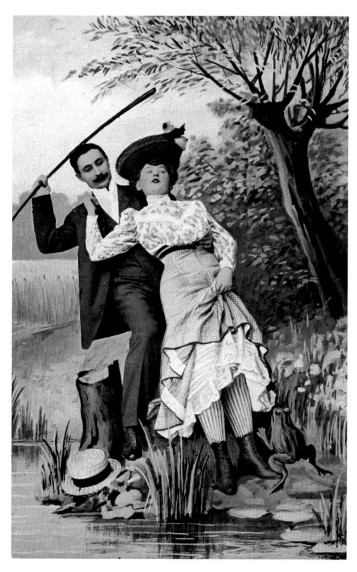

Losing her footing by the stream was an opportunity to show a little leg (ca. 1905). Antique postcard. Collection of J. M.

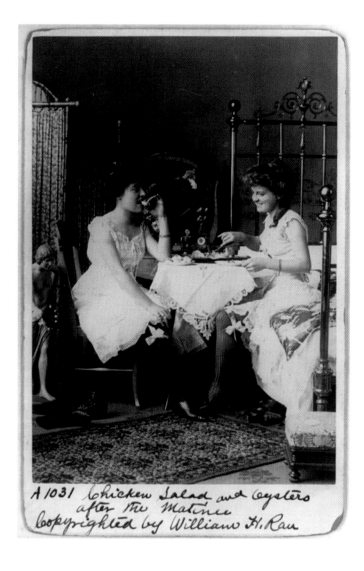

Chicken salad and oysters after the matinee (ca. 1901). Library of Congress Prints and Photograph Division, Washington, DC.

▪ The Shaped and Unshaped

Changes in fashion at the first half of the twentieth century stimulated by couturiers such as Paul Poiret, Coco Chanel, Lucile, and Vionnet, resulted in softer, less constructed undergarments. Although the shape transformed between the 1910s, the '20s, and '30s, the fashionable body had a modern, streamlined shape throughout this period. Undergarments smoothed the shape to make the body look naturally "unshaped." During the 1930s when sleek fabrics adhered to the body, girdles and all-in-one corselets streamlined the silhouette from the waist to the hips. Through the mid-1960s foundation garments such as girdles molded the body of most grown women to present a figure that was more ideal than natural. The feminist American writer Betty Friedan reminded college students:

Girl modeling a corsellette at a Detroit, Michigan, fashion show presented by the Chrysler Girls' Club at Saks Fifth Avenue (Spring 1942). Photograph by Arthur S. Siegel. Library of Congress Prints and Photographs Division.

"How many of you have ever worn a girdle?" They laugh. So then I say: "Well, it used to be, not so long ago, when I was your age, or your mothers were your age, that every woman from about the age of 12 to 92 who left her house in the morning encased her flesh in rigid plastic casing. She wasn't supposed to notice that the girdle would make it difficult for her to breath or move. She didn't even ask why she wore it. But did it really make her more attractive to men?"

I ask them: "How can you know what it was like to wear a girdle, when you've never worn anything under your blue jeans except a bikini brief?

And how can I expect you to know what it felt like when being a woman meant that you wore a girdle over your mind, your eyes, your mouth, your heart, our feelings, your sexuality, as well as the girdle on your belly?"[5]

The first half of the twentieth century ushered in a modernized body ideal and an end to rigid underpinnings. Ideals, however, change quickly, and with Europe and the United States trying to recover from the rampage of World War II, fashion took a turn back. The 1947 Corolle collection by Christian Dior (later termed the New Look by renowned fashion editor Carmel Snow) offered a body so shaped and constructed that it required the comeback of undergarments unseen since the 1860s. Dior had the *guepieres* (from the French *guepe*, or wasp), undergarments needed to cinch in the waist and achieve the hourglass figure built into the outfits. The Dior dresses awakened American ingenuity to create products that gave women the desired figure—arched back,

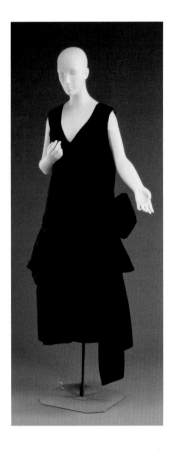

This American silk taffeta dress was from the department store Bonwit Teller. It was probably adapted, according to Historic Deerfield curator Ned Lazaro, from a French couture model by Madeleine Vionnet (1920–25). Photograph by Penny Leveritt. Courtesy of Historic Deerfield, Deerfield, MA.

Cocktail dress from designer Suzy Perette's 1957 collection. Library of Congress Prints and Photographs Division.

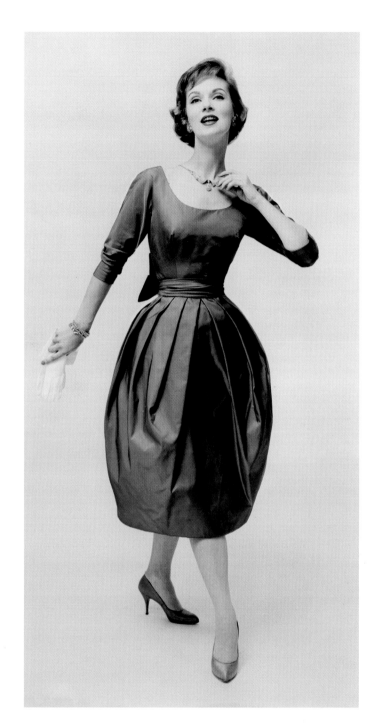

shoulders dropped (the "Dior slouch") and protruding hips. The Metropolitan Museum of Art has in its collection American-made undergarments such as panniers that hang down from the waist and are meant to extend the skirt around the hips, "Bell o' the Ball" hoops, and a 1950s version of the cage crinoline. Relating the women's undergarments industry to space flight attire, Matthew H. Hersch quipped in *Fashion Theory* magazine that fashionable women became the New Look's test pilots:

> To prevent a "jutting rear," *Good Housekeeping* suggested that readers thrust their pelvises forward as if "flinching from a spank"; to perfect this posture, women were encouraged to lay down with their knees bent and
> waists pressed against the floor, mimicking the stances astronauts later adopted to survive high g-loads in space capsules.

Changes in ideal body and shape during the twentieth century were almost as hectic as in the century prior. Emphasis on erogenous zones shifted from decade to decade. The post-modern era in fashion, starting from the 1980s, has been ruled by designers who have reappropriated and reinterpreted many of ideas found in the past. Jean Paul Gaultier, for example, fixed a cage crinoline sloping down from the back of the runway

model's head, and attached strings to the front of a dress where it can be pulled up as though the wearer is a self-marionette. Extracting the physical underpinnings of fashion to the outside is both playful and subversive, yet it builds on a long standing tradition of fashion evolution.

Trading on similar ideas, British designer Vivienne Westwood has explored fashion's intricate constructions like bustles, crinolines, panniers, and corsets. As its name suggests, the 1985 Mini Crini collection, drew inspiration

from the structure of the cage crinoline, yet unlike the historical undergarment, showed much of the leg. Mixed in with inspiration from the world of ballet, the collection is a wild blend of historicized fashion.

Through history both men and women have desired the fashionable body or reacted against it. No matter what side they take, they can't ignore it. History has shown that the force of fashion is stronger than reason. Fashion often has no reason whatsoever other than achieving what is considered beautiful at the time. After a gala at the Metropolitan museum in the 1980s, where all the women were outfitted in theatrical Lacroix confections, *Vogue* editor Grace Mirabella made this comment:

Often they were tortured: their crinolines didn't permit them to sit down and they had to turn sideways to fit through doorways. When I saw this, and the glee with which so many women swallowed it up, I realized that it wasn't Lacroix, it was I who was falling out of step with them.

Corsets and undergarments have helped women to mold their bodies along the lines of fashion, and technology and marketing have been there to comply. Fashion historians often ask themselves, why the bustle? Why a very tight long skirt that makes it almost impossible to walk? Why the flounces or the corset to the knees? The only answer is fashion: fashion and, by extension, the fashionable body.

Christian La Croix evening dress from the Luxe Collection (spring/summer 1988). Silk chiné taffeta with silk grosgrain ribbon trim. LACMA/Art Resource, NY.

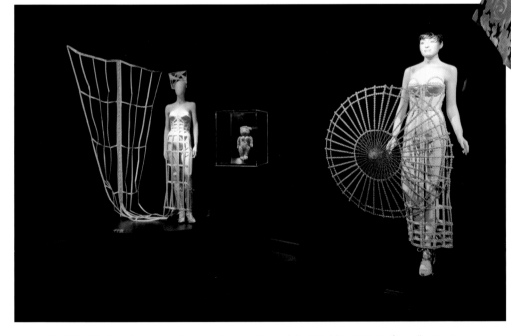

Jean Paul Gaultier's satin cage-look corset dresses, Around the World in 168 Outfits collection (women's prêt-à-porter spring/summer 1989). T *The Fashion World of Jean Paul Gaultier: From the Sidewalk to the Catwalk.*
Organized by the Montreal Museum of Fine Arts in collaboration with Maison Jean Paul Gaultier. Photo MMFA, Denis Farley.

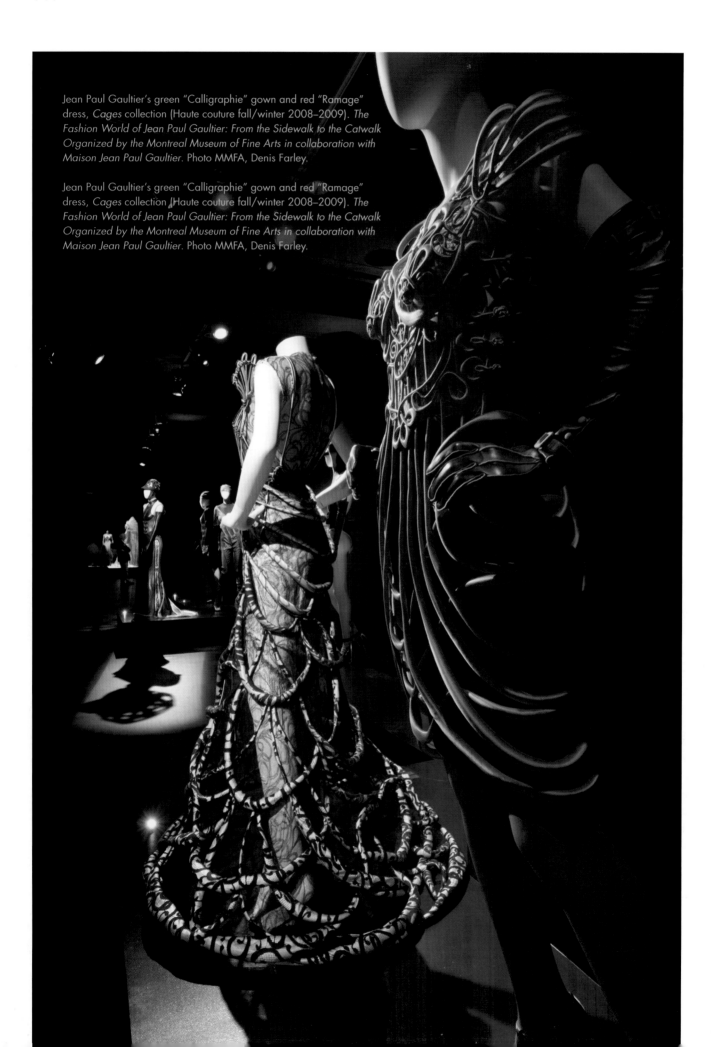

Jean Paul Gaultier's green "Calligraphie" gown and red "Ramage" dress, *Cages* collection (Haute couture fall/winter 2008–2009). *The Fashion World of Jean Paul Gaultier: From the Sidewalk to the Catwalk Organized by the Montreal Museum of Fine Arts in collaboration with Maison Jean Paul Gaultier.* Photo MMFA, Denis Farley.

Jean Paul Gaultier's green "Calligraphie" gown and red "Ramage" dress, *Cages* collection (Haute couture fall/winter 2008–2009). *The Fashion World of Jean Paul Gaultier: From the Sidewalk to the Catwalk Organized by the Montreal Museum of Fine Arts in collaboration with Maison Jean Paul Gaultier.* Photo MMFA, Denis Farley.

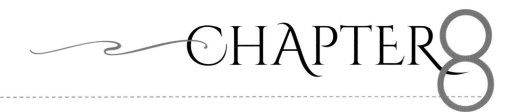

CHAPTER 8

Dressing to Dance

Throughout history, dance performers have pushed the boundaries of acceptable dress. At a time when it was considered inappropriate for a woman to expose an ankle or calf, on stage doing so was, conversely, required. For the sake of improving technical skills and freeing the body to move, ankles, calve, and knees started to emerge, until eventually practically the entire leg was visible.

Dancers have paved the way for fashionable women to explore new ways to display their bodies in general, and their legs in particular. One of the most famous modern dancers was Isadora Duncan. In 1900, she took the stage by storm in Paris, questioning and breaking all boundaries of propriety and good taste. Although she was born and raised in the United States, her breakthrough occurred on European ground, where her radical performances enchanted high society, artists, and taste-makers. She was known as the "barefoot dancer" although she claimed to be "shocked dreadfully" to hear herself so described.[1] Footwork aside, her great innovation as a dancer was to eliminate the corset, which in turn unified the upper body and legs to create a smooth, sensuous, and extended movement.

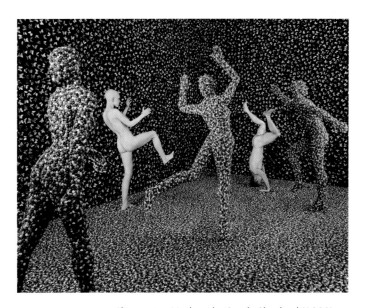

Shimmering Madness by Sandy Skoglund (1998). By permission of the artist.

Duncan was not a classic beauty, but when she danced her whole being was transformed. She seemed to cast a spell on her audience, and her admirers were legion. The English novelist Sewell Stokes was one of them:

> One forgot, watching her move very slowly, that she was there at all. She drove out of the mind, with one slight movement of her foot, or of her hand, the impression one had had a short time before of a large red-haired woman drinking lager beer. Her largeness, with everything else about her, disappeared. In its place was a spiritual vitality that defied the body it animated.[2]

When Isadora Duncan was born, in 1878, the most fashionable type of dance was not performed on stage, but rather in the private ballrooms of America's high society. During the last decades of the nineteenth century, wealthy industrialists spent lavishly on hosting dance and fancy dress, or costume, balls. In these extravagant events, men and women were costumed in their finery, often portraying figures such as Marie Antoinette or Cleopatra, depending on the theme of the ball. Historical as they were, costumes were often chosen by how easily they could be adapted to the fashion of the day. How well they displayed the wearer's wealth and social rank was another important consideration. Cleopatra might wear a tight corseted bodice and a full skirt reaching all the way to the floor or Marie Antoinette have a bustle under her shepherdess dress. Although by the 1880s skirts were no longer supported by the enormous cage crinolines of mid-century, clothes were still tailored around confining undergarments that shaped and formed the body.

Society leader Alva Vanderbilt organized one of the most extravagant balls. Balls like this were much anticipated and reported on, with *The New York Times* describing in lush detail the décor, guests, costumes, and dances, namely the quadrilles—square dances performed by four couples. New York's elite spent months preparing elaborate costumes, ranging from historical figures such as the Duchess of Burgundy and Joan of Arc for the women and Louis XVI and Duke De Guise for the men to animal-themed costumes and others simply titled "light" or "summer." On the eve of March 26, 1883, the carriages pulled up to 660 Fifth Avenue, where crowds of curious spectators, held back by police, waited to get a glimpse of the rich and beautiful. One of the most spectacularly costumed guests to climb the stairs of the Vanderbilt mansion must have been Mrs. Cornelius Vanderbilt II, who wore the House of Worth's "Electric Light" gown. This luxurious, floor-length, yellow satin dress is now at the Museum of the City of New York. The elaborate lightning bolt and starburst embroidery

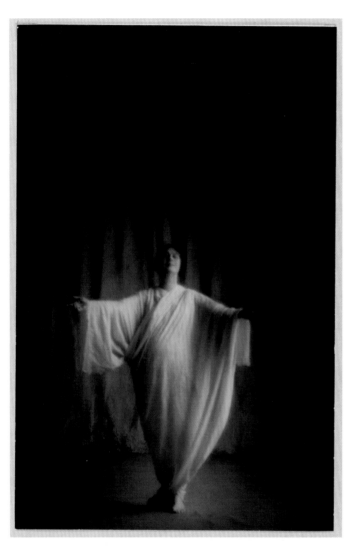

Dancer Isadora Duncan in white robe (c. 1917) photographed by Arnold Genthe. Library of Congress Prints and Photographs Division.

on the surface of the satin, the beaded fringe of the skirt with its massive train, and the pronounced bustle all epitomize how vital dressing up was to these balls. While other costumes that were worn that night may have showed a bit of the wearer's shoes and stocking, probably allowing more freedom when performing the quadrilles, Mrs. Vanderbilt II opted for a costume that reflected her sophisticated, fashionable taste.

Dance balls were not only an opportunity for prosperous industrialists to establish themselves as a kind of American royalty, but also an arena for the practice and enforcement of moral codes. A chaperone accompanied each young lady and the two were separated only when the young socialite was invited to the dance floor. Even in the name of comfort, showing the legs would have been very indecorous; to manage a long train discreetly, women sometimes used a skirt lifter on a ring.

One of Duncan's first performances was at the request of Caroline Astor, the queen of Gilded Age society, at Beechwood, her summer home in Newport, Rhode Island. Some of Mrs. Astor's neighbors and perhaps she herself were using Isadora Duncan's methods to dance with their children, and "The Mrs. Astor", as she chose to call herself, was not one to be left behind. Although this would have been an honor for the dancer, Duncan later observed that Mrs. Astor and her affluent society friends "had no art sense whatsoever."[3]

Duncan's performance was also a far cry from the popular vaudeville stage productions in which singers, ballroom dancers, escape artists, and other curiosities appeared one after another. It was certainly different from ballet of the time, when ballerinas still glided between five basic movements. Critics often lacked the vocabulary to describe what they experienced watching Isadora Duncan dance.

Duncan fiercely objected to the idea that fashion should change the form of the body, and so she liberated herself from the confinements of undergarments and tailored clothing. Compared to the elaborate dresses worn by most fashionable and financially capable women at the turn of the century, Duncan's costumes, on and off the stage, were radical. She rejected tailored clothes and appeared in draped white tunics, sometimes reaching all the way to the floor, and sometimes only to the knees. Anne Daly, author of *Done Into Dance*, explains that Duncan's dress was

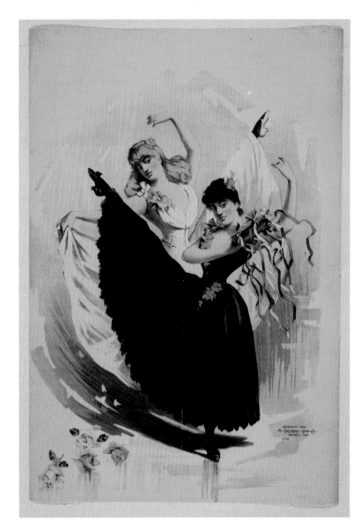

Two women dancing, Calvert Litho. Co., (ca. 1892). Library of Congress Prints and Photographs Division.

anchored with elastic to the shoulders and at the waist. Since Duncan did not wear undergarments, the dress was long enough to ensure pubic hair was not visible, while underarm and leg hair was almost certainly removed.[4]

Duncan herself describes in her autobiography an even more radical appearance, when she arrived in Germany to perform:

> My transparent tunic, showing every part of my dancing body, had created some stir amidst the pink-covered legs of the ballet, and at the last moment even poor Frau Cosima lost her courage. She sent one of her daughters to my loge with a long white chemise which she begged me to wear under the flimsy scarf which served me for a costume. But I was adamant. I would dress and dance exactly my way, or not at all.[5]

Because Duncan's tunics resembled those of the figures on ancient Greek and Roman vases, her cultured audience did not consider her costume vulgar, but rather artistic. For Duncan, the Hellenic garb was a way to distinguish herself from the leg business of the ballet dancers she despised. In reality, her idea of cultured dress was not that new; the draped costumes of the ancient Greek and Romans were considered the most dignified, as far back at the ballets of Louis XIV, if not for suggesting cultivation then for the freedom of movement they afforded.

Dance in the Country by Auguste Renoir (1883). National Gallery of Art, Washington, DC.

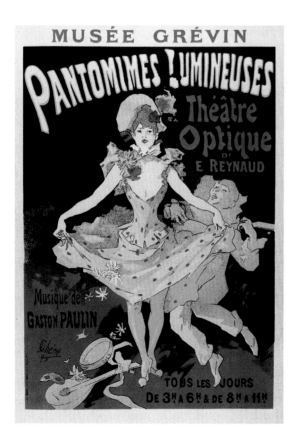

Poster for the first public dance screening of the Optical Theater, derived from Praxinscope, Paris (1892). J. Bedmar/ Iberfoto/ The Image Works.

▪ Choreographing Clothes

Until the seventeenth century, ballet was performed with masks and costumes that followed luxurious contemporary fashion. Père Menestrier, who wrote *Des Ballet Anciens et Modernes* in 1682, had in fact ideas similar to Duncan's even back then. He too believed the body was a tool for expressing deep emotions and that fashionable costume was inferior and unnecessary. He asserted that "costume [for ballet] shall not be cumbersome and shall leave the legs and body quite free to dance." He did recognize, however, a problem for female dancers—their "costumes are the least suitable because they must be long." A problem indeed.

It was not until a century later that the ballerina Marie Camarago, simply known as La Camarago, dared to raise her hemline high enough to be able to perform what thus far had been done only by her male partners. La Camarago is credited as the first woman to execute the *entrechat*, in which dancers crisscross their legs midair. To achieve this movement, and to show it off, she shortened her skirt by several inches and exposed the calf. The turmoil caused by the exposure of legs, even on stage, was only resolved when La Camarago consented to wear *caleçons de précaution*, a kind of tight knickers that may very well have been the precursors to the pinkish tights that Duncan so vocally detested. Other dancers were quick to adopt the new shorter style of dress, which in turn resulted in a police order that a shortened skirt would only be worn with caleçons de precaution.[6] Despite shortening the hemline and attempting daring steps, La Camarago conformed to high fashion. In a painting by Nicholas Lancret, she is depicted wearing a tight pointed bodice and low, squared neckline, and the edges of her sleeves and skirt are adorned with garlands, ribbons, and lace—all features of a fashionable woman's wardrobe of the time.

Marie Salle, La Caramago's rival, was even more progressive. In 1734, she appeared on a London stage in *Pygmalion*, which she herself had choreographed, without a pannier and with her hair loose and unadorned. The pannier, because it extended wide on both sides of the wearer's body, was the perfect foundation to display the rich, opulent silks of the period, and at this time, the fashionable undergarment was at its largest. Although she most likely wore a corset and a

Women posing in knee-length ruffled dance costumes (ca. 1898, copyrighted by the U.S. Printing Co., Cin.). Library of Congress.

La Camargo Dancing by Nicolas Lancret (ca. 1730).
National Gallery of Art, Washington, DC.

chemise, Salle's simple draped, Greek-style costume and the lack of decoration must have been a stark contrast to the attire of the audience. Some thirty years later, Madame de La Tour du Pin, a lady in waiting for Marie Antoinette, described in her published *Memoirs* how social dancing almost disappeared because of fashionable attire:

> There were fewer balls than in later years [1778–1784], for the ladies' fashion of that day made dancing a form of torture: narrow heels, three inches high, which kept the foot in the same position as if standing on tiptoe to reach a book on a highest shelf in the library, a pannier of stiff, heavy whalebone spreading out on either side; hair dressed at least a foot high, sprinkled with a pound of powder and pomade which the slightest movement shook down on the shoulder, and crowned by a bonnet known as a "pouf" on which feathers, flowers and diamonds were piled pell-mell—an erection which quite spoiled the pleasure of dancing.

Meanwhile, at the Paris Opera Ballet, the costumes changed to lighter and shorter, and slippers and sandals replaced high heels so the dancers had a freedom of movement. The Paris Opera Ballet did not skip a beat during the French Revolution. Pierre Gardel was the master of ballet at the Opera from 1787 until 1820, surviving the Terror, Empire, and Restoration. His wife, Marie Miller Gardel, played Psyche in the production of that name in 1788 and wore a dress that had an unboned handkerchief-like bodice with shoulder straps, tied at the high waist by fancy embroidered ribbon. The dress dropped only to her knees, and at the hem appliqued acanthus leaves

and bands of color, like on a Roman fresco, drew attention to her legs.

There was a new attempt to match the drama of the ballets with dramatic, usually classically inspired, costumes. A star dancer named Clothilde Chameroy had different roles in *Telemaque*, which debuted in 1790. She danced as Calypso in a draped blouson and skirt gathered and tied at the center waist, which ended mid-thigh. The border hem decorations were a series of ribbons. Clothide also triumphed as Cupid, a role usually played by a man. This ballet stayed in the repertoire for thirty-six years and played 408 times.

Originally rejected by the Paris Opera for her unusual physique, the ballerina Marie Taglioni transformed how ballet dancers dressed, and her style endures today. For her role in the ballet *La Sylphide* in 1832, Taglioni wore a dress of tight-fitting bodice, short puffy sleeves, bare shoulders and neck, and a soft bell-shaped muslin skirt reaching down to the calf. In contrast to her strong, muscular legs, the shoes on her feet were delicate satin with leather soles, square or rounded toe, and satin ribbons that laced up around the ankle. Other than the fact that her calf was visible, Taglioni's dress and shoes were unremarkable. Bourgeois women walking the streets of Paris could have been seen dressed similarly. So why did Taglioni's costume became the enduring uniform of ballerinas around the world, with slight modifications of decoration and of length of sleeves and hemlines?

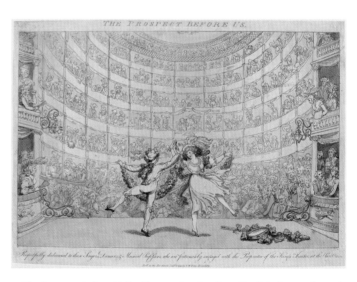

The Prospect Before Us by Thomas Rowlandson (English, late eighteenth century). This caricature of political satire incidentally shows a dancer's costume. The National Gallery of Art.

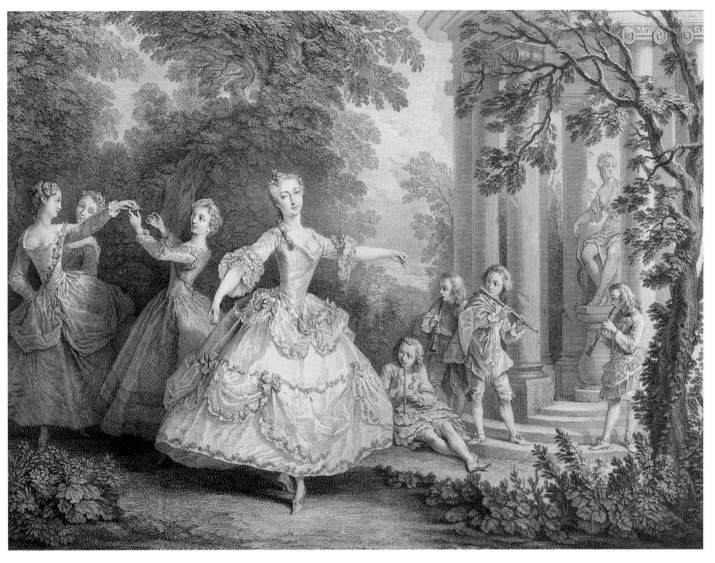

Mlle. Salle (1732) by Nicolas de Larmessin IV after Nicolas Lancret. Widener Collection. National Gallery of Art.

Thais, c. 1740–1790 by Sir Joshua Reynolds. HIP/Art Resource, NY.

Mademoiselle Clothide wears a short Grecian-style skirt falling above the knee to play Calupso in the ballet *Telemachus on the Isle of Calypso* (1790). Bibliotheque Nationale de France.

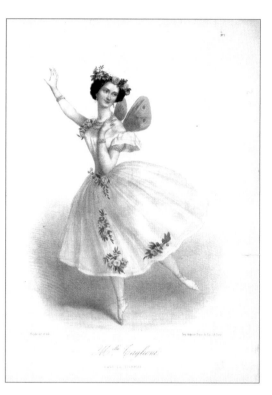

Mlle. Taglioni, dressed as la sylphide (c. 1850) by Alophe. Library of Congress Prints and Photographs Division.

Jennifer Homans, author of *Apollo's Angels: A History of Ballet*, explains that Taglioni fostered a bourgeoisie image of a loving and devoted mother and wife. Coupled with her fashionable, unassuming style of dress, she seemed to bourgeois women to be one of them, or made them dream of becoming her. As Taglioni rose to stardom, her image was disseminated through paintings, prints, and even paper dolls, all depicting her as La Sylphide. Her style of hair, clothes, shoes, and dress was so sought after that for a short period of time she published a fashion magazine, not surprisingly called *La Sylphide*.

What Taglioni wore under her skirt remains a mystery. Because she was a beloved star of the stage and a respectable person, her undergarments were not discussed in contemporary sources. In addition, the artwork of the day emphasized the bareness of the legs, and every wrinkle of the tights was smoothed out. A source from 1844 gives a clue, however, to what other ballet girls in the corps may have been wearing under the soft muslin skirt: "[the dancers'] thighs are chastely concealed beneath large calico knickers, impenetrable as a State secret."[7]

Taglioni was also admired for her pointe work. Her legs were so strong that she could rise to her toes effortlessly, without moving other parts of the body. But unlike ballerinas today, Taglioni did not rise to full pointe, but rather a very high half-pointe, which means she danced almost on the tip of her toes but not quite. Although she had a layer of supportive material sewn at the toe, which enabled this physically straining move, Taglioni's shoes were not blocked like modern pointe slippers. Her body had a heavy muscular quality, but hours upon hours of training made her movements smooth, light, and airy. When she combined her considerable physical presence with a simple, yet fluffy costume, the result fit perfectly into the Romantic aesthetic of the era. She was both Earthly and angelic at the same time.

Taglioni's technical legwork paved the way for other women dancers to emphasize extreme physical strength and arduous training regime. By the end of the nineteenth century, the muslin skirt was nothing but a puff of short cloud-like drape, allowing an undisturbed view of almost acrobatic legs. Nowhere is this more beautifully illustrated

The Dance Lesson by Edgar Degas (ca. 1879). National Gallery of Art, Washington, DC.
Collection of Mr. and Mrs. Paul Mellon. National Gallery of Art, Washington, DC.

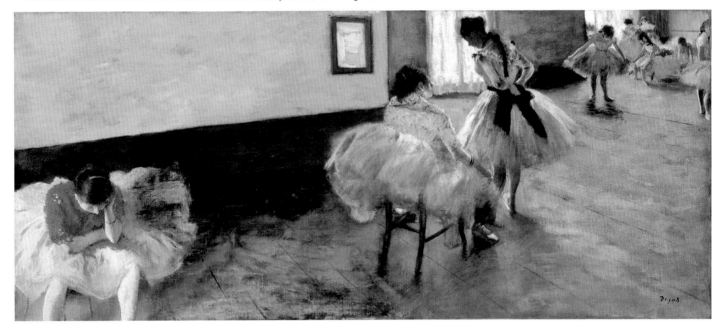

Before the Ballet by Edgar Degas (ca. 1890–92). Widener Collection. National Gallery of Art, Washington, DC.

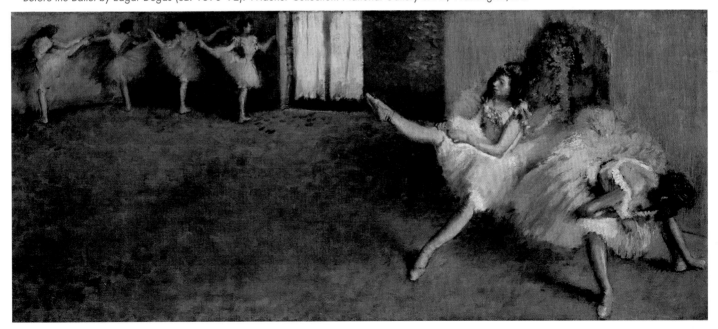

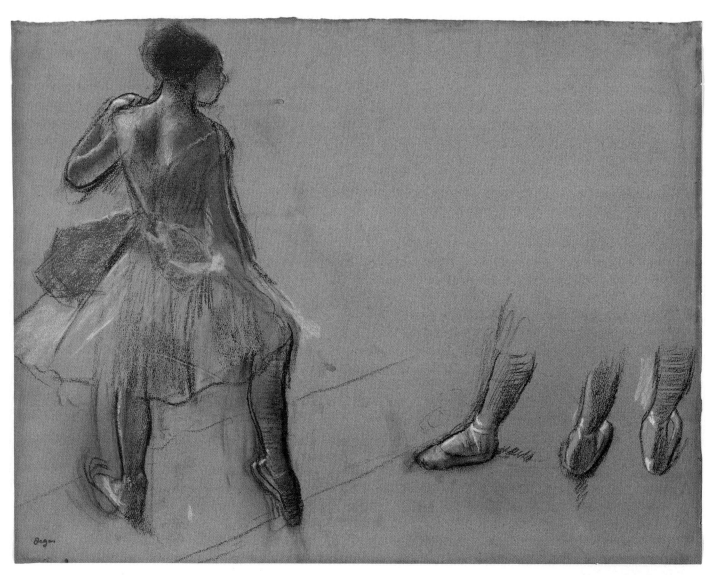

Dancer Seen from Behind and Three Studies of Feet by Edgar Degas (1878). Gift of Myron A. Hofer. National Gallery of Art, Washington, DC.

than in the art of Edgar Degas. He created a massive body of work depicting ballerinas in Parisian studios, mostly during rehearsals. Looking at his paintings, one can almost feel the pain of strenuous exercise. The vivid colors and heavy brush strokes give the dancers an immediate physicality. Unlike the airy Taglioni, these young, middle-class girls express the effort with which their body achieved its strength. Contrasting with the smoothness that characterizes how Taglioni's legs were depicted, Degas emphasized the ripples and wrinkles of the dancers' stockings. His paintings strip ballet of its ethereal glamour while also creating a new, unrefined aesthetic that still defines the "coolness" of dancers today. The behind-the-scenes style of Degas's dance paintings prevails in dance photography, paintings, and drawings today. It was to this emphasizing of the flesh, rather than the soul, to which Duncan so fiercely objected.

Two young women posed informally wearing long underclothing (ca. 1903); photograph by F.W. Guerin. Library of Congress Prints and Photographs Division.

After the encore (ca. 1902). Library of Congress Prints and Photograph Division, Washington, DC.

Anna Pavlova, (1885–1931), in point position on one leg. Date and photographer unknown. Library of Congress Prints and Photographs Division.

Anna Pavlova (1885–1931) as the "Dying Swan." Date and photographer unknown. Library of Congress Prints and Photographs Division.

■Modern Body, Modern Dress

Duncan was without a doubt the mother of "natural dancing" or "aesthetic dancing." By the 1910s, many dance schools had integrated this popular style into the repertoire. Dancers all over the world danced outdoors with only flimsy tunics on their body and with bare feet. A characteristic posture, which became associated with Duncan, is one leg slightly raised up on the toe and the other smoothly bent forward, with the torso arched back, the arms tossed up in the air, and the head slightly thrust backwards. This posture was born from the Greek imagery Duncan studied carefully in her frequent visits to the Louvre.

Loïe Fuller, Duncan's contemporary, also took a new approach to the dancing body, at the time when most dancers wore corsets and tights. To emphasize the natural, flowing movement of her dance, Fuller wore a costume made of yards of delicate silk and rods to extend her sleeves, which flew around her like wings. She also used lighting to accentuate the transparency of her costume.

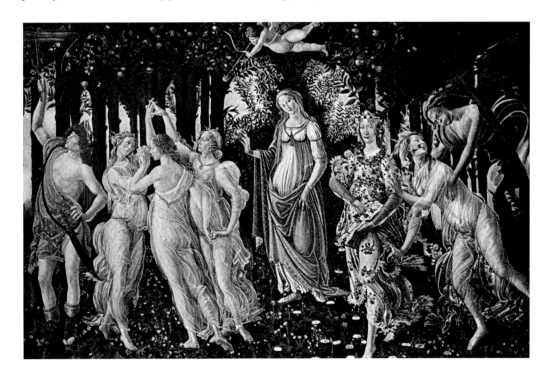

Primavera by Sandro Botticelli (ca. 1478). Uffizi Gallery, Florence, Italy. Newagen Archives/The Image Works.

It is probably not a coincidence that Duncan's and Fuller's rise to prominence among the high echelons of society, as well as among artists, transpired while couturiers like Paul Poiret, Lucile (Lady Duff Gordon), and Madeleine Vionnet advanced and experimented with uncorseted silhouettes. Poiret specifically revolutionized fashion by drawing inspiration from draped shapes like the Greek chiton, the Japanese kimono, and the North African and Middle Eastern caftan. His loose-fitting shapes that hung down from the shoulders gave the body a modern look that made the Edwardian ladies seem a hundred years old. It was not only the shape but also the overall attitude that ushered in the twentieth century. Poiret wrote, "I like a plain gown, cut from a light and supple fabric, which falls from the shoulders to the feet in long, straight folds, like thick liquid, just touching the outline of the figure and throwing shadow and light over the moving form."[8]

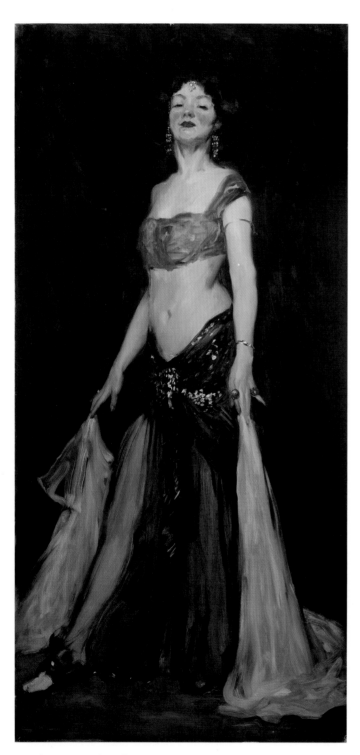

Salome Dancer by Robert Henri (1909). Mead Art Museum, Amherst College, Amherst, MA.

Duncan and Poiret formed a personal friendship; she even agreed to discard her white tunic in favor of his luxurious couture creations. As she wrote in her autobiography:

> And now, for the first time, I visited a fashionable dressmaker, and fell to the fatal lure of stuffs, colours, form—even hats, I, who had always worn a little white tunic, woolen in winter, linen in summer, succumbed to the enticement of ordinary beautiful gowns, and wearing them. Only I had one excuse. The dressmaker was no ordinary one, but a genius—Paul Poiret, who could dress a woman in such a way as also to create a work of art.[9]

Duncan also wore the designs of the Spanish-born designer and artist Mariano Fortuny. His pleated silk gowns took direct inspiration from ancient Greek costume. His famous Delphos gown, for example, was meant to drape about the body like the chiton of marble statues. The Delphos was designed as a tea gown, a luxurious garment for the home. Duncan, however, was among Fortuny's progressive customers who actually wore the dress, without undergarments out and about. It is not surprising that other dancers, too, like Duncan's contemporary, Ruth St. Denis, were among the first to buy Fortuny's designs. Using the full width of the fabric, Fortuny created pleated silk dresses that hugged the body, yet afforded freedom of movement unlike any other fashionable style at the time. While Poiret was called the king of fashion, Fortuny remained outside of fashion. He continued to experiment with loose-fitting shapes throughout his long career of forty-four years, never really obeying the force of changing fashions.

By the first decade of the twentieth century, social and cultural changes brought some loosening of past conventions. Sports, for example, became an acceptable pastime that allowed women to experience the wearing of pants for bicycling and horse riding. On the fashion scene, the lingerie dress, daintily detailed with lace, ribbons, and embroidery, modeled after the eighteenth-century chemise gown, dominated the decade. The chic woman wore it in summer months for afternoon garden parties, promenading, and the seaside. Although the name suggests an underwear kind of dress, it was always worn with a slip, corset, chemise, or combination underwear and stockings. It was a far cry from Duncan's simple linen tunic.

The lingerie dresses underline just how radical Duncan's performance was. By 1900, some women in America and England had already experimented with dress reform for two decades, asserting that corseting and tight-fitting clothes were not healthful. However, these

ideas had no notable penetration to mainstream fashion. Despite sports becoming more acceptable for women, the height of fashion was a corset that forced the body to curve unnaturally, like the letter S. Duncan's appearance without undergarments or corset and bare-legged was a shocking departure from fashion.

Duncan's influence reached far. It is especially evident in the works of the legendary dance company Ballets Russes. The choreographer Mikhail Fokine, who saw Duncan perform in Russia, built on her approach in his ballets. Although Fokine denied her influence, he implemented Duncan's ideas both in dance style and in costume. In *Eunice*, one of his famous ballets for St. Petersburg's Imperial Theatre, he implemented Duncan's freedom of movement and essentially adapted her solo act into an ensemble performance. In his costume designs, Fokine dressed the dancers in traditional tutu and tight bodice for Romantic ballets, heeled shoes and Spanish costume for Spanish ballets, and Greek tunics for Greek ballets. Yet the showing of legs was still taboo in 1907 when *Eunice* was performed, and Fokine was forced to clad the dancers in tights, onto which he painted to suggest toes and nails.[10]

From its 1909 inception, the Ballets Russes, founded by Serge Diaghilev, engaged prominent artists, composers, and fashion designers to create visually striking acts never before seen. During its twenty-year run, Diaghilev commissioned set designs from artists like Pablo Picasso and Robert Delaunay, and costume designs by active couturiers like Jeanne Paquin, Paul Poiret, Coco Chanel, and Sonia Delaunay. However, the company's most innovative designer came from theater, not couture, when Leon Bakst designed the costumes and sets for several performances. His illustrations, used for promoting the shows, set the tone for a sensual, erotic atmosphere. Bakst introduced non-Western costumes and vivid, strong colors, and showed an unprecedented interest in exposing the body under the costume. He used light, the transparency of fabric, low necklines, exposed abdomen, and the cut of the garment to emphasize physique. Instead of using the costume as a means to conceal the body, Bakst used it to accentuate movement. Even if the costumes suggested nakedness, the dancers in fact wore full body suits underneath. These allover stockings simulated naked legs and the natural body but allowed the dancers to keep their modesty intact.

Florence Walton (b. 1890/1891), photograph by George Grantham Bain. Library of Congress Prints and Photograph Division.

◾Let's Dance

In 1910, *Vogue*, the stronghold of mainstream fashion, ran several pieces about Greek-inspired dancing and dance clothes style. However, when Duncan and her pupils arrived in New York with the onset of World War I, they discovered that bare feet and white tunics no longer fascinated the fashion-forward crowd or the avant-garde:

> At the moment all New York had the "jazz" dance craze. Women and men of the best society, old and young, spent their time in the huge salons of such hotels as the Baltimore, dancing the fox-trot to the barbarous yaps and cries of the negro orchestra In fact the whole atmosphere is 1915 disgusted me, and I determined to return with my school to Europe.[11]

Lyonnelle (1917) by George Barbier. Akg-images/The Image Works.

Although Duncan's movement was free and flowing, she connected it with the Western Classical tradition and prized practice and control to achieve what she considered "natural" and civilized dance. In contrast, she regarded African-American dance to be "primitive" and wild. There is no question that by the mid-1910s social dancing, and specifically styles that were born in Harlem's clubs, swept the country off its feet. No one could resist the rhythm of ragtime.

The history of social dancing in America is intertwined with that of black dance. From the early days of the twentieth century through the Jazz Age, the twist, disco, breakdance of the 1980s, Michael Jackson and the MTV generation, and up to recent days' hip-hop, African-Americans led and innovated dance culture. There has been reciprocity and also, essentially, the adoption and reappropriation of dance styles by whites. By the 1910s, white society was dancing to African-American orchestras. Dance shows carried outstanding African-American casts across the US, while white dancing duos gained acceptance for black dance and music.

Vernon and Irene Castle, the most famous white dance duo in the 1910s, emphasized smooth partner dancing and an aura of refined elegance. Those who could not afford to see their act or visit their Castles in the Air café and dance school in Manhattan could read all about them in the newspapers. Irene became a style icon and fashion leader; moreover, her new approach to dance dressing paved the way to a far more famous era—the roaring 1920s. In *The Glass of Fashion*, Cecil Beaton writes:

> When Mrs. Vernon Castle suddenly appeared she was greeted with the shock of recognition that people always reserve for those who—as Wordsworth once said—create the taste by which they are to be appreciated. . . . It is no coincidence that Stravinsky's early music and Picasso's cubist period coincided with the success of a woman who was to be one of the most remarkable fashion figures the world has known. Mrs. Castle was as important an embodiment of the 'modern.'

Irene Castle had a fashionably slim and narrow figure. In a time when women were adorned to excess, Irene's simple, clean look and the absence of jewelry and feathered hats made her stand out. Irene favored less restricting undergarments and loose-fitting dresses that swayed and swung around her legs when she danced. While Poiret may have released women from the corset, in the early teens he bound their legs in a tight fitting hobble skirt. Women wearing the long and narrow hobble skirt were confined to small and measured steps enforced further by a train

swirling around the feet. Irene, in contrast, advocated the "plaited skirt," especially for dances such as the maxixe, one step, and hesitation waltz, which required longer glides and more complicated steps. The pleats opened up with every movement of the legs, but also accentuated a graceful and romantic appearance:

> The plaited skirt of soft silk or chiffon, or even of cloth, is by far the most graceful to dance in, and one which lends itself best to the fancy steps of these modern days. Therefore, while fashion decrees the narrow skirt, the really enthusiastic dancer will adopt the plaited one.[12]

Soon, not only enthusiastic dancers, but also fashionable women, favored tiered and tunic-dresses with fuller skirts achieved by folds and excess of fabric.

The actress Elsie Janis recalled how early in her career, Irene ungracefully struggled with the hobble skirt on stage, and "suddenly pulled up her skirts like a naughty little girl, showing her 'complete understanding.' . . . Mother's gasp of dismay must have been heard in Trenton!"[13] Later on as Irene refined her sophisticated fashion sense, bearing of the legs was not an option. Even the provocative, and controversial, tango dip was not an excuse for such exposure:

Dance partners. Cover of *Firlefanz* [*Nonsense*] (1920). Akg-images/The Image Works.

> A dip is hardly more than bending the knee. It does not mean an exposure of silk stockings, or should not, if the dancing costume is properly cut; and it should not be done in a romping spirit.[14]

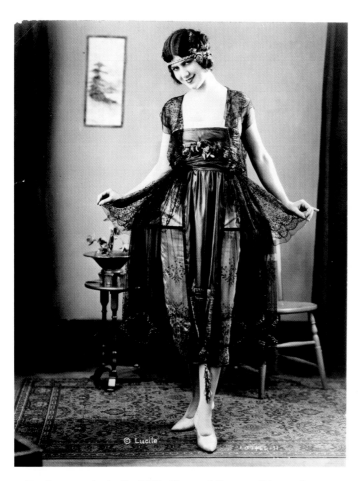

Evening gown by Lucile, 1921. Library of Congress Prints and Photograph Division.

In addition, Beaton continues, Irene developed a liking for an outfit composed of pleated petticoat worn over silk bloomers and paired with tango-heeled shoes that laced up around her ankle. Her favorite designer was Lucile, who designed one such outfit for her, and also designed dresses for Irene's stage rival, Florence Walton. This dress had a high waistline, a calf-length sheer skirt gathered into the waist seam, and horizontal bands of silk and garlands that emphasized the hips. Peeking from under the skirt was a pair of silk bloomers similar to the harem pants in Bakst's Ballets Russes productions but wholly modern, communicating a fresh, youthful, and comfortable attitude.

The Castles performed in cafés and cabarets, first in Paris and then in New York City, where the fashionable society came to eat, watch them dance, and then hop on the dance floor to learn the steps themselves. The Castles owed much of their success to the lively ragtime scene of Harlem's clubs. The man who gave them the youthful, charming beat to which they danced was James Reese Europe, an African-American man from Alabama. Europe

introduced them to nightclubs that were closed to white visitors unless accompanied by a black member of the community. It was this up and close interaction with the African-American community in Harlem, its upbeat music, and the intense craze for dancing that kept the Castles' performance fresh.

Pre-World War I America was in such a dance craze that people of all classes could not even wait until the evening to dance. Instead, they flocked the city's hotels for *thé dansant,* or Afternoon Tea Dance. *Harper's Weekly* published an article titled "Where Is Your Daughter This Afternoon?" suggesting that she might be foxtrotting with strangers.[15] Irving Berlin's lyrics to "That International Rag," a song composed in 1913 overnight, capture the sensation:

What did you do, America?
They're after you, America
You got excited and you started something
Nations jumping all around
You've got a lot to answer for
They lay the blame right at your door
The world is ragtime crazy from shore to shore
London dropped its dignity
So has France and Germany
All hands are dancing to a raggedy melody
Full of originality
The folks who live in sunny Spain
Dance to a strain
That they call the Spanish Tango
Dukes and Lords and Russian Czars
Men who own their motor cars
Throw up their shoulders to that raggedy melody
Full of originality
Italian opera singers have learned to snap their fingers
The world goes 'round to the sound of the International Rag!

Although people called almost every danceable, uplifting tune ragtime, it was largely associated with African-American culture. The dancing scene it fostered was a catalyst for social change. Its vivacious atmosphere appealed to people of all classes, and it provided a less formal arena for young men and women to mingle. Most importantly, in a time of grievous segregation and racism, social dancing not only adapted the movement and music of African-American communities but also made the sight of whites and blacks on the same stage acceptable.

Brenda Dixon Gottchild, author of several books on black dance, explains that "from the Africanist standpoint, movement may emanate from any part of the body, and two or more centers may operate simultaneously."[16] Essentially,

in dances that originated from Africa, the legs sometimes dance to one beat and the torso to another. This kind of free-form movement is a contrast to the stately movement of ballet, in which every glide and move is measured and practiced relentlessly. Naturally the body posture is also very different; while European dancers tend to have an erect torso and a tucked-in pelvis, perhaps as a result of centuries of corset wearing, African dances are often performed with bent knees and loose pelvis and hips, two centers from which the movement starts before it spreads outward to the rest of the body.

In addition, in their original form, African dance styles were often danced with bare feet on the earth and were more likely than European dances to incorporate pulling and shuffling leg motions. It is not surprising then, that in white dance routines that built on African origins, the legs required more freedom of movement, which in turn inspired designers to create clothing that afforded movement and drew attention to the dancing legs. Asymmetrical drapes, tiered skirts, tassels, and trains enhanced the graceful movement of the dancer with every dip and

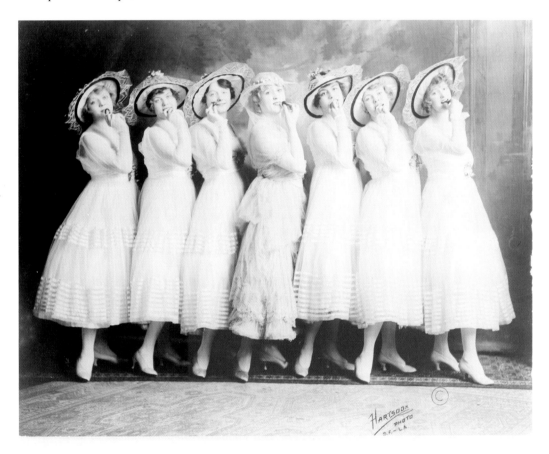

Seven "Canary Cottage" young women of the burlesque theater (1916). Hartsook photo, S.F.-L.A. C.

glide and therefore came into vogue. The African-American dance is certainly where to look as a source for the mainstream dramatic changes in fashion as the 1910s drew to a close and the waistline dropped while the hemline began to rise. Thanks to repercussions of the dance, legs were about to get center stage.

Tangomania

"Tango-mad is the only phrase which adequately describes the fashionable craze of the moment," said *The New York Times* on October 2, 1913. There is no question that 1913 was the year of the tango. New York, Paris, London, Berlin, and Rome were under its spell. In a time when young people started dancing at 11 in the morning, dance fads came and went, but the sensual tango may have been the one with the longest life span and the deepest influence on fashion.

The tango originated from brothels in the slums and outer-boroughs of Buenos Aires, Argentina. In some parts of the Spanish-American empire, the word tango meant a place where African slaves or free blacks gathered to dance, and in Argentina, specifically, it often referred to black dances. During the mid- and late nineteenth century, young blacks started to adopt European dances like the polka and waltz, while whites started to incorporate black steps into their dance routines. It was from this cultural mishmash that the tango was born in the 1880s.

The dance made its way through upscale bordellos closer to the city's affluent center and to street fairs, musical shows, and comedies. By the last years of the nineteenth century, the tango was no longer the dance of the poor and unfortunate but it was still frowned on by the upper class. Its big break occurred in 1910, a few years after Argentine musicians imported it to Paris. The city was already under the spell of the Ballets Russes. This was the opportune moment for the sensual dance that brought men and women who were strangers closer than ever before. The dance of the poor became the dance of the chic.

From Paris, the tango spread to other European capitals and by the fall of 1913, reached the shores of New York. The Argentine dance resonated with contemporary tastes and was considered elegant and refined for its long glides and sinuous movement. Compared to the turkey trot, the grizzly bear, and the bunny hug, the slower tempo and graceful steps of the tango appealed to even the most dignified socialites.

Tango was often danced during afternoon thé dansants when, between sips of tea, couples joined professional dancers to learn the moves. Never before were unmarried young men and women engaged in such close physical contact as when dancing the tango, pelvises forward, hips swaying, and feet interlaced, gliding together on the dance floor. Naturally, the tango, along other social dance styles, raised moral concerns. In 1913, *The New York Times* warned

parents of the Tango Pirates, young men of questionable morals who lurked at tea parties for society's young and innocent. In addition to persuading the young socialites to dispatch their fortune, the Tango Pirates also introduced them to cocaine and heroin.[26]

The provocative, sensual movement of the tango was both happily embraced and sometimes greeted with unease. In October 1913, for example, a department store in Berlin introduced tango classes for $3.75 for a half hour. Wishing to stay anonymous, a well-known society woman explained to a reporter of *The New York Times*: "What we are all cracking our heads over is whether the tango will succeed in breaking the sacred precincts of the Kaiser's Court ballroom, where hitherto only dances of the most approved, primmest, and most proper types have been permitted Scandalous gyrations like the one-step have been rigidly barred."[27]

To dance the tango, women had to abandon the hobble skirt and acquire a special wardrobe. Tango dresses often had a slit, or were shorter at the front and with a train. In the 1913 book *The Tango and How to Dance It*, the author explains that tango ball frocks "are almost all cut to clear the ground by about two inches, so that a dancer's shoes may show. The tango can, however, be performed by a dancer wearing a frock with short, pointed train, though the point is generally . . . caught up for dancing."[28]

The afternoon tea parties became a place to display the newest fashion, and gradually clothes migrated from the dance floor to everyday wear. In 1913 the French couturier Madame Jeanne Paquin organized "dress parades" in which dresses designed specifically for dancing the tango were introduced. Paul Poiret offered *jupes culottes*, or trouser skirts, under knee-length tunics; these gave the hips and the legs all the freedom they needed for the dips and long strides of the tango. The outfit, combined with the interlacing of the partner's legs, stirred quite a sensation. The tango itself helped to free women's legs from the constrictions of long and narrow hemlines. Interestingly, tango is danced so close together that the woman's legs are not scrutinized by the gaze of the male partner. Rather, it was the synchronized movement of the legs, the hips, and the pelvis that made the tango so shocking.

Lucile was another designer who showcased her designs in theaters and dance parties. Because she dressed famous dancers like Irene Castle and Florence Walton, in addition to designing costumes for the Ziegfeld Follies, Lucile became

synonymous with modern dress for the dancing young woman. "Lucille has been showing an afternoon costume with a skirt that trails on the floor two inches all around," reported *Vogue* in January 1914. "It is slashed both in the middle-front and middle-back, and gives the odd effect of having a short train on either side."[29] Lucile's dresses often had high waistlines and asymmetrical hemlines with trains, slits, tiers, and tassels in order to emphasize the graceful movement of the legs.

The artist turned designer Sonia Delaunay also took inspiration from the energy and movement of dances like the tango and foxtrot. Together with her husband Robert, she experimented with juxtaposing bold colors and geometric shapes. They named these experiments of color and movement "simultaneous." These dresses were a kind of wearable art, which through its association with dance communicated the vigor of modernity.

Stores offered an array of accessories targeted for dancing, or related to it. Tango corsets, tango perfume, a tango color (a deep reddish-orange tone), and of course tango shoes. Although tango shoes were introduced in the late nineteenth century, it was only in the 1910s when skirts became shorter that the dancer's shoes were exposed and became fashionable outside of the dance floor. Tango shoes often had a small sturdy "Louis" heel and a satin ribbon that crisscrossed around the ankle—a detail that further drew attention to the movement of the legs.

Tango dancing had much greater influence on fashion than merely introducing slits and slashes. Because dresses were cut shorter and were made to reveal more than before, underwear had to be adjusted. The skirt-knickers, for example, were constructed from a width of fabric that was draped between the legs, with slits at the sides, allowing complete mobility and ensuring underwear was not visible when legs glided open. Vogue patterns from 1914 include instructions for the home sewing of appropriate underwear like "a dance petticoat slashed and laced on the side to accommodate the deepest tango dip." This illustrates that even women of moderate means were looking to participate in the sultry South American dance and in the fashion that resulted. The tango, like other fashionable dances of its day, blurred the boundaries of class. Women and men from almost all social standings started to dance to the same tune and to strive for the same fashionable look. ■

▪ The Decade of the Legs

By the 1920s, Paul Poiret's ideas of drape and freedom reached full prominence. Dresses hung straight from the shoulder and were worn without corsetry. The right look was slim, streamlined, long, and youthful. The post-war years brought prosperity to some and a desire to escape reality to many. The Roaring Twenties had arrived and for the first time in Western fashion history women proudly bared their legs. Unquestionably, dancing and the new ideas of comfort and youthfulness it brought forth in the 1910s were the catalyst for the shorter hemlines of the Jazz Age.

Despite a simple silhouette, fashions of the 1920s emphasized movement. Designers employed every possible surface treatment to call attention to the dancing body— silk fringe, scalloped and jagged hemlines, fabric covered with glass and wooden beads, feathers, and even long necklaces and scarves, all moved along with the wearer's body. It was also the first time evening dresses exposed legs, which, coupled with naked arms, was the most skin fashion had seen in its history.

The 1920s were dubbed the Jazz Age because during this decade black culture had a tremendous influence on music, fashion, dance and aesthetic. The allure of Harlem's jazz clubs was felt internationally. Nowhere were black performers and musicians more successful than in France— so much so, that during this decade white musicians found it hard to find a job in Paris. During World War I, African-American GIs found that Parisians were "colorblind"— theaters, restaurants, and hotels were open to all. Quite opposite to the United States, where racism was hindering basic, normal life, Parisians not only allowed black people to walk the streets freely but were also fascinated by their skin color and their culture.

In the aftermath of the war, many African-American artists, writers, and musicians abandoned their segregated communities in favor of the French capital. At that time the French were already accustomed to non-Western aesthetics, promoted by taste arbiters like Paul Poiret and the Ballets Russes. In addition, modern artists like Paul

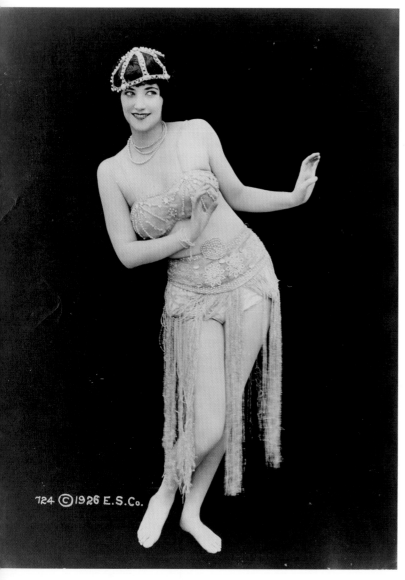

724 ©1926 E.S.Co.

Studio portrait of young woman dancing barefoot (ca 1926). Library of Congress Prints and Photographs Division.

Voguing

When Madonna released her 1990 hit song, "Vogue," with its lyrics about escaping life's pain on the dance floor, the word "vogue" to most people was only associated with a style-setting fashion magazine. But in Manhattan of the late 1980s, young African-American and Latino gay men and transgenders turned this noun into a verb: voguing became the vogue. By the time Madonna picked up on it, it was already a lively scene where society's unwanted kids could feel at home; in her own words, it was "a place where you can get away."

New York of the 1970s and 1980s was a harsh place to live in, especially if you were from Harlem or the Bronx, especially if you were African-American, and ten times more if you were all of that and homosexual. New York's black communities were struggling with poverty, drugs, and violence. Starting from the mid-1970s, African-American gay men, transvestites, and transgenders grouped to form alternatives to the gangs that ruled their neighborhoods. These groups, which they called "houses," got together for balls, usually starting at four or five in the morning, in which the houses competed with each other in categories such as "walks," where they imitated haute couture runway walks, and "realness," in which participants had to be so convincing that they could pass as heterosexual gang members. Each house had a mother or a father who was responsible for guiding their kids through the hardships of their existence. For many, the houses replaced the families that rejected them for their sexual transgression.

The houses sported names like LaBeija, Pendavis, Xtravaganza, Saint Laurent, Mugler, Chanel, Afrika, and Ninja, and the number of categories grew to include best face, best body, best dressed, executive realness, butch queen, and many more. Yet the category that put the scene on the mainstream map was voguing. In this category, participants mimicked the poses of supermodels as seen on the pages of *Vogue* magazine and the Parisian runways. In a sort of reversed transgression, the voguers seeking to pass as supermodels defied social conventions and created an alternative universe in which their sexual identity and the color of their skin became a virtue.

By the late 1980s, the balls were such a blooming scene in Lower Manhattan and Harlem that they drew not only a growing number of people who were seeking to explore their sexual identity but also underground fashion designers who wanted a piece of the action and eventually also mainstream performers like Madonna who were searching for new dance moves.

The fashion designer Patricia Fields, who would become the stylist for the hit television show *Sex and the City* in the 1990s, also had a house. Andre Leon Talley, the famous impresario of fashion, recalled:

> I know Field since way back in the '80s, when voguing was the rage. Those downtown and outer-borough houses …were frequented by young men, women, and drag chanteuses who dreamed of the Paris runway. The houses would throw marathon competitions in which contestants would pose and prance for the audience as if they were on the set of a fashion shoot with Francesco Scavulo. In this fashion subculture, Field was treated like a deity.24

The balls scene fostered other personalities who penetrated the mainstream, like the African-American drag queen RuPaul and Willi Ninja, who later performed with Madonna on the runway of French designer Thierry Mugler and even established a school for runway walking.

The voguing dance style started as a kind of battle form. Participants would "harsh a vogue" (as in throwing an insult) at each other, and the one who realized the pose best won. Clothing was also a crucial component, and while some people made their own, increasingly the demand was for actual high-end brands. Most ball-goers had very low incomes, if any, but the demand to meet "real" supermodel standards led them to theft. The effort made in costuming oneself, and the risk involved, may explain why balls where usually held just once a month.

The voguing style originally imitated exaggerated feminine poses, but gradually evolved to include fast breakdance-like movement, sometimes imitating moves from ninja B movies. Each category of competition naturally demanded different attire, and while butch queen may have appeared in sneakers and jeans, femme queen always sported evening gowns and very high heels.

In 1990 Jennie Livingston's award-winning documentary *Paris is Burning* introduced some of the main dance party players to a wider audience. That same year, at the MTV music awards, Madonna staged a full-fledged costume party as a backdrop to her hit song. Dressed à la Marie Antoinette, Madonna vogued alongside male dancers of all races in short shorts. Her lyrics crystallized the voguing scene:

> It makes no difference if you're black or white
> If you're a boy or a girl
> If the music's pumping it will give you new life
> You're a superstar, yes, that's what you are, you know it

It was the community's fifteen minutes of fame. What was once merely a haven for rejected kids at the fringe of society was now broadcast to millions on national television. As is often the case, mainstream fashion swallowed and quickly chewed up the subculture it had embraced just a minute before. Although the scene continues, if on a smaller scale, many of the original voguers were lost to drug abuse, prostitution, and the AIDS epidemic.

Linda Evangelista's remark to a *Vogue* reporter in 1990 that she and other supermodels didn't "wake up for less than $10,000 a day,"25 underscores more than anything else one attitude of the arts during the Ronald Reagan era. Fashion was all about supermodels, glamour, and excess The voguers succeeded in creating an alternative culture to high fashion by reclaiming the movement, the body, and the freedom to be themselves. When the very people they admired imitated them, it made a full circle. ■

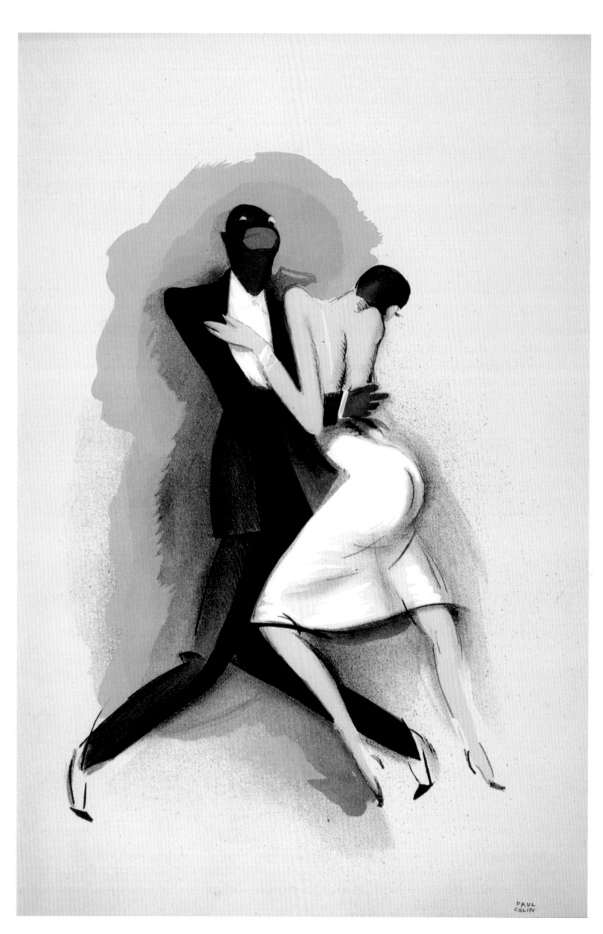

Couple dancing the Charleston, lithograph from *"le Tumulte Noir."* Kharbine-Tapabor/The Art Archive at Art Resource, NY.

Gauguin and Pablo Picasso, who drew inspiration from so-called "primitive" sources, were already established and accepted for their genius. Although the French were not innocent of colonial patronizing, they offered African-Americans freedom of expression. Entertainment establishments in the capitals of Europe caught the trend quickly and started featuring performances of all-black casts.

One American woman who embodied everything about jazz culture that enthralled the French was the legendary Josephine Baker. Baker combined an outrageous, electric personality on stage, and a chic, glamorous appearance off stage. Her risqué costumes underscored what was already on everyone's mind during this decade—legs, legs, and more legs. The notorious banana girdle, for example, gave the behind a sort of a bustled Victorian shape, only its full effect was revealed when Baker started dancing. The bananas swayed freely around her hips with every move of her wild steps. Off the stage, photographs often captured her in bias cut, floor-length dresses that hugged the hips and accentuated the silhouette of her legs.

Although Baker performed on black vaudeville stages from age fourteen, it was in 1924, in the musical comedy *Shuffle Along*, that her true theatrical talent flourished. This extremely successful all-black vaudeville show built on traditional and contemporary dance routines and introduced the Charleston and the Black Bottom to white audiences. Even when Baker was a substitute chorus girl, her sensational improvised steps were untamable. She was soon promoted to the lead, becoming the highest paid performer in the cast.

Despite her success, in the United States career options for African-Americans were limited and she jumped at the opportunity to appear in a popular production in Paris, *La Revue Nègre*. The review was an instant hit. Her charisma, unique appearance, comic talent, and sensual aura swept the Parisians off their feet. At the same time, Baker tapped into a white colonial stereotype of Africa. She entered the stage like a jungle creature—her body shaking with jerky movements, her throat making strange, animal-like sounds, eyes crossed, cheeks puffed, legs spread apart, knees bent, and behind plunged out.[17] This wild, untamed representation of "another" culture mesmerized the white audiences who enjoyed the indulgent, sexual atmosphere of the 1920s, both in Europe and the US. By playing a role of a highly sexualized, less cultured woman, Baker afforded her white audience the opportunity to feel superior but at the same time to experience a

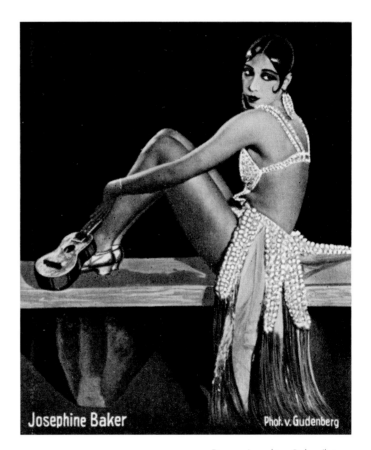

Josephine Baker Phot. v. Gudenberg

Dancer Josephine Baker (late 1920s) by unknown photographer . Library of Congress Prints and Photographs Division.

thrilling encounter forbidden in their everyday life. Baker's comic talent, her long, lean black body, and above all her totally uninhibited movement were so strong, that her custom of appearing cross-eyed on stage never registered as unattractive. Baker, through her unique style, epitomized "cool." As Dixon Gottschild suggests, she used a long African dancing tradition, in which, while the body is vigorously at work, the face offers comic relief with smiles, or in Baker's case, eyes crossed.[18]

It seems that to some degree Baker's onstage attire was overshadowed by her skin color and her—to European eyes—new dancing style. When Baker advanced to a solo act at the famous Folies-Bergère's *La Folie du Jour*, observers described her as appearing nude except for feathers of pink flamingo between her legs. In fact, she was not naked, but rather wearing a sort of early-day satin bikini and the feathers covered larger parts of her body.[19] Her nakedness was in the eyes of the beholder. It was more likely the color of her dark, black skin and her shocking movement that made the French perceive her as more naked than she really was.

By 1926, the twenty-year-old Baker was highly successful and extremely rich. She was also loved and admired by fashion designers and Paris's elite. Like Irene Castle a decade earlier, her body type fit into contemporary taste: she was tall and lean, with beautiful smooth legs, and she oiled her short hair to hug her skull. Hailed as the "Jazz Cleopatra," Baker had full control of her image, which she continued to perfect, becoming eventually the chic fashion leader she was:

> From the flies overhead, an egg-shaped mass of flowers descended, opening its petals as it approached the stage and revealing therein Josephine, in a silk fringe skirt, prostrate on a mirror. Bursting forth from the egg-flower into a version of the Charleston unknown to the stage, a flurry of gleaming flesh and fringe, multiplied by the mirror's reflections and the shadows speeding about the theater, Baker seemed to be a goddess of vitality, Eros in blackface.[20]

The Legs That Flapped

In the United States, music and dance that originated from African culture were also flourishing. To the white American public it was easier to accept black culture through association with Eastern notions, which were already fashionable and acceptable as an alternative to Western aesthetic. It was easier to categorize black culture as "exotic" than to accept it for what it is.

On the dance floor, white Americans could cheerfully adopt black culture. The Charleston became a national craze. In 1926, *Vogue* recognized that even the wealthy residences of Fifth Avenue could not afford to be left out:

> A strange rhythm in dancing brought from Harlem by Broadway has set all New York steeping to a new tune. Fifth Avenue came back from Newport and South Hampton to find a gay procession with Broadway in the bandwagon prancing through the city, and Fifth Avenue is following breathlessly in the dust at the tail end of the parade. The origin of the Charleston is shrouded in darkest mystery; perhaps someone above One Hundred and Twenty Fifth Street knows who started it.[21]

The Charleston is actually very similar to a dance called the King Sailor in Trinidad and the Obolo dance of the West African tribe Ibo. Fifth Avenue royalty probably did not realize they were following the steps of African tribes.

Not everyone approved. Irene Castle, for example, perhaps frustrated that her own stardom had started to fade, called the Shimmy a "nigger dance," and complained, "Jazz, jazz, jazz! Survival of the days of barbarism, paganism. The parading of savages."[22] The fast, jerky movement of the Charleston, the Black Bottom, and the Shimmy crystallized the free spirit of the 1920s' heroine, the flapper. These dances favored improvisation, allowing self-expression and individual interpretation regardless of formal training. The free-style of the Jazz Age encouraged the young to break with tradition. Dance schools continued to exist, but the new generation did not seek instructions for the free-spirited life they wanted to lead.

The charming, happy-go-lucky Irene was replaced with a new, brash flapper who was seeking to defy accepted social norms with her lifestyle. She was drinking at a time of Prohibition, smoking, driving fast, carelessly getting involved with whomever she desired, dancing to the rhythm of the jazz, and of course, showing off her legs. Much of the flapper's modern identity and her rebellion against the old was conveyed through emphasizing the legs. Some flappers wore unfastened rubber galoshes that flapped when they walked. They were notorious for rolling their stockings

below the knees, and were rumored to rouge their knees. Irene Castle, who was careful not to expose her leg in the tango dip just a decade earlier, commented that, "the rolled-down hosiery fad is abominable."[23]

Mainstream fashion of course, was quick to adapt, offering luxurious silk stockings to cover exposed legs gracefully, fringed skirts to emphasize the movement of the legs, and an array of accessories to go along with a fashionable outfit. "The Charleston Leather Garter," for example, was designed to withstand strenuous activities such as dancing the Charleston. The packaging asserted that this is a "garter with a kick," acknowledging just how fundamental dancing was to the lifestyle of young American women.

The first two decades of the twentieth century shaped our current perception of what is modern. The art of the dance allowed women to experience a freedom, both physically and socially, which was not available to them previously. Couturiers like Coco Chanel and Jean Patou created a wardrobe that made the rich look

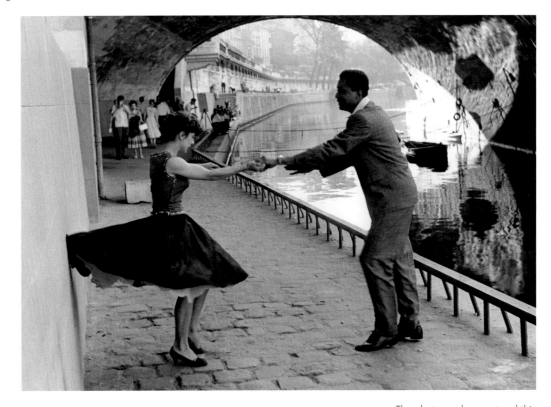

The photographer captured this iconic shot in the late 1950s by the Seine. Sailing into a twirl was the reason to wear the circular skirt. By permission of akg-images/Paul Almasy/2013 Artists Rights Society (ARS), NY/ADAGP, Paris

young and casual, and the elaborate, prewar style look dated. The casual, youthful look was in accordance with social currents that started putting the young, fast, and exuberant at the center. In four decades, the counterculture youth of the 1960s would use very similar ideas for their own rebellion against the old and established. Reaching full bloom in the 1960s, civil rights and antiwar movements, the birth control pill, and a kaleidoscope of cultural fads and dress fashions including the twist and nonpartner dancing, braless attire and the minidress were all ideas that were planted in the dance floors of Manhattan in the 1910s and 1920s.

Prima Tango by Nazim Artist. Courtesy of Celeste Yarnall.

Tango Shoes *by Celeste Yarnall*

I love Argentine tango—the music, the dance itself, and its sensuality. And it is all about the legs, and the heart. The dancers seem connected by invisible threads that bind them for the length of one song. Tango helped me find and connect to the person to whom I am now married and living happily ever after with.

I thought my days of romance and certainly going out dancing were over, and then a friend took me to a dance class soirée of Argentine tango performances. At first I watched happily from the sidelines; I had bought a little pair of black, strappy low heels just for that night but they were not dance shoes. Then the teacher asked me to dance. I turned and looked behind me but that hand, extending the cabaseo (an invitation to dance), was meant for me.

At the end of the dance, the instructor said in his heavily accented English, "You.can dance tango!" What, who me? Well, why not, I am open to the possibilities life offers me.

The instructor had a class coming up for beginners and so I invested in my first pair of black suede T-strap two-inch tango shoes right there at the class. They felt wonderful; one could slide on that polished springy, floor as if gliding on clouds.

I continued with lessons and bought every imaginable tango shoe I could get my hands on. I bought knee-high black leather tango boots, practice flats, low heels, high heels, open-toe, pumps, sling-backs, all different colors and materials; and then came the stockings and leggings, always black, well almost always, with jewels and swirls, little bows or patterns of lace, some with feet some without . . . and the flirty skirts with the handkerchief hems that point right to the legs and the feet.

Soon my life changed in an amazingly romantic way, when a tango girlfriend and associate teacher connected me with the love of my life—just a chance introduction. I live in LA, and Nazim lived in London, but that wouldn't stop us. I flew to London for our first dance. Nazim painted tango, loved the music of Astor Piazzola, and was the dreamiest, most sublime person I had ever met. I became his muse, wearing those tango shoes and black stockings, which were often bejeweled, with skirts of all lengths, some with slits up the sides and fish-tailed in the back, anything that draws attention to the legs in Argentine tango. He painted me and continues to do so, always giving me great legs, in great shoes that often have me soaring through the air, dressed or undressed in something divine that comes either from my closet or his imagination.

Celeste Yarnall is an actress, pet natural healthcare author, and co-producer of the documentary Femme.

CHAPTER 9

Baring Our Legs

More than any other piece of clothing, the bathing suit bares legs. At least in recent fashion history, on beaches and resort towns, no other part of the body is as exposed as legs. In the twentieth and twenty-first centuries, the fashion and standard for beautiful legs is set by powerful, baring-all bathing beauties: the memorable Ursula Andress emerging from the water in a white bikini in the film *Dr. No*, Farrah Fawcett in a Norma Kamali cinnamon red suit from 1976, Bo Derek in a gold one-piece suit running on the beach in the film Ten, Pamela Anderson in a scarlet bathing suit cut high above the thigh in the TV show *Bay Watch*, and Keira Knightley in a pristine white one-piece suit in the film *Atonement*. What one bares, rather than what one wears, is key in dressing up for the seaside.

Although women experimented with showing off good legs while dancing or participating in sports from the turn of the twentieth century, it was clothes for bathing and swimming that pushed the boundaries of propriety to the limit. At the end of the nineteenth century, exposing legs remained a taboo that even bathing could not break. Isadora Duncan, the daring and groundbreaking dancer, remembered in her autobiography how in the early days of the 1900s she dared what very few other women did:

I inaugurated a bathing costume which has since become popular—a light blue tunic of finest crepe de Chine, low necked, with little shoulder strap, skirt just above the knees, with bare legs and feet. As the costume of the ladies of that epoch was to enter the water severly [sic] garbed in black, with skirt between the knees and ankles, black stockings, and black swimming-shoes, you can well imagine the sensation I created.[1]

A picture taken in 1886 by the prolific American photographer Alice Austen shows a group of friends on South Beach dressed in the same traditional fashion. While some young women expose a shoulder, legs are safely concealed under black stocking and skirts reaching down over their knees. Black offered additional protection from exposure since it did not become sheer when wet and it protected the skin from the damages of the sun. Austen and her friends are modest but fashionable. Their striped tunics and belted waistlines were fashionable attire for bathing in the 1880s, and continued to be so well into the 1910s.

▪ Modesty Rules

Until the nineteenth century, people practiced bathing for medicinal benefits rather than for pleasure. Fashion, accordingly, was not a factor in choosing bathing costumes. From the late seventeenth century, when bathing was thought to be a treatment for various illnesses, visitors to health resorts such as Spa in Belgium, Baden in Germany, and Bath in England wore long-sleeved and knee-length linen shifts—the undergarment of the period. Their stiff fabric did not adhere to the body when wet. Modesty, rather than appearance, was the universal concern and thus men and women did not bathe in mixed company.

Modesty continued to be a concern in the nineteenth century and some bathers had weights sewn to the inside of a costume's hemline to prevent it from indecently rising. Still, bathing garments were no more than a longish gown worn over a naked body. Modesty was further ensured with the invention of the "bathing machine." Visitors to the beach

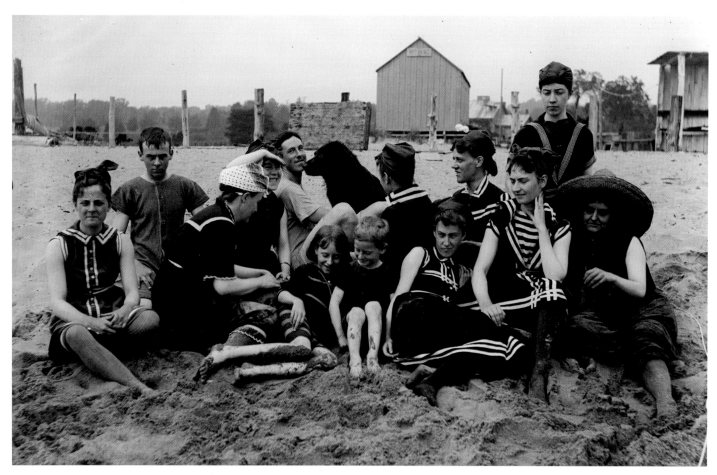

Group of bathers at South Beach, photograph by Alice Austen (1886). Staten Island Historical Society.

entered these wooden rooms on wheels in their everyday clothes; then a horseman carried them into the water, where they could safely emerge in a bathing costume for a dip in the cold water. Except for in the privacy of one's home, pretty legs of the nineteenth century were a sight unseen.

The 1850s were a turning point in bathing costumes. The hitherto bathing costume, the shift, floated when inside the water and exposed the naked body underneath, which meant women had to take a quick dip away from the beach, or just paddle at the edge of the water. As beaches and summer resorts became fashionable places for families to gather, women began to wear outfits that allowed greater ease but kept their modesty intact. That is when drawers—up until then worn by women as an undergarment—started to be worn under shorter bathing dresses. The ankle-length drawers were attached to the dress to protect the body for indecent exposure. Although some women were recorded in a type of ankle-length trousers under thigh-length robes as early as the 1830s, this audacious outfit was worn only for the actual act of dipping. Respectable women would not have dared to be seen by men in such a creation.

Later on, Amilia Bloomer wore Turkish pants under a shortened day dress as part of her dress reform. The conservative Victorian women were outraged by this inconceivable outfit, but the French enthusiastically adopted the puffy "bloomers" as a bathing costume. Many illustrations and photographs from the period show bloomers peeking from under tunics or skirted bathing costumes. The bloomers caught on quickly and soon became the most widely used, and long lasting, bathing costume on both sides of the Atlantic. First they were ankle-length, but as the century progressed the bloomers became shorter, eventually reaching under the knees. Not surprisingly, Americans were more conservative than their European contemporaries and wore bloomers over black wool or silk stockings. One can only imagine how heavy this costume must have been when wet, but for women of the period it was modest and comfortable enough to swim in.

When bathing for recreational pleasure started to gain popularity, fashion naturally stepped in. Women's magazines, fashion publications, and department stores—increasingly a destination for ready-mades and novel trimmings—started to offer resort fashions. Fashion for the seaside did not deviate from mainstream day wear; billowing floor-length dresses and

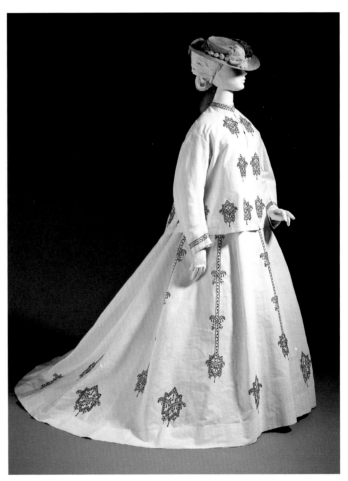

Three-piece seaside ensemble; cotton plain weave with cotton machine embroidery (1864–1867). Los Angeles County Museum of Art.

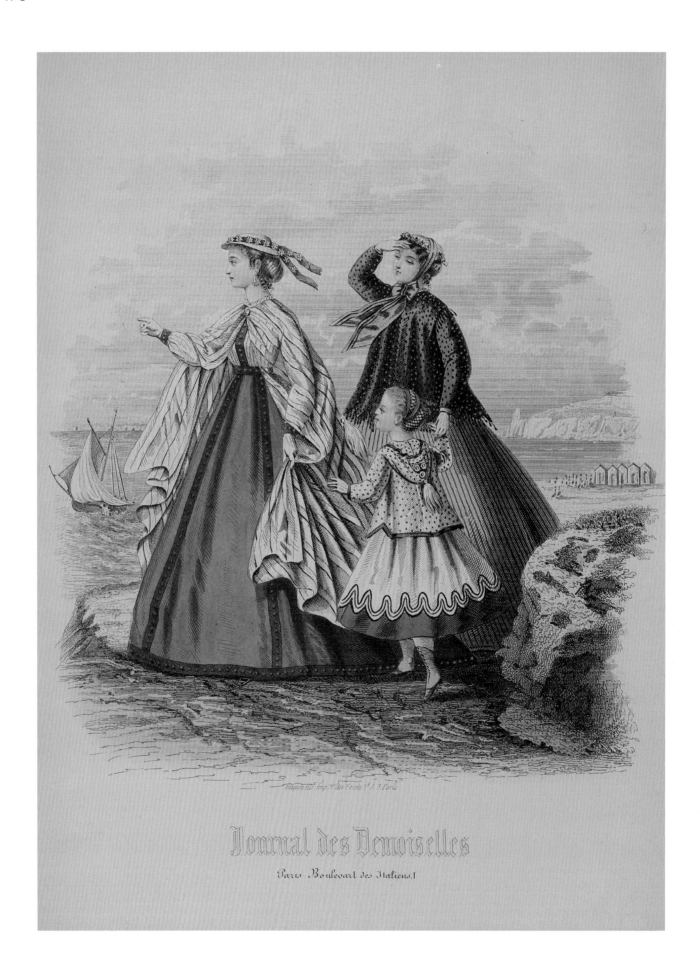

Journal des Demoiselles

Paris Boulevart des Italiens, 1

East Hampton Beach, Long Island by Winslow Homer (1874).
Collection of Mr. and Mrs. Paul Mellon, National Gallery of Art.

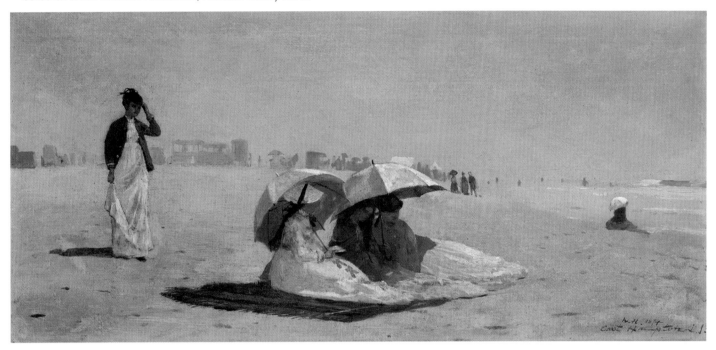

even trains were a common sight along fashionable beaches. Interestingly, clothes designed for an outing of swimming and bathing or just for strolling along the beach or promenade had distinct features. The sailor collars and braid trimmings as well as stripes in white with navy or red that were popular then are still elements in resort collections today and can be seen everywhere from the window displays of the Gap to the runway shows of Jean Paul Gaultier. Resort collections as a separate entity with unique features and functions were born in the nineteenth century.

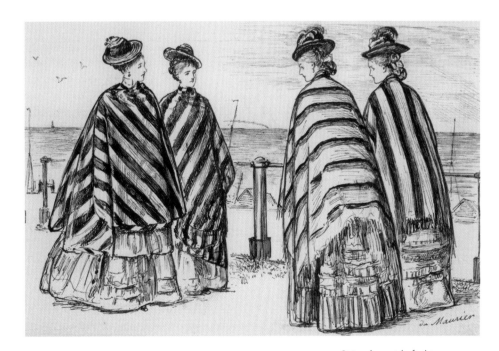

Striped seaside fashion. *Women and their Garments Artistically Described* by George Du Maurier (1874). Yale Center for British Art, Paul Mellon Collection, New Haven, CT.

Opposite: Fashion for promenading and the seaside. Hand-colored lettergraph, *Journal de Demoiselles*, 1867. Collection of J. M.

A Highball. American seaside bathing costume (late nineteenth century). Collection of J. M.

worn short, sometimes with deep side slits, which meant bloomers were now on full display. What was once a simple undergarment was now visible, thus a design complimentary to the bathing costume was desired. Bloomers were made in contrasting color and fabric or trimmed to match the outfit.

Although bathing fashion has rules of its own, it intrinsically stems from street fashion. Each period dictates fashionable proportions and styling details. In the 1910s, for example, costumes with frilled bloomers, underskirts with gathered flounces, and a higher waistline were the vogue. By contrast, reflecting the mode of a period that favored a streamlined and androgynous look, men and women of the 1920s were similarly clad in a simple boyish combination, stripped of excess and decoration.

The Australian swimmer and vaudeville star Annette Kellerman was among the first to wear and promote the one-piece bathing suit, which was essentially a sleeveless woolen unitard. In the early 1900s her swimming outfit caused a sensation because it accentuated a natural, uncorseted body underneath. This was a time when bathers in the United States could still be arrested if more than nine inches of their leg was showing above the ankle. Like her

The next evolution of bathing costumes was a garment that combined a top and knee-length bloomers, usually worn with a belted overskirt and sometimes with just a wide corset belt. An account in an English magazine in 1884 shows that women were increasingly looking for lighter and more comfortable swimming attire: "… some young ladies who are good swimmers have adopted the striped woolen jersey of the fisherman and wear it with full knickerbockers of blue serge."[2] Americans were still clad in black stockings at this time, regardless of the bathing costume on top, while their English contemporaries were barefoot on sandy beaches. Pebbled beaches did require some kind of protection for which slip-on shoes that laced up the ankle were worn.

By the early years of the twentieth century many women in bathing combination suits lost the overskirt. On beaches, men and women were similarly dressed. The one-piece bathing suit was cut fairly close along the legs and gradually became shorter as new body ideals took shape. The bloomers continued to be worn in the late 1910s and early 1920s but were now much shorter, reaching a few inches above the knee. Bathing dresses and tunics were

Edwardian bathing costume (ca. 1890); original drawing by "L. S." Collection of J. M.

The women who worked in the fishing industry wore short skirts and drew male tourists (1880–1900). Collection of J. M.

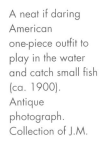

A neat if daring American one-piece outfit to play in the water and catch small fish (ca. 1900). Antique photograph. Collection of J.M.

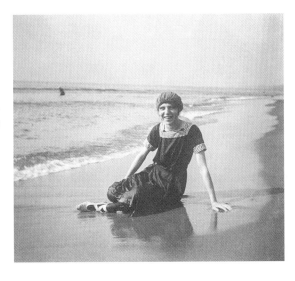

Victorian women dressed in black stockings and shoes laced up around the ankles to paddle or bathe in the sea (late nineteenth century). Vintage photograph. Collection of J. M.

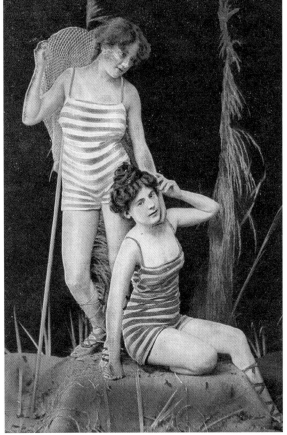

The fashion for striped resort and swim wear prevailed from the mid-nineteenth century on. *Striped Maillots* (1910s). Dopisnice – Inion Postale Universelle. Collection of J. M.

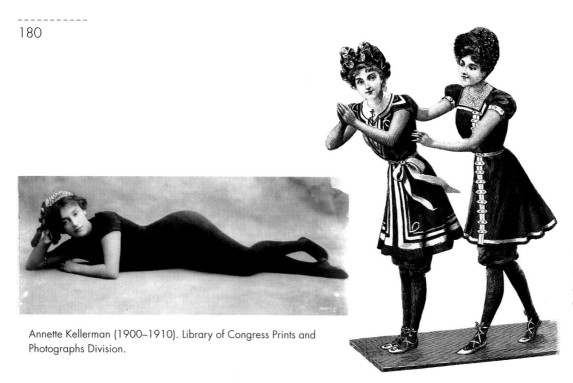

Annette Kellerman (1900–1910). Library of Congress Prints and Photographs Division.

Fashions for the Seaside, 1899. Victorian Fashions: Pictorial Archive. Selected and arranged by Carol Belanger Grafton, Dover Publications.

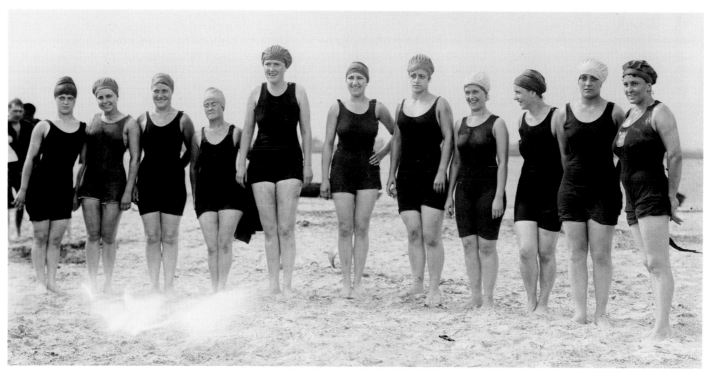

Women's swimming contests at Sheepshead Bay, Brooklyn, New York (July 16, 1914). Library of Congress Prints and Photographs Division.

contemporary Isadora Duncan, Kellerman took inspiration from classical sculptures for her streamlined, simple style, although unlike Duncan she did wear full-length stockings for most of her earlier public appearances. Kellerman built a celebrity aura around her physical ability and modernist ideas. She traveled the world with her diving act and starred in Hollywood films. In her book *The Body Beautiful* (1912), she offered a series of exercises designed to shape and improve the feminine body. This was a decidedly innovative idea because at that time women still heavily relied on undergarments to shape the body to the glass of fashion. Legs in particular were not a concern since they were hidden under long skirts and petticoats. Kellerman's approach marks a leap from the modesty of the nineteenth century to a new body image of the twentieth century.

Two women in bathing costumes drying their hair (1925–1932). National Photo Company Collection, Library of Congress.

▪ Shaping the Legs

Before the twentieth century, bathing costumes concealed and protected the body—either from the sun or from men's gaze. Beginning in the 1920s bathing suits began displaying the body rather than concealing it, and did so in a way that fitted the fashionable idealized body. As bathing suits became skimpier and more revealing, cover-ups became more important; capes, coats, and removable skirts were now a necessary addition to a fashionable beach wardrobe.

Although bloomers were still worn, by the mid-1920s, the fashion-forward were sporting low-waisted trunks furthering the long and lean look that dominated the decade. Another 1920s advancement was the knitted bathing suit, which allowed greater freedom of movement. Leading designers like Jeanne Lanvin, Elsa Schiaparelli, the artistic Sonia Delaunay, and the modernist Jean Patou offered bathing suits with their own signature looks. Patou particularly favored machine-made knits. The knitted bathing suits hung close to the body, outlining the legs and therefore creating a more youthful appearance, perfect for the decade that let the young lead fashion. Several knitting factories were quick to sense the business opportunity in fashionable bathing suits; former hosiery knitters like Jantzen and Cole of California transformed their businesses and subsequently the market. Jantzen for example, gave away free car stickers of their red Diving Girl, an illustration of a long-legged, lean young woman in a sleek red one-piece that became the company's recognized symbol and was embroidered on all of the suits. Jantzen used the catchy advertising slogan, "The suit that changed bathing to swimming." Finally, modern women had a costume they could swim in.

The article "Chic at High Tide" in the June 1, 1928 issue of *Vogue* is a clear indication this decade was all eyes on legs:

French swimwear (early 1920s). Collection of J. M.

> We all remember the old-fashioned bathing-girl as a ridiculous figure, with her bunchy bloomers, and her long-sleeved, high-necked blouse, and we poke fun at her on every occasion in a thoroughly ungrateful manner. We seem to forget that, while the lady tennis enthusiasts were still tripping over their flowing skirts, and the lady golfer found it impossible to tee up her own ball, owing to the number and tightness of her garments, and the equestrienne, if she wanted to ride astride had to hide her legs under a divided skirt, the bathing-girl—bless her—defied society, ignored the raised lorgnettes and exclamations of horror, and came forth with her legs almost entirely exposed.

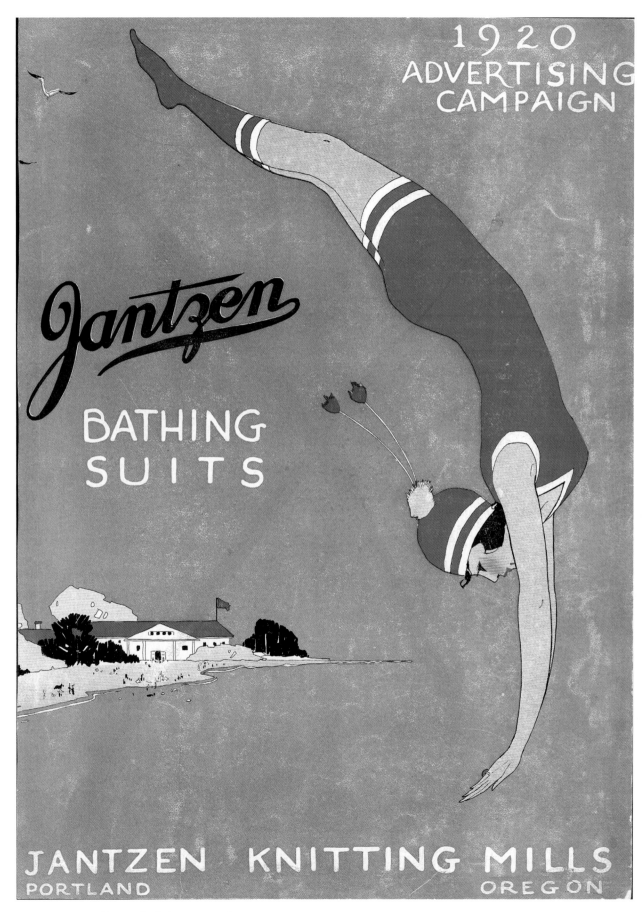

1920 Diving Girl by Frank Clark. Courtesy of Jantzen.

Resorting to Fashion

Evidence to how important resort fashion was becoming can be found in the fact that Coco Chanel's first ventures into fashion after Paris were at Deauville and Biarritz, two French retreats for the wealthy and fashionable. Chanel was also among the first to sport the beach pajama suit. An iconic image of her in white pajama pants, black sweater, and strands of white pearls, alongside Serge Lifar of the Ballet Russes, who is similarly dressed in draped pants and tight black sweater, underlines the spirit of the epoch. While Chanel is often credited as the "inventor" of the pantsuit, she did not in fact wear pants as street clothes until the 1960s; the pajama suit was worn for resort and seaside occasions only. By the 1930s pajama suits for the beach were available in every price point, from Elsa Schiaparelli to Lord & Taylor.

Resort towns in the United States hosted bathing girl parades featuring young women in daring bathing suits and high heels as a way to encourage late-season tourists. The Miss America pageant was a reincarnation of such a parade in Atlantic City in 1920.[3] Since then, exhibiting the female body in bathing suits has been a fixture in beauty pageants.

What started in the 1920s boomed in the 1930s when swimwear became an inseparable part of sportswear, which in turn was an important component of the modern urban wardrobe. Women of the 1930s were devoted sun worshipers; they wore shorter and smaller bathing suits and more elaborate resort outfits. Tanned skin and swimming were associated with health before the connection between sun exposure and skin cancer was known.

Evening gowns were grazing the floor, covering the legs completely, but at the same time exposing a very low-cut back. Bathing suits mirrored the trend and had the back cut to or below the waist. The correlation between the cut of evening wear and swimwear also ensured that sunning marks were only visible where desired. In addition, bias-cut fabrics made beautiful evening wear, but even if dresses were long, legs had to be nicely shaped since a fabric cut on the diagonal tends to tenuously cling to the body. Clingy knitted jersey fabrics were widely used in bathing suits and cover-ups so shapely legs were also an asset at the beach. Increased attention to shaping the body, rather than letting the clothes shape the

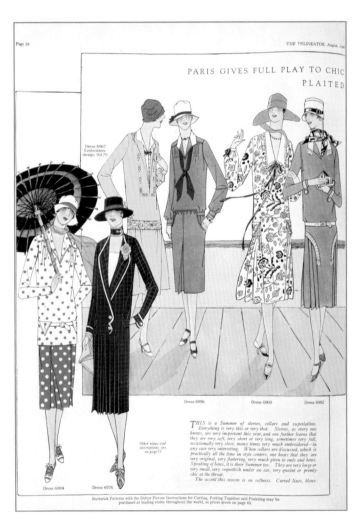

Butterick Publishing Company patterns of resort fashion. August 1926. Library of Congress Prints and Photographs Division.

Beach pajama, (ca. 1930). Photographer unknown. Library of Congress Prints and Photographs Division.

Marian Marsh and Laura La Plante in striped beach pajamas by Underwood and Underwood (1930). Library of Congress Prints and Photographs Division.

figure, resulted in a new obsession for fitness. Swimming and exercise were interchangeable, but that did not mean bathing suits were less fashionable—quite the contrary.

The fashion in swimwear was tight as a second skin; manufacturers experimented with new fibers and textile innovations. Lastex, invented in 1932, was elastic yarn consisting of a rubber core covered in cotton, silk, wool, acetate, or rayon. Its elastic qualities made the fabric firmer and more able to retain its shape after frequent wear. Another 1930s innovation were non-absorbent rubberized fabrics that dried quickly and made bathing suits easier to swim in. Printed crepe-rubber and a crinkled rubberized fabric called cloque also came in bright colors and made up fashionable suits.

By the end of the 1930s, bathing suits became even more form-fitting with an increased emphasis on the hips. The most fashionable styles were a tight maillot, which sometimes had a short little skirt attached, or, for a more

conservative woman, the dressmaker bathing suit, which had a tailored bodice and a full skirt. Some variations of these styles came with a detachable skirt. How bare the body might seem depends not only on how deep the neckline is or how wide the straps are, but also on how many inches of the leg are covered. In a decade when two-piece bathing suits exposing the midriff first made an appearance, the shortness of the costumes was highlighted by the way they ended in a straight line over the thighs. Just how attitudes toward body exposure had changed is evident in a two-piece suit designed by Margit Fellegi for Cole of California in 1942. This sexy style had laces down the side of the bottom part that exposed the leg all the way up. It showed a strip of tanned skin and reminded the gazing eye of the lack of a barrier between the bathing suit and the body.

Resort collections continued to be even more diversified than before, with an array of leisure fabrics like French terry, linen, and piqué. The shape and styling followed street fashion, with one very important difference— clothes for the beach were worn sans stockings: decades would pass before even rebellious women would appear out and about in urban settings without stockings. By the sea, however, bareness ruled and even respectable women were sporting smooth and totally naked legs. To cover naked legs and bare

Two-piece bathing suit with ruffles in front, bandeau top and matching cape that the model is holding up (ca. 1938); Italian postcard. Collection of J. M.

bodies, designers started to offer a new item of clothing called a pareo or pareu. The French designer Jacques Heim is credited as the first to promote this style inspired by the South Seas, which was essentially a rectangular piece of fabric that ties around the waist and covers the hips. In just a few years the pareo reached mass market and became an important component of beach fashion. In 1936 the American bathing suit manufacturer B.V.D. showed a jersey pareo printed with seahorses in a *Vogue* advertisement, saying that "From South Sea Isles, from tropic seas and golden sands comes B.V.D.'s native Pareo—a fascinating new marine phenomenal!"

Yellow two-piece with scarf-like top and hip-hugging bottom that cuts straight across the thigh (late 1930s). Collection of J. M.

▪Glamming the Legs

By this time fashion magazines were, of course, an established tool for spreading information and inciting desires, but lighter photographic equipment and easier transportation to far-away places enabled them to do so in a more elaborate manner. The camera made the twentieth century the era of swimwear; photographs charged the bathing suit with fantasies of exotic destinations, travel, and adventure. Photographers such as George Hoyningen-Huene, Edward Steichen, and later Louise Dahl-Wolfe created distinct imagery that tied bathing suits to a worldly lifestyle, by extension allowing ordinary women to experience the fantasy.

This was also a time when the first connection was made between Hollywood and the bathing suit as a luxurious fashion piece. It was a two-way street, with manufacturers such as B.V.D. and Jantzen using Hollywood stars in their advertisements on the one hand, and Hollywood enticing trends like tropical prints, wrap suits, and glamorous bathing costumes on the other. Furthering this bond were the resplendent MGM films starring Esther Williams. The Aquamusicals, as they were known, featured

synchronized swimming and elaborate sets never before seen. They provided a great opportunity to display not only fabulous bathing suits but also fabulous legs. Strong but gracious legs were instrumental to the glamour and beauty of the Aquamusicals.

In 1952, Williams starred in the film *Million Dollar Mermaid* about the life of Annette Kellerman. The Technicolor scenes introduced Williams in glittering swimsuits created by Helen Rose. The shimmery golden Lastex suits covered with scale-like sequins were later adapted to the mass market by Cole of California. Hollywood through its stars and starlets had the ability to stimulate trends in fashion in general and in swimwear in particular. Another example is the sarong suit, created by the famed costume designer Edith Head for Dorothy Lamour in the film *The Princess Jungle* (1936). The sarong was a one-piece suit with a little wrap skirt draping from one side. Manufacturers soon imitated the style for the wider public, which made both the sarong and Dorothy Lamour into stars.

1948 Diving Girl, artist unknown. Courtesy of Jantzen.

"The Long-Legged, Tennis-Playing, Swimming Girl"

These words were used by *Life* magazine in 1946 to describe the ideal woman in the minds of a new breed of young, American female designers. Tina Leser, Carolyn Schnurer, Bonnie Cashin, Clare Potter, and Claire McCardell created youthful sportswear, simple in shape, without restricting foundations and with a wink of self-humor. While most bathing suits of the 1940s and 1950s, and certainly the ones that came from the sets of Hollywood, had intricate underpinnings that supported and shaped the body, theirs were unlined and contoured the body in the most revealing of ways.

In 1947 Christian Dior inaugurated his New Look , but designers in both Europe and the States were already showing similar silhouettes during the war years. In the post-war era, women's legs were buried under layers and layers of ruched, gathered, and pleated skirts and their torsos were shaped by rigid understructures. Most designers followed the same lines and silhouettes when they adapted street style to beach style—formed and curved with emphasis on feminine features, the breasts and the hips. Contrastingly, Leser, Schnurer, and McCardell catered to women who did not need or did not want to alter their natural form. Their swimwear was lightweight and virtually a second skin. These were suits for the young and carefree.

Fashion model Dovima wearing a bikini, lying on a platform near the water in Montego Bay, Jamaica (1946). Library of Congress Prints and Photographs Division.

An Abercrombie & Fitch catalog from the early 1940s shows and describes a "printed rayon bathing suit designed in a new silhouette. It emphasizes the uplift bra, defines the waist and has a full skirt with unpressed pleats."[4] At about the same time, McCardell was showing the "diaper suit," a one-piece of wool jersey that tied around the neck, passed between the thighs and tied again around the waist. The style left the back bare and created a turned-up V shape on each leg, exposing more of the leg than ever before. McCardell rejected the period's heavy skirted bathing suits in favor of lightweight, knitted ones that demanded a trim body and a brave soul. McCardell also incorporated her famous details, like brass hook-and-eye closures, into some of her swimwear which, with the addition of a wrap or overskirt, quickly transformed into a dinner dress. Kohle Yohannan and Nancy Wolf, who researched McCardell extensively for their book *Claire McCardell: Redefining Modernism*, point out that she herself wore the diaper suit with a black taffeta skirt for a benefit dinner in New York.

Fashion models posing in bathing suits (October 1948), photograph by Toni Frissell. Library of Congress Prints and Photographs Division.

In the 1950s traveling by air became more affordable; places like Hawaii, Mexico, and the Caribbean became major vacation destinations for more Americans. This continued the relationship between traveling and swim fashion as both designers and photographers were taking inspiration from other cultures. In 1956, for example, Carolyn Schnurer created the collection "Destination Norway." One bathing suit from the collection is made of printed cotton and is shaped like short overalls with black shoulder straps and a black trim along the edges of the mid-thigh shorts. This playful design foreshadowed the youthful and bare fashion of the 1960s.

The versatility of swimwear was something new. At many American beaches and vacation destinations all over the world, resort wear outfits were allowing quick transformation from swimming clothes to dinner outfits. Many bathing suits came with detachable or wrap skirts that were covering enough and casual enough for the free spirit of vacationing. New attitudes toward body exposure and the informality of clothes that were born along beaches in the 1950s flourished with the movement of young fashion in the 1960s.

▪ Baring It All

The 1960s was the decade of legs, second only to the 1920s. Legs in miniskirts, boots in varying heights, and colored or patterned stockings epitomized the era. In fashion magazines, models abandoned the lifeless poses of decades past in favor of cheeky postures and legs spread apart. While the Mod girls were wearing black stockings and trapeze dresses, in California girls with golden hair and golden skin wore minimal bathing suits and partied at the beach.

Early in the decade, the ideal body was feminine, curvy, and almost feline-like. Later on, fashion icons such as Twiggy and "Baby" Jane Holzer dictated a slender, boyish figure with small breasts and lean, supple legs. Whether curvy or slender, the body was the decade's most important fashion item and the legs its coveted accessory. In 1965, *Vogue* featured French-born actress Catherine Spaak, noting that she was:

> . . . the girl with the marvelous knees: Narrow, slender knees—as rare in beauty as truly pretty ears; a strong lean stretch of body with the vitality of a young leopard's. This is the figure that fits the fashion now…and Catherine Spaak has it—all that leggy verve and the added flame of charm that's made her the rage of young Italy.

Young Spaak was shown in a knitted dress; according to *Vogue,* "the only shape it has is hers, which proves, in our mind, that the figure makes the fashion." Indeed, designers in general and designers of bathing suits in particular were experimenting with body exposure in new and exciting ways.

The 1960s with its new platform of sexual freedom allowed designers to create playful bathing suits that showed lots of skin. Inspiration from op art influenced the shape of suits that now had cutouts in unusual positions, straps that crisscrossed a naked midriff, mesh inserts, and sheer panels. The hemline of the bathing suit also changed. Instead of ending in a straight line at the thigh, it curved suggestively above it. One style above all is associated with the young and free spirit of the '60s, the bikini. Although on American beaches the style was not popular before the

early 1970s, fashion magazines and forward-thinking designers were already showing the style in the early years of the 1960s.

The first bikini was actually introduced in 1946 and was comprised of two triangles to cover the breasts and one to cover the pubic area. Two Frenchmen showed similar styles in the same year; Jacques Heim named his atome and Louis Reard dubbed his bikini. Both styles got their names from the nuclear bomb testing the United States was conducting near the island of Bikini. Although two-piece bathing suits already existed at that time, the bikini was a metaphorical bomb in the sky of fashion when it first appeared. The bikini was so outrageous that when Reard showed it for the first time he could not find a model to agree to wear it, and instead had to hire the racy dancer Micheline Bernardini to model his creation.

In addition to exposing the navel and the torso like never before, the bikini also showed a lot of the leg. Rising high above the thigh, the skimpy bathing suit exposed the body almost in its entirety, a concept that even given the free spirit of the 1960s, most people found hard to accept. For comparison, early in the 1960s, Australian gold medalist swimmer Dawn Frasier caused a stir when she was determined to remove the traditional skirt from her swimsuit for competitive events. Fashion historians Harold Koda and Richard Martin point out that even in Elvis Presley's films in Hawaii "nice girls wear maillots and bad girls wear bikinis."[5]

Swimwear was a wonderful arena for the designers of the period to challenge notions of propriety because fashion for the beach side had always existed slightly off the mainstream. The American designer Rudi Gernreich, for example, parlayed the styles of dancing clothes into sportswear but really defied fashion in his famous "monokini," a kind of one-piece topless jersey bathing suit that had two spaghetti straps between the breasts. His lesser-known swimwear designs were an equally daring thong that exposed the bottom, and the "pubikini" that exposed the pubic hair.

Opposite and above:
Celeste Yarnall as jungle goddess in *Eve*, 1968.
Courtesy Celeste Yarnall.

On and off of the beach, slim bodies and long legs were desired. *Vogue* recognized that "even the non-bikini wearer has sensed this: because of bikinis, standards of figure excellence are the highest this century has known."[6] For those who lacked the figure, the magazine suggested, "Tie a scarf over your bikini like a sarong."[7] Fiber innovation was also key to the 1960s sleek and "naked" look. In 1959 DuPont invented spandex, a stretch fiber also known as Lycra, and a year later the swimwear manufacturer Speedo introduced nylon tricot suits worn by the Australian swim team for the 1960 Rome Olympic Games. The Italian designer Emilio Pucci was among the first to use Lycra for bathing suits, which he printed in bright colors.

In the late 1960s seemingly conflicting currents affected swimwear. On the one hand, revealing styles like the bikini and stretch fabrics like Lycra demanded a very toned body, contrary to the ideals of the hippie movement that embraced the beauty of a relaxed or natural body. On the other hand, fashion designers began taking elements from non-Western cultures (which were already influencing swim fashion as early as the 1930s). Fluid natural fabrics, exotic prints, and oversized shapes were enthusiastically adopted as beach cover-ups, if not for their on-trend appearance, at least for concealing imperfections. Imperfect legs could now be somewhat obscured by chiffon printed caftans or wide-legged pants. The hippie interest in handicraft also gave birth to the crocheted bikini and one-piece suit, which needless to say, showed more than they covered.

■ More Glamour, More Legs

Evening is the time for glamour…and if the party is in a hot-weather zone and there's a swim by moonlight or spotlight, it's a golden chance for a glamorous night bathing suit. Something shiny, sleek, bare. Curvy where it's there, cut away in flattering lines where it isn't. A suit that lets you flash through the water like a beautiful iridescent fish…that slides under a great sweep of caftan on land…

This advice from *Vogue* in December 1972 sums up the change in taste that was beginning to take place in the 1970s. While caftans were still fashionable as cover-ups, handmade-looking bathing suits were replaced with lustrous, skintight fabrics. Big fashion names like Dior, Chanel, and Versace were also stepping into the deep waters of swim fashion with their own collections of glamorous, glittering, and provocative bathing suits.

During the 1970s bathing suits shrank to a minimum, culminating in the Brazilian tanga. Christie Brinkley was shot in one designed by Giorgio di Sant'Angelo for *Sports Illustrated* in 1975. The back of her tanga suit is comprised of just three thin straps of fabric attached to a metal ring above her buttocks. Bathing suits were also beginning to rise daringly above the thigh, sometimes so high they revealed the hipbone, making legs appear longer. The fashionable body was now more athletic. By the end of the 1970s the idealized women were near Amazonian, with broad shoulders and sculpted, long legs. Bathing suits were perfect for their ability to highlight a beautifully built athletic body, and street fashion eventually caught up with shorter and shorter hemlines as the 1980s progressed.

Legs made a big comeback in the 1980s after a decade of hippie maxi dresses. The legs of the 1980s, however, were a far cry from the girlish legs of the 1960s. A generation of gym-goers and professionals exposed strong, toned, tanned, and muscular legs. And these legs were either bare, or seemingly bare; opaque stockings or black tights were a thing of the past.

Whether the fashion for bare swimwear made women run to the gym to tone their thighs and midriff, or whether women who were spending long hours sculpting the body were just looking for a garment to showcase their effort, is hard to determine. In any case, the athletic trend also influenced the vocabulary of swimwear design. Manufactures increasingly used technological fabrics, shapes were directly influenced by active wear (like the racer back), and one-piece bathing suits came into fashion again, although that didn't mean they covered much of the body. In 1984 Raquel Welch posed with the American men's Olympic swim team for *Vanity Fair*. The men's bronzed bodies and Walsh's skimpy suits tie swimwear and sports together, charging the mix with high sexual tension.

TARZAN DRESS & BAG

TAMBOURIN BA

Tami Ben-Ami, photograph by Ben Lam for Gottex (1982).

When Lea Met Tami, Gottex's House Model

The Israeli swimwear manufacturer Gottex was among the greater contributors to the shaping of fashionable legs in the 1980s. Armin and Lea Gottlieb were two young immigrants from Hungary when they established the company in 1956. In their native country they had a factory for raincoats, but in the dry climate of their new-found home, raincoats were not a hot commodity. "When we made raincoats we used to look at the sky and pray for rain," said Lea. "That's when we decided to make swimsuits."[9] They named the company Gottex, combining the first part of their last name with the first syllable of "textile."

Although other companies specialized in swimwear, Gottex was unique because it implemented a high-end approach to both designing and branding the swimwear collections. In the late 1970s, the company, helmed by Lea Gottlieb as creative director, and joined by her daughters Judith and Miriam, stood out in the global swimwear market. Combining non-Western influences, stunning, colorful prints, innovative textiles, and daring cuts and silhouettes, Gottex became the go-to brand for the bold and the beautiful.

During the heyday of the 1980s and 1990s, leading department stores worldwide sold Gottex resort collections. The deluxe catalogs featured international supermodels such as Claudia Schiffer, Naomi Campbell, Tyra Banks, and Stephanie Seymour and were shot in exotic destinations.

Gottex's house model was the Israeli Tami Ben-Ami. During the heyday of the company she became the face of Gottex in Israel and around the world; however, in the early 1970s, as the company's fit model, she was not included in catalog shoots. Ben-Ami came from a Jewish Sephardic background at a time when Gotten mostly featured models of European descent who had fair skin and light hair color.

In about 1972, Gottlieb started using Ben-Ami for location shoot. Gottlieb may have sensed the global trend toward showcasing beauties of different ethnicities, or she may have been influenced by Yves Saint Laurent, whom she admired and who was using black models for his shows. The Gottex catalogs placed Ben-Ami on the fast track to stardom. In Israel she achieved celebrity status with newspapers and magazines covering her every move and romantic adventures.

Ben-Ami had strong facial features, and her body epitomized the beauty ideal of the 1980s—broad shoulders and long toned legs. Her look was such an influence on Gottlieb that she chose runway models based on Ben-Ami's look; if they were not as tanned as she was, they were sent to a tanning salon on the spot.[10]

Tami Ben-Ami, photographs by Ben Lam for Gottex (1983).

Ben Lam, who shot many of the Gottex catalogs, has said that "Tami did not have a classic beauty; she looked strange, she had an extraordinary body and the way she moved was inspirational."[11] Ben-Ami's unapologetic sexuality and her collaboration with Lam produced unforgettable photographs including the "snake picture." Lam said of the day that picture was taken: "It is the kind of thing you don't really understand how it happened, half a minute work, three clicks and wrap."[12] Ben-Ami, in a serpentine bodysuit on the sand of the Negev Desert, embodies the perfect-legs fantasy that drove so many women to the gym in the 1980s. Her Amazonian look, underlined by the skin-tight and revealing suit that covers her legs and torso, encapsulates the image women of the time were buying into—powerful, sexual, and unapologetic.

Gottex's identity as an innovative house for expensive resort fashion was epitomized by Ben-Ami's physique. The company produced styles that contoured, supported, and accentuated the body. In addition to swimwear, Gottex made coordinated cover-ups. Each collection included styles of the pareu, a rectangular printed fabric meant to be wrapped around the waistline to cover the legs. The pareus, in addition to caftans and maxi dresses, were often made of sheer fabrics. The legs were covered but at the same time exposed. Such was Lea Gottlieb's approach to swimwear design—sexy but sophisticated, stunning and luxurious. ■

Tami Ben-Ami, photograph by Ben Lam for Gottex (1982).

The shape recalled the short, flaring dresses that attracted attention in the Paris couture shows the week before, where they were hailed as marking a change from the tightly wrapped skinny clothes that have dominated fashion in recent years.

If bathing suits of the 1930s and '40s provoked exotic destinations and smart socializing, those of the 1980s were all about sexual empowerment and the male gaze. More than any other outlet, the swimsuit issue of *Sports Illustrated* was the marker for fashionable bodies and, by extension, fashionable bathing suits. The magazine, intended mostly for male consumption, was criticized for the exploitative way in which female bodies were displayed. Despite the criticism, models and swimwear designers were eager to be featured. *Sports Illustrated* swimwear issues are still highly anticipated by the fashion industry and its followers, and the magazine can be credited for launching and promoting some of the biggest names in modeling, including Christie Brinkley, Elle Macpherson, Tyra Banks, and Heidi Klum.

As the new millennium approached, more and more attention was given to performance. Manufacturers competed to offer styles in more durable fabrics that were also less absorbent and had less drag. The unitard was back. Covering the body neck to ankles, it became the go-to outfit for professional swimmers. Speedo's Fastskin line was modeled after sharks' skin and was proven in studies to enhance performance. Jean-Claude Chatard, PhD, who led the research on Fastskins, says that the idea was similar conceptually to how engineers "design cars for racing and how we can employ physics to compliment human performance."[8] Conceptually and aesthetically fast suits underline how modern Annette Kellerman's ideas were a century ago. The one-piece suit she designed herself was intended to enhance her ability to dive, swim, and perform under water. That it so gracefully contoured her toned body was an added effect that did not go unnoticed. It is only natural that her emphasis on a beautiful and streamlined natural figure as a tool for superb physical performance resurfaced at a time when our obsession with shaping the body has been greater than ever. The new generation of fast suits, some of which are banned from professional competition, are more than swim suits; they are the second skin swimmers hoped would enhance their personal bests for the past century.

The 1980s was a time when fashion was looking to decades and centuries past for inspiration. Designers borrowed from every possible period, often mixing several influences in one design. In particular, the broad shoulders of the '80s were influenced by the styles of the '40s. In bathing suits, American designer Norma Kamali reinterpreted the skirted styles of the 1940s, and *The New York Times* reported in August of 1986 on the new collection of the Israeli Gottex (see "When Lea Met Tami, Gottex's House Model") saying that:

> The Gottex swimsuit fashion show opened with a bevy of models wearing short red terry cloth beach coats belted in black patent. The coats flared out like skating skirts as the models twirled around the stage and the audience at the Parsons School of Design broke into applause.
>
> The enthusiasm mounted as the models doffed their cover-ups to show the swimsuits underneath. They were navy blue styles with white polka dots, but it wasn't the fabric that was so arresting. Several of the suits were supple princess shapes with tiny flaring skirts. It was the first time a skirted swimsuit had made a ripple since the advent of the bikini decades ago.

CHAPTER 10

Sporting Legs Attire - - - - - - - - - - -

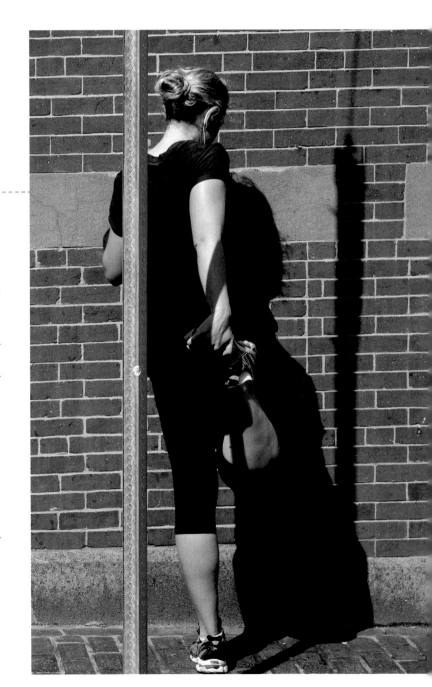

In 2010, the audience and the press at the French Open went wild when champion Venus Williams stepped on the court looking ready to perform the can-can in a black lace number trimmed with red ribbon. With the first full swing, Venus's short lacy skirt flew up, stunning the audience. Could she be naked under that dress? In fact, Venus had on skin-toned Lycra shorts. "It's really all about the illusion," she told the press. "What's the point of wearing lace when there's just black under? The illusion of just having bare skin is definitely, for me, a lot more beautiful."

Venus and her sister Serena have competed in outfits ranging from fringed skirts (Venus), denim skirt with knee-high socks (Serena), to catsuit (Serena), and embellished mini dresses (both). On the tennis court, the sisters have encouraged spectators to embrace a muscular beauty ideal that contradicts what fashion magazines purvey. In this sense, they have joined a long line of sportswomen who have used their individual style to send a message to mainstream fashion, and push it forward.

Sport has been a most successful vehicle for women's emancipation both socially and physically. However, until well into the twentieth century, sports attire did not have thorough penetration to mainstream fashion. Fashions of the nineteenth century laid down very strict guidelines for

appropriate attire for each hour of the day and type of social occasion. The long skirts hid legs; any activity that risked exposure of even a sliver of stockings was avoided in mixed company. Women were confined to the spectator role with some unusual exceptions. Yet while it is commonly believed that until the second decade of the twentieth century sportswomen were few and far between, women did take part in physical activity for recreational pleasure. Some of these activities, like snowball fighting and types of bowling, are not described as sports today; nevertheless, women have always gone out to play and often adapted their attire to play well.

Statutes, vases, and written accounts dating back to ancient Greece and Rome indicate that small numbers of women participated in strenuous, recreational activities in the ancient world. A 500 BC statue, for example, depicts a young Spartan girl hitching her skirt above the knee, her muscular legs and her posture suggesting she is a runner ready to launch. Pausanias, a Greek who relayed the ins and outs of everyday life in ancient Greece in his *Description of Greece*, provides another early account of sportswomen. At about 175 AD he wrote:

> Every fourth year there is woven for Hera a robe by the sixteen women, and the same also hold games called Heraea. The games consist of foot-races for maidens. These are not all of the same age. The first to run are the youngest: after them come the next in age, and the last to run are the oldest of the maidens. They run in the following way: Their hair hangs down, a tunic reaches to a little above the knee, and they bare the right shoulder as far as the breast. These too have the Olympic stadium reserved for their games, but the course of the stadium is shortened for them by about one-sixth of its length. To the winning maidens they give crowns of olive and a portion of the cow sacrificed to Hera. They may also dedicate statues with their names inscribed upon them.[2]

In the fourteenth century, both men and women practiced tumbling. Men usually performed a clownish act, tumbling down from their horses, while women specialized in acrobatic balance, often to the sound of beating drums and to the rattle of tiny bells attached to their clothes. Women tumblers deviated from the day's fashion by wearing colored stockings and short tunics cut close to the body

Horseback riding was taken up by women for practical reasons quite early on. During the second century BC, Spartan women won chariot races and skillfully rode horses. Beginning in the early seventeenth century, women started to adopt a specialized wardrobe for riding, which

had masculine characteristics, and the term "riding habit" was first used to describe a distinctive style of clothes for riding horses. Tailors made riding habits for both men and women. In the female version, the skirt was the distinguishing feature; from the waist up, women's habits were designed to follow men's fashion, including jackets, cravats, and even wigs. On June 12, 1666, Samuel Pepys, the English parliament member, wrote in his diary, published later as *The Diary of Samuel Pepys*:

> Walking in the galleries at White Hall, I find the Ladies of Honour dressed in their riding garbs, with coats and doublets with deep skirts, just, for all the world, like mine; and buttoned their doublets up to the breast, with periwigs under their hats; so that, only for a long petticoat dragging under their men's coats, nobody could take them for women in any point whatever; which was an odde sight, and a sight did not please me.

The vogue for stylish riding attire may have had its origins in the famous portrait *Charles I at the Hunt* (c. 1635) by Anthony van Dyck. The English king was depicted in his country clothes, alongside his horse. At the same time, his French contemporaries were portrayed in their wigs and all their finery. The equestrian leisure enjoyed by King Charles I eventually influenced how city people dressed and created a fashion for more casual, elegant country-style dress.

In 1776 Sir Joshua Reynolds painted Lady Worsley in a chic red riding habit. Known for her scandalous love affairs, Lady Worsley is attired in a redingote, a long masculine coat worn over a waistcoat and a matching long voluminous skirt reaching a few inches above the ground. Derived from the English "riding coat," the redingote was originally a men's garment that was adopted by women of the eighteenth century not just for riding but also as casual, traveling clothes. That Lady Worsley chose to be depicted in a riding habit speaks for the status and elegance it reflected.

By the early nineteenth century, riding habits became simply referred to as "habits," and sometimes included skirts so long they had to be held up for the woman until she was seated on the horse. For walking, hidden tabs were used to tie up and shorten the hem of the skirt. Voluminous fabrics have always been a marker of status and, draped over a back of a horse, the fine skirt made for a majestic sight.

Between the fifteenth and the early twentieth centuries, respectable women were expected to ride sidesaddle. Ann of Bohemia, the wife of King Richard II, is credited for introducing the sidesaddle in the late fourteenth century. Although some earlier depictions of women riding with their legs on one side of the horse exist, it was during the fifteenth century that it became prevalent in Europe.

Women wishing to ride in their everyday clothes found it difficult to manage the long skirts over the back of a horse. Sitting sidesaddle, one leg draped over the pommel, allowed women to be modest and appear feminine. Long skirts, however, ran the risk of catching on the saddle and injuring the rider, so "safety skirts" were devised. They might have an asymmetrical hemline, an apron-skirt that covered the front and buttoned at the back after dismounting, or even a "safety train" that had a hole to fit comfortably over the pommel. The riding habit, building on a traditional English tailoring style, suggested elite class and elegance. It easily transferred to street clothes and is the precursor to modern sportswear.

During the nineteenth century breeches were added under riding skirts. They were made of the same material and color as the skirt so not to be visible if the skirt were to hitch up. Despite the protection breeches afforded, women continued to sit sidesaddle until almost the 1920s. To modern-day eyes, breeches are a modest addition to an already traditional outfit, but for Victorian men and women, a glimpse of breeches was equivalent to the modern-day sight of Venus's skin-toned shorts. It would take several decades before the skirt was ditched altogether, and jodhpurs, a style of riding pants that originated from a district by the same name in Rajasthan in northwest India, replaced breeches. Eleanor Hewitt, one of the two Hewitt sisters who founded the Cooper-Hewitt Museum in New York, was an accomplished equestrian and enthusiastic sportswoman who wore suede jodhpurs for riding on the family's estate grounds in New Jersey. "Miss Nelly," as she was known, most likely wore them under a matching suede skirt shortened to mid-calf height. Eleanora Sears, who reportedly won 240 trophies in horse racing, tennis, squash, golf, swimming and field hockey, rode astride wearing jodphurs and no skirt early in the twentieth century. Eventually young equestrians would favor the masculine jodhpurs as standalone items, but before that, Victorian sportswomen endured decades of restricting clothes and endless discussions of proper attire.

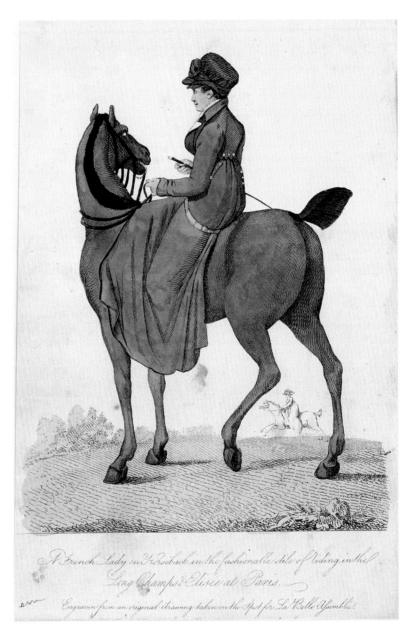

A French Sports Lady on Horseback (fashion plate, London, 1781–1812). Los Angeles County Museum of Art.

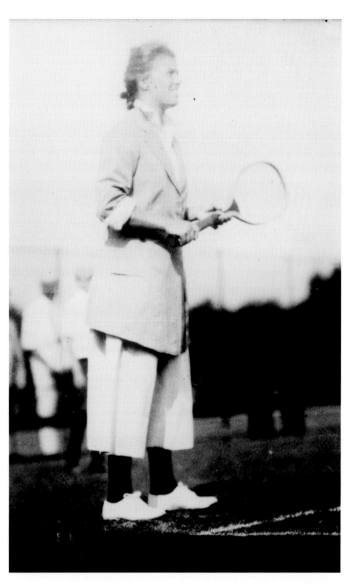

Eleanor Sears, photograph by Bain News Service. An accomplished equestrian, she shocked society by riding in a men's riding habit and astride. She reputedly won 240 trophies in golf, tennis, squash, field hockey, horse racing, swimming, and long-distance walking. Library of Congress Prints and Photographs Division.

▪ Striking and Gliding

During the 1860s, several technological innovations converged to create the most exaggerated look of the nineteenth century—pinched waist, enormous skirts, and abundance of decorations. By the 1860s, the domestic sewing machine was widely used, allowing women to easily and quickly decorate their dresses with elaborate trims. The skirts grew to their widest when the cage crinoline was introduced. Made of flexible iron hoops attached to each other by a ribbon, the cage crinoline swung around a woman's legs and had the tendency to rise up, allowing a peek of the leg when sitting and walking. As a result, during this period, feet and ankles became erogenous zones of the female body; tiny feet, along with fair skin and narrow waistline, were the mark of absolute beauty.

The fair ladies of the 1860s, however, enthusiastically adopted a spirited game that allowed them, for the first time, to play alongside men. Croquet existed in one form or the other for about a decade, but in 1865 it became very fashionable, especially at summer garden parties and social events. The wealthy appreciated that croquet required a fancy set of equipment and greensward. Other than the habit for riding horses and the bathing suit for paddling or dipping in the ocean, clothes designed specifically for sports did not yet exist. The woman who played croquet did so in her best afternoon dress, with its wide, bouncy skirt. With the ball placed on the grass and the mallet positioned to hit it, the female feet got a lot of attention. Homer Winslow's depiction of a game of croquet shows a young man kneeling to position the ball by the feet of a young woman, poised with the hem of her skirt a few inches above the grass.

Socialites of the Gilded Age had abundant money to spend, and what better way to do so than shopping? Department stores, which in the mid-nineteenth century became booming businesses, offered specialized accessories for croquet, like Bloomingdale's "Ladies Croquets," a slip-on shoe with a matching pair of rubber soles, or the fashionable "Croquet Sandals," an early version of sneakers made of canvas and rubber soles.[3]

During the winter months, the same fashionable women who played croquet, started to meet the men on the ice. Ice-skating was also performed with the challenging hoop skirt, but an inner set of cords helped to draw the hemline up, exposing the petticoat and allowing the legs to move around freely. After skating, the female released the cords to return her skirt went to its modest length. Like croquet, ice-skating drew attention to the legs and how they were garbed. A comment in *Godey's* magazine in 1864 shows how much sportive pursuits influenced everyday fashion:

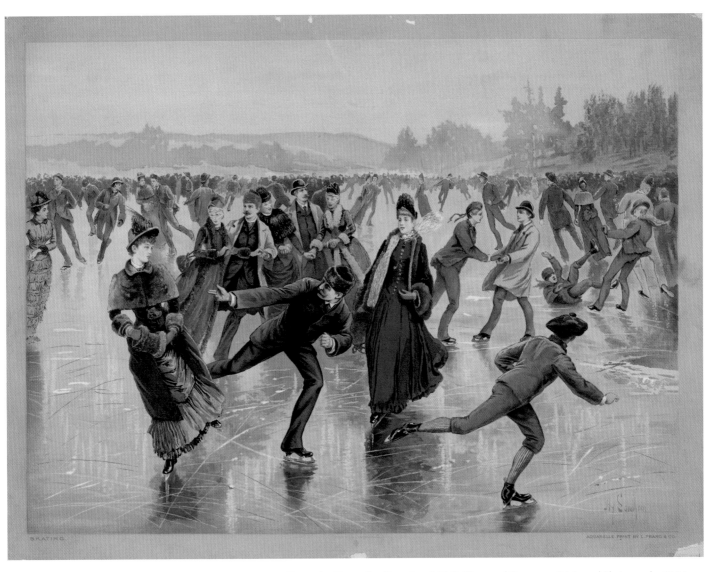

Skating by Henry Sandham (ca. 1885). Library of Congress, Prints and Photographs Division.

Winter – a Skating Season from *Harper's Weekly* (January 25, 1868).
Library of Congress, Prints and Photographs Division.

Miss Nancy Rowe, a competitor in St. Paul Outdoor Sports Carnival
Fancy Skating Contest (ca. 1914). Library of Congress Prints and
Photographs Division.

The fashion for colored stockings has certainly extended since the skating mania. Naturally the ankles are visible during this exercise, and white stockings have a miserable effect with a colored petticoat. Never, therefore, have colored stockings appeared so much an advantage; plaid looked especially well. They are worn in silk, spun silk, and fine wool, and they are always selected to match the dress.[4]

Ice-skating may have been a new sport for women in the nineteenth century, but evidence exists that as early as the twelfth century women, men, and children enjoyed the pleasures of skating on ice. An 1899 excavation in Ipswich, England, revealed the remains of a medieval woman who had drowned in the river. Still attached to her feet were a pair of bone ice skates she wore when she probably broke through the ice.[5] The Museum of London has a similar pair of bone skates from the twelfth century that were excavated outside of the city. They attach to the wearer's feet with a leather strap. William Fitzstephen's account of London in 1173 corroborates that skating was young Londoners' favorite winter game:

> When the great marsh that laps up against the northern walls of the city is frozen, large numbers of the younger crowd go there to play about on the ice. Some, after building up speed with a run, facing sideways and their feet placed apart, slide along for a long distance...Others are more skilled at frolicking on the ice: they equip each of their feet with an animal's shinbone, attaching it to the underside of their footwear; using hand-held poles reinforced with metal tips, which they periodically thrust against the ice, they propel themselves along as swiftly as a bird in flight or a bolt shot from a crossbow.[6]

Engravings and paintings from the Renaissance show that men and women enjoyed ice skating together with little to no modification to dress. Women may have held their skirt in their hand a few inches above the ground, but even during the seventeenth century the wide cumbersome pannier did not hinder them from skating with the boys. It was only in the nineteenth century that women wishing to do more than needlework had to overcome some major obstacles.

Skater with Scarf by Ethel Rundquist (published January 1916).
Library of Congress, Prints and Photographs Division.

▪ Safety Versus Modesty

In the Victorian era, women who wanted to take up sports faced the challenge of how to be fashionably modest but safe and comfortable. In particular, the bicycling craze in the United States starting in the late 1880s tested notions of public propriety. At the beginning, women cyclists just made do with their corsets, bustles, and petticoats, which unfortunately tended to get caught in wheels and cause injuries. Despite the dangers, modesty was a greater concern. The American Women's Rescue League condemned bicycling by women saying that "it produced immoral associations, both in language and in dress, which have tendency to make women not only unwomanly, but immodest as well."[7] Despite some objections, by the early 1890s bicycling for both sexes was a popular pastime. The introduction of the pneumatic tire in 1888 smoothed the ride, and next came the safety frame. Similar to bicycles today, the early bicycle had two wheels of the same size with a bar in between. For the ladies the bar was dropped to accommodate the skirt. Although women today often ride wearing pants or shorts, the dropped top tube persists.

Skirts tended to billow up while cycling; one solution was to sew weights into the hem of skirts. Then bloomers or knickerbockers were added under skirts for modesty's sake. When bicycling became the rage everyone from fashion magazines to retailers jumped in to promote specialized outfits for cyclists. In October 3, 1895, *Vogue* advised that:

> The bicycling skirt should measure only some two to two and a quarter yards around the hem. The most convenient shape is buttoned up either side; these buttons should be left undone while riding from the knees only, be it understood, and the cloth should be course, have a very wide wrap so that no possible peep at the knickerbockers can be obtained.[8]

Daisy Elliott standing on the pedals of a bicycle, photograph by Alice Austen (ca. 1895). Staten Island Historical Society.

The *"new woman" and her bicycle* by Frederick Burr Opper (1895). Library of Congress Prints and Photographs Division, Washington, DC.

The Bicycle – the Great Dress Reformer of the Nineteenth Century! by Samuel D. Ehrhart (ca. 1862), published by Keppler & Schwarzmann, 1895. Library of Congress.

Photograph by Nasser K., 2013.

Even dress reformers, who sported the Turkish style bloomers from the 1850s, wore them under shortened skirts and not as standalone items. In all-female colleges the bloomers were adopted as gymnastic uniforms. At the women's college Mount Holyoke in Massachusetts, for example, an 1883 mandatory gymnasium suit was bloomers under a skirt reaching seven inches above the floor.[9] In 1873 the magazine *Le Sport* noted that bloomers were useful for some activities, but concluded that it "is a man's article of clothing… and because of that, women who have the true intuition of elegance of their sex will always abstain from it."[10] By the late 1890s, however, at most colleges, bloomers were worn over tights and paired with a blouse.

Gymnastics, unlike bicycling, was practiced in closed all-female settings, which explains why bloomers, despite being rejected by the mainstream for decades, were a sensible choice. Any garment that contoured the legs was deemed inappropriate for public appearance, but worn under skirts, the bloomers allowed women to wear a more comfortable, shorter hemline.

Women who felt bloomers worn without a skirt were compromising their modesty opted for a divided skirt. It was essentially a very wide-legged pair of pants. Some divided skirts had an additional panel that buttoned double-breast style on the front. It concealed the divided leg, but also created a fashionable flat front. Despite such measures,

Portrait of Lillian Russell in the Bijou Opera House Production of Patience. Courtesy of the collection of Harold Kanthor, Department of Rare Books & Special Collections, University of Rochester.

Bovril for Health Strength & Beauty. The makers of the meaty bouillon ran many sporting advertisements (early twentieth century). Collection of J. M.

Tug of War Team in the Gerald W. Williams Collection, Special Collections and Archive Research Center, Oregon State University.

the divided skirt was still viewed primarily as trousers and did not affect street fashion to any extent. Like the gymnasium suit, the divided skirt stayed just within the realm of specialized sporting attire.

An 1895 caricature titled "The bicycle—the great dress reformer of the nineteenth century!" sums up the significance of bicycling attire for women's social emancipation. In this caricature, a man and woman similarly dressed in breeches and tailored jackets shake hands over a bicycle, while behind each of them the changing fashions of the nineteenth century in all their grandiosity are depicted. Another contemporary source proclaimed that bicycling had "done more for dress reform than the advice of the

medical profession and lecture platform have accomplished in fifty years."[11]

Bicycling itself did not make women abandon their bustles and shorten their skirts; rather, a more gradual evolution of taste made clothing for sport seem appropriate and attractive at that point in time. The American illustrator Charles Dana Gibson captured the new type of young athletic woman and made her into a style icon with his famous "Gibson Girl." Often depicted in the outdoors, in mixed company, or by her bicycle the Gibson Girl was fashionably dressed and epitomized a new generation of exuberant young men and women.

▪ Swinging These Skirts

As American women surrendered to the joys of bicycling, tennis was also becoming a favorite pastime. It was a fashionable game for men among upper classes as early as the Renaissance and its origins date even further back to medieval France. From its genesis, tennis was perceived as an elite game. In 1523 Henry VIII, the king of England, alongside the Holy Roman Emperor Charles V, challenged the princes of Orange and Brandenburg to a doubles match. Until the late nineteenth century, however, women were merely observers and not players for the most part. It was the introduction of lawn-tennis that changed that. In 1874 the English Major Charles Wingfield set rules for the sport and patented the equipment. Fashionable men and women played tennis (and its allied sport of badminton) together.

But what did women wear? The concern was still the length and modesty of the skirt. Women accustomed to upward of ten pounds of undergarments, petticoats, and layers of fabric swung the ball in their street clothes.

Everyday clothes often comprised a chemise, a wire bustle hanging over the behind, a corset, petticoats, and a dress with folds of fabric draped over the back. The floor-sweeping hemline made it nearly impossible to chase balls or retrieve them from the ground although Victorian ladies managed. Maud Watson, the winner of the first ladies Wimbledon championship in 1884, apparently defied conventions by shortening her skirt to ankle length, a departure that did not go unnoticed by the audience.[12]

The modestly dressed women of the time aspired to look their best regardless of the occasion. Although dresses for tennis retained the general look and shape of street clothes, some distinctive features developed. Stripes were a stylish choice. They worked beautifully with the fashion to drape "poofs" of fabric over the bustle because they created a playful interest with the stripes going in different directions. A matching striped petticoat, often with knife pleats adding both texture and some ease of movement, was also worn. A beautiful tennis dress from 1885 has an apron, which was another specialized tennis item for the fashionable women. A tennis apron had pockets to hold the balls and was embroidered or trimmed to match the outfit.

Although the Victorian era gave way to a new attitude with the turn of century, skirt length remained an issue. May Sutton, a young, vigorous American player, was forced to lengthen her skirt, which was a mere four inches above the ground, when she played at Wimbledon in 1905. Still a glimpse of May's ankle caused a sensation at the tradition-heavy Wimbledon. May won the singles championship that year and again in 1907. Years later, May's sister Violet, herself a tennis player recalled: "…it's wonder we could move at all. Do you want to know what we wore? A long underskirt, pair of drawers, two petticoats, white linen corset cover, duck shirt, long white silk stockings, and a floppy hat. We were soaking wet when we finished a match."[13]

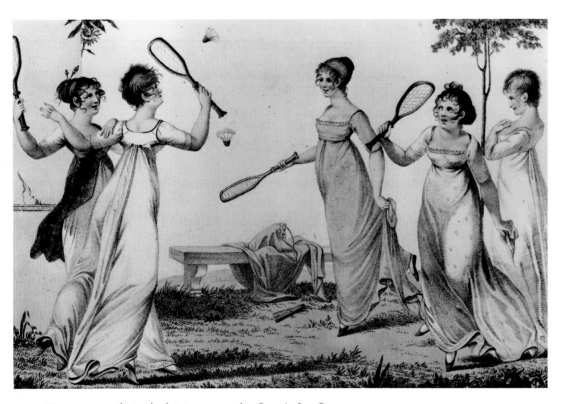

Young women playing badminton in a garden. From Le Bon Genre, No. 11: le Volant (1820s). Paris. Snark/Art Resource, NY.

In general, tennis attire was not a ground for innovation and did not steer much away from street clothes—until Suzanne Lenglen arrived. The year was 1919, the place, Wimbledon. Lenglen wore a short-sleeved, calf-length, loose white cotton dress. Worn corsetless, with white stockings and a linen hat, Lenglen's outfit epitomized the woman of the modern era. The sensational outfit was designed by the French couturier Jean Patou. Patou's brother-in-law, the tennis champion Raymond Barbas, had introduced him to Suzanne and the name Lenglen became synonymous with Patou's couture house. Later, Patou also created Lenglen's iconic outfit of knee-length pleated skirt and sleeveless sweater. Suzann Lenglen's off-the-court wardrobe, also principally by Patou, inspired not just other female players, but also fashion-forward women who adopted the dynamic look and effortless chic of both Patou and Coco Chanel. Patou at that time was advocating a simple loose style for his clientele. He was among the first to recognize a growing interest in fitness and sports fashion, and he opened a specialized boutique called Sports Corner that was inspired by Lenglen's dynamic style of play. Patou's chic simplicity was a mark of modernity, and his designs crossed over between leisure and actual sports.

Trained as a ballet dancer, Lenglen's game was like a dance. Patou's knee-length pleated skirt allowed her to swing her legs in any direction, jump in the air, and zoom after balls. College girls had been sporting knee-length skirts for gymnastics as early as 1910, a full decade before Lenglen, yet it was really the shorter skirt's appearance for a public match of the elite sport of tennis that made the dazzling impression. Lenglen was also known to fold her stockings daringly above the knees over the garters.

The 1920s were all about showing the legs and using them, whether to play, dance, dive, or swim. Taking the lead from Patou, fashionable women who were after the tennis look, flocked the sportswear departments of a growing number of couture houses. Couturiers such as Jeanne Lanvin, Jacques Heim, Rochas, and Hermès now catered to a younger clientele who wanted to look sportive every day.

Although Lenglen never played in the French Open at Roland Garros, which was built in 1927 after her retirement, a statue depicting her mid-flight, pleated skirt swaying around her spread legs, stands outside a court that bears her name. Lenglen was admired for her

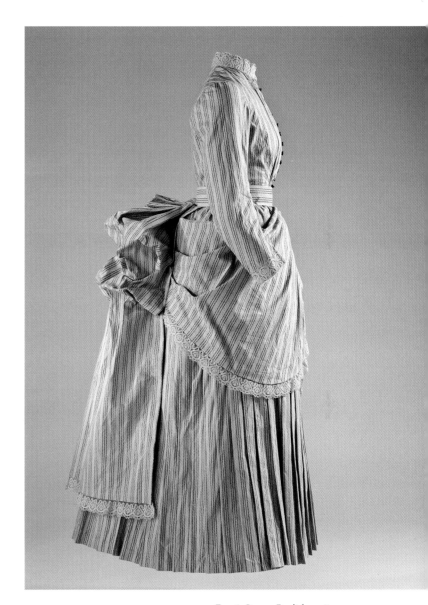

Tennis Dress, English; cotton plain weave, printed, with cotton-lace trim (ca. 1885). Los Angeles County Museum of Art.

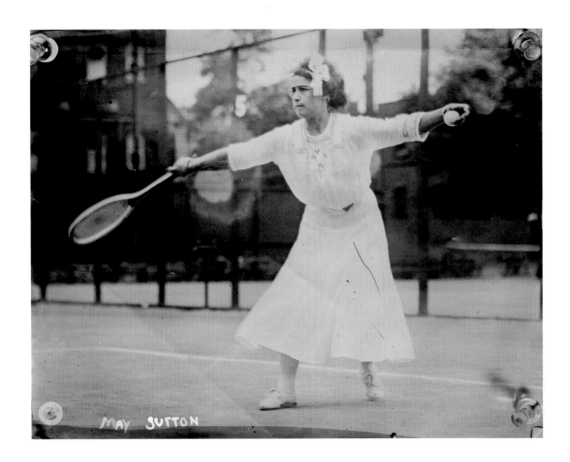

May Sutton, published by Bain News Service (between 1910 and 1915). Library of Congress Prints and Photographs Division.

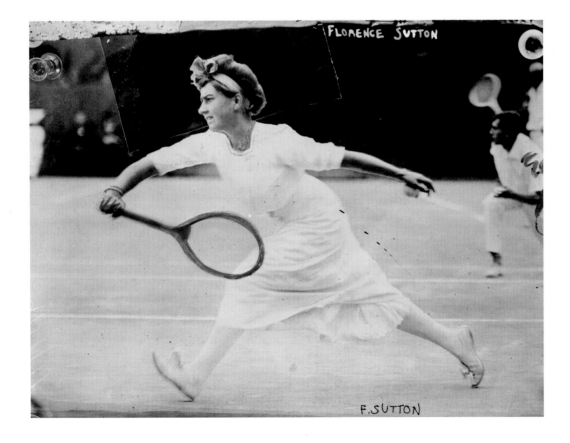

Florence E. Sutton, sister of May Sutton and accomplished tennis player by her own right. Flickr Commons Project, Library of Congress Prints and Photographs Division.

athletic game, which was considered light years away from any female player before her. Her branded image was so strong that she inspired a character in *Le Train Bleu*, a 1924 Ballets Russes production. The blithe ballet featured costumes designed by Coco Chanel, Diaghilev's friend and collaborator, with the tennis-playing character dressed à la Lenglen in a white, loose-fitting, below-the-knee dress and bandeau. A golfer costume, inspired by the young Prince of Wales and additional costumes of striped, knit bathing suits highlighted the fact that sports had become the mark of the fashionable. Lenglen's influence has been far reaching: Kate Middleton, the Duchess of Cambridge, was photographed in an Alexander McQueen cable-knit flared dress inspired by Lenglen's iconic outfit on two different occasions, in a 2011 tour with her husband William and a year later when she attended the Royal Box at Wimbledon.

Sporting pursuits in American colleges promoted adoption of a more casual attire and, by extension, a less formal interaction between young men and women (ca. 1908). Collection of J. M.

Suzanne Lenglen (June 29, 1925). Library of Congress Prints and Photographs Division.

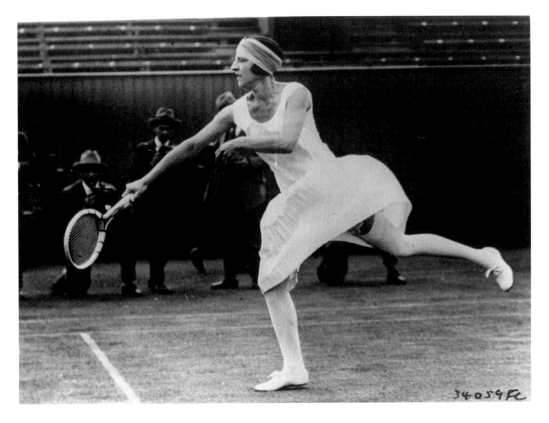

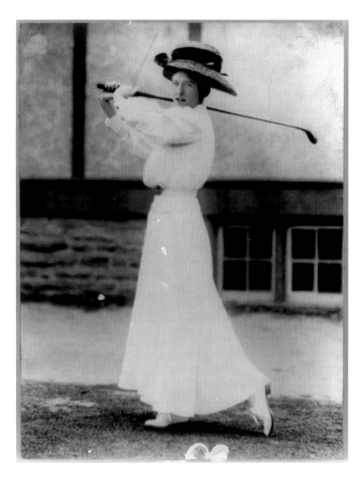

Mrs. Kate C. Harley, winner of the U.S. Women's Amateur Golf Championship at the Chevy Chase Club, Maryland (1908). Library of Congress Prints and Photographs Division.

Driving an automobile, like riding a bicycle, often called for new attire. These ladies are not out for a spin but at a fair in a staged photograph against a painted backdrop (ca. 1910). Collection of J. M.

Antique postcard postmarked Ness City, Kansas, March 7, 1910. Collection of J. M.

A white, crisp skirt with thick contrasting dark border feminizes the young woman's masculine-inspired outfit (ca. 1890). Collection of J. M.

▪ The Short Story

Innovation in dress on the tennis court did not stop at Lenglen. A much-discussed debate over whether women should or shouldn't be allowed to appear without stockings at Wimbledon culminated in 1931 during a match between Joan Lycett and the Spaniard Lili de Alvarez. The debate persisted throughout the 1920s but left the choice to the players, who in order to avoid controversy chose not to forgo the white stockings. By 1931, the audience was accustomed to seeing bare-legged women on other tennis courts and on beaches. When Joan Lycett stepped on the court bare-legged for the first time in Wimbledon's history, it went almost unnoticed because nothing prepared the audience for her opponent's choice of dress. Clad in a tunic and a divided skirt designed by Elsa Schiaparelli, de Alvarez's "trousered frock" reached below the knees. The abundance of fabric allowed greater movement and a more aggressive game without any concern of immodest exposure. The press, however, were not convinced. On June 24, 1931, *The New York Times* reported:

Golf Lesson – Bohnert Park, California (ca. 1922). Collection of J. M.

> Old Ladies gasped and old gentlemen gurgled as the comely Spanish player pranced about in preliminary practice in her "divided skirt" of cream crepe de chine, topped by a close-fitting bodice.[14]

There was much speculation about the ramifications of Senorita de Alvarez's revolutionary gesture. Most of the tennis experts, turned stylists for the moment, were of the opinion the innovation in dress would be short lived. Most of them agreed the costume, despite the freedom of movement it gave, was not very becoming.

More than immodesty, what alarmed the critics was what was perceived as a female adoption of masculine attire. Although women of the 1920s bobbed their hair, gave up corsets, and wore one-piece bathing suits similar to those of their male counterparts, the wearing of trousers remained taboo. De Alvarez's choice of dress was declaimed for

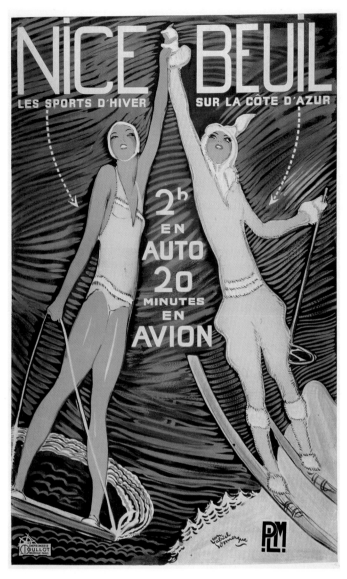

Nice-Beuil, winter sports on the Riviera, 2 hours by car, 20 minutes by plane, poster advertising tourism, for PLMPhoto. Kharbine-Tapabor/The Art Archive at Art Resource, NY.

revealing more than before. It actually didn't; rather, it was intruding into the male sphere.

Wearing pants, especially if they reached above the knees, was newsworthy. Although hemlines dropped to calf- and floor-length in the 1930s, some female tennis players pushed the envelope with shorts. Helen Jacobs, the celebrated American champion, was very nervous before appearing in shorts for the first time at the 1933 US Championship. It was only a year prior that men were allowed to play in shorts, not without controversy as well.

A headline in *The New York Times* on August 15, 1933, announced: "Miss Jacobs Plans Debut in Shorts Today." The "queen of American tennis" as she was called in the report, had been wearing shorts for practice, but not yet in public. The shorts, she claimed "improve my game and all the other girls say the same. I know I have lost many points through my racquet catching in my skirt."[15] She won the finals in front of an audience of 8,000 when after only three rounds, Helen Wills, her longtime rival and fashion icon, abandoned the court mid-game. Jacobs continued to wear shorts reaching a few inches above the knee despite criticism that this was unbecoming for a lady. Other female tennis players adopted her look and *Vogue* reported that some society women opted for it: "Miss Whitney Bourne, like many of the younger set, prefers to wear shorts for tennis. Mrs. Hardin… has joined the bicycle enthusiasts. She favours a divided linen skirt and a white ribbed sweater."[16] Although for a moment in 1933 it seemed women were finally ready to substitute modesty for comfort, several decades elapsed before shorts were no longer considered a transgression.

All the same, some players used the courts for daring fashion statements. In 1949, the American Gertrude "Gussy" Moran, also known as "Gorgeous Gussy," flashed lace-trimmed panties at Wimbledon. Worn under a white dress designed by tennis player-turned-fashion designer Ted Tinling, the lace underwear caused quite the sensation. It was said that media photographers lay on the ground to capture the sight.

From the 1940s and through the late 1970s, Ted Tinling designed some of the most controversial outfits in tennis history. Other than Gussy's famous lace panties, Tinling was also known for the racy outfits he designed for Italian tennis star Lea Pericoli, including a 1964 micro-miniskirt of ostrich feathers that showed the full length of Perioli's legs. In 1965 she appeared with another creation of his; this time the short, short skirt was covered with three-dimensional white fabric roses.

Tinling was always on trend, and his tennis costumes followed the mode. His daring designs included unconventional details like pleated hemlines, sheer insets, embroideries and lace trims, and even more unconventional fabrics like leather dress and shorts, lamé panties, satins, and eyelet fabrics.

Outfitted for a racket sport (1947), photograph by Toni Frissell. Toni Frissell Collection, Library of Congress.

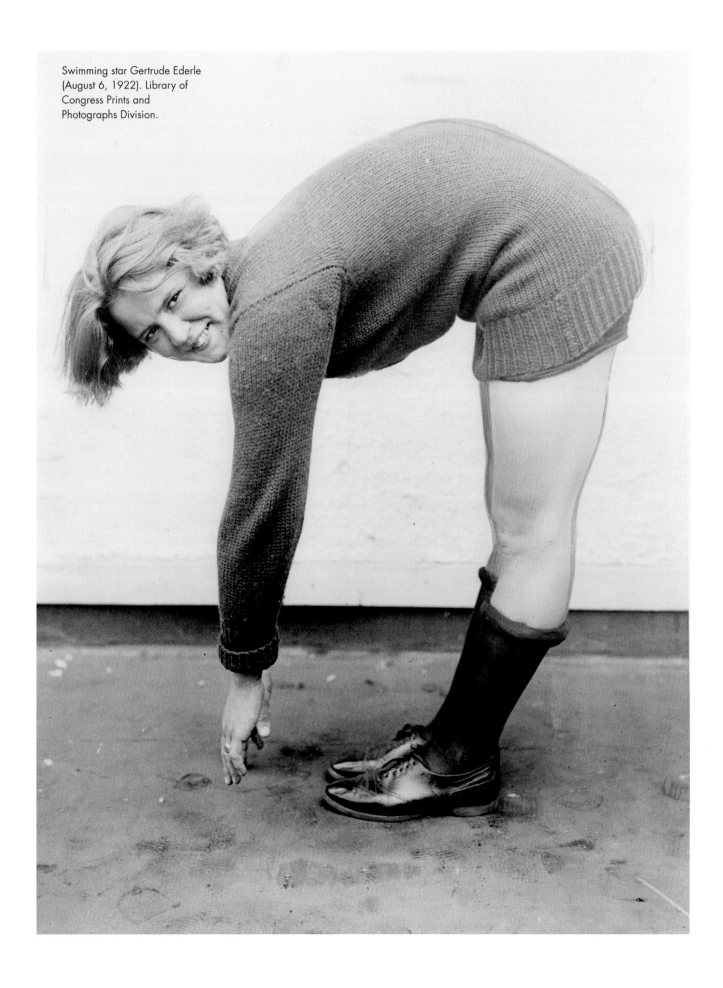

Swimming star Gertrude Ederle
(August 6, 1922). Library of
Congress Prints and
Photographs Division.

▪ School of Dress

Beginning in the 1930s fitness became a national, if not international, obsession. The fashions of the era required the semblance or actuality of a perfect body. Fashion magazines gave the lead with advice on what to wear and how to get the sleek figure for it. Increasingly, sportswomen were becoming newsmakers. The tennis player Helen Willis, the athlete Ella "Babe" Didrikson, the swimmer Gertrude Ederle, and the aviator Amelia Earhart all gained celebrity status. Their accomplishments were praised, and their style was equally and carefully followed. These women helped form a new ideal femininity—youthful, athletic, and even openly sexy. Their exuberant lifestyle inspired women to participate in sports. The greater variety in sports clothes meant that women could be comfortably attired for their choice of play without compromising their fashion sense.

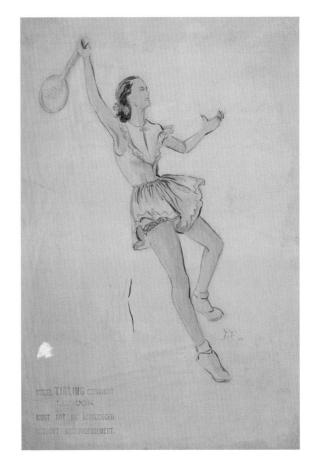

In the 1930s, fitness and exercise became an inseparable part of campus life at women's colleges, and by extension a sporty look came to signify a free-spirited American lifestyle. The all-female setting allowed young women to experiment with dressing in ways that may have been considered inappropriate otherwise. Skirts were boldly shortened, sometimes worn with knee socks, or stretchy knitted fabrics adhered to the body.

In fashion, designers were looking back to classical times and a muscular, streamlined, idealized body. Young athletic college girls were now regularly featured in fashion magazines and their sportive attitude and style trickled down. The lines between sport clothes and sportive-looking clothes were blurred. By the 1940s, college girls were a growing market for designers to test new ideas. A July 1943 edition of *Harper's Bazaar* shows a photograph of two young women in Claire McCardell dresses worn over a sweater and leggings. The caption reads: "in January we tossed out an idea, a new silhouette based on the leotard of ballet school tights.... The *New Yorker* ribbed us but fashion followed us. This month we present leotards for the college girls. Under them, wear nothing but brassiere and pantie girdle."

The original sketch of the Ted Tinling design for Gertrude "Gussy" Moran (1949). Ted Tinling Archives of the International Tennis Hall of Fame & Museum, Newport, RI.

Vera Maxwell was another American designer who regularly created ensembles equally suitable for the court and for socializing at the clubhouse. She too favored jersey leotards that appealed to confident, young women who wished to dress in comfortable and effortless style. During World War II, a shortage of nylon fiber to make stockings made women seek alternatives. Some adopted slacks for sports. Those who loved to ski created leggings-like looks by slimming their trousers. After the war and early in the

This fashion plate outfit, masculine with reservations, includes a sleeveless tailored long jacket, necktie, and a combination short plaid skirt with pedal pushers (ca. 1920–1930). Collection of J. M.

Claire McCardell, black and white plaid cotton sunsuit (1957). The Museum at the Fashion Institute of Technology, NY.

1950s, slim black pants were worn by young girls who rode Vespas, the ultimate fashion accessory of the decade. Pants were no longer taboo, and sportive activities were now an integral part of young men and women's lives.

Late in the 1940s and increasingly throughout the 1950s and 1960s, skiing led the pack as a status recreational pursuit. Skiing was one of the only sports for which women adopted pants as early as the 1920s. In the 1930s ski pants were wide or women wore streamlined overalls, following the silhouette of pajama pants that were typically worn in resort towns. As the jet-setters favorite sport, skiing was naturally embraced by couturiers, like the French Christian Dior and the Italian Elsa Schiaparelli who were quick to react and create specialized skiwear lines.

Toni Frissell, *Harper's Bazaar* fashion photographer, in many ways was responsible for shaping the image of the twentieth century's new athletic ideal. For the December 1948 issue, she shot Swiss skier Poppi de Salis in an outfit that Italian sportsman-turned-designer Emilio Pucci

designed for her. The streamlined outfit had high-waisted pants that tapered down at the ankles to create an elongated, slim silhouette. Pucci himself was a member of the Italian Olympic ski team in 1933 and 1934. He became famous first for his fashionable sportswear and later for his vibrant prints. After his initial appearance in *Harper's Bazaar* he went on to

design a ready-to-wear line of skiwear for Lord & Taylor. Pucci's innovation went far beyond chic outfit. He was among the first to use Lycra and in 1953 developed a lightweight silk jersey fabric. Pucci's textiles, which he developed specifically for his body-skimming designs, allowed sports clothes to have more elasticity and street clothes to be sexier and closer to the body.

Celebrity and society women in the 1950s and 1960s wanted to be photographed on the slopes, resulting in a distinctive ski and après-ski fashion. The multitalented Ann Bonfoey Taylor—aviator, ski champion, fashion designer, model, and society fixture— received fashion icon status in great part because of her chic American athletic look. She was often captured on the slopes in skimming ski outfits and one famous picture shows her in a short tutu-like skirt worn over stretch leggings. Even Queen Farah Diba of Iran was shot in 1962 arriving for a ski lesson in leggings and an oversized sweater.

Anne Bonfoey Taylor, standing next to birch tree in snow, wearing a ski outfit including a military hat, and goggles (1969). Library of Congress Prints and Photographs Division.

Ann Bonfoey Taylor on skis in Vail, Colorado, wearing a white vinyl jacket, black pants, and a black rabbit hood, photograph by Toni Frissell (1969). Library of Congress Prints and Photographs Division.

Photograph by Nasser K., 2013.

▪The Long, Long legs

In 1963 the French designer Hubert de Givenchy designed several ski outfits for Audrey Hepburn's character in the film *Charade*. The most memorable one is a head-to-toe brown outfit that looks like a catsuit. It fit perfectly over Hepburn's petite figure, and matched to a new ideal body, one that was long and slim.

Michele Rosier, the daughter of *Elle* magazine publisher Helen Lazareff, was a fashion designer known as "The Vinyl Girl" because of her affinity for the material. She designed ski outfits in vibrant colors made of vinyl and quilted nylon. These technological fabrics, alongside Lycra, defined the modish new look of skiwear. The new fabrics echoed a fascination designers had with the Space Age. Elastic bodysuits, or at least head-to-toe outfits that simulated the skintight bodysuit, best achieved the futuristic look. Sportswear became the model of clothes for the future. It reflected a lifestyle that was distinctly American and undeniably young. According to *Vogue* in 1969, "Sport clothes showed fashion how to be fast and free. Now they show how to steal the thunder from all the other competitors, with racing colors …all-in-ones, second skin shapes."[17]

The appeal of athletic-looking clothes translated into a

Man and woman getting ready to ski, Mount Hood, photograph by Ralph I. Gifford (ca. 1930). Gifford Photographic Collection, Special Collections and Archive Research Center, Oregon State University.

sports attire mania in the 1970s with women wearing basically gym and workout clothes for parties. Lycra was the favorite fiber and colorful stretch velour tracksuits were acceptable for informal social activities and running errands. Leotards paired with short skirts or sweater tunics, and of course leg warmers—a must-have accessory—also drew attention to toned legs and boasted an athletic-inspired lifestyle.

Young, free-spirited teenagers and edgy jetsetters are one thing, but highly traditional Wimbledon is entirely another. In 1985, Ann White shocked the old guard of tennis when she chose a white Lycra bodysuit to play Pam Shriver. *Vogue* reported that, "The skintight stretch warmup produced a fuss reminiscent of the one caused by the lace panties Ted Tinling designed for Gussie Moran in '49. Wimbledon officials barred White from playing in the bodysuit a second time—but good news—you can find it in stores this fall…"[18] The catsuit may have not had success outside of athletics and performance, but in 2002 the ever-inspiring Serena Williams continued the tradition of convention-defining outfits when she played the US Open in a skin-tight catsuit. Eyebrows were raised, and Williams had to admit that she might be among the few who could actually rock this racy look. "If you don't have a decent shape," she said, "this isn't the best outfit to have."[19]

Sportswomen continue to look for clothes that allow them to achieve a greater competitive success, and in the new millennium skin-tight overalls in techie fabrics seems to be the solution. A fashionable look is still desired, on and off the court. Sportswear has penetrated fashion to the extent that fashion brands like Juicy Couture have built their multimillion dollar businesses around sportive appearances and energetic attitudes.

Taking Stockings

Voluminous folds of fabric may have hidden legs for centuries, but women went to great lengths to enhance their shape with stockings, shoes, and other leg-specific accessories. Stockings in particular propelled major technological innovations that revolutionized the textile industry and the business of fashion.

Milton N. Grass in his *History of Hosiery* says that stockings were the last item of clothing that men and women added to their wardrobes. Stockings, in the contemporary meaning of the word, are documented in use as early as the eleventh century, yet covering the leg and foot for protection dated as far back as ancient Egypt. Shoes and leg-coverings protected people from the elements, informed the stance of the wearer, and reshaped the body—the essence of fashion.

Stockings have an erotic power, only shadowed by that of shoes. According to Harold Koda, "Shoes have been the most persistent example of fashion's imposition of an idealized form on the natural anatomy."[1] This transformative quality is why so many women obsess over shoes. Together, shoes and stockings make the leg a focus of chic and erotic lure.

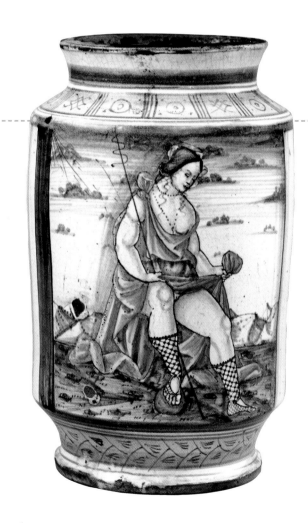

Venetian albarello, or pottery apothecary's jar (1500–1520 A.D.) The woman wears woven half-stockings that appear very similar to fishnets. Walters Art Museum, Baltimore, MD.

Royals and Commoners

The Duchess of Cambridge, Kate Middleton, has had a far-reaching influence on the fashion industry, so the fact that she almost always has donned stockings since becoming a duchess has not gone unnoticed. Both the *Daily Mail* online (July 5, 2011) and *The New York Times* (November 9, 2012) have reported on Middleton's stockinged legs.

The royal protocol dictates that royals not appear for public functions in bare legs. Kate Middleton, along with other young British royals like Princesses Beatrice and Eugenie, obey. A glossy shine often defines Middleton's legs, suggesting the demure protection of a luxurious fabric

Well-made stockings have been used as means to distinguish royals from commoners probably as early as they were invented. In Europe, during mediaeval times and the Renaissance, sumptuary laws often dealt with stockings. An English act of 1555 stated that: "No men shall wear silk upon his hose, except Mayors and Alderman, under the pain of imprisonment, and the forfeiture of 10 pounds."[2]

Philip Stubbs in *The Anatomie of Abuses*, the 1583 potent criticism of the fashions and manners of the day, said that:

> . . . every one (almost), though otherwise verie poor, having scarce fortie shillings of wages by the yeer, wil be sure to have two or three paire of these silk neither-stocks, or else of the finest yarne that may be got, though the price of them be a Royal or twentie shillings or more, as commonly it is; for how can they be lesse, when as the very knitting of them is worth a noble or a royall, and some much more?

And added that:

> [Women's] netherstockes, in like maner, are either of silke gearnsey, worsted, crewell, or, at least, of as fyne yarn, thread, or cloth, as is possible to be had, yea, thei are not ashamed to weare hose of all kinde of chaungable colours, as greene, red, white, russet, tawny, and els what, which wanton light colours, any sober chaste Christian can hardly, without any suspicion of lightnesse, at any tyme weare; Then these delicate hosen must bee cunningly knit and curiously indented in every point with quirkes, clockes, open seame, and every thing els accordingly.

That sumptuary laws concerning stockings existed implies that stockings were worn by most people. Eleanor of Toledo, the Spanish-born Duchess of Florence, was buried on December 17, 1562, in crimson silk stockings, hand-knitted in an intricate pattern. Queen Elizabeth I was known to wear cloth stockings before her silk-woman, Mistress Montague, knitted for her fine, black silk stockings in the Spanish tradition. The knitted stockings fit snugly and thereafter the Queen is believed to have never gone back to the cloth kind.

The hand-knitting of stockings, especially using very fine silk yarn, was laborious. During Elizabeth I's reign, however, a clergyman named William Lee invented a simple frame knitting machine that was quicker. Although the knitting machine would eventually become one of the most important technological innovations of the fashion industry, during his lifetime Lee had little success. Upon seeing the coarse wool stockings that were the first prototype produced, the Queen dismissed Lee's machine. She said it threatened the livelihood of the thousands of domestic knitters. After his death, Lee's relatives continued to improve the machine, which eventually produced fine fully fashioned stockings on par with the hand-knitted ones. The stockings were knitted in one piece and seamed at the back.

A Well-Turned Ankle

During the eighteenth century, art, furniture, and costume inspired a romantic ambiance of seduction. Stockings with daintily designed decorations called clocks emphasized well-turned ankles and heeled shoes created graceful arched feet. Slightly shorter hemlines allowed both shoe and stockings to peek through.

Artists of the period used suggestively exposed feet and ankles to depict romantic and domestic scenes. The 1767 painting *The Swing*, by Jean-Honoré Fragonard, portrays a young lady swinging in a lush nature setting. One leg is exposed from the knee down amidst a froth of petticoats, while the other sends a small pink shoe flying through the air. Fragonard illustrated the white stockings with their tiny creases, the ribbon of the shoes, and the pink garter that is erotically tied above the knee to hold the stockings from slipping down the leg.

Fashion historian Anne Hollander, when looking at Fragonard's painting in her book *Seeing Through Clothes*, points to the exaggerated length of the tights. Similar proportional distortion exists in François Boucher's 1742 painting *La Toilette*. Here the calf is elongated, allowing the artist to eroticize the stockinged leg. Boucher depicted a lady dressing in her toilette, binding her thigh with a pink ribbon garter. Matching in color to the dress and stockings, a heeled slipper encases a tiny little foot. The shape of the slipper's sole forces the feet to arch in a way that must have made walking nearly impossible.

During the eighteenth century garters became more than just a functional item: many carried messages. One

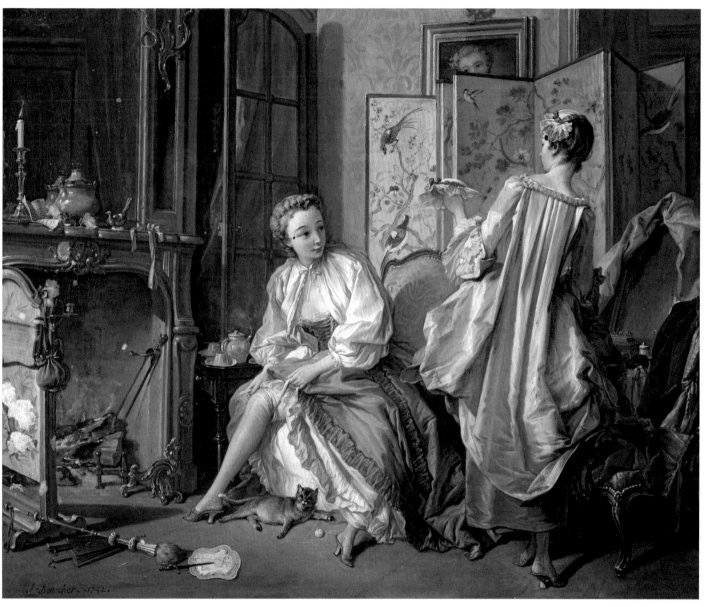

La Toilette by François Boucher (1742). Museo Thyssen-Bornemisza, Madrid.

Lady with a Harp: Eliza Ridgely by Thomas Sully (1818). National Gallery of Art, Washington, DC.

example from the collection of The Metropolitan Museum of Art is a red silk ribbon garter with the words "Plus sincere que je le suis, vous n'aurez jamais d'amis, or "If you're any more honest than I am, you'll never have any friends. Such messages suggest that, for men and women of the eighteenth century, the unseen upper leg was an arena to show off beautiful items of clothing.

Garters, which enabled stockings to cover the leg, were made of woven silk ribbons, sometimes with metal springs channeled between two layers for elasticity. The dentist Martin Van Butchell may have invented the spring garter; this eccentric person apparently also embalmed and put on display his deceased wife.

Garters refocused attention somewhat to the thigh. A 1734 brothel scene by William Hogarth, *The Rake at the Rose Garden*, shows a scantily clad prostitute reaching to remove a shoe. Her red-clocked stockings, held with a matching red garter, contrast with her naked thigh. A small hole in one stocking emphasizes her low social standing.

Linda Baumagrten and John Watson of Colonial Williamsburg, say that by the 1750s an estimated fourteen thousands stocking frames, in addition to many other hand- knitters, produced stockings for the local market and the American colonies.[3] Judging by the art works of the period, men and women alike were fascinated by legs and the accessories that adorned them. Harold Koda and Andrew Bolton, curators of the 2004 exhibition *Dangerous Liaisons: Fashion and Furniture in the Eighteenth Century*, point out that fashionable women played the pedal harp because it drew attention to their delicate feet. The pedal harp became a fixture in portraits of aristocrats and society women. The 1790 self-portrait of painter and harpist Rose Adélaïde Ducreux shows the pointed toe of her shoe extending through the fringed hem of a luxurious petticoat. Artists continued to depict women with harps well into the nineteenth century.

The fashion for white or cream muslin dresses in the neo-Classical style induced a demand for flesh-toned stockings. Women of the early decades of the nineteenth century wore their flesh-toned stockings with flat slippers to create a streamlined, natural appearance. The contemporary fashion magazine *The Ladies' Monthly Museum* said in 1797 that: "Small Italian heels are coming in with [the] rising generation, and simplicity of dress is now the criterion of good taste."[4] Heels co-existed alongside flat shoes, until they flattened completely by the 1830s.

■ From Unisex to Sexiness

By the early nineteenth century, men also abandoned the elaborately ornate clothes of yesteryear. While men of the eighteenth century wore equally, if not more, decorated stockings to show off muscular calves, a new generation of men replaced breeches with trousers. Gradually, from that point on, only women wore long stockings, under increasingly widening skirts.

Stocking styles changed slowly and gradually. The structure of stockings remained virtually unchanged throughout the nineteenth century and well into the twentieth century, consisting of two separate legs reaching above the knee. Materials included silk, cashmere, cotton, and wool with plaited or embroidered clocks.

Colors corresponded to the fashion of the moment. In the 1860s synthetic dyes brought new ranges of color into the market, such as bright purple, deep red, and shades of green. To match the dress, stockings became daringly colorful. Stripes and plaids were also fashionable, and black, which was previously very expensive to make, became cheaper and easier to control. By the 1900s, black became the most popular color; about nineteen out of twenty pairs of stockings sold were black.[5] It was a practical choice for women promenading in dirty city streets or going out for work and served as a good backdrop for handsome decorations in bold colors.

Starting from the 1840s, garters were reinforced with vulcanized rubber, which added elasticity. In a century obsessed with chastity, even the height of where the garters were worn caused debate. A periodical, *Graham Illustrated Magazine*, published in 1858 a letter from a Milwaukee reader:

> You will take notice, that just above the knee there is no hollow or depression in which garters could be retained, no projection on which it could be made to hold. The action of the muscles in walking would surely displace elastic put there As legs were made before stockings, we can hardly suppose that this hollow was purposely for elastics, but whether it was or was not, we make use of it as the proper place to attach our garters to keep our stockings in place while on promenade. This is the only spot where garters can be retained with any comfort—the spot designated by Nature and made use of by ladies who have well formed limbs. Those women who resemble men in their shape may perhaps tie the garter above the knee, but they are exceptions to the general rule.[6]

Three Dancing Women, Courier Litho. Co., (ca. 1899). Library of Congress Prints and Photographs Division.

Chorus girl in short stockings (ca. 1880). Library of Congress Prints and Photographs Division.

Another innovation introduced in the 1870s was the suspender belt. The belt, worn atop a corset, hung from the waist to hold the stockings from slipping down while walking. As Lynn Eleri from the Victoria and Albert Museum notes in *Underwear Fashion in Detail*, these garments endured through the twentieth century as seductive bedroom clothes because "they allude to a time when undressing was a slow and complicated procedure, hindered by the clasps, fastening and ties of corsets, girdles and belts."[7]

Artists of the nineteenth century often traded on these notions and portrayed women in partial undress. As scholar Janice West points out, when Edouard Manet dressed *Nana* (1877) in a white petticoat, pale blue embroidered stockings, and black heeled shoes, he created sexual tremor

by combining underwear and outerwear. The shoes, she says, are "worn to emphasize nakedness."[8]

As the nineteenth century came to a close, corsets, stockings, garters, and suspenders became so fancy that they were no longer mere undergarments, but rather lingerie—a name befitting the effort and detail that went into making them. Tea gowns, meant to be worn at one's home, were also becoming fashionable and equally complex in design. Women wore them to receive guests, so they were worn on top of undergarments, including stockings designed to match the color and elements of the gown.

The 1890s, known as the Naughty Nineties, were a heyday of stockings. This period is another example that refutes the commonly held belief that hidden under long skirts were plain and boring undergarments. Although skirts still swept the floor, stockings were designed to seduce. A pair of Gay Nineties navy blue stockings from the collection of The Metropolitan Museum of Art has an alternating design of open work that would have exposed the skin through the delicate knit. The pattern only covered the leg to the calf; when lifting her skirt to climb stairs or a street car, a woman would have allowed a glimpse of the evocative design.

In the late 1890s and early 1900s a striking snake wound down the calf of some of the fanciest women's stockings. Snake motifs proliferated during the art nouveau period, which favored meandering elements and sinuous lines. Luxurious examples had the motif embroidered with sequins and beads down each leg. One such pair of stockings, now at the Victoria and Albert Museum in London, was exhibited at the Paris Exposition Universelle of 1900 where the art nouveau style was prevalent. The curving shapes of a crawling snake echoed the curving line of the body and clothes of the period, in addition, of course, to connoting the ultimate, most biblical act of seduction.

Other stockings incorporated lace and floral motifs embroidered in silk or ribbon-work. When describing the singer and actress Gaby Deslys, Cecil Beaton in *The Glass of Fashion* said that she "made a point of revealing her legs, too, well-rounded legs encased in lace stockings. Her small feet were shod with stub-toed shoes whose buckles glittered, whose incredibly high heels were studded with flashing rhinestones."[9] Irene Castel, the famous dancer, shunned the over-the-top frills and poufs of the Belle Époque, yet she too said that, "There are filmy stockings with anklets embroidered in colored gems, lace-encrusted hose with silver embroideries, and of course, all kinds of clocks and butterflies to draw attention to a slender foot or ankle. Any of these may be worn without violating good taste."[10]

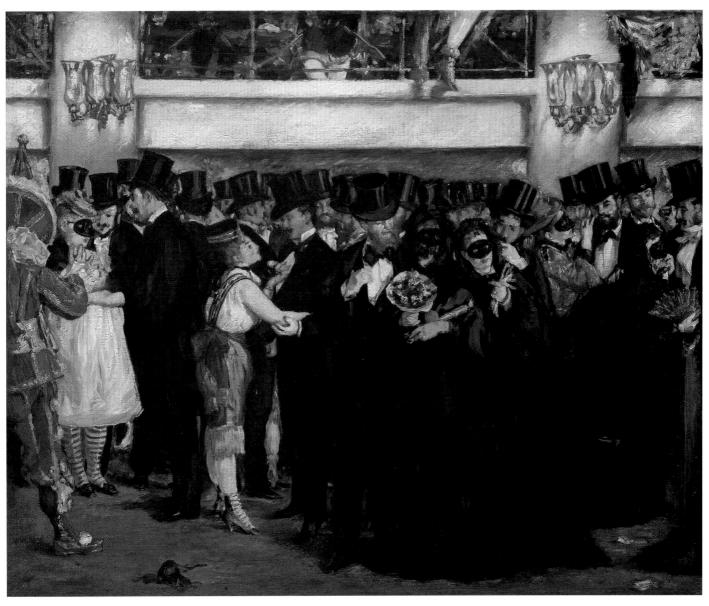

Masked Ball at the Opera by Edouard Manet (1873). National Gallery of Art, Washington, DC.

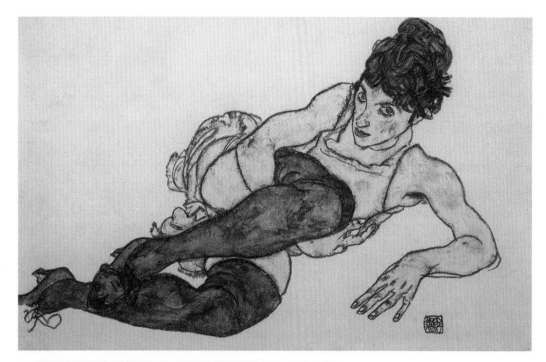

Reclining Woman with Green Stockings by Egon Schiele (1917). Old postcard reproduction. Collection of J. M.

A quick lift of a hemline, with a small step, or with the swing of a dancing leg, made the glimpse of ornate stockings piquant. Between the years 1900 and 1910, *Vogue* regularly featured exquisite designs with open work or embroidered and decorated with dainty trimmings in an array of floral patterns.

Young woman standing outside savings bank raises her skirt to insert a five-dollar bill inside her gartered stocking (ca. 1908). Library of Congress Prints and Photographs Division.

By 1900 most women opted for black stockings, a practical choice especially for urban women. In this photograph the ribbon garter is handsomely tied below the knee (ca. 1900). Collection of J. M.

In the Latin Quarter (Au Quartier Latin) by Jules Chéret. Gift of the Grey Froelich Memorial Fund, National Gallery of Art, Washington, DC.

▪Dare to Bare

When in the 1920s hemlines started to get shorter, exposing more and more of the leg, suddenly the shape and line of the leg became the focus of attention. Women wanted stockings to appear bare, so while dresses were heavily decorated with dangling beads and fringes, stockings became plain with an emphasis on the fit and not the decoration. Contrary to logic, stockings became less elaborate and less decorated than previously. Now that legs were in full view, rather than decorating them, women were striving to make their legs appear as natural as possible.

Continuation school girls topping stockings in Ipswich Mills, Boston, Massachusetts (February 2, 1917), photograph by Lewis W. Hine. Library of Congress Prints and Photographs Division.

"A new fashion - rolled stockings" by Underwood and Underwood (early 1920s). Library of Congress Prints and Photographs Division.

If black was the favorite color the previous decade, during the 1920s women were gradually adopting flesh-tone colors, with the young and adventurous leading the way. Flappers preferred sheer stockings that scandalously exposed their knees. Advertisements for stockings emphasized sheerness and colors ranged from "realistic" tans and flesh-tones, to browns and deep red-tans. By the end of the decade, seamless stockings made legs seem entirely nude.

The length, material, and color of stockings came to define the fine line between decent and indecent, young and dated, fashionable and old-fashioned. The daring fashion-forward young women donned sheer silk stockings and caused social tension. *The New York Times*, for example, reported in March 29, 1923, on the suicide of fifteen-year-old Suzanne Poyer, who jumped from a bridge into the Seine river because her parents refused to let her wear silk stockings and did not grant her "permission to attend dances."

On August 25 of the same year the small town of Somerset, Pennsylvania, was "somersaulted into a style class war with bobbed hair, lip-stick flappers arrayed on one side

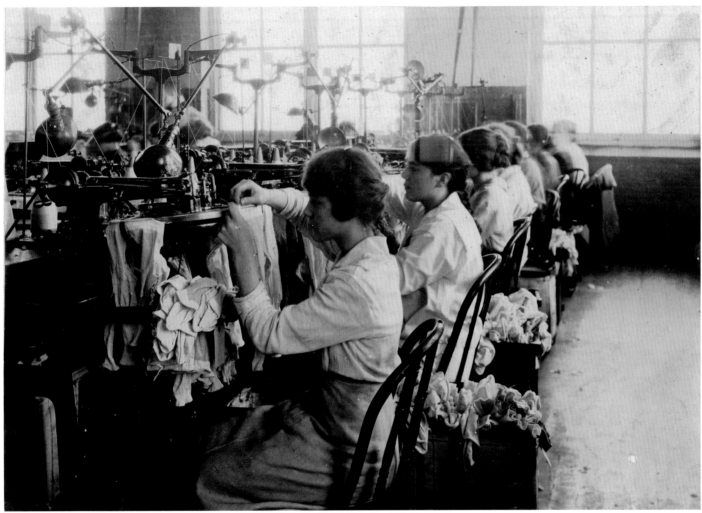

and their sisters of long tresses and silkless stockings on the other."[11] When the Parent Teacher Association banned silk stockings, short skirts, bobbed hair, and sleeveless dresses, students rioted to overrule the decision. The young students protested in a rhyme:

I can show my shoulders,
I can show my knees;
I'm a free-born American
And can show what I please

Continuation school girls topping stockings in Ipswich Mills, Boston, Massachusetts (February 2, 1917), photograph by Arthur S. Siegel. Library of Congress Prints and Photographs Division.

Shimmering silk stockings (ca. 1916). Old French postcard. Collection of J. M.

That night the baffled parents and teachers decided not to decide by turning the issue over to the school board.

Two years later, *Life* showed on its cover a caricature of a flapper with stockings slipped down her legs and garters around her ankles, captioned "Hold 'Em." Despite the ridicule and objection of the older generation, the flapper look became as glamorous as Zelda Fitzgerald, Clara Bow, and Coco Chanel and lasted a decade. The animated character Betty Boop wore a skimpy skirt and wasn't shy about showing off her garters. In the early 1930s Hollywood mandated the Motion Picture Production Code, known as the "Hays Code," which aimed to impose a moral standard for all movies. Scenes with people undressing, for example, were scotched as were revealing costumes, and a woman had to have at least one foot on the ground during a kiss. By 1935, the code caught up with Betty, whose garters disappeared and whose dress descended to her knees; even her body curves and her movements toned down. The original character's garters and stockings trumpeted her sexuality, but her makeover left Betty with little sexiness and less charm.

Colorful stockings to match the dress (late 1910s). Vintage postcard. Collection of J. M.

Showgirl in black stockings, antique postcard (ca. 19100–1910). Produced by M. M. Vienne. Collection of J. M.

Life magazine cover satirizes the flapper, by John Held Jr. (1925). Library of Congress Prints and Photographs Division.

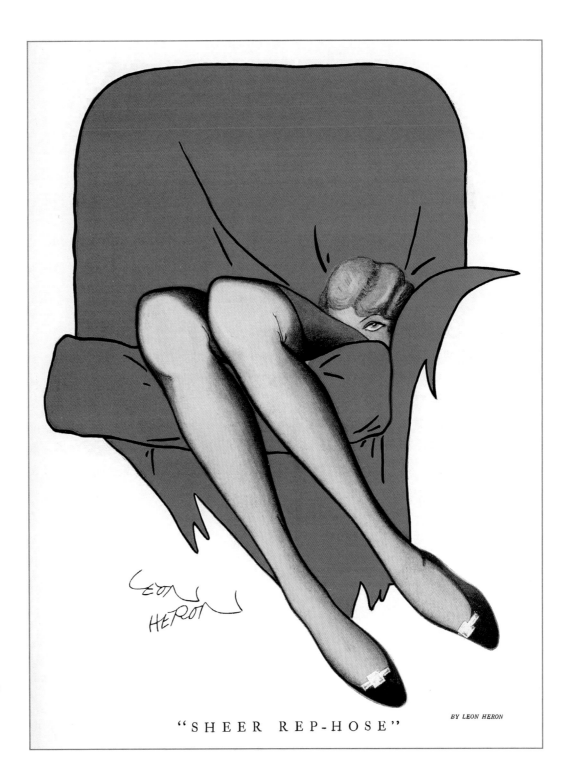

In the 1920s women's legs were scrutinized and exposed; high fashion demanded long, lean, and smooth-looking legs as evident in this advertisement. *Sheer Rep Hose* (1929). Mary Evans/ILN/The Image Works.

BY LEON HERON

"SHEER REP-HOSE"

A dancer, "Mlle. Rhea," inaugurating the garter flask fashion in Washington (January 26, 1926). National Photo Company Collection, Library of Congress.

■Technology Stepping In Once More

In the 1920s, it wasn't fashion but a new fiber that revolutionized the stockings market: rayon. Invented in 1846, rayon derived from cellulose, but it took a long time before it was developed into a yarn strong enough to run through a knitting machine. In 1911, the American Viscose company introduced rayon to the American market, branding it as "art" silk, shorthand for artificial silk.

The next advance in stocking manufacturing occurred in 1940. The previous year, during the World's Fair in New York, the DuPont Company of Delaware introduced nylon, a synthetic yarn that looked like silk but did not wrinkle or shrink when washed and was quite strong. Within a year nylon stockings, marketed simply as "nylons," were promoted as an alternative to silk stockings. The new products were launched on May 15, 1940, in the United States, and their success was immediate. Millions of women rushed to purchase a pair of flesh-toned nylons. Macy's sold their entire stock in mere hours.

During World War II, nylon production shifted from stockings to military needs, and silk stopped coming from Asia. Stockings became a coveted rarity. Many American women donated their used nylon stockings, which were shipped back to the DuPont factory, dissolved into the original chemicals, and remade into parachutes for the American paratroops. For those who kept a pair or two of precious stockings, the A.B.C. Stocking Service in New York offered repairs for a small fee. "Don't throw away precious, hard-to-get stockings because of runs or snags! Our experts can quickly repair them like new," said their 1943 advertisement.[12]

It was not illegal to sell stockings, but they were so scarce that a black market was created around them. Stores sold their old stock by word of mouth. Meanwhile, women began painting their legs to appear stockinged. Helena Rubinstein, for example, presented at her Fifth Avenue salon a solution that was applied directly to the skin.[13] Members of the Radio City Music Hall Rockettes modeled the "cosmetic" stockings, which came in either a form that looked like a giant lipstick, a bottled liquid, or a spray gun. Several layers of the leg makeup were applied to give skin a darker tone, then a makeup pencil was used to draw a line along the back of the leg to imitate the seam of nylons. Other women, especially those who had to go out to work in place of their drafted husbands, decided to forgo stockings altogether in favor of ankle socks.

Nylon hose publicity photo, New York World's Fair (1939). Hagley Museum, Wilmington, DE.

Nylon demonstrated at DuPont Pavilion, New York's World Fair (1939). Hagley Museum, Wilmington, DE.

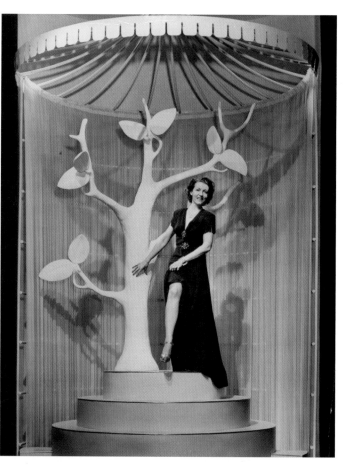

Katherine Mitten, "Miss Stockings Chemistry," models nylon stockings at New York World's Fair (1939 or 1940). Hagley Museum, Wilmington, DE.

Girl in Detroit, Michigan, straightening the seam in her stocking, by J. E. Jackson (1941). Library of Congress Prints and Photographs Division.

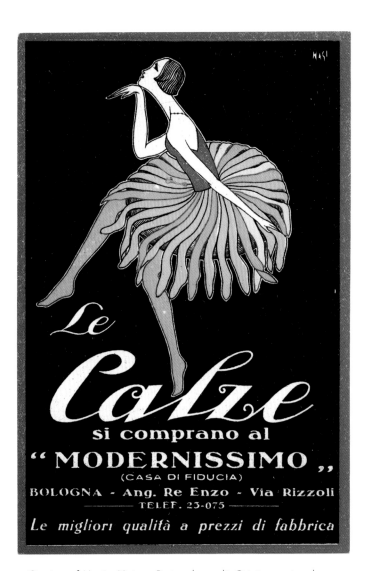

Courtesy of Martin, Vintage Postcards, quality@vintagepostcards.com

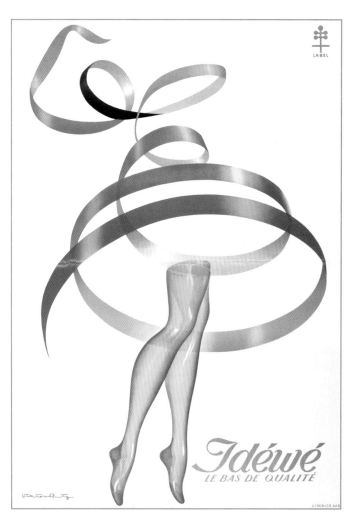

Jdéwé, le bas de qualité. Advertising poster for hosiery, by Victor Ruzo (1940s), Aarau: A. Trüb & Cie. Prints and Photograph Division.

▪The Glamorous Years

When the war was over and rations eased, nylon stockings returned to stores and sold quickly. In 1945, "nylon riots" ensued around the country when hundreds and sometimes even thousands of women queued up to try to snag a pair. The situation got out of hand in Pittsburgh when 40,000 people lined up for over a mile vying for 13,000 pairs.[14] Dior and his contemporaries revived the glamour of the Belle Époque and with it, strict guidelines for dressing. Stockings were a must. Since nylon did not stretch, stockings were shaped to fit different leg sizes and joined with a seam at the back.

The fashions that trickled down from the Parisian couture houses demanded elaborate underpinnings. Designers, recognizing a new market for luxury goods, started to promote high-end stockings. The prominent French couturier Jacques Fath, who was known to the American market for his Lord & Taylor collection in collaboration with the Seventh Avenue manufacturer Joseph

Betty Grable removes her stockings to be auctioned at a World War II bond rally (between 1941 and 1945). Hagley Museum, Wilmington, DE.

Marilyn Monroe and Jane Russell from *Gentlemen Prefer Blondes* (1953). The Everett Collection.

Halpert, had a line of silk and nylon stockings. A rare film from a 1950 presentation shows Fath's models lifting up their skirts to reveal stockings in floral motifs or incrusted with jewels and suspenders with bows and jeweled clasps. He also created designs trimmed with leopard prints and lace inserts.

Meanwhile in Hollywood, legs had unerring glamour and increased display. A 1946 ad for the film *The Thrill of Brazil* shows tap dancer and actress Ann Miller in red stockings with a large bow tied to her thigh that forms the capital T of the word "thrill." In her 70s Miller took credit for the invention of pantyhose:

> When I was under contract with RKO, I wore these long black stockings and the wardrobe ladies would sew them on briefs. If I got a run, they'd say "cut" and I'd have to take them all off and put on new ones. One day, Mr. Willis [hosiery maker] of Hollywood came by the set and I said, 'Mr. Willis, why don't you make some stockings like you make for ballerinas, like tights, but let them be silk,' and that was the birth of pantyhose. I kind of figured that I was the mother of pantyhose and I'll bet all the men hate me, but I thought it up.[15]

He'll Never Guess You Shave. A magazine full-page advertisement (1957) for Lady Schick, Schick Inc. Collection of J. M.

The story may be true but a few decades would pass before pantyhose replaced the gartered nylon stockings.

Marlene Dietrich was also known for audacious slits in her dresses. In the 1935 film *The Devil is a Woman*, she wore black stockings with a gold scalloped appliqué that ran from the tops of her feet to her thighs. The scholar Maureen Turim explains that in film noir of the postwar era, displaying the legs and feet symbolized the attraction of the femme fatale. The heels, she says, "play an integral role in telling her story. Her heels might well be black, but in key moments of early seduction, they are just as likely to be white."[16]

Oftentimes, the femme fatale is introduced with a camera movement that makes its way up from the feet along bare, or seemingly bare, legs before it reaches her face, implying the sexual power of a beautiful woman over men. As Valerie Steele explains, "Legs are not only the organs of locomotion, they are also the pathway to the genitals, as well as consisting an erogenous zone of their own."[17] In the golden age of couture and the Silver Screen, legs were glamorized and idolized; leg accessories such as stockings and shoes were there to build up the fantasy, to sexualize the leg even more.

Not surprisingly, stiletto shoes came to prominence in the early 1950s. The term stiletto was used first in 1953 to describe a thin, pin-like heel, reinforced with steel. Roger Vivier designed shoes for the House of Dior and is synonymous with stiletto heels. His designs took fantasy to extreme and emphasized the posture and curve of the feet. In 1953 for example, the Delman-Dior Shoe Salon in Paris and Bergdorf Goodman in New York introduced a sandal with a "Cleopatra Needle Heel" patent by Vivier. The designs, in collaboration between the American Herman Delman and the House of Dior, had a genius detail with a separate ankle strap that slipped into the heel-groove. Women could purchase straps separately in various colors and materials like kidskin, calfskin, suede, velvet, and brocades.

Dukas "Silhouette" heel, 2014. Courtesy of Dukas.

Putting on Old Stockings

By Julia Bloodgood Borden

I'm a student of old lingerie, especially for the legs. In September of 2008 my husband and I were walking down Lexington Avenue in Manhattan and we passed a building's service entrance where workmen were piling boxes onto the curb for trash pickup. Immediately I spied a thin box in Schiaparelli pink—an unmistakable bright, almost red pink. I ran over to the trash pile and discovered an entire box of vintage, deadstock thigh-high stockings. There must have been thirty or forty boxes. With a look of excitement I turned to my husband: "Yes, I'll carry them home," he said.

From the moment I saw my first 1950s black lace merry widow, with a small light blue silk bow at the center front, I was in love with vintage lingerie. I felt so incredibly sexy in it. It wasn't the fact that a man was looking at me in it to make me feel sexy; it was the way the undergarment hugged my curves and projected my breasts forward that made me feel sexy all on my own. It had garter attachments, and so naturally I wanted to find period stockings to complete the look.

I began collecting vintage clothes more than twenty years ago, but it took me a few years to learn to appreciate the entire look of a period, including the accessories, hairstyle, makeup, and the inner workings. Today, I collect pieces from many time periods, but I feel a strong affinity for both the Victorian and mid-century eras. Those periods have a lot in common in terms of undergarments. They both had copious amounts of very controlling, corseting lingerie. A respectable woman of those eras would never have dreamed of leaving the house without her stockings on.

It is difficult to choose a favorite garment! I go through periods of time when I'm in love with something, and then I relegate it to the closet and move on to the next find. The past few summers I've been keen on a simple 1950s circle-skirt sundress. It has a pale purple watercolor-like floral print, a boned bodice that points upward over each breast, one neck strap, and stretch ruching across the back. I feel great in it, in part because I get so many compliments when I wear it. What would a fashion fanatic do without that validation?

I feel it is important to wear each piece in my collection at least once. Not only is it fun to dress up, but also it is important to me to understand how each era's garments make you feel. When I started to do this I realized that clothes from various time periods make you comport yourself differently. In a slinky 1930s silk bias-cut slip of a dress you want to slouch and thrust your hips forward to prowl across a room in a louche way. The newly introduced one-piece stretch undergarments of the 1930s allowed for this new posture. In a boned 1950s cocktail dress with accompanying undergarments, you feel very different. Your posture is pin straight from the corseting and the stockings gripping your legs. The stiletto heels make you wiggle while you walk, but it is a constrained sexuality. The undergarments of each time period can teach you a lot about the social mores of the day. For example, in the 1920s social expectations that had previously been placed upon women were relaxing, and this went hand in hand with the uncorseting of the female body.

I wear complete period ensembles to weddings, motorcycle events put on by The Rockers, including Rockabilly concerts, themed house parties, especially Halloween, and expensive dinners when I'm on vacation. Sometimes I will dress in Victorian garb. Although, for a period costume I consider whether it's too fragile to be worn. I have reproduction corsets and chemises to wear under them. I love to wear corsets because they correct my posture, and they hold all the body in place.

When I began to wear the thigh-highs from the cache my husband so gallantly lugged home, I discovered that the box included stockings from different time periods, including the 1930s. High-end thigh-highs from this era have little stretch because they are made of silk. The smoothness feels incredible against my legs; they hug me tightly and that constant control is quite alluring. I feel powerfully armored in them, as though I am a dominant woman who can handle any challenge that comes my way.

One evening, a few years ago, I went out to a nightclub in my lingerie—and no dress. I wore a white one-piece, stretch shapewear undergarment from Rago, the company that provides the underclothes for the women of the *Mad Men* television show. It covered my chest, went down below my rear, and was held in place by garters attached to my 1930s thigh-high stockings. I wore 1950s black alligator stilettos, minimal jewelry, a Marilyn Monroe wig, and fire-engine red lipstick. It was a fantastic night. I felt inordinately attractive because the lingerie was holding me in place. The stockings were still new and very tight; all night long they made me feel seductive and desirable. ■

Julia Bloodgood Borden is a fashion historian in New York City.

Leg makeup for Marilyn Monroe. 20th Century Fox/The Kobal
Collection at Art Resource.

▪The Sexual Revolution of the Legs

When the first baby boomers came of age and flouted convention, hemlines became so short it was no longer possible to wear stockings. Pantyhose definitely partnered with miniskirts. Before pantyhose, high hose had to be washed by hand and blocked. In 1959, the DuPont company came up with another innovation, Lycra, an elastic fiber that can retain its shape after being stretched seven times its original length. Lycra eliminated the need for a back seam and a wide range of sizes. During the '60s and '70s, pantyhose became a staple as hemlines rose, and by 1970 pantyhose sales exceeded those for stockings. Seamless pantyhose exploded in bright colors, geometric patterns, and lace. Black fishnet stockings, which had ruled in French cinema, were now on the streets. When models like Veruschka and Jean Shrimpton sported their miniskirts, the demand for pantyhose escalated. It came in new colors, control-top, and textures from sheer to ribbed and nubby. Pantyhose production more than tripled from 200 million in 1968 to 624 million in 1969, as women discovered they could be both daring and decent. Knee socks were also big and came in bright colors like "screaming pink," a reference to the film *Psycho*. Perhaps the most famous image of legs in 1968 was, paradoxically, not those of young girl but those of Anne Bancroft playing a bored rich housewife in *The Graduate*.

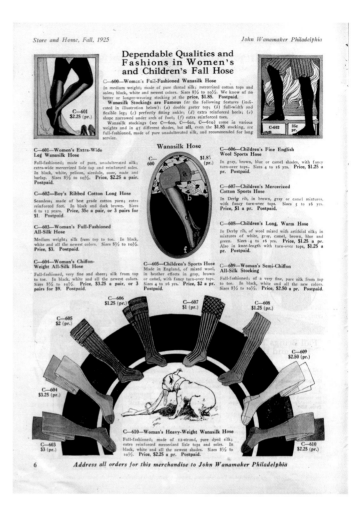

Du Pont Sparkling Nylon" (spring/summer 1960). Hagley Museum, Wilmington, DE.

As a child I remember always wearing socks with every pair of shoes, whether I was going out in my "play clothes" or dressed up in a fancy expensive dress. I always had bare legs with socks! I'm not sure why that was, but my mother believed the leather was more durable and not so pliable against a bare foot.

As a middle school adolescent, I remember wearing knee socks with crazy patterns or vibrant colors with my skirts or minishorts, creating this weird mix of segmented blocks of colors and textures. ▪

Marianne Brown, *who now works in the fashion industry in New York City*

Dad, Me, and Mom – 1965. Courtesy of Marianne Brown.

*Du Pont Sparkling Nylon,
announcing a new fiber using
a 15-denier yarn,* cover
(spring/summer 1960). Hagley
Museum, Wilmington, DE.

Twiggy became the poster girl of the 1960s and gave her name and face to promote colorful pantyhose by Trimfit. American retailers were quick to recognize the buying power of the young and the appeal of British Mod stars like Twiggy. Writing about French singer Françoise Hardy in 1967, Cecil Beaton in *The Glass of Fashion* said that she exemplified the look of the day, "With her leather belt pulled into its last notch, soft sweet sweater and schoolboy's hat, her strands of drowned hair, her puma features, and long patterned stockings, she belonged to a young group that makes all earlier fashions seems fussy and frowsty [*sic*]."[18]

An interesting hybrid that came out of this period was the stocking shoe. First introduced by American shoe designer Beth Levine in 1953, the style was for the avant-garde. She continued to produce versions and variations through the 1970s. Styles were made of fishnet with a black pump or a white mesh with clear square heel or in bright colors. Levine also gained renown for thigh-high boots that adhered to shapely legs; some zipped at the back while others were pull-on and stretch vinyl.

"Boots convey a very different message than other kinds of shoes, because they not only cover the foot, they also have a 'leg' that rises," says Valerie Steele.[19] During the 1960s, a decade obsessed with showing off legs, boots, especially worn with novel stockings, symbolized the liberated sexuality of the youth culture. It was also a decade when designers such as Yves Saint Laurent and Mary Quant borrowed the high-heeled knee or thigh-high "kinky boots" from the underground fetish scene and made them into a viable fashion accessory.

The equation of boots and sex also resonated with the gay and drag underground scene in New York of the early 1970s. The eccentric scene that grew around Andy Warhol's factory allowed men and women to challenge mainstream definition of gender and along the way influenced a whole generation of musicians, artists, designers, and performers. The famous downtown drag queen Jackie Curtis was described as:

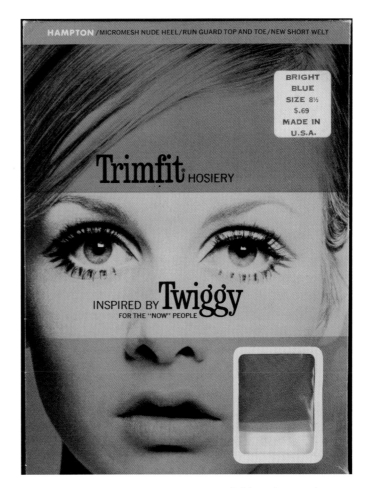

Trimfit blue nylon pantyhose
(1967–68). The Museum at the
Fashion Institute of Technology,
NY.

A hip drag queen, [who] took everything to extremes. She walked around in ripped stocking and big tears in her dresses with threads hanging off . . . she had that combination of trash and glamour . . . a lot of her dresses were from the '30s and '40s, things that she'd pick up from thrift stores for 25 cents . . . she wore old-lady shoes that she sprayed silver, and her tights were always ripped . . . No one thought [she and Candy Darling] were women, no one thought they were men! No one knew what they were.[20]

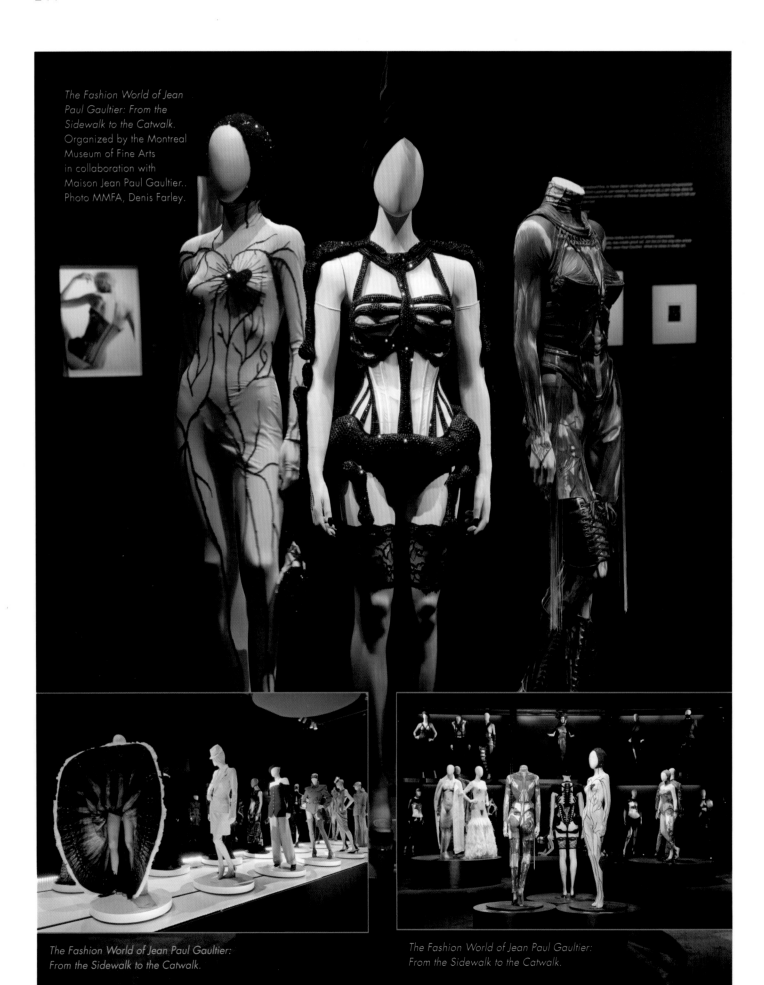

The Fashion World of Jean Paul Gaultier: From the Sidewalk to the Catwalk. Organized by the Montreal Museum of Fine Arts in collaboration with Maison Jean Paul Gaultier.. Photo MMFA, Denis Farley.

The Fashion World of Jean Paul Gaultier: From the Sidewalk to the Catwalk.

The Fashion World of Jean Paul Gaultier: From the Sidewalk to the Catwalk.

Ripped pantyhose came to typify the punk scene that bloomed in New York and London. Imperfect pantyhose were not only rebellious but also evoked a time when, like in William Hogarth's 1734 painting *The Rake at the Rose Garden*, a woman with a hole in her stocking lived on the fringe of society. In a subversive reversal, the drag queens and punks of the 1970s exposed the rips and tears as means of feminist empowerment. Obvert sexuality was the dish of the day.

In 1976, when punk was emerging in London, the then-young designer Jean Paul Gaultier was showing his first collection. Gaultier has been deeply influenced by anti-fashion movements and urban subcultures throughout his career. Gaultier explains that:

> The total rebellion, the trash, "destroy" look, the raw side of punk, with its Mohawk haircuts, almost tribal make-up, allusions to sex, torn fishnet stockings, black, kilts, bondage straps mixing of genders and materials—all that appealed to me. It spoke to me, suiting me much better than some of the ossified couture conventions.[21]

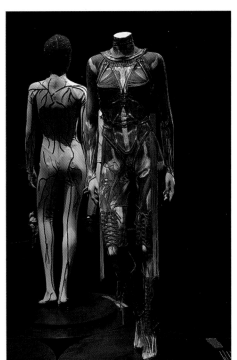

Gaultier mastered the fine line between couture and street fashion. He brought the raw sensibility of do-it-yourself fashion into the fine craft and laborious handwork of couture. In the early 1980s Gaultier created body stockings printed in tattoo-like patterns for choreographer Régine Chopinot. Gaultier later adapted that same idea into a ready-to-wear collection. What appealed to Gaultier about tattoos was that the body becomes a work of art in a way, which is even more extreme and radical than wearing a garment because tattoos are permanent.[22]

In the Morphing couture collection of fall/winter 2003–2004, Gaultier continued to explore the notion of stockings as second skin with a hooded body stocking embroidered with heart, veins, and arteries motifs. In 2009 he created a stage costume for the singer Mylène Farmer that was a body stocking printed with flesh and muscles. Gaultier, in his subversive, playful manner, took the idea that stockings should simulate "realness" or "naturalness" to the fore. "I thought showing how beautiful the inside of the body is, what is normally invisible, was a wonderful idea." Gaultier said, "Our body, the way we present ourselves—it's a form of communication. Our clothing, hair and body decoration reflect our true identity."[23]

Shoe designer Christian Louboutin has also explored in his work the seductiveness of a seemingly naked leg. His "Les Nudes" Collection from 2013 included high-heeled shoes in five different skin tones. Louboutin explains that "Nude elongates your leg and doesn't take space away from your body... it disappears completely and dissolves into your legs."[24] The inspiration came from Louboutin's travels, "When you travel to many different places you realize that nude does not mean the same thing in every country," he says. "Mostly when people talk of nudes they are talking of their own color of skin."[25]

The Fashion World of Jean Paul Gaultier: From the Sidewalk to the Catwalk. Organized by the Montreal Museum of Fine Arts in collaboration with Maison Jean Paul Gaultier.

Dollface Dames (2013).
Courtesy of Christopher King,
Wing's Art & Design Studio,
Somerset, UK.

▪Mainstream Showgirls

By the 1990s, bare legs, even in a professional setting, no longer constituted a fashion crime. Women could wear a short dress sans stockings and sandals even to the office. "For many women, not wearing hose was part of a bigger rebellion against dressing up, and a celebration of their freedom," says Laurie Ann Goldman, chief executive of Spanx.[26]

While some designers played around with leg "nakedness"—whether actual or simulated—others exploited the suggestive sexuality of old-fashioned stockings. The stage personae of burlesque stars like Dita Von Teese and Immodesty Blaize is built around wearing vintage-style undergarments as outergarments—like corsets, thigh-high stockings, and suspenders—and pairing them with heavy makeup, a vixen look, and most importantly, very high heels.

Louboutin, known for his towering heels, spent his teenage years as a wardrobe apprentice at the French burlesque hall the Folies Bergère. Watching the showgirls had an evident impact on his aesthetic. The high heels of his creation arch the feet and elongate the leg in a manner that is at the same time empowering and crippling.

Manolo Blahnik is another shoe designer who made his name with extremely high heels, especially stilettos. He cut the shoe very low in front to elongate the leg and create a toe cleavage. "The secret of toe cleavage is a very important part of the sexuality of the shoe," he said. "You must only show the first two cracks."[27] In the famous episode of HBO's Sex and the City, Carrie Bradshaw's favorite pair of Manolos is stolen at gun point in a downtown alley. "Please, sir, they're my favorite pair!" she begs, but to no avail.

Like Louboutin, Blahnik's background is in the stage. He started as a set designer for the theater but was encouraged by the legendary Diana Vreeland to give it up and design shoes instead. Blahnik heels are carved by hand, and his designs are coveted. Recounting her love-hate relationship with impossible stilettos, author Lorraine Gamman says:

> Since my feet are not like Barbie's, it took me a long time before I let myself realize that the expensive heeled objects of my desire would never be more than a one-night stand. So I paid the price and kept my Manolo Blhanik snakeskin and patent shoe collection . . . primarily in the closet. They were meant for the big outing or more often for private viewing or admiration purposes only. Finally, I got bored with the masquerade and even the fantasy of wearing them, and have recently developed a penchant for black suede hybrid shoe-sneakers (known as "Merrills") instead.[28]

Starring Legs

STILETTO 2

This drawing was produced for a show in Reno, Nevada, called "Lipstick Cabaret" and used in many shows after. The shoe prop was built large enough for the dancers to move around it, and was mounted on wheels so it could be moved throughout the number.

Stiletto 2. Courtesy of Mistinguett Productions, Inc.

One in a series of different costume designs for *Stiletto 2.* Courtesy of Mistinguett Productions, Inc.

TIFFANY

The idea behind this dance number is that the showgirl begins bending down inside the jewel box and her head-dress acts as the bow on the box. When the number begins, the showgirl springs to the top of the box with her crystal-encrusted cane and begins to dance. Mistinguett, the choreographer, says: "It reminds me of the very first dance performance I did as a child, where I tap danced on a pink glittered box that was two by two by two feet that my father had to build for me. My mother also made the costume. I was five years old."

Tiffany. Courtesy of Mistinguett Productions, Inc.

MIRANDA IN THE MIRROR

This drawing was commissioned by a former showgirl from the show *Jubilee* at Bally's Hotel & Casino in Las Vegas, based on a costume she had worn.

Miranda in the Mirror. Courtesy of Mistinguett Productions, Inc.

JOAN OF ARC

Although usually depicted in knight's armor, she faced the inquisitors at her trial in a short tunic.

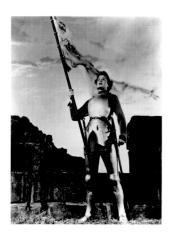

Ingrid Bergman as *Joan of Arc*, 1948. Sierra Pictures/ The Kobal Collection at Art Resource.

GRETA GARBO

For *Queen Christiana* (1933), MGM costume designer and friend Adrian created for her a sixty-five-pound fawn gown with beads and jewels as well as a knight's disguise that showed off her legs. Garbo walked like a queen.

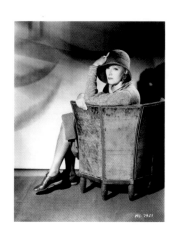

Greta Garbo, photograph by Mary Evans/Ronald Grant. The Everett Collection.

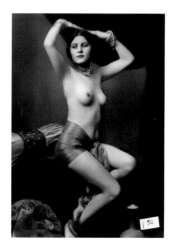
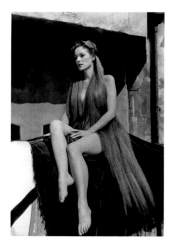

The Odalisque justified more nudity of the legs than a European subject (ca. 1920s). Collection of J. M.

Maureen O'Hara as *Lady Godiva*, 1955. Universal/ The Kobal Collection at Art Resource.

LADY GODIVA

She performed her heroism with her hair like a mantle covering everything but her legs.

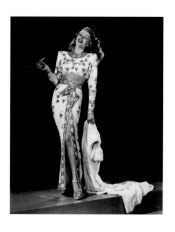
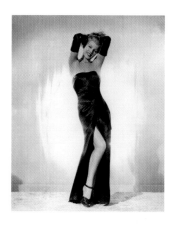

Rita Hayworth in *Gilda*, 1946. The Kobal Collection at Art Resource.

Rita Hayworth in *Gilda*, 1946. Columbia/ The Kobal Collection at Art Resource.

RITA HAYWORTH

Parisian designer Jean Louis created the black satin strapless with a long slit she wore as the femme fatale in *Gilda*. It looked as though it would slide off her body in a striptease as she sang "Put the Blame on Mame."

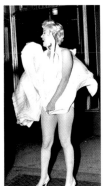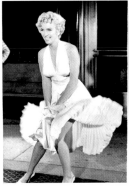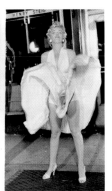

Marilyn Monroe making a series of scenes for *Seven Year Itch*, in downtown Manhattan (September 16, 1954). TopFoto/The Images Works.

MARILYN MONROE

Of all her ultra-sexy poses none exceeded her in the metallic sequin dress Orry-Kelly designed for *Some Like It Hot*.

CYD CHARISSE

Even "dancing in the dark" she expressed sensuality with the fluid movements of her long legs.

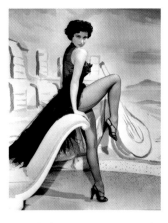

Cyd Charisse, 1953. MGM/ The Kobal Collection at Art Resource.

ANN MILLER

For her incredible tap dance numbers, she wore rubber-soled shoes and the click-clacks were added later. According to "Private Screenings: Ann Miller" (1997), a one-hour special from Turner Classic Movies, the hosiery she asked to be manufactured for her was the first modern pantyhose. Her legs were stunning in the motion of the dance.

KATHERINE HEPBURN

In her second screen role, *Christopher Strong*, she looked perfect in pants as an aviatrix and also was incredible in the silver moth costume that Walter Plunkett designed for her.

JOSEPHINE BAKER

It was her idea to dance the Charleston in a string of artificial bananas. Possibly the most photographed woman of the early twentieth century, she wore clothes created by the great designers of her day, including Paul Poiret, Balenciaga, Chanel, and Dior.

BETTY GRABLE

Photographed in sweetheart poses. Her studio had her legs insured with Lloyd's of London for a million dollars as a publicity stunt. Since then, other actresses, including Jamie Lee Curtis, Angie Dickinson, and Brooke Shields have had their legs famously insured.

MAE WEST

She looked, talked, and acted every inch the siren. Sometimes a duplicate dress was made for sitting and walking. Edith Head designed her spider web–inspired gown for *She Done Him Wrong* (1933).

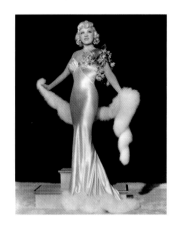

Mae West. The Kobal Collection at Art Resource.

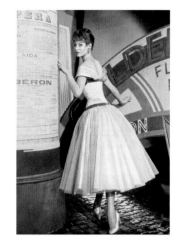

Brigitte Bardot in a ballerina skirt over layers of petticoats (ca. 1960). Old photograph. Collection of J. M.

MARLENE DIETRICH

The focus when she performed was frequently on the shimmering legs.

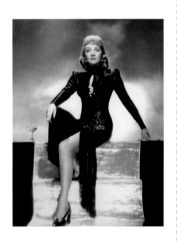

Marlene Dietrich in *Manpower*, 1941. The Kobal Collection at Art Resource.

TINA TURNER

For the ageless beauty, Giorgio Armani designed a chartreuse taffeta and black silk tulle gown that showed her legs in glitter-trimmed black leggings that she wore at her second wedding in July 2013.

MITZI GAYNOR

She could carry off an unlikely costume of long kid gloves, a huge saucer-shaped hat and dance leotards with bare legs (designed by Orry-Kelly for *Les Girls*, 1957).

VENUS WILLIAMS

Venus's outfits, from red sequined to black lace and a white jumpsuit with plunging neckline, have a pizzazz never before seen on the tennis court.

ESTHER WILLIAMS

She wore silver lame underwater and Technicolor bathing suits and popularized the strong athletic leg.

Hemline Memories

By Jane Merrill

Early in the 1960s

In the 1800s, the Shakers hung their clothes on tidy wooden pegs in full view. The little farmhouse in Westport, Connecticut, into which I moved after a divorce in 2002, had closets so shallow that bars for coat hangers were not feasible. Before department stores extended beyond the downtowns of major cities, one simply did not see really fancy dresses. *Life*, *Look*, and *Vogue* had these gowns in their pages, but my mother did not subscribe to such magazines or seem to know anybody that did. Whereas in Connecticut's Cheever country, women wore aprons over their cocktail dresses to entertain, my Navy family settled in New Jersey in 1960, where dressing up meant what you wore on Sunday to church. I had seen my mother in Europe in the simplest Grecian gowns that she dyed and accessorized to look new. I had seen photos of my older brother with girls he escorted to balls: My mother fashioned these corsages herself, and laid them in tissue paper in florist boxes. A diplomat's wife once remarked approvingly she could see the corsage came "from a good house." This story is about the first time I, at 17, touched and wore a very dressy dress.

Each spring, the Choral Club of my girls preparatory school (now combined with the boys school next door as the Dwight-Englewood School) held a joint concert with the Yale Freshman Glee Club. Most girls at my school took this in stride since they had numerous occasions to see young men at the country club, ice cream shop, debutante parties, ski weekends, Cape Cod summers, and so forth. I was a scholarship student from a very small town quite far from the school, with no expectations of "coming out" or ski weekends, or other such falderol since I worked every day after school. In fact, I made no small extra wages babysitting for the families of my fellow students when they gave parties and wanted to sleep in and have someone take care of the younger children.

Therefore, for me, the idea of young men coming in a bus all the way from Yale to sing with my school conjured a glittering fantasy. My singing range, however, was one octave and I was not in the Choral Club. Each year I longed for, but did not draw, a lucky number to be paired up with one of the extra boys from this annual event. So senior year was my last chance to attend the big dance following the concert.

Again I didn't draw the right number. But the night before the dance, the choral director pulled strings and I got an invitation to attend. It had turned out there were several boys who had signed up to come on the bus even though they weren't singers, just in order to meet girls (our school had a reputation for pretty students). However, now is when the story parallels Cinderella's—I didn't have a dress. By that I mean . . . literally I didn't have *any* dresses! Not one of my Sunday church outfits could possibly pass for a bonafide party dress.

The afternoon I was invited as an extra girl to the Yale-Dwight dance, and before I had a chance to decline, I went to the house of a new friend—a girl who would become a lifelong friend. Mayra's father worked in the world of entertainment, and his wife and daughters had occasion to go to premieres that required formal dress. When Mayra told her mother that I had stars in my eyes for a dance but had nothing to wear, her mother brought out dress after

dress, in their dry cleaner's transparent bags, for my selection. These were very fancy dresses that my friend or her sister had worn once, if at all. I swooned over a brocaded silver and pink one but it was too late to take in the bodice (and these party dresses were, believe me, constructed). Another was green silk with squarish neck and a wide satin cummerbund and a big flat green bow. In it I looked very dressy and also very green. Mayra's mother had green patent leather heels to lend me as well. I could have been an attendant of the Green Count in the medieval French court, who arrived on the occasion of his knighthood not only in green plume and silken tunic over his armor but with eleven green ladies leading eleven green knights, and all their horses carparisoned likewise.

The next day, before the dance, a gift came from the girl and her mother, perhaps flowers, with a note that advised me to "dance with the wings of a butterfly." And that is how the evening went! A tall, very blond, and well-mannered young man who had hopped a ride on the bus liked me and loved to dance. What's more, Richard was the self-same captain of the safety patrol I used to admire coming up the stairwell in the military dependents school in France five years before—a magical coincidence activated by the shamrock green silk dress.

The styles changed right then, in 1964, and no one when I went to college the next year would ever require this sort of very classic party dress anymore, at least no one of my generation, which was a good thing in that you really couldn't go to a preppy dance unless you had one —and I had only this one.

Late 1960s

The smaller one's wardrobe in the early 1960s, the easier to transition in the late '60s when the revolution in hemlines occurred. Except winter coats and bathing suits, my clothes had been home sewn. Compared with store-bought clothes, they wrinkled readily, so a skirt had to be smoothed carefully before sitting down, and to look one's best it was prudent to stand on a bus or trolley until arriving at a destination. Being leggy, I leapt early into miniskirts at college. Infused with enthusiasm, I traveled from my suburban college into Boston to Filene's Basement, the giant discount store—then actually a basement, with honest-to-Betsy designer clothes for a proverbial song. First I went to the fabric remnants department and bought two-thirds of a yard each of candy-striped chintz and a stretchy fabric plastered with red-gold sequins. But I wouldn't have a chance to go home and sew my minis until summer.

At Wellesley College we were supposed to study every hour of the day we weren't eating, sleeping, or biking to class!

Except, of course, on Friday and Saturday nights when a little extra free time was permitted to visit the Ivy League colleges, which our future husbands attended. If I took time to dress-make at college, I'd fail out fast and have to go to (this was my father's threat) "Katie Gibbs." Impatient all the same to make the switch to high fashion, to raise it up to mini-length, I folded my going-out skirt over a rope belt (since it was Courrèges-style with a big cream wool border at the hem and it wasn't possible to simply hem it) and topped it with a boxy velour dark chocolate jersey.

In that era, we dated different men, and, come senior spring, waited for the returns of one or several marriage proposals. The process didn't take a lot of outfits! However, since I was risking being the last of my friends to lose her virginity, I began to imagine disrobing and having a man see the truth of my roped-up mini—not a mini at all. I needed a real mini and I found that in another trip to Filene's Basement. It was dark blue denim of an unusually heavy weight, closed by a wonderful, big, wide gold zipper with a brass ring, like a curtain ring but a bit like a door knocker. Was the zipper pull a metaphor for having sex?

Now a Harvard man whom I found most divine invited me to his house share in Cambridge. He said he was going to cook "something with capers" for dinner. "Don't be intimidated, Jane," Armand told me, "before my roommates and their girlfriends go to a lawyers guild gala, we'll all have drinks." This invitation suggested enormous sophistication and who knew that when Armand had spoken of capers he meant condiments, not foreplay. No question but this was the occasion for the fabulous jean skirt—couture but with that sporty brass-ring touch.

The three other couples were draped around two opposing couches in front of a crackling fire. The game they found so hilarious involved coming up with as many famous names as you could for whatever the letter was for that round. I was struck dumb, I froze and wouldn't play. The women literally were in evening clothes, and I was in a jean skirt, feeling about ten years old. Standing rigid at the other end of the couches, looking to either side wishing for an escape, I got one: suddenly the lock on my skirt failed, the door-knocker brass ring lifted up, and down slipped the skirt in a second to the floor. I ran to the bathroom—soon people were leaving, my date was cooking and distracting me with talk of Chopin and William Blake. We did lie on his bed as I'd imagined, but when he asked why females wore panty girdles when they didn't need them, it made me feel one among many, and so I got off the bed and zipped up the remarkable skirt.

You learn by some mistakes to find your own style. I have always loved miniskirts, but from sewing that summer I got to know which fabrics and patterns work well for them.

Jane Merrill on her wedding day, August 12, 1968.

Dressed for Success

Once I bought from a sidewalk rack in the Avenue Montaigne in Paris two long beach skirts identical except in color that became a talisman for my life of temporary work in Paris.

I had sobbed on the flight to Europe. Between living with parents and marriage, I had never really been on my own. When I arrived at my destination, Munich, where I would take a German course, letters that my spouse had written me ahead of time were waiting, just as the entrees I had prepared awaited him in the freezer compartment of our Manhattan apartment. But a few months later, my spouse informed me that he was moving on. In my fantasy, were I to return to New York I would break a piece of china on his head. Instead, because I speak French, I chose to live in Paris—no prospects, no money, just a family friend who put me up on the rue Saint-Dominique while I sought work.

Spring in Bavaria had been cold, it even snowed; now it was July in Paris and hot, and I had no clothes. And I had so little money left that I ate from a supermarché and drank from a little thermos, decorated in pink Scotch plaid, bought at a hardware store. My desire to sit in cafés and drink espresso and eat pastries was as big an impetus for getting a job as I have ever known—there could be no expat fun without a paycheck. With no work permit, however, it was going to be quite a trick.

On one of my first promenades, a rack of long skirts in bright solids caught my eye. This was on the posh Avenue Montaigne where putting sales items on the street was an exception. I bought two, one daffodil yellow and one raspberry pink. They were meant as resort-wear for Cannes, St. Tropez, or Antibes, which is why they were past season and deeply

discounted. Unexpectedly, they turned out to be the perfect interview skirts because their cheerful colors and panache brightened and even transformed how I presented myself.

I had to seek jobs at the margins—barmaid, private secretary, and receptionist in a family-run hotel, opportunities where the employer could pay me in cash. What happened was I got an offer for each job I applied for, from stringer at *The Herald Tribune* to typist for a publishing firm to, yes, barmaid at a bar patronized by Asian businessmen. Desperate need stirs determination, but I believe it was because of the skirts.

They were long, narrow, and fit neatly around the hip and flared gracefully. Their linen blend, almost like sailcloth, didn't wrinkle through the day. The colors were delicious. Paired with cotton voile tops and discreet platform sandals, for that particular moment in the 1970s before women in the workplace were dressing in quasi-corporate uniforms, my two skirts were absolutely perfect for job-hunting in Paris. Who would have known?

Going from daffodil to raspberry on alternating days for that first month or so, when my situation was uncertain, was the greatest thing. I'm certain that by being imaginatively transported to the places I felt in these skirts, I came across with a certain *je ne sais quoi*—as if I could just as well be strolling down an avenue with no cares in Biarritz, yet sure to be hard-working all the same. Once I took a permanent job at a research institute, I put away my beachy plumage. And by the time I returned to America, the message was if you wanted a job, you didn't stand out. So I confronted the '80s with John Molloy and *Dress for Success* for women and *Color Me Beautiful*, wearing the subtle shades for blending in. ∎

Notes

CHAPTER ONE (pages 7–18)

1. Quoted in Bruce Bower, "Lucy's Ancestor, 'Big Man' Revealed," Discovery.com. http://news.discovery.com/history/archaeology/lucy-ancestor-fossils.htm.

2. Sophie Bergerbrant, "Bronze Age Identities: costume, conflict and contact in Northern Europe, 1600–1300 BC," Volume 43, *Stockholm Studies in Archaeology* (Bricoleur Press, 2007).

3. Personal communication with Augusta McMahon, Department of Archaeology and Anthropology, University of Cambridge, Sept 30, 2013.

4. Lyn Green, "Seeing Through Ancient Egyptian Clothes," *KMT: A Modern Journal of Ancient Egypt*, Vol. 6, No. 2 (Winter, 1995), 34–38 passim.

5. Personal communication with Bob Brier, Department of Philosophy, Long Island University, May 1, 2013.

6. Personal communication with Deborah Coulter-Harris, June 10, 2013.

CHAPTER TWO (pages 19–26)

1. Personal communication with Ariane Marcar, Warwick University, May 13, 2013.

2. Tammy Jo Eckhart, "An Author-Centered Approach to Understanding Amazons in the Ancient World," PhD thesis, 2007.

3. Elaine Fantham, *Women in the Classical World: Image and Text* (Oxford University Press, 1995).

4. Larissa Bonface, *Etruscan Dress: Updated Edition.* (Johns Hopkins Press, 2003).

5. Norma Goldman, "Reconstructing Roman Clothing," in *The World of Roman Costume*, edited by Judith Lynn Sebesta and Larissa Bonface (University of Wisconsin Press, 2001).

6. Juvenal, *Satire VII*, http://webspace.ringling.edu/~ccjones/curricula/11-12/satire/readings/1overview/juvenal.html.

7. Richard Zacks, *History Laid Bare: Love, Sex and Perversity from the Ancient Etruscans to Warren G. Harding* (NY: HarperCollins, 1994).

8. Personal communication with Shelley Hales, Department of Classics and Ancient History, University of Bristol, May 13, 2013.

9. Ibid.

CHAPTER THREE (pages 27–40)

1. Quoted in Clare McManus, *Women on the Renaissance Stage: Anna of Denmark and Female Masquing in the Stuart Court, 1590–1619* (Manchester University Press, 2002).

CHAPTER FOUR (pages 41–60)

1. Giovanni Della Casa, *Galateo: Or, The Rules of Polite Behavior*, edited and translated by M.F. Rusnak (Chicago: Chicago University Press, 2013).

2. Ibid.

3. Marie d'Aulnoy, la comtesse, *Relations du Voyage d'Espagne*, (Paris: Editions Desjonqueres, c. 1691, 2005).

4. Quoted in Flora Fraser, *Beloved Emma: The Life of Emma, Lady Hamilton* (A&C Black, 2012).

5. Ibid.

6. John R. Young, *Our Deportment Or the Manners, Conduct and Dress of the Most Refined Society* (Quality Classics, 2010).

7. Maria Edgeworth, *Belinda* (NY: Oxford University Press, 1999).

8. Quoted in Meg McGavran Murray and Margaret Fuller, *Wandering Pilgrim* (Georgia: University of Georgia Press, 2012).

9. Martha Davis and Shirley Weitze eds., *Gender and Nonverbal Behavior* (Springer Series in Social Psychology, 1981).

CHAPTER FIVE (pages 61–96)

1. Joan L. Severa, *Dressed for the Photographer*, (Kent, Ohio: Kent State University, 1995).

2. Claudia L. Bushman, *"A Good Poor Man's Wife": Being a Chronicle of Harriet Hanson Robinson and Her Family in Nineteenth-Century New England* (Hanover, NH: University Press of New England, 1981).

3. Paul Poiret. *King of Fashion: The Autobiography of Paul Poiret*, translated by Stephen Haden Guest (Philadelphia & London: J. B. Lippincott Company, 1931).

4. Steele, Valerie. "From Hitler to Dior." The Berg Fashion Library, 1998.

5. Quoted in Valerie Steele, *Fifty Years of Fashion: New Look to Now* (New Haven, Yale University Press, 2000).

6. The Metropolitan Museum of Art, *Schiaparelli and Prada: Impossible Conversations*, introduction to exhibition on metmuseum.org, accessed September 13, 2014.

7. Laird Borrelli-Persson, *The Cocktail Dress* (New York: Harper Collins, 2009).

8. Bard, Christine, *Ce Que Soulève la Jupe* (Edition Autremente, 2010).

9. Josh, Eells, "Barry Gibb: The Last Brother," *Rolling Stone*. July 4, 2014,

10. Andy Warhol and Pat Hackett, *POPism: The Warhol '60s* (Harcourt Brace & Company, 1980).

CHAPTER SIX (pages 97–116)

1. Peter B. Golden, personal communication with author, June 8, 2014.

2. John Wertime, personal communication with author, summer 2013.

3. Tammy J. Eckhard, PhD, personal communication with author.

4. Elizabeth Howe, *The First English Actresses: Women and Drama, 1660–1700* (Cambridge University Press, 1992).

5. David Cordingly, *Seafaring Women: Adventures of Pirate Queens, Female Stowaways, and Sailors' Wives* (Random House, 2011).

6. James Woodfrode, *The Diary of a Country Parson, 1758–1802* (Hymns Ancient and Modern Ltd, 2011).

7. Daniel Defoe, *A General History of the Pyrates: from their first rise and settlement in the island of Providence, to the present time*, http://www.gutenberg.org/files/40580/40580-h/40580-h.htm.

8. David Cordingly, *Seafaring Women: Adventures of Pirate Queens, Female Stowaways, and Sailors' Wives* (Random House, 2011).

9. Quoted in Anne M, Mode, *Susan B. Anthony: Activist* (Infobase Publishing, 2009).

10. "Elizabeth Smith Miller," History of American Women Blog, http://www.womenhistoryblog.com/2012/10/elizabeth-smith-miller.html.

11. "California Retrospective: In 1938, L.A. woman went to jail for wearing slacks in courtroom," *Los Angeles Times*, October 23, 2014, accessed at www.latimes.com/local/california/la-me-california-retrospective-20141023-story.html.

12. Ibid.

13. Paul b. Magit, personal communication with author, 2013.

14. Paul Poiret. *King of Fashion: The Autobiography of Paul Poiret*, translated by Stephen Haden Guest (Philadelphia & London: J. B. Lippincott Company, 1931).

15. Mr. and Mrs. Vernon Castle, *Modern Dancing* (New York: Harper and Brother Publishers, 1914), quoted in Catherine Lynn Campbell, *Social Dance: The Influence on Fashion, 1910–1914* (Fashion Institute of Technology, 1997).

16. *Vogue*, April, 1917.

CHAPTER SEVEN (pages 117–144)

1 Penny Storm, *Functions of Dress: Tool of Culture and the Individual* (Saddle River, NJ: Prentice-Hall, 1986).

2. Anne Hollander, *Seeing Through Clothes* (New York: The Viking Press, 1978).

3. Rene Konig, *A La Mode: On the Social Psychology of Fashion*, translated by F. Bradley (NY, Seabury Press, 1973).

3. Louis Simond, *Journal of a Tour and Residence in Great Britain, During the Years 1810 and 1811*, Volume 1 https://books.google.com/books?id=nrcuAAAAMAAJ&printsec=frontcover&source=gbs_ge_summary_r&cad=0#v=onepage&q&f=false.

4. Quoted in Michael and Ariane Ruskin Batterberry, *Fashion, The Mirror of History* (Greenwich House, 1977).

5. Quoted in Patricia Fallon, Melanie A. Katzman, and Susan C. Wooley, *Feminist Perspectives on Eating Disorders* (Guilford Press, 1996).

CHAPTER 8 (pages 145–172)

1. Isadora Duncan, *My Life*, revised and updated (W. W. Norton & Company, 2013).

2. Quoted in Ann Daly, *Done Into Dance: Isadora Duncan in America*, (Wesleyan University Press, 2010).

3. Isadora Duncan, *My Life*, revised and updated (W. W. Norton & Company, 2013).

4. Ann Daly, *Done Into Dance: Isadora Duncan in America*, (Wesleyan University Press, 2010).

5. Isadora Duncan, *My Life*, revised and updated (W. W. Norton & Company, 2013).

6. Diana de Marly, *Costume on The Stage 1600–1940* (B.T. Batsford, 1982).

7. Albéric Second, *Les Petits Mystères de l'Opera*, 1844, https://archive.org/details/lespetitsmystr00seco.

8. Paul Poiret, "Fashion: Poiret on the Philosophy of Dress," *Vogue,* October 15, 1913.

9. Isadora Duncan, *My Life*, revised and updated (W. W. Norton & Company, 2013).

10. Cyril W. Beaumont, *Five Centuries of Ballets Designs* (The Studio, Ltd., 1939).

11. Isadora Duncan, *My Life*, revised and updated (W. W. Norton & Company, 2013).

12. Mr. and Mrs. Vernon Castle, *Modern Dancing* (New York: Harper and Brother Publishers, 1914), quoted in Catherine Lynn Campbell, *Social Dance: The Influence on Fashion, 1910–1914* (Fashion Institute of Technology, 1997).

13. Quoted in Eve Golden, *Vernon and Irene Castle's Ragtime Revolution* (University Press of Kentucky, 2007).

14. Mr. and Mrs. Vernon Castle, *Modern Dancing* (New York: Harper and Brother Publishers, 1914), quoted in Catherine Lynn Campbell, *Social Dance: The Influence on Fashion, 1910–1914* (Fashion Institute of Technology, 1997).

15. Quoted in Marshall and Jean Stearns, *Jazz Dance: The Story of American Vernacular Dance* (Da Capo Press, 1968).

16. Brenda Dixon Gottschild, *Digging the Africanist Presence in American Performance: Dance and Other Contexts* (Praeger, 1998).

17. Karen C. C. Dalton and Henry Louis Gates Jr., "Josephine Baker and Paul Colin: African-American Dance Seen through Parisian Eyes," *Critical Inquiry*, Vol. 24, No. 4 (Summer, 1998).

18. Brenda Dixon Gottschild, *Digging the Africanist Presence in American Performance: Dance and Other Contexts* (Praeger, 1998).

19. Ibid.

20. Karen C. C. Dalton and Henry Louis Gates Jr., "Josephine Baker and Paul Colin: African-American Dance Seen through Parisian Eyes," *Critical Inquiry*, Vol. 24, No. 4 (Summer, 1998).

21. "The Charleston Takes the Floor," *Vogue*, February 15, 1926.

22. *Dancing Times*, 1922, quoted in Eve Golden and Vernon and Irene Castle *Ragtime Revolution* (University Press of Kentucky, 2007).

23. Unidentified newspaper article quoted in Eve Golden and Vernon and Irene Castle *Ragtime Revolution* (University Press of Kentucky, 2007).

24. Andre, L. T. "Style fax: Let's talk about sex," *Vogue*, August 2001.

25. Jonathan, V. M. "Fashion: Pretty women," *Vogue*, October 1990.

26. "Tango Pirates Infest Broadway," *New York Times,* May 30, 1915.

27. "Berlin is Tango Mad," *The New York Times*, October 19, 1913.

28. Gladys Beattie Crozier, *The Tango and How to Dance It* (London: Andrew Melrose, Limited, 1913).

29. "Vogue patterns: The pretty intimacies of dress," *Vogue,* April, 1914.

CHAPTER NINE (pages 173–194)

1. Isadora Duncan, *My Life*, revised and updated (W. W. Norton & Company, 2013).

2. *Girls' Own Paper*, September 28, 1884, quoted in Avril Lansdell, *Seaside Fashions 1860–1939: A Study of Clothes Worn in or Beside The Sea* (Princes Risborough: Shire, 1990).

3. Susan Ward, "Swimwear," *Encyclopedia of Clothing and Fashion*, edited by Valerie Steele, Vol. 3 (Detroit: Charles Scribner's Sons, 2005).

4. Abercrombie & Fitch Co. catalog undated, FIT Special Collections.

5. Richard Martin and Harold Koda, *Splash! A History of Swimwear* (New York: Rizzoli, 1990).

6. "The bikini point of view," *Vogue*, June, 1963.

7. *Vogue*, July, 1965.

8. "Fastskin Suits Improve Performance in Swimmers," news release on the website of the American College of Sports Medicin, http://www.acsm.org/about-acsm/media-room/acsm-in-the-news/2011/08/01/fastskin-suits-improve-performance-in-swimmers.

9. Broria Broor-Avidan, "Three Faces to Fashion: Interview with Lea Gottlieb," *LaIsha,* Issue 1341, December 18, 1972.

10. Martha Levi, telephone interview by author, October 31, 2010.

11. Itay Yaacov, interview with Ben Lam, *Signon,* June 6, 2008.

12. Ibid.

CHAPTER TEN (pages 195–220)

1. "Venus and Serena Williams win French Open Doubles: Lace tennis outfit outshines win," Examiner.com, June 7, 2010, http://www.examiner.com/article/venus-and-serena-williams-win-french-open-doubles-lace-tennis-outfit-outshines-win.

2. Quoted in Betty Spears, "A Perspective of The History of Women's Sports in Ancient Greece," *Journal of Sport History*, Vol. 11, No. 2 (Summer, 1984).

3. Patricia Campbell Warner. *When The Girls Came Out To Play: The Birth of American Sportswear* (Amherst and Boston: University of Massachusetts Press, 2006).

4. *Godey's Lady's Book*, May, 1864.

5. John A. Nicholas, "Women in Sport: Images from the Late Middle Ages." Slippery Rock University faculty website, http://srufaculty.sru.edu/john.nichols/research/womensport.htm.

6. William Fitzstephen's account of London 1173 (cleric and Thomas Becket's administrator).

7. *Godey's Lady's Book*, February, 1897.

8. "Some English notes on bicycle costumes for women," *Vogue,* October 3, 1895.

9. Joel Shrock, "Fashion," In *The Gilded Age* (Santa Barbara, CA: Greenwood, 2004).

10. Quoted in Valerie Steele, *Fashion and Eroticism: Ideals of Feminine Beauty from the Victorian Era Through the Jazz Age* (Oxford University Press, 1985).

11. William Davis, "The Bicycle and Its Adaptability to Military Purposes," *The Philistine,* Vol. 6, July, 1895.

12. "Tennis Costume," *Fashion, Costume, and Culture: Clothing, Headwear, Body Decorations, and Footwear through the Ages,* edited by Sara Pendergast and Tom Pendergast. Vol. 3: *European Culture from the Renaissance to the Modern Era* (Detroit: UXL, 2004).

13. Jeane Hoffman, "The Sutton Sisters," in *The Fireside Book of Tennis: A Complete History of the Game and its Great Players and Matches*, edited by Allison Danzig and Peter Schwed (Simon & Schuster, 1972).

14. "Senorita de alvarez creates a sensation at Wimbledon, playing in short trousers," *The New York Times,* June 24, 1931.

15. Miss Jacobs plans debut in shorts today; first net champion ever to adopt attire," *The New York Times*, August 15, 1933.

16. "Working play clothes," *Vogue,* July, 1933.

17. Quoted in Charlie Lee-Potter. *Sportswear in Vogue Since 1910* (New York: Abbeville Press. 1984).

18. Robinson, A. "Beauty style: What's news in beauty and fitness? Just about everything," *Vogue*, September, 1985.

19. Interview with Serena Williams, ASAP Sports, at the US Open, August 26, 2002, http://www.asapsports.com/show_interview.php?id=11692.

CHAPTER ELEVEN (pages 221–246)

1. Harold Koda, *Extreme Beauty: The Body Transformed* (New York: The Metropolitan Museum of Art, 2004).

2. Strutt, Joseph, *Complete View of the Dress and Habits of the People of England, London 1778*, quoted in Milton N. Grass, *History of Hosiery: From the Piloi of Ancient Greece to the Nylons of Modern America.* (New York: Fairchild Publications, 1955).

3. Linda Baumagrten and John Watson with Florine Carr, *Costume Close-Up: Clothing Construction and Pattern 1750–1790* (The Colonial Williamsburg Foundation, 1999).

4. Quoted in Avril Hart and Susan North, *Fashion in Detail: From the seventeenth and eighteenth centuries* (New York: Rizzoli, 2004).

5. Eleri, Lynn. *Underwear Fashion in Detail* (V&A Publishing, 2010).

6. *Graham's Illustrated Magazine*, Vol. 53, 1858, accessed at http://hdl.handle.net/2027/inu.32000000690125.

7. Eleri, Lynn. *Underwear Fashion in Detail* (V&A Publishing, 2010).

8. Janice West, "The Shoe in Art, the Shoe as Art," in *Footnotes on Shoes*, edited by Shari Benstock and Suzanne Ferriss (New Burnswick, NJ, and London: Rutgers University Press, 2001).

9. Cecil Beaton, *The Glass of Fashion* (Cassell, 1954).

10. Irene Castle, *Castles in the Air* (Doubleday, 1958).

11. "Flappers Resent Move for Regulation Dress," *The New York Times*, August 25, 1923.

12. Advertisement: "Save your nylon stockings," (A. B. C. stocking service), *Vogue*, September, 1943.

13. "Cosmetics 'Stockings' are Displayed Here," *The New York Times*, June 3, 1942.

14. Emily Spivack, "Stocking Series, Part 1: Wartime Rationing and Nylon Riots," Smithsonian.com, accessed at http://www.smithsonianmag.com/arts-culture/stocking-series-part-1-wartime-rationing-and-nylon-riots-25391066/?no-ist on September 29, 2014.

15. "Private screenings: Ann Miller," Turner Classic Movies, one-hour special, 1997.

16. Maureen Turim, "High Angles on Shoes," in *Footnotes on Shoes*, edited by Shari Benstock and Suzanne Ferriss (New Burnswick, NJ and London: Rutgers University Press, 2001).

17. Valerie Steele, *Shoes: A Lexicon of Style* (New York: Rizzoli, 1999).

18. Joel Lobenthal, *Radical Rags: Fashion of The Sixties* (Abbeville Press, Inc., 1990).

19. Valerie Steele, *Shoes: A Lexicon of Style* (New York: Rizzoli, 1999).

20. Cole, Shaun. "Trash, Glamour, Punk." Berg Fashion Library. 2000, accessed through Fashion Institute of Technology database, August 3, 2014.

21. Thierry-Maxime Loriot, ed., *The Fashion World of Jean Paul Gaultier: From the Sidewalk to the Catwalk* (Montreal: Museum of Fine Arts, New York: Abrams, 2011).

22. Ibid.

23. Ibid.

24. Hannah Marriot, "Les Nudes: how high heels in a variety of skin tones became museum pieces," *The Guardian.*, July 8, 2014, at http://www.theguardian.com/fashion/2014/jul/08/les-nudes-skin-tones-v-and-a-christian-louboutin-high-heels-controversy.

25. Ibid.

26. Tatiana Boncompagni "For Pantyhose, It's Back to Work," *The New York Times*, November 9, 2012.

27. Margo DeMello, *Feet and Footwear: A Cultural Encyclopedia* (Santa Barbara, CA: Greenwood Press/ABC-CLIO, 2009).

28. Lorraine Gamman, "Self Fashioning" in *Footnotes on Shoes*, edited by Shari Benstock and Suzanne Ferriss (New Burnswick, NJ and London: Rutgers University Press, 2001).

Sources

Abrantes, Laure Junot. *At the Court of Napoleon: Memoirs of the Duchess d'Aedbrantes.* Cassell Reference, 1992.

Adams, Tracy. *The Life and Afterlife of Isabeau of Bavaria.* Baltimore, MD: Johns Hopkins Press, 2010.

Albrecht, William P., ed. *The Loathly Lady in "Thomas of Erceldoune."* Albuquerque, NM: University of New Mexico, 1954.

Anderson Hay, Susan. *Paris to Providence: French Couture and the Tirocchi Dressmakers' Shop, 1915–1947.* Rhode Island School of Design, 2000.

Arnold, Dorothea. *The Royal Women of Amarna: Images of Beauty from Ancient Egypt.* NY: Metropolitan Museum of Art, dist. Harry N. Abrams, 1996.

Arnold, Janet. "Dashing Amazons: The Development of Women's Riding Dress, c. 1500–1900." In *Defining Dress: Dress as Object, Meaning and Identity,* edited by Amy de la Haye and Elizabeth Wilson, 10–29. Manchester U.K.: Manchester University Press, 1999.

Arnold, Rebecca. *The American Look: Fashion, Sportswear and the Image of Women in 1930s and 1940s.* London, New York: I.B. Tauris & Co, 2009.

D'Aulnoy, Marie la Comtesse. *Relations du voyage d'Espagne, c1691,* edited by Maria Susana Seguin. Paris: Editions Desjonqueres, 2005.

Bahrani, Zainab. Interview by e-mail, June 28, 2013.

———. *Women of Babylon: Gender and Representation in Mesopotamia.* London: Routledge, 2001.

Barber, Elizabeth Wayland. Interview by e-mail, May 1, 2013.

———. *Women's Work: the First 20,000 Years — Women, Cloth, and Society in Early Times.* NY: Norton, 1995.

Baumgarten, Linda. *Eighteenth-Century Clothing at Williamsburg.* The Colonial Foundation, 1986.

———. *Costume Close-Up: Clothing Construction and Patterns, 1750–1790.* Quite Specific Media Group, Ltd., 2000.

———. *What Clothes Reveal.* New Haven, CT: Yale University Press, 2002.

Beard, Patricia. *After the Ball.* NY: HarperCollins, 2003.

Beaumont, Cyril W. *Five Centuries of Ballet Design.* The Studio, Ltd., 1939.

Beaton, Cecil. *The Glass of Fashion.* Cassell, 1954.

Benhamou, Reed. "Fashion in the Mercure: From Human Foible to Female Failing," *Eighteenth-Century Studies,* 31,1, fall 1997, 27-43.

Ben-Horin, Keren. "What's Under Your Pareo? Unraveling the History of Gottex Beachwear." Master's thesis, Fashion Institute of Technology, 2013.

Benson, Elaine and John Esten. *Unmentionable: A Brief History of Underwear.* Simon & Schuster, 1996.

Benstock, Shari and Ferriss, Suzanne, eds. *Footnotes on Shoes.* New Burnswick, New Jersey, London: Rutgers University Press, 2001.

Bergerbrant, Sophie. "Bronze Age Identities: Costume, Conflict and Contact in Northern Europe 1600–1300 BC," *Stockholm Studies in Archaeology,* 43, 2007.

Bibesco, Martha (Princess). *Noblesse de Robe.* Paris: Bernard Grasset, 1928.

Blundell, Sue. "Clutching at Clothes." In *Women's Dress in the Ancient Greek World,* edited by Lloyd Llewellyn-Jones. Classical Press of Wales, 2002, 143-70.

Boucher, François. *20,000 Years of Fashion: The History of Costume and Personal Adornment.* NY: Harry S. Abrams, 1987.

Brier, Bob and Hoyt Hobbs. *Daily Life of Ancient Egyptians.* Westport, CT: Greenwood Press, 2000.

Bushman, Claudia L. *"A Good Poor Man's Wife"; Being a Chronicle of Harriet Hanson Robinson and Her Family in Nineteenth-Century New England.* Hanover, NH: University Press of New England, 1981.

Calmette, Joseph. *The Golden Age of Burgundy: The Magnificent Dukes and Their Courts,* translated by Doreen Weightman. NY: W. W. Norton, 1962.

Campbell, Catherine Lynn. "Social Dance: The Influence on Fashion, 1910–1914." Master's thesis, Fashion Institute of Technology, 1997.

Campbell Warner, Patricia. *When The Girls Came Out To Play: The Birth of American Sportswear*. Amherst and Boston: University of Massachusetts Press, 2006.

Chan, Susan K. *Coming On strong: Gender and Sexuality in Twentieth Century Women's Sport*. Cambridge, MA, and London: Harvard University Press, 1994.

Chazin-Bennahum, Judith. *Dance in the Shadow of the Guillotine*. Carbondale, IL: Southern Illinois University Press, 1988.

Clapp, Nicolas. *Sheba: Through the Desert in Search of the Legendary Queen*. Houghton Mifflin, 2001.

Cohen, Lisa. " 'Frock Consciousness': Virginia Woolf, the Open Secret and the Language of Fashion," *Fashion Theory*, 3, 2, 140–174.

Cole, Shaun. "Trash, Glamour, Punk." Berg Fashion Library. 2000, accessed through Fashion Institute of Technology database, August 3, 2014.

Coleman, Elizabeth Ann. *The Genius of Charles James*. NY: Holt, Rinehart and Winston, 1982.

Commire, Anne and Klezmer, Deborah, eds. "Sears, Eleanora (1881–1968)." *Dictionary of Women Worldwide: 25,000 Women Through the Ages*. Vol. 2. Detroit: Yorkin Publications, 2007.

Cordingly, David, Email interviews, July 3, 2013 and July 10, 2013.

———. *Under the Black Flag: The Romance and the Reality of Life among the Pirates*. NY: Random House, 1990.

———. *Women Sailors and Sailors' Women: An Untold Maritime History*. NY: Random House, 2001.

Cosgrave, Bronwyn. *The Complete History of Costume and Fashion from Ancient Egypt to the Present Day*. NY: Facts on File, 2000.

Coulter-Harris, Deborah M. *The Queen of Sheba: Legend, Literature & Lore*. Jefferson, NC: McFarland, 2013.

Crozier, Gladys Beattie. *The Tango and How to Dance It*. London: Andrew Melrose, Limited, 1913.

Cunningham, Patricia. "Annie Jenness Miller and Mabel Janness: Promoters of Physical Culture and Correct Dress," *Dress*, Vol. 16, 1990.

Cunnington, C. Willett and Phillis Cunnington. The History of Underclothes. London: Faber & Faber, 1951, revised edition 1981.

Dalton, Karen C. C. and Gates, Jr., Henry Louis, "Josephine Baker and Paul Colin: African-American Dance Seen through Parisian Eyes." *Critical Inquiry* , Vol. 24, No. 4 (Summer, 1998).

Daly, Ann. *Done Into Dance: Isadora Duncan in America*. Wesleyan University Press, 2010.

Davanzo Poli, Doretta. *Beachwear and Bathing Costumes*. Drama Pub., 1996.

David, Rosalie. *Handbook to Life in Ancient Egypt*. NY: Facts on File, 1998.

Davis, Martha and Shirley Weitz. "Sex Differences in Body Movements and Positions." In *Gender and Nonverbal Behavior*, edited by Clara Mayo and Nancy M. Henley. NY: Springer-Verlag, 1981, ch. 5.

Della Casa, Giovanni and M. F. Rusnak. *Galateo: Or, the Rules of Polite Behavior.* Edited and translated by M. F. Rusnak. Chicago: University of Chicago Press, 2013.

Delpierre, Madeleine. *Dress in France in the Eighteenth Century.* New Haven, CT: Yale University Press, 1997.

De La Tour du Pin Gouvernet, Henrietta-Lucy Dillon. *The Memoirs of Madame De La Tour du Pin.* London: Harvill Press, 1999.

De Marly, Diana. *Working Dress: A History of Occupational Clothing.* NY: Houghton Mifflin, 1986.

_____, *Costume on The Stage 1600–1940.* B. T. Batsford, 1982.

Dior, Christian. *Christian Dior and I.* Translated by Antonia Fraser. NY: E. P. Dutton, 1957.

Dixon Gottschild, Brenda. *Digging the Africanist Presence in American Performance: Dance and Other Contexts.* Praeger, 1998.

Duncan, Isadora. *My Life.* Revised and updated edition. W. W. Norton & Company, 2013.

Eckhart, Tammy Jo. "An Author-Centered Approach to Understanding Amazons in the Ancient World." PhD thesis, 2007.

Eleri, Lynn. *Underwear Fashion in Detail.* V & A Publishing 2010.

Emery, Lynne Fauley. *Black Dance: from 1919 to today.* Princeton, NJ: Princeton Book Co., c. 1988.

Ewing, Elizabeth. *Dress & Undress: A History of Women's Underwear.* London: B.T. Batsford, 1978.

Famiglietti, R. C. *Tales of the Marriage Bed from Medieval France, 1300–1500.* Providence, RI: Picardy Press, 1992.

Fischer, Gayle. "'Pantalets' and 'Turkish Trousers': Designing Freedom in the Mid-Nineteenth Century." *Feminist Studies,* Vol. 23, No. 1 (Spring, 1997), 110.

Font, Lourdes. "Dior, Christian." Oxford Art Online. Website of Oxford University Press, www.oxfordartonline.com, accessed October 6, 2014.

———. "Lanvin, Jeanne." Oxford Art Online. Website of Oxford University Press, www.oxfordartonline.com, accessed October 6, 2014.

———. "Vionnet, Madeleine." Oxford Art Online. Website of Oxford University Press, www.oxfordartonline.com, accessed October 6, 2014.

———. "Worth, Charles Frederick." Oxford Art Online. Website of Oxford University Press, www.oxfordartonline.com, accessed October 6, 2014.

Font, Lourdes and McMahon, Beth. "Fashion: Origins and development." Oxford Art Online. Website of Oxford University Press, www.oxfordartonline.com, accessed October 6, 2014.

Font, Lourdes et al. "Fashion: Categories of design." Oxford Art Online. Website of Oxford University Press, www.oxfordartonline.com, accessed October 6, 2014.

Fossoy, Solvi Helene and Sophie Bergerbrant. "Creativity and Corded Skirts from Bronze Age Scandinavia," *Textile,* 11,1, 20-37.

Frantham, Elaine. *Women in the Classical World.* NY: Oxford University Press, 1995.

Fraser, Flora. *Beloved Emma: The Life of Emma, Lady Hamilton.* NY: Anchor, 2004.

Gay, Robin. *The Art of Ancient Egypt.* Cambridge, MA: Harvard University Press, 1997.

Gero, Cassandra. "Pucci, Emilio." Oxford Art Online. Website of Oxford University Press, www.oxfordartonline.com, accessed October 25, 2013.

———. "Gernreich, Rudi." Oxford Art Online. Website of Oxford University Press, www.oxfordartonline.com, accessed October 1, 2014.

Gibbons, Rachel C. "The Queen as 'Social Mannequin': Consumerism and Expenditure at the Court of Isabeau of Bavaria, 1393–1422," *Journal of Medieval History,* 26,4, 371–95.

Gilligan, Ian. "Neanderthal Extinction and Modern Human Behavior: the Role of Climate Change and Clothing." *World Archaeology,* 39,4, 499–514.

Golden, Eve. *Vernon and Irene Castle's Ragtime Revolution.* University Press of Kentucky, 2007.

Graham F. Barlow, et al. "Theatre." Oxford Art Online. Website of Oxford University Press, www. oxfordartonline.com, accessed October 12, 2014.

Grass, Milton N. *History of Hosiery: From the Ploi of Ancient Greece to the Nylons of Modern America.* New York: Fairchild Publications, 1955.

Green, Lyn. "Seeing through Ancient Egyptian Clothes," *KMT: A Modern Journal of Ancient Egypt,* 6, 3, Fall 1995, 28–40, 76–77.

Grendler, Paul F., ed. "Sports." In *Renaissance: An Encyclopedia for Students.* Vol. 4. New York: Charles Scribner's Sons, 2004.

Groom, Gloria. *Impressionism, Fashion and Modernity.* Chicago: The Art Institute, 2012.

Grossbard, Judy and S. Merkel, Robert. " 'Modern' Wheels Liberated 'The Ladies' 100 Years Ago," *Dress,* Vol. 16, 1990.

Hales, Shelley. Interview by e-mail, May 24, 2013.

Hannel, Susan L, "The Influence of American Jazz on Fashion." Berg Fashion Library. 2004, accessed through Fashion Institute of Technology database, Oct. 1, 2014.

Hart, Avril and Susan North. *Fashion in Detail: From the seventeenth and eighteenth centuries.* NY: Rizzoli, 2000.

Hawthorne, Rosemary. *Stockings & Suspenders: A Quick Flash.* London: Souvenir Press, 1993.

Hersch, Matthew H. "High fashion: the women's undergarment industry and the foundations of American spaceflight." *Fashion Theory,* 13.3, Sept. 2009.

Hill, Colleen. *Exposed: A History of Lingerie.* Yale University Press, 2014.

Hoffman, Jeane. "The Sutton Sisters," in *The Fireside Book of Tennis: A Complete History of the Game and its Great Players and Matches.* Edited by Allison Danzig and Peter Schwed. Simon & Schuster, 1972.

Hollander, Anne. *Fabric of Vision: Dress and Drapery in Painting.* London: National Gallery, 2002.

———. *Sex and Suits.* NY: Knopf, 1994.

———. *Seeing Through Clothes.* New York: The Viking Press, 1978.

Holmstrom, Kirsten Gram. *Monodrama, Attitudes, Tableaux Vivants: Studies on Some Trends of Theatrical Fashion, 1770– 1815.* Stockholm: Almqvist & Wiksell, 1967.

Homans, Jennifer. *Apollo's Angels: A History of Ballet.* New York: Random House, 2011.

Horrox, Rosemary. *The Black Death.* NY: Manchester University Press, 1994.

Horton, Shaun. "Of Pastors and Petticoats: Humor and Authority in Puritan New England." *The New England Quarterly,* 82, 4, Dec. 2009, 608–36.

Howe, Elizabeth. *The First English Actresses: Women and Drama, 1660–1700.* NY: Cambridge University Press, 1982.

Hughes, Diane Owen. "Sumptuary Law and Social Relations in Renaissance Italy." In *Disputes and Settlements: Law and Human Relations in the West,* edited by John Bossy. NY: Cambridge University Press, 1984, 69–99.

Jirosak, Charlotte. "Ottoman Influences in Western Dress." In *Ottoman Costumes: From Textile to Identity*, edited by S. Faroqhi and C. Newmann. Istanbul: Eren Publishing, 2005.

Jones, Inigo. *Festival Designs by Inigo Jones: An Exhibition of Drawings for Scenery and Costumes for Court Masques of James I and Charles I*. International Exhibitions Foundation, 1967–68).

Kasson, John F. *Rudeness & Civility, Manners in Nineteenth Century Urban America*. NY: Hill and Wang, 1990.

Klapisch-Zuber, Christiane. *Women, Family, and Ritual in Renaissance Italy*. Translated by Lydia Cochrane. Chicago: University of Chicago, 1985.

Klepp, Ingun., Sørheim, Stig and Enstad, Kjetil. "Sports and Dress." Berg Fashion Library, accessed through Fashion Institute of Technology database, Sept. 30, 2014.

Koda, Harold. *Extreme Beauty: The Body Transformed*. New York: The Metropolitan Museum of Art, 2001.

Koda, Harold and Andrew Bolton. *Dangerous Liaisons: Fashion and Furniture in the Eighteenth Century*. New York: The Metropolitan Museum of Art, 2006.

Koda, Harold and Andrew Bolton. *Poiret*. New York: The Metropolitan Museum of Art, New Haven and London: Yale University Press, 2007.
Konig, Rene. *A La Mode: On the Social Psychology of Fashion*. Translated by F. Bradley (New York: Seabury Press, 1973.

Lansdell, Avril. *Seaside Fashions 1860–1939: A Study of Clothes Worn in or Beside The Sea*. (Princes Risborough: Shire, 1990).

Lassner, Jacob. *Demonizing the Queen of Sheba: Boundaries of Gender and Culture in Postbiblical Judaism and Medieval Islam*. Chicago: University of Chicago Press, 1993.

Lee-Potter, Charlie. *Sportswear in Vogue since 1910*. New York: Abbeville Press. 1984.

Leinwand, Gerald. *1927: High Tide of the Twenties*. NY: Basic Books, 2001.

Llewellyn-Jones, Lloyd. "A Woman's View? Dress, Eroticism, and the Ideal Female Body in Athenian Art." In *Women's Dress in the Ancient Greek World*, edited by Lloyd Llewellyn-Jones, Classical Press of Wales, 2002, 171–202.

Lobenthal, Joe. *Radical Rags: Fashion of the Sixties*. Abbeville Press, Inc., 1990.

Lorimer, Fanny Sra. *Booty: Girl Pirates of the High Seas*. San Francisco: Chronicle, 2002.

Marcar, Ariane in *The Clothed Body*, edited by Lisa Cleland, Mary Harlow and Lloyd Llewellyn Jones. Oxbow Books, 2005.

Martin, Richard and Koda, Harold. *Splash! A History of Swimwear*. New York: Rizzoli, 1990.

Meagher, John C. *Method and Meaning in Jonson's Masques*. Notre Dame, IN: University of Notre Dame Press, 1966.

Mendes, Valerie. *Fashion Since 1900*. Second edition. London: Thames & Hudson, 2010.

Müller, Florence, et al. *Yves Saint Laurent*. Paris: Musée des Beaux-Arts de la Ville de Paris, fondation Pierre Bergé-Yves Saint Laurent, 2010.

Mutnick, Nan. "Snapshot: Hosiery." Berg Fashion Library. Accessed through Fashion Institute of Technology database, July 17, 2014.

Newton, Stella Mary. *Fashion in the Age of the Black Prince: A Study of the Year 1340–1365*. New York: Boydell Press, 1980.

Nicholas, John A. "Women in Sport: Images from the Late Middle Ages." Slippery Rock University faculty website, http://srufaculty.sru.edu/john.nichols/research/womensport.htm.

Pendergast, Sara and Tom, eds. *Fashion, Costume, and Culture: Clothing, Headwear, Body Decorations, and Footwear through the Ages. Vol. 3: European Culture from the Renaissance to the Modern Era*. Detroit: UXL, 2004.

Plante, Ellen M. *Women at Home in Victorian America: A Social History*. NY: Facts on File, 1997.

Poiret, Paul. *King of Fashion: The Autobiography of Paul Poiret*. Translated by Stephen Haden Guest, Philadelphia, PA: J. B. Lippincott, 1931.

Poirier, Diane Elisabeth. *Tennis Fashion*. New York: Assouline Publishing, 2003.

Ravelhofer, Barbara. *The Early Stuart Masque*. London: Oxford University Press, 2006.

Reede, Jane. *High Style: Masterworks from the Brooklyn Museum Costume Collection at the Metropolitan Museum of Art*. The Metropolitan Museum of Art, 2010.

Roberts, Helene E. "The Exquisite Slave: The Role of Clothes in the Making of the Victorian Woman." *Signs*. Vol. 2, No. 3 (Spring, 1977), 554–69.

Roberts, Sarah, ed. *The Stocking Book*. (UK: Papadakis Publishers, 2010.

Rosenthal, Margaret F. *The Honorable Courtesan: Veronica Franco, Citizen and Writer in Sixteenth-Century Venice*. Chicago: University of Chicago Press, 1993.

Ross, Ishbel. *Crusades and Crinolines: The Life and Times of Ellen Curtis Demorest and William Jennings Demorest*. New York: Harper & Row, 1963.

Rusnak, M.F., ed. and translator. *Galateo or, The Rules of Polite Behavior*. Chicago: University of Chicago Press, 2013.

Richard Rutt. "Knitting." Oxford Art Online. Website of Oxford University Press, www.oxfordartonline.com, accessed October 2, 2014.

Scarce, Jennifer. *Women's Costume of the Middle East*. London: Routledge Curzon, 2003.

Schmidt, Christine. *The Swimsuit : Fashion from Poolside to Catwalk*. New York: Berg, 2012.

Sebesa, Judith Lynn, "Tunica Ralla, Tunica Spissa: The Colors and Textiles of Roman Costume in Sebesta and Larissa Bonfante." In *The World of Roman Costume*. University of Wisconsin, 1994.

Severa, Joan L. *Dressed for the Photographer*. Kent, Ohio: Kent State University, 1995.

———— and Bonfante, Larissa, *The World of Roman Costume*. Madison, WI: University of Wisconsin, 1994.

Shrock, Joel. "Fashion." In *The Gilded Age*. Santa Barbara, CA: Greenwood, 2004.

Sobol, Donald, *The Amazon of Greek Mythology*. South Brunswick, ME: A.S. Barnes, 1972.

Spears, Betty. "A Perspective of The History of Women's Sports in Ancient Greece." *Journal of Sport History*, Vol. 11, No. 2 (Summer, 1984).

Stearns, Marshall and Jean. *Jazz Dance: The Story of American Vernacular Dance*. Da Capo Press, 1968.

Steele, Valerie. *Shoes: A Lexicon of Style*. New York: Rizzoli, 1999.

————. *Fashion and Eroticism: Ideals of Feminine Beauty from the Victorian Era Through the Jazz Age*. Oxford University Press, 1985.

————, ed. *Encyclopedia of Clothing and Fashion*. Detroit: Charles Scribner's Sons, 2005.

Stoneman, Richard. *Palmyra and its Empire: Zenobia's Revolt against Rome*. Ann Arbor, MI: University of Michigan Press, 1993.

Strong, Roy. *Art and Power: Renaissance Festivals, 1450–1650*. Berkeley, CA: University of California Press, 1984.

Symons, David J. *Costume of Ancient Rome*. London: Chelsea House, 1987.

———— and Jack Cassin-Scott. *Costume of Ancient Greece*. London: Chelsea House, 1988.

Thomas, Chantal and Catherine Ormen. *Histoire de la Lingerie*. Paris: Pierrin, 2009.

Tyldesley, Joyce A. *Nefertiti: Egypt's Sun Queen*. NY: Viking, 1998.

Van Wees, Hans. "Clothes, class and gender in Homer." In *Body Language in the Greek and Roman Worlds*, edited by D. Cairns. Swansea: Classical Press of Wales, 1–36.

Veness, Ruth. "Investing the Barbarian? The Dress of Amazons in Athenian Art," In *Women's Dress in the Ancient Greek World,* edited by Lloyd Llewellyn-Jones, Classical Press of Wales, 2002, 95–110.

Vincent, Susan J. *The Anatomy of Fashion: Dressing the Body from the Renaissance to Today*. NY: Berg, 2009.

Vogelsand, Willem. "Trouser Wearing by Horse-Riding Nomads in Central Asia." *Berg Encyclopedia of World Dress*, Vol. 5, Sept. 2010.

Von Bothmer, Dietrich. *Amazons in Greek Art*. London: Clarendon, 1957.

Wallace, Carol McD., Don McDonagh, Jean L. Druesedow, Laurence Libin, and Constance Old. *Dance: A Very Social History*. New York: Metropolitan Museum of Art: Rizzoli, 1986.

Walker, Susan and Peter Higgs, eds. *Cleopatra of Egypt: From History to Myth*. Princeton, NJ: Princeton University Press, 2001.

Walters, Elizabeth J. *Attic Grave Reliefs that Represent Women in the Dress of Isis*. Princeton, NJ: American School of Classical Studies at Athens, 1988.

Ward, Susan. "Swimwear." *Encyclopedia of Clothing and Fashion*. Edited by Valerie Steele. Detroit: Charles Scribner's Sons, 2005.

Warhol, Andy and Hackett, Pat. *POPism: The Warhol '60s*. Harcourt Brace & Company, 1980.

Waugh, Nora. *Corsets and Crinolines*. London: Routledge, 1990.

Wilcox, R. Turner. *The Dictionary of Costume*. New York: Macmillan, 1987.

Wildeblood, Joan. *The Polite World: A Guide to Deportment of the English in Former Times*. London: David Poynter, 1973, 75.

Wilfond, *Terry G. Women and Gender in Ancient Egypt: From Prehistory to Late Antiquity*. Ann Arbor, MI: Kelsey Museum of Archaeology, 1997.

Wilson, Elizabeth and Lou Taylor. *Through the Looking Glass: A History of Dress from 1860 to the Present Day*. London: BBC Publications, 1989.

Young, John H. *Our Deportment, or the Manners, Conduct and Dress of the Most Refined Society*. Detroit: F.B. Dickerson, 1984.

Index